A PLAIN AND EASY
INTRODUCTION TO
PRACTICAL MUSIC

Thomas Morley

A PLAIN AND EASY
INTRODUCTION
TO
PRACTICAL MUSIC

Edited by
R. ALEC HARMAN

Lecturer in Music in the Durham Colleges,
University of Durham

With a Foreword by
THURSTON DART

Professor of Music at Cambridge University

W. W. NORTON & COMPANY INC.
Publishers New York

PRINTED IN GREAT BRITAIN

TO

R. O. MORRIS

1886–1948

CONTENTS

FOREWORD

THE PART music played in the life of the average sixteenth-century Englishman has perhaps been exaggerated; it is rather easy to assume that the wide and varied musical life of the last twenty-five years of Elizabeth's reign is typical of the century as a whole, but in fact this is by no means true. Many documents, manuscripts, and printed books must have been destroyed during the turbulent period from 1530 to 1560, and much has undoubtedly been lost since then. But sufficient material survives for some kind of picture of the musical life of the century as a whole to be reconstructed, even though some of the details, especially those concerning improvised music, folk-song, and folk-dance, are irrecoverably lost; and it is a picture that must be sketched as a background to Thomas Morley and his great *Introduction*.

In the early years of the century the performance of sacred and secular music was largely confined to the court, the musical chapels of the king and the greater nobility, and the larger monastic establishments. Most singers, composers, and players were professionals, and amateur musicians were extremely rare, though the king himself was one of the more outstanding ones. Musical notation was still most intricate, and any one who wished to become really familiar with its complexities needed to spend many years studying it. Moreover, the medieval guild tradition persisted that musical notation was an arcane art, not to be revealed to all comers; musicians were reluctant, too, to tell all they knew, for the obvious and perhaps rather sordidly commercial reason that their livelihood depended on their possession of specialized knowledge and skill. Printed books of music were dear, and so were manuscript copies. Even music manuscript paper was by no means cheap, and it had to be imported from the Continent.[1] Musical instruments were imported, too, and many of the musicians working here in the sixteenth century were foreigners. Fra Dionisio Memo, an organ virtuoso from Venice, long held an honoured position at the court of Henry VIII, and other Italian instrumentalists held posts as court musicians for many years, their instruments, their books, and their appointments being inherited at their death by their sons. Names like Bassano, Lupo, and Ferrabosco speak for themselves.

[1] Paper was first made in England in 1494, but the mill soon closed down. Throughout the following century virtually all the paper used in England was imported from the Continent, mainly from France.

The music surviving from this period falls into two categories: music written by Englishmen, and music written by foreigners. Nearly all of it is in manuscript, and much of it is foreign. From many poetical and other references it is clear that the favourite dance in aristocratic English circles was the French basse-danse, and the favourite tunes were ones that had been popular at the court of Burgundy years before. A treatise on dancing published in London in 1521 is more or less a translation of a French tutor of 1484, for instance, this in its turn being related to a Burgundian manuscript of forty years earlier still. Collections of motets in use in the royal chapels during the first thirty years of the sixteenth century contain quantities of Flemish motets; the hands in which they are written show all the characteristics of contemporary Flemish work. If a note in a manuscript now in the Royal College of Music collection is to be believed—and there is no reason to doubt its evidence—Anne Boleyn's favourite motet was a Flemish one. Catherine of Aragon, the king's first wife, came from a music-loving court; her train certainly included acrobats and dancers, and there is every reason to suppose it included musicians as well. Early sixteenth-century song books contain French and Flemish chansons popular in continental courts a generation or so earlier. This suggests that English musical taste lagged behind the Continent, and this is borne out by the musical style of the English songs, carols, and instrumental pieces found in these books. Though these have a distinction and dignity of their own, they seem stiff and archaic by comparison with songs by Flemish composers, or Italian frottole and madrigals of the same date; and it is interesting to note how little Italian music is found in the manuscripts of Henry VIII's time. Not that it can have been unknown, for there is a record of the Venetian ambassador's asking for a book of frottole to be forwarded to him from Venice, but the evidence of the English manuscripts seems to show that it cannot have been anything like as popular as the earlier French chansons.

The same distinction and dignity is found in the church music of Fayrfax and Taverner; yet this too is comparable in style with continental work of twenty or thirty years earlier. And none of their church music was printed during their lifetimes; no English press produced anything to compare with Petrucci's volumes of music by Josquin, Brumel, Agricola, and the rest. The little that was published is crude and trivial when placed by the side of the flood of exquisitely printed music pouring from the presses of men like Petrucci and his imitators in Italy, or Schoeffer and his successors in Mainz. And there is no English parallel to the output of the Parisian printer, Attaingnant; his first book appeared in 1528 or so, and by 1530 he had issued seventeen books of up-to-date chansons, dances, motets, and so on, including some for lute

and keyboard. These were only the first items in a long series of com-
paratively cheap music books. When it came to an end in 1550,
Attaingnant had made available to the public some thirty masses, more
than three hundred motets and other sacred works, and over two thousand
chansons, as well as ten books of keyboard music. The whole output
of the London music printers by the same date could be comfortably
carried in one hand: a ballad or two, a song or two, a collection of psalm
tunes (suppressed almost immediately it was published), and a single book
of *XX Songes* (1530) in three and four parts. This song book is some-
thing of a landmark in English music, it is true; but the men who
printed it 'at the Blackamoor's Head,' London, were almost certainly
foreigners. Moreover, copies must have been exceedingly expensive, and
the music it contained was for connoisseurs rather than for amateurs.

During the first thirty years of the century, then, music was an
embellishment of the ceremonies of the Court and the Church, and
something for a sophisticated man to listen to. Its dominant influences
were those of fifteenth-century France and Flanders, and it was distinctly
old-fashioned by contemporary Italian standards. Virtually nothing was
available in print, and the man in the street had to content himself with
ballad tunes picked up by ear, with the music he heard in church, and
with the noise of the trumpets, fifes, and drums that accompanied cere-
monial processions.

A picture of this kind is, of course, a faithful reproduction of the
economic and cultural links between the British Isles and the Continent.
For more than a century England's biggest export had been woollen
cloth, and the Low Countries were her best customers. The liturgy of
her Church closely resembled the rites of her cross-channel neighbours;
the costumes of her people, the architecture of her buildings, the manners
of her royal courts, her laws, her literature, her language—all represented
an extension of the traditions of the nearest continental peoples and were
intimately linked with them.

The events of the years between 1530 and 1560 cut across many of
these links, severing the continuity of the English cultural tradition in an
altogether unprecedented way, and greatly changing the internal organiza-
tion of the country as a whole. There is no time to do more than glance
at the effects of the Reformation in one narrow field, that of the country's
musical life. The suppression of the monasteries dispersed their great
accumulation of musical knowledge and experience throughout the land.
Cut off from their accustomed way of life, many monastic musicians
found fresh employment in the new cathedral foundations. Some
abandoned music altogether. Others took posts as resident tutors and
secretaries in the households of the great *nouveau riche* families. The
redistribution of monastic lands and wealth into the hands of the king,

his leading courtiers, and their friends, the growing number of high bourgeois merchants who had made fortunes in the wool trade and who modelled their households on those of the social strata immediately above them, the founding of new colleges at the twin universities of Oxford and Cambridge, and the heavy additional endowments received by many of the older colleges: all these circumstances and many others helped to provide the soil in which the new seeds of humanism and of the Italian renaissance were to take root. The London printers began to turn their attention to books of a new kind; books of courtesy and romances of chivalry yield their place to the Coverdale-Cranmer translation of the Bible and to Eliot's *Governour*. The new stirrings of later literature are represented by the poems of Wyatt and Surrey, Tottel's best-selling verse *Miscellany* of 1557, the magnificent collection of stories and histories comprising the *Mirror for Magistrates* (1555–9), and Hoby's translation of Castiglione's *Courtier* (1561).

The events of the Reformation and of the years following it placed no barrier across the flow of artists from abroad. Men like Parmigiano and Holbein lived and worked in England for many years. Flemish and German instrument makers with outlandish names—Beton, Theewes, Tresorer, Mercator—settled in London. Cabezon, the greatest Spanish organist of his time, Philip de Monte, and other eminent foreign musicians visited the capital and met the leading English composers; it is possible that Lassus, too, visited England. Music manuscripts from Henry's own establishment and those from the establishments of his nobles and their successors (the earls of Arundel, for instance) began to include a repertory of Italian and French dances of the newest kind. Pavanes, galliards, almans, and branles replaced the basse-dance as the fashionable formal dances.

Henry's children were as fond of music as their father had been. Tye dedicated his *Acts of the Apostles* to King Edward VI, who was probably his pupil. Mary played on the virginals before the King of France when she was still only a young girl; her New Year's gifts in 1556 included a 'fair cittern' and a roll of songs from John Shepherd. Elizabeth's musical tastes and accomplishments are too well known to need stressing here. Under the enlightened patronage of these monarchs English music made great strides; new forms included the In Nomines and Fantasias of Taverner, Tallis, Tye, and Parsons, and the first tentative steps towards the English anthem. An increasing amount of music was written or arranged for lute, virginals, and organ. Though not much of the output of secular song of this period has survived, what little there is shows a freshness and grace unknown in the music of twenty or thirty years earlier, coupled with that strangely sweet harmony that seems always to have been a feature of English music. The declamation is still rather

stiff and the polyphony is sometimes rough; much the same can be said
of the new music for the Anglican rite. Yet the promise of greatness is
there, and sometimes greatness itself.

The stage is now set for the splendour of the last forty years of the
century. By the fifteen-sixties Italian madrigals are beginning to circu-
late in England. The splendid set of part-books in the Fellows' Library,
Winchester College, contains the pick of French chansons and Italian
madrigals of twenty years earlier. While in the fifteenth century musical
establishments were a feature of only the very largest country castles
and mansions, by the end of Elizabeth's reign even the smaller houses
have their music books, their instruments, their distinguished resident
musicians and composers, and their visiting minstrels. Wilbye is at
Hengrave Hall, Kirbye at Rushbrooke, Dowland in the service of Lord
Howard de Walden. Sir Francis Drake takes a band of musicians round
the world with him. Belvoir Castle is visited almost yearly by the waits.
And in addition to the numerous professional musicians that appear on
the scene, there are the gentleman-composers like Thomas Whythorne,
Michael Cavendish, Antony Holborne, Sir Ferdinando Heybourne, and
John Cowden. Three lute tutors and another for the cittern and gittern
—the poor man's guitar—were published between 1560 and 1570, all
translated from the French. In 1571 appeared the first book of English
songs published for more than forty years, written by Whythorne and
printed probably at his own expense. Though its contents betray an
amateur at work, some pieces are clearly modelled on the Italian style and
others resemble contemporary French chansons and dances. Three years
later another lute tutor was published, as well as a simple book on the
rudiments of music. Byrd and Tallis's *Cantiones Sacrae*, printed by
Vautrollier in 1575, are the culminating point of this short but important
burst of music printing. They were the first product of a twenty-one-
year monopoly of music printing granted to the two composers by the
queen, and this was a fine beginning. But during the next twelve years
no new music was published in London at all, with the exception of
settings of the Genevan psalm tunes. And these were in any case not
included within the terms of the Byrd-Tallis monopoly, a situation which
was to lead to trouble later on. One new primer on the rudiments of
music was printed in 1584 and it must have met with some success,
since it was reprinted three years later. Written by an enthusiastic young
Irishman with unorthodox views on the teaching of singing, it was,
however, only a superficial and unimportant little pamphlet that made
no attempt to provide the comprehensive survey of the subject the
Elizabethan amateur was soon to need.

The sadly meagre results of the music printing monopoly may perhaps
be accounted for by the fact that neither Byrd nor Tallis had the leisure

and inclination to occupy himself with the office work involved. They certainly lost money quite heavily; in 1577 they petitioned the queen for help, perhaps exaggerating their losses to some extent, and they pointed out that Tallis was old and poorly off, and that Byrd was in debt and too busy with his Chapel Royal duties to supplement his income by teaching. Things were not much better in 1582, when the Stationers' Company maintained that the monopoly of music printing was not worth having, except for the possible profits to be made from printing manuscript paper. Their statement was signed by many members of the Company, including a certain Thomas East; when Tallis died three years later it was to East that Byrd assigned the monopoly, and East must have changed his mind very much during the intervening period, to judge by the tremendous changes in music publishing that resulted. In the hands of this business-like and enterprising man the printing of music became an important element of English musical life.

East started off well. He took over Vautrollier's fine but old-fashioned fount of music type, cast from punches cut by Petreius of Nuremberg, and since this was by now showing signs of wear, he acquired several new founts. These seem to be Dutch in design; he may have imported the punches, or he may have had them made on the spot by some of the Dutch craftsmen then resident in London. One of the results of the religious upheavals on the Continent had been a flood of refugees to England, and among them were undoubtedly many craftsmen of various kinds. In 1567 there were no fewer than 2,030 Dutchmen [1] in London alone—four-fifths of the foreign population of the city—and many had settled in the towns of East Anglia. Later on it was worth East's while to issue a Dutch psalter for them. Vautrollier himself was a Huguenot refugee.

In addition East provided himself with up-to-date founts of roman and italic letters in various sizes, together with some fine initial letters, borders, and blocks, and he set to work on his first book, Byrd's *Psalms, Sonnets, and Songs* (1587). Though its contents were perhaps still rather old-fashioned by Italian standards, its format and appearance showed that a new era in music printing had begun. It was in the standard small quarto size, long used in Italy for madrigal sets though never before used in England, and the printing was painstaking, crisp, and exact. Moreover, the buyer who wished to compare Byrd's rather non-madrigalian style with what was then being sung in Italy had only to wait for a year; in 1588 appeared Yonge's *Musica Transalpina*, a collection of Italian madrigals made by a singing man of St. Paul's for the daily pleasure of himself and a circle of 'Gentlemen and Merchants of good accompt.' The madrigals, a not very distinguished selection

[1] The term includes Netherlanders and Germans.

perhaps, are provided with an English translation, and two of the finest
of them are by Byrd himself.

Nor was the sale of these books confined to the really wealthy en-
thusiasts. *The French School-master* (1573) includes among its dialogues
a charming description of family music-making after dinner in the
household of an ordinary citizen. East clearly had a ready market for
his new ventures among men such as these, brought up to music at
school. At Dulwich, Westminster, Christ's Hospital, Merchant
Taylors', and even at a few local grammar schools, music was part of
the regular curriculum. The page, the apprentice, and the schoolboy
were expected to be able to sing and to play some instrument or other,
not necessarily very well.

By the end of 1593 East had been working as a printer-publisher for
six years. During this period the output of new music books from his
press was greater than that of all the previous eighty years of the century
added together.[1] He had published a fine anthology of Italian madrigals
in 1590, 'Englished' by the poet Thomas Watson (whose *Hecatompathia*
(1582) was the first use of the Italian form of the sonnet-cycle in England),
and more than three-quarters of its contents were by the most advanced
and brilliant of the Italian school, Luca Marenzio. Thirteen of them
had been printed for the first time in Venice only three years before their
London publication. East had also published the first of a consecutive
series of madrigal publications by Thomas Morley which inaugurated
the English madrigal school, perhaps the most splendid thirty years in
the whole history of English music. This book was the collection of
three-part canzonets, and it is worth noting that the canzonet—a par-
ticular kind of madrigal 'wherein little art can be shewed, being made
in strains the beginning of which is some point lightly touched, and
every strain repeated except the middle,' to give Morley's own definition
—was one of the newest Italian forms. In 1594 appeared Morley's four-
part madrigals, the first time this title had been used for music written
in England by an Englishman to English words. A year later came
Morley's two-part canzonets and five-part balletts: the ballett, another
special kind of madrigal in binary form with a fa-la refrain, had been
invented in Italy by Gastoldi and Quagliati only a few years earlier.
Some of the canzonets appear to be reworkings or adaptations of four-
part canzonets by Anerio published in 1586. Both Morley's books
were also issued in the same year in an edition with Italian words,
perhaps for export to East's agents abroad.

Byrd's music-printing patent expired in 1596 and the London printing
trade was quick to take advantage of this. Printers like Short and
Barley added music books to their lists of publications. Barley in fact

[1] Excluding settings of the metrical psalms.

probably began work on his music book for lute, pandora, and orpharion well before the actual expiry of the patent, and before the year was out he had produced not only this but also a 'plain man's guide to music.' Morley treats it contemptuously in his own book and, it must be admitted, not without justification. 1597 was a year of wonders: volume ii of *Musica Transalpina*, an inaugural lecture given at Gresham College by John Bull, Dowland's *First Book of Ayres,* madrigal books by Kirbye and Weelkes, a collection of Italian canzonets selected by Morley, a book of five‑ and six‑part canzonets of his own composition, many of them being provided with a lute part so that they could be sung as solo songs, a tutor for the virginals and an excellent book of cittern music, a book of chansons by the fashionable French composer, Tessier, and Morley's encyclopaedic *Plain and Easy Introduction to Practical Music* (entered on the Stationers' Register on 9th October 1596; it was by no means uncommon to stake a claim for a book in this way, some time before its actual publication).

Though Morley's health had long been poor, he was as active as ever during the next four years. He applied for a new printing monopoly in the place of the one held by his revered master and friend, William Byrd, and was granted it on 28th September 1598.[1] In 1598 he also found time to see a collection of five‑part Italian madrigals through the press. In 1599 he broke entirely new ground with the publication of the *Consort Lessons*, twenty‑one pieces arranged for the fascinating

[1] The methods by which he obtained it seem to have been as unethical as could be, though Morley was merely typical of his time in this respect. Morley's *Balletts* of 1595 had been dedicated to Sir Robert Cecil, then one of the most powerful and influential men in England, and on 23rd July 1598 Morley wrote to him to ask his help in obtaining the patent, promising half of the proceeds to young Christopher Heybourne, Ferdinando's brother. This was not Morley's first letter to Cecil on the subject, though the others are lost. The letters patent he was eventually granted assigned him sole right 'to imprinte or cause to be imprinted, any sett songs or parts of songs whatsoever or howsoever to be songe or playd.' By the time this appeared among the Decrees and Ordinances of the Stationers' Company on 6th October 1598, it had been expanded (as the result of Morley's letter to Cecil) to 'the sole printinge of sett songes in parts &c. in any tonge servinge for the musick either of church or chamber and also for the rulinge of any paper by impression to serve for the pricking or printinge of any songe or songes.' Now the company itself held a patent for the Psalter, Seres one for the Psalms of David, and Day one for the Psalms in metre, and the overlapping of these patents with Morley's led to undignified squabbles between Morley and Day in the following year, mark d by a very intransigent attitude on Morley's part. The Bishop of London was called in to try to settle the dispute, but had to write to Cecil on 18th October 1599 confessing his failure. These and other abuses of the system of monopolies led to their being considered *en bloc* by the House of Commons in 1600, and the House ruled that when Morley's patent expired no further monopoly on music printing would be granted— one of many decisions that they made on this occasion. The patent must have been a com‑ fortable source of income to Morley. A lawsuit of 1600 shows that his fee for permitting Dowland's second song book to be printed was £9 10s., and though half of this presumably had to go to Heybourne, Morley would still have been left with some £70 modern money. And Dowland's was only one of the books he licensed that year.

combination of treble and bass viols, bass recorder, lute, cittern, and pandora (a kind of bass cittern). Some of them were certainly designed as incidental music for the stage, and may perhaps have been heard during performances of Shakespeare's plays. Others are pure chamber music in which all six instruments are indispensable if the music is to sound as the composer intended: sensitive and discriminating instrumentation, no less than eight years before the production of Monteverdi's *Orfeo*! And abstract chamber music is something entirely new. In 1600 appeared his book of ayres for voice and lute, and new editions of the four-part madrigals (with additional numbers) and the five-part balletts. In 1601 the collection of Oriana madrigals was published, dedicated to the queen and composed by more than twenty of the most eminent contemporary composers. This completes the list of publications of Morley's work that appeared during his lifetime; much of his best music was never printed until centuries after his death (most of his church music, for instance, and his keyboard music). His music for viol consort is still in manuscript, and there is an unpublished madrigal or two. A pavane and galliard for lute were included in his book of ayres but are missing from the only surviving copy; another pavane was printed in Robert Dowland's *Variety of Lute-lessons* (1610).

Biographical details of this extraordinarily gifted and energetic man are rather sparse, and many even of these are pure conjecture. Born in 1557 or 1558, Morley was certainly a pupil of William Byrd and perhaps also of Sebastian Westcote, organist of St. Paul's Cathedral until his death in 1582. From 1583 until 1587 he was choirmaster of Norwich Cathedral, in the latter year marrying a certain Susan, sometime in the service of Lady Periam, a member of an old Exeter family. In the following year he graduated B. Mus. at Oxford, though there was no formal instruction in music at this time in either University. Morley's pride in this distinction must have been clouded by the death of his infant son, Thomas, in the same year. It is possible that Morley was organist of St. Giles, Cripplegate, for a period, and he was certainly organist of St. Paul's in 1591 (the date of his appointment is said to have been 1589). When the queen visited Elvetham in 1591 she was sumptuously entertained by the Earl of Hertford and among the music she heard was a pavane of Morley's that much pleased her. Morley himself is unlikely to have been present. Indeed it seems that he was mixed up in some rather shady affair in Flanders this year; on 3rd October a Catholic agent there named Charles Paget wrote to a colleague in England: 'ther is one Morley that playeth on the organes in poules that was with me in my house . . . suspecting his behaviour I intercepted letters that Mr. Nowell [the Dean of St. Paul's? or Henry Nowell, the courtier?] wrote to him whereby I discovered enough to have hanged

him. Nevertheless he showing with teares great repentaunce, and asking
on his knees forgivenes, I was content to let him goe.' In July 1592
Morley left St. Paul's and was sworn in as a Gentleman of the Chapel
Royal. Between 1596 and 1601 he was living in the parish of Little
St. Helen's, Bishopsgate; so was Shakespeare. Three of Morley's
children were baptized at St. Helen's: Frances (19th August 1596;
buried there on 2nd January 1598/9), Christopher (26th June 1599), and
Anne (28th July 1600). Their father's health had not been good for
some time and he had been 'compelled to keep at home'; this may have
been one of the reasons for his assigning the printing monopoly to East
for three years, on 29th May 1600. Certainly the monopoly seems to
have caused Morley constant worry, and he was probably glad to be rid
of it for a while. On 7th October 1602 George Woodson was sworn
in as a Gentleman of the Chapel ('in Thomas Morley's room'), and
since chapel appointments seem to have been for life, it is probable,
though not certain, that Morley was already dead by this date. Though
in 1603 a Margaret Morley was granted letters of administration for the
estate of her late husband, Thomas Morley, there is no reason to assume
she was the widow of the composer, since she lived in a different parish
(St. Botolph's, Billingsgate) and bore a different Christian name. At
least three men named Thomas Morley are mentioned in the pages of
the reports of the Historical Manuscripts Commission dealing with this
period; one was keeper of the queen's storehouses at some time before
1589, and another was a member of the Company of Eastland Merchants
in 1603. Both were Londoners and exact contemporaries of the com-
poser. Another was an alehouse keeper in Worcestershire in 1621.
Even as late as 1624 the name recurs among the reports. A further piece
of evidence bearing on the date of the composer's death would seem to be
the republication of his three-part canzonets in 1606, with four additional
numbers (almost certainly early works). At p. 19 of his edition of Court-
Book C of the Stationers' Company (London, The Bibliographical
Society: 1957) Professor W. A. Jackson publishes an entry strongly
suggesting that Morley was dead by 25th June 1606. Weelkes's three-
part Ayres (1608) contain an elegy on Morley's death. In short, Morley
was certainly dead by 1608, probably by June 1606, and very possibly as
early as the autumn of 1602.

There is no doubt that Morley was the right man to devise and produce
a comprehensive guide to music for the intelligent amateur. He had
received a thorough training as a pupil of Byrd, who must be accounted
one of the great teachers as well as one of the greatest composers of all
time; Morley's writings show that he was well grounded in medieval
treatises on music and acquainted with the other subjects of the Quad-
rivium. His knowledge of logic, rhetoric, and grammar was evidently

considerable. At least one collection of treatises rescued by Thomas
Tallis from the library of Waltham Abbey became part of Morley's own
library. His music itself shows that he was academically inclined, for
it is written in a very pure style and he nowhere allows himself to make
the daringly unorthodox experiments of men like Wilbye or Ward.
The writing of the *Introduction* took much time, as Morley tells us in his
preface, and it is fortunate that East could take over so much of the
detailed management of the printing business, thus leaving Morley free
to work. His ill health presumably kept him indoors, and he was thus
able to concentrate on the book over long periods of time; it is certainly
difficult to see how else it could have ever been finished.

The book is clearly the result of many years spent in reading, in
research, and in planning the form such a work should take. Morley's
printed collections of Italian madrigals and canzonets are probably by-
products of the immense amount of scoring he must himself have done
during the preparation of the book. His list of ninety composers, 'the
most part of whose works we have diligently perused for finding the true
use of the moods,' and twenty-one theorists, 'whose authorities be either
cited or used in this book,' is a formidable one, though not without a
touch of window-dressing; it is extremely doubtful, for instance, whether
he knew the work of obscure men like Tzamen, Vinea, and Luyr at
first hand. They are some of the many composers quoted by Glareanus
in his monumental *Dodecachordon* (1547), and almost unknown outside
its pages. Nevertheless Morley's list includes nearly all the leading
European composers and theorists of the late fifteenth and sixteenth
centuries as well as many earlier ones, and it is a fine index to Morley's
industry and patience. Perhaps Morley is a little disingenuous in
omitting Tigrini's name, since about half of the examples of cadential
treatment found on pp. 229–40 of the present edition of his book
are taken without acknowledgment from Tigrini's *Compendium* of 1588.
Of the composers he lists, thirty-nine are English; while many of them—
Power, Dunstable, Fayrfax, Taverner, Tallis, and Byrd, for instance
—are well known to-day, a number are mere names, little if any of
whose music has survived. 'Then was I forced to run to the works of
many, both strangers and Englishmen (whose labours, together with
their names, had been buried with me in perpetual oblivion if it had not
been for this occasion) for a solution and clearing of my doubt,' says
Morley, and names like Testwood, Ungle, Risby, Hodges, and Oclande
illustrate Morley's point very adequately to any one reading his book
some three and a half centuries after the death of its author.

It is not only the erudition lying behind the pages of the *Introduction*
that make it an important book. Unless an author is very skilful,
erudition compels respect but repels a reader, whether he is an Elizabethan

or a man of our own time, and not the least attractive feature of the book is Morley's light and certain touch in dealing with a difficult and often bewildering subject. His treatment of the complexities of sixteenth-century notation is a model exposition, almost the best of its kind, and his illustrative examples throughout the book cannot be bettered. Nearly all are by Morley himself and their style ranges from the beginning to the end of the sixteenth century. Morley is far better at pastiche of this sort than most modern writers of text-books on harmony and counterpoint, though he admittedly possessed advantages which they cannot have. Credit too must go to Peter Short, Morley's printer on this occasion and a comparative newcomer to music printing,[1] for his very competent production of what must have been a most trying book to handle from a typographer's point of view. The musical examples contain almost no misprints, more than can be said of much contemporary music printing, and the lay-out is spacious. Italic type and marginal headings are used very systematically to draw attention to important words, phrases, or points in Morley's argument. The press-work is clean and the register of the two-colour printing used in certain parts of the book is most exact.

In this discussion considerable stress has been laid on the physical appearance and lay-out of the book. This side of the technics of book-making is of the highest importance, yet it is one that has been much neglected in so many of the books about music printed in England since Morley's time. John Dowland's translation of Ornithoparcus' *Micrologus* (1609), Ravenscroft's *Brief Discourse* (1614), Playford's best-selling *Introduction to the Skill of Music*, which ran through innumerable editions, the 1771 reprint of Morley's book, the nineteenth-century harmony and counterpoint books, even the majority of twentieth-century books on musical subjects too often fall far below the standard set by Morley and Short in 1597, as far as ease of comprehension achieved by a well-thought-out presentation of material on the printed page is concerned. Much, too, can be learnt from Morley's prose style and orderliness, even though he now and then fumbles his way into impenetrable obscurity. He presents the material of his book in the form of a dialogue between a *Master* (Morley himself) and two pupils, *Philomathes* and his brother *Polymathes*. Ben Jonson might have called them Lovewit and Knowall, I suppose. During the course of the book the characters of all three come to life in a way which one might expect in a novel but hardly in a technical treatise. The Master is patient, kindly, and a great keeper of the peace when his scholars tend to fall a-brawling. On occasion he

[1] It is not at all clear why Morley abandoned his usual printer, East, when the time came to print the *Introduction* and the five- and six-part canzonets. Perhaps East already had all the work he could cope with in 1597; or Morley may have wanted to increase his income by eventually drawing patent fees from two printers.

seems tired; on occasion a gust of sharp-tongued wit shows that Morley
must have been able to hold his own among a generation of musicians
many of whom appear to have been almost as irrational, gossiping, and
malicious as those of any other generation. Of his two pupils, Philo-
mathes is earnest and apologetic and slightly on the defensive, Polymathes
more flashy and argumentative, and a bit of a prig as well.

As a literary work, then, the *Introduction* is a lively, stimulating con-
versation-piece, and for nearly all of its 322 pages of closely packed
teaching the reader is kept in a good humour. Some of the Annotations
are harder going, it is true, but the reader is given fair warning of this, and
it is difficult to see how the material they contain could be otherwise
presented. The book contains many sly allusions and catch-phrases
that must have provided some quiet amusement to an Elizabethan reader
who was well up in the literature of his own day; the flavour of most
of them cannot easily be recaptured now.

So much for the lay-out of the book and for its literary style. Morley's
aim in writing it was to train the average and ignorant music lover of
his time to the point where he was a competent scholar and a composer,
able to turn out a madrigal or motet in a sound contemporary style and
able, too, to move confidently through the intricate notation used at
various times between 1450 and 1600. A study of sixteenth-century
polyphony forms the basis of much university and conservatoire teaching
for the music student of to-day, and if he wishes to turn musicologist
then the period Morley deals with is by far the best for a beginner.
Morley's approach to these problems should therefore be of special value
to him, since it is that of a man far better acquainted with sixteenth-
century musical thought than any student living in 1962 can hope to be.

Morley divides his book into three sections. The first deals with what
may be considered as the sixteenth-century equivalent of the rudiments
of music, the second with the arts of counterpoint and canon, and the
third with composition. Morley begins by explaining notes and their
names, clefs, the hexachord system (a knowledge of which solves many
problems confronting the sixteenth-century musician, including some
involved in the application of *musica ficta*), ligatures, time-signatures, and
metres and other special features of mensural notation (coloration, dots of
division, proportions); his discussion is illustrated by musical examples
throughout. It is perhaps a little curious that Morley spends so much
time on matters which were obsolescent twenty years before he wrote his
book and had entirely dropped out of use twenty years afterwards.[1]
Even the up-to-date Morley seems not to realize the speed with which
musical fashions change; the English madrigal itself had only thirty

[1] Morley was a good scholar and he may well have felt that his laborious researches
deserved putting on record; moreover the subject he is dealing with is a very fascinating one.

years of splendour, and as it declined viol music took its place as the fashionable diversion of the musical amateur. Thirty years later his taste ran to catch-singing, the flageolet, and the fiddle.

The second part of the book 'treats of descant,' that is to say, of two- and three-part counterpoint on a *canto fermo*. Morley shows off his own skill as a contrapuntist by using the same *canto fermo* for all fifty-six of his examples of two- and three-part counterpoint, and the fourteen examples of canon are also on a single *canto fermo*. Phrases like 'Now I pray you set me a plainsong and I will try how I can sing upon it' emphasize that counterpoint must not be regarded as mere paper-work but as music for performance; that the rules of counterpoint in fact spring from, and are identical with, the rules for singing a satisfactory extempore countertune to a given theme.

This attitude underlies Morley's teaching in the third part of the book, dealing with composition. Once again Morley begins by setting his pupils to extemporize freely on a given *canto fermo*. The results, together with certain fragments of 'descant' and counterpoint by Taverner, Risby, and Pigott, are analysed in detail and corrected. Then the rules of three- and four-part harmony are given, together with a large number of model cadences in from three to six parts. Much of this material is taken from Tigrini and Zarlino, though the Morley who in Part I of his book was so scrupulous to note his authorities makes no such acknowledgment here.[1] After writing in a simple almost note-against-note four-part style, the pupil is set to construct a piece of sustained imitative counterpoint in four or five parts based on a given theme five or six notes long. Morley ends with a concise, perhaps rather summary, discussion of the various current musical forms of his time, again in large part adapted from Zarlino.

Morley's book contains some rather surprising obscurities and omissions. There may be three reasons why an author omits to deal with any given subject within the field he sets out to survey. The subject may not yet exist; we should not expect Morley to deal with continuo-playing, for instance. It may be something that he has forgotten about; perhaps an example of this in Morley is the question of underlaying words and music, which even in music written as late as the fifteen-nineties is still very much of a problem to a modern scholar. Or it may be one that he assumed his reader knew all about: the rather enigmatic discussion of 'high key' and 'low key,' and the entire omission of reference to *musica ficta* or to the duration of accidentals (even though many of the musical examples in the book require editorial accidentals if they are to make sense) may be instances of this. But it is clearly impossible to discover Morley's reasons for omitting some topics, and for discussing others so

[1] '. . . and as for the last part of the book, there is nothing in it which is not mine own.'

cursorily. I can do no more than note some of those I have come across during a fairly prolonged study of his book, in the hope that some other researcher may be able to follow them up. Underlay, *musica ficta*, and tessitura[1] are three that have been mentioned already; here are some others. Improvised ornamentation (p. 156): many of the variant readings in *Tudor Church Music* appear to be instances of this. Solfeggio: were the six duos to be sung to the sol-fa names of their notes, or to be played on instruments? (And how were the astonishing lower parts of 'Christ's Cross' to be performed?) The system of temperament in use on Elizabethan keyboard instruments: mean-tone, to judge by p. 103. Contemporary instruments and their music: the *Consort Lessons* show that this must have been a subject in which he was very interested, but he says almost nothing about it, making only the most casual of references to half a dozen instruments. The choice or composition of madrigal verse: we are told how to match the music to the words, but not how to find a poem for making into a madrigal. The natural sign: used only for b fa b mi, it seems, but in the fifth duo the printed flat in the phrase F♯ E F♭ has been corrected in ink to a natural in all the copies of the 1597 edition that I have seen (though in 1608 it appears once again as a flat). The sharp: Morley does not even define it or explain it at its first appearance on p. 18.

Something must be said about the impact of the book on the musical life of later times. It is difficult to say much about the commercial side of the early editions, for though the first edition exists in four different states, the differences do not seem to imply that the book was sold out the moment it appeared, being reprinted therefore three times within the year, but rather that alterations and corrections to the text were made while the book was still printing. Further corrections were incorporated in the musical text before the book reached the buyer; in addition to an errata list at the end of the book, there are ink corrections at certain points of the first edition, and these are found in all known copies. Morley seems to have been determined that his public should be well served. The second edition (1608) is an ugly page-by-page reprint of the first. Most of the faults in the music examples of 1597 are set correctly this time, but there are several new ones, and a number of minor slips in the setting-up of 1597 are scrupulously but ineptly retained in the new edition. Some of the wood blocks cut especially for the music examples of the 1597 edition were still in the printing shop and were used again; others

[1] For I interpret 'high key' and 'low key' as referring to the problems of pitch and transposition implied by the very stylized groupings of clefs used by Morley in his four-part madrigals and five-part canzonets and balletts. For instance, a treble clef in the top part is never accompanied by a bass clef in the lowest part, nor a soprano clef by a baritone clef, even though these clefs might be more suitable for the tessitura of the part concerned. See also pp. 274–5 of the present edition.

had to be recut, not always very accurately. One good feature of the
1608 edition is that much of the text is respelt and repunctuated. The
colon and semicolon are rare in 1597, but they have ousted many of the
commas in 1608 and the text consequently becomes much easier to
read. Humphrey Lownes, the printer of the second edition, must have
taken over some of the sheets of the first edition, for he issued some copies
between 1603 and 1608 under his own imprint and with the spurious
date 1597. The first edition probably consisted of five hundred copies
in all—an average sale of one a week for ten years. Its price was about
4s. unbound (perhaps 6s. bound in full leather); these prices are roughly
equivalent to £3 and £4 10s. modern money.

The *Introduction* was widely known in the seventeenth century. Ravens-
croft draws on it freely for his *Brief Discourse* (1614); so does Butler in
his *Principles of Music* (1636) and Praetorius in his *Syntagma Musicum*
(1618). The Italian theorist and historian of the *Camerata*, G. B. Doni,
speaks of Morley as 'il erudito musico inglese' in his *Discorso* (1635).
A German translation of Morley's book was made by Caspar Trost in
the early seventeenth century, but it seems not to have been published;
this is a little surprising in view of the undoubted popularity of Morley's
music on the Continent, for some of his collections were reprinted intact,
but to German words, and copies of the English editions seem to have
been in a number of foreign libraries.[1] Christopher Simpson's *Com-
pendium* (1665; the ninth edition was published in the seventeen-seventies),
Playford's *Introduction to the Skill of Music* (1654 onwards), and Mace's
Music's Monument (1676) contain a number of echoes of Morley's teaching.
Anthony à Wood, an enthusiastic amateur, writes in 1691–2 that
Morley was 'admirably well skill'd in the Theoretic part of Music,' and
Roger North agrees: 'for certain all the precepts in . . . [this] operose
tract of musick by way of dialogue . . . are sound.' The judicious
Burney (volume iii of his *History*, p. 99) says:

'If due allowance be made for the quaintness of the dialogue and
style of the time, and the work be considered as the first regular treatise
on Music that was printed in our language, the author will merit great
praise for the learning and instruction it contains. At present, indeed,
its utility is very much diminished, by the disuse of many things which
cost him great pains to explain; as well as by the introduction of new
methods of notation, new harmonies, and new modulations, since his
time, which, to render intelligible, require a more recent elementary
treatise. Yet though this work is redundant in some particulars, and

[1] References to some of the continental editions of M.s music may be found in M. H.
Schacht's curious *Musicus Danicus* (Copenhagen, 1687); M. himself is there described as
an Italian (!), and 'Musicus doctrina et ingenio clarus.'

deficient in others, it is still curious, and justly allowed to have been excellently adapted to the wants of the age in which it was written. However, its late republication in the original form, *totidem verbis,* whatever honour it may reflect on the memory of the author, some-what disgraces later times, which have not superseded this, by producing a better and more complete book of general instructions in English, after the lapse of so many years, and the perpetual cultivation and practice of the art, in our country, both by native musicians and foreigners.'

Burney is here referring to the subscription edition of the *Introduction* pre-pared by Walsh's successor, William Randall, and published in 1771 at 10*s*. 6*d*. to subscribers, 15*s*. to the public. Randall's transcription is not entirely satisfactory and his edition has become almost as rare as the originals. The importance and rarity of Morley's book prompted Dr. E. H. Fellowes to suggest to the Shakespeare Association that it should be reproduced in facsimile as one of their 'rare texts illustrating life and thought in Shakespeare's England,' and it was so published in 1937 by the Oxford University Press for the Association, at a price of one guinea. This edition in its turn has been unobtainable for some years, and the considerable reduction in page size from the original made it tiring to use. While it was still in print, however, it was responsible for a great revival of interest in Morley's book, and it is yet another instance of the indebtedness of all students of sixteenth-century music to the untiring energy and interest of Dr. Fellowes.

The present edition differs from the earlier reprints in one important respect; just as Morley saw fit to add an appendix to his book, con-sisting of 'Annotations necessary for the understanding of the Booke,' so the present edition has been provided with annotations designed to to help the present-day reader. But, to quote Morley: 'Seeing therfore further discourse wil be superfluous, I wil heere make an ende.'

THURSTON DART

Jesus College, Cambridge, 1962

EDITOR'S PREFACE

THOMAS MORLEY'S *A Plaine and Easie Introduction to Practicall Musicke* was first published in 1597, but the second edition did not appear, unfortunately, until 1608, some years after the author's death, for if Morley had lived to see it through the press he would certainly have made several corrections. The British Museum's copy of this edition originally belonged to Thomas Linley senior, for on the fly-leaf is written 'Thos. Linley, Bath 1756,' and underneath, in a different hand, 'Lent by him to W. J. who made the marginal MS. notes—they were begun at the request of T. L.—were proceeded in with a view of publishing a new edition of the author—discontinued from having things of more conse-quence which claimed superior attention. . . . William Jackson, April 24, 1797.' Jackson must have known of William Randall's edition of 1771, and his idea of publishing a new edition may have been abandoned for this reason rather than for those he mentions. The marginal notes are few and are almost entirely restricted to Part II.

Randall's edition mentioned above was issued by subscription in a completely new format in which he modernized a few words (e.g. 'dotted' for 'pricked') and, in an Appendix, arranged in score the motets and madrigals which occur both between the Peroratio and the Annota-tions and which follow the latter. All three editions contain a number of errors, especially that of 1771, and one of the aims of this new edition is to present the book in a completely accurate form. No other edition followed Randall's, but in 1937 the Shakespeare Association issued a fac-simile of the first edition with an introduction by Canon E. H. Fellowes; unfortunately the copy from which the facsimile was taken contains several insertions by a later hand, and the reduction in size from the original makes reading a matter of some difficulty, especially in the Annotations. On the other hand we must be grateful for the fact that this facsimile has made the book more generally available, the first three editions being of some rarity.

The present edition has aimed at producing the book in an easily readable form (and Morley's dialogue is eminently readable) and is designed more for the student than for the specialist; thus the following points should be mentioned:

(1) The original words (with a few exceptions) and construction have been retained, but the spelling and punctuation have been modernized. Any editorial additions are enclosed in square brackets.

(2) All the music examples have been transcribed into modern notation

and clefs, and bar-lines have been added where lacking in the original; this applies especially to Part I, for in Parts II and III Morley scores the majority of his examples with bar-lines; where these are missing 'dotted' bar-lines have been inserted. The original notation has been included (usually in facsimile) where it has been thought necessary. All original clefs are shown when they are not reproduced in facsimile; where there is no facsimile, the first note of the original has been inserted immediately after the original clef, unless the original note values have been retained. Redundant accidentals are omitted and editorial ones added above the notes. ⌐—⌐ above notes indicates that they are in ligature in the original, and ⌐ ⌐ that they are in black coloration. All other differences are indicated by footnotes.

(3) The footnotes in general have been inserted for the following reasons:

 (*a*) To give the full names, dates, and publications of the theorists and composers mentioned in the text. Only those works published before 1597 are included, except in the case of a composer who died before that date, when no list of publications is given. References to the works of Morley and Byrd are taken from the editions by Fellowes.

 (*b*) To remark on any point of particular interest.

 (*c*) To point out some of the stylistic features of the music examples.

 (*d*) To attempt to explain any passage or word whose meaning is not clear. (Many of these will doubtless be superfluous to the specialist of the period, but it is hoped that they will be of some help to the general student.)

 (*e*) For purposes of cross reference.

 (*f*) To indicate any departures from the original other than those specified in this Preface.

(4) The various sections of the book have been arranged in a more convenient form as follows (the original arrangement being shown first):

Part I	Part I
Part II	Annotations
Part III	Part II
Peroratio	Annotations
5 Motets and Madrigals	Part III
Annotations on Part I	Annotations
Annotations on Part II	Peroratio
Annotations on Part III	2 Motets
2 Motets	List of Authors
List of Authors	General Index

(5) The ornamental panels on the jacket have been taken from the original, where they are placed at the beginning of Parts III and II respectively. Morley's signature on the binding is reproduced from a cheque book of the Chapel Royal, by gracious permission of Her Majesty the Queen. The title-page which follows this Preface is that of the first edition.

(6) Whenever possible Morley's textual and musical quotations have been checked with the originals.

(7) In order to save engraving costs and also because they do not illustrate any point of notation all the pieces which Morley includes between the Peroratio and the Annotations have been omitted. They have in any case been reprinted elsewhere: *Eheu sustulerunt Dominum meum* (in *Morley's Collected Motets,* ed. H. K. Andrews and Thurston Dart—Stainer & Bell—as are the two motets retained) *Ard 'ogn hora* and *Perche tormi* (included in *Madrigals for Four Voices,* ed. Fellowes—Stainer & Bell); *O Amica mea* (ed. Terry—Curwen); *O Sleep, fond fancy* (included in *Canzonets to Two and Three Voices,* ed. Fellows—Stainer & Bell).

Quite apart from its historical importance (which is considerable) the book gives a vivid picture of Morley himself, both as a man and as a musician. As a man he was clearly outspoken in his opinions, but as sincere in his praise as he was severe in his criticism. He could tolerate neither conceit nor views that had no rational foundation, yet he preserves an admirable balance between the intellectual and emotional aspects of his art. He was widely read, knew Greek, Latin, and Italian, and must have possessed a considerable library. The masterly way in which he selects what to him were the essentials of music reveals a keen and critical brain, and, like his great teacher Byrd, he was probably something of a mathematician. Moreover, he possessed an excellent sense of humour, and it is this more than anything else which gives his characters life and makes much of the book such enjoyable as well as profitable reading.

As a musician Morley has often been labelled 'conservative,' and there is no doubt that he was neither as versatile nor as progressive as Byrd, for instance; on the other hand it is not, I believe, generally realized that the music examples in the *Plain and Easy Introduction* are not only among the last concerted vocal music that he ever composed (and how attractive some of it is), but also contain some quite 'advanced' passages, especially when one considers the nature of the book and Morley's claim 'that any of but mean capacity, so they can but truly sing their tunings (which we commonly call the six notes or Ut, Re, Mi, Fa, Sol, La) may, without any other help saving this book, perfectly learn to sing, make descant,

and set parts well and formally together.' Even assuming (as we must assume in a work of this kind) that Morley's pupils were of extraordinary aptitude, many of the examples whereby he instructs them are surprising for a musical 'Primer.'

This edition, perhaps inevitably, is the work of more than one hand, and I should like to thank all those who have contributed to it in any way, but more especially the following: First, Mr. Thurston Dart, not only for the masterly sketch of the social and musical background of Tudor England which precedes this Preface, but also for reading both my type-script and transcriptions and making numerous valuable suggestions; without his co-operation this edition would hardly have merited publica-tion. Secondly, Mr. R. J. Hall of J. M. Dent and Sons, who has spent a great deal of time and trouble over the production of a book of more than usual complexity. Thirdly, my wife, who has sacrificed many hours to the indispensable but dreary task of checking both my typescript and the proofs with the original. Lastly, the Durham Colleges Research Fund Committee for their generous assistance during the preparation of this edition.

<div align="right">R. ALEC HARMAN</div>

Durham, 1952

PREFACE TO THE SECOND EDITION

IN THE ten years that have elapsed since the First Edition of this book a number of errors have been noticed and a few second thoughts come to mind. Some of the former were pointed out in reviews (notably in those by Robert Stevenson and Gilbert Reaney), but most of them came to light during a careful perusal shortly after publication. The number and importance of the errors did not, I think impair the value of Morley's book, as all but a handful occurred in the footnotes, but it is very satis-factory to have this opportunity of correcting them and of incorporating the second thoughts mentioned above, and I am most grateful to the publishers for making it possible.

<div align="right">R. ALEC HARMAN</div>

Durham, 1962

(*Facing.*) Title-page of the first edition, reduced from
its original folio size. The woodcut border is signed
'I[ohannes] B[elles] F[ecit].'

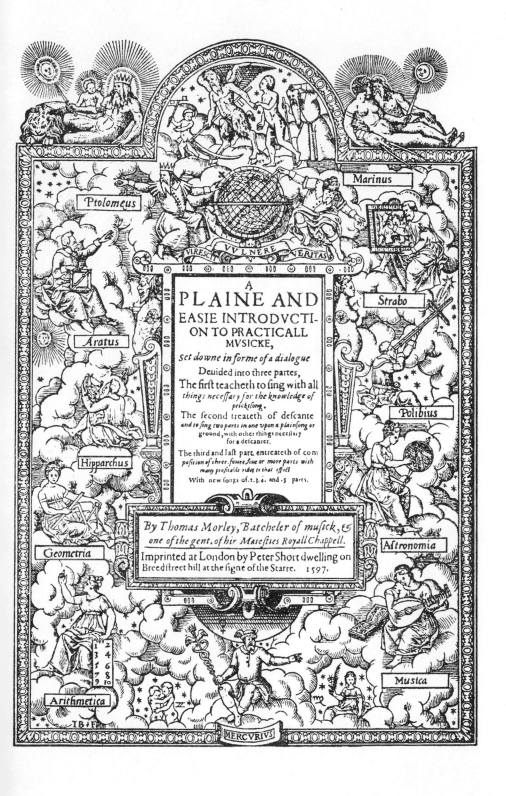

VIRESCIT VVLNERE VERITAS

A
PLAINE AND
EASIE INTRODVCTI-
ON TO PRACTICALL
MVSICKE,

Set downe in forme of a dialogue

Deuided into three partes,

The first teacheth to sing with all
things necessary for the knowledge of
pricktsong.

The second treateth of descante
and to sing two parts in one vpon a plainsong or
ground, with other things necessary
for a descanter.

The third and last part entreateth of com
position of three, foure, fiue or more parts with
many profitable rules to that effect

With new songs of. 1. 3. 4. and . 5. parts.

By *Thomas Morley, Batcheler of musick, &*
one of the gent. of hir Maiesties Royall Chappell.

Imprinted at London by Peter Short dwelling on
Breedstreet hill at the signe of the Starre. 1597.

MASTER WILLIAM BYRD,

One of the Gentlemen of Her Majesty's Chapel.

THERE BE two whose benefits to us can never be requited: God, and our parents; the one for that He gave us a reasonable soul, the other for that of them we have our being. To these the prince and (as Cicero termeth him) the God of the Philosophers added our masters, as those by whose directions the faculties of the reasonable soul be stirred up to enter into contemplation and searching of more than earthly things, whereby we obtain a second being, more to be wished and much more durable than that which any man since the world's creation hath received of his parents, causing us live in the minds of the virtuous, as it were, deified to the posterity. The consideration of this hath moved me to publish these labours of mine under your name, both to signify unto the world my thankful mind, and also to notify unto yourself in some sort the entire love and unfeigned affection which I bear unto you. And seeing we live in those days wherein envy reigneth, and that it is necessary for him who shall put to light any such thing as this is to choose such a patron as both with judgment may correct it, and with authority defend him from the rash censures of such as think they gain great praise in condemning others, accept (I pray you) of this book, both that you may exercise your deep skill in censuring of what shall be amiss, as also defend what is in it truly spoken, as that which sometime proceeded from yourself. So shall your approbation cause me think the better of it, and your name set in the forefront thereof be sufficient to abate the fury of many insulting Momists,[1] who think nothing true but what they do themselves. And as those verses were not esteemed Homer's which Aristarchus had not approved, so will I not avouch for mine that which by your censure shall be condemned. And so I rest,

In all love and affection to you most addicted,

THOMAS MORLEY

[1] Momus was the Greek god of censure and mockery (see also the verse by I. W., p. 4).

Ant. Holborne

in commendation of the Author

To whom can ye, sweet Muses, more with right
Impart your pains to praise his worthy skill,
Than unto him that taketh sole delight
In your sweet art, therewith the world to fill?
Then turn your tunes to Morley's worthy praise,
 And sing of him that sung of you so long,
 His name with laud and with due honour raise,
 That hath made you the matter of his song.
Like Orpheus sitting on high Thracian hill,
 That beasts and mountains to his ditties drew,
 So doth he draw with his sweet music's skill
 Men to attention of his science true.
Wherein it seems that Orpheus he exceeds,
 For he wild beasts, this, men with pleasure feeds.

Another, by A. B.[1]

What former times, through self-respecting good,
Of deep hid music closely kept unknown,
That in our tongue of all to b' understood,
Fully and plainly hath our Morley shown;
Whose worthy labours on so sweet a ground
(Great to himself to make thy good the better,
If that thyself do not thyself confound)
Will win him praise and make thee still his debtor.
 Buy, read, regard, mark with indifferent eye,
 More [2] good for music elsewhere doth not lie.[2]

Another, by I. W.[3]

A noise did rise like thunder in my hearing,
When in the East I saw dark clouds appearing,
Where Furies sat in sable mantles couched,
Haughty disdain with cruel envy matching,
Old Momus and young Zoilus all watching
How to disgrace what Morley hath avouched.
But lo, the day star with his bright beams shining,
Sent forth his aid to music's art refining,
Which gave such light for him whose eyes long hovered
To find a part where more lay [4] undiscovered,
That all his works with air so sweet perfumed
Shall live with fame when foes shall be consumed.

[1] The A. B. of *England's Helicon* (1590)? [2] A deliberate pun?
[3] Perhaps the John Wootton (Wotton) of *England's Helicon*. [4] A deliberate pun?

TO THE COURTEOUS READER

I DO NOT doubt but many (who have known my disposition in times past) will wonder that, amongst so many excellent musicians as be in this our country at this time, and far better furnished with learning than myself, I have taken upon me to set out that in our vulgar tongue which of all other things hath been in writing least known to our countrymen, and most in practice. Yet if they would consider the reasons moving me thereunto, they would not only leave to marvel but also think me worthy, if not of praise, yet of pardon for my pains. First, the earnest entreaty of my friends daily requesting, importuning, and, as it were, adjuring me by the love of my country, which next unto the glory of God ought to be most dear to every man. Which reason, so often told and repeated to me by them, chiefly caused me yield to their honest request in taking in hand this work which now I publish to the view of the world, not so much seeking thereby any name or glory (though no honest mind do condemn that also, and I might more largely by other means and less labour have obtained) as in some sort to further the studies of them who, being endued with good natural wits and well inclined to learn that divine art of music, are destitute of sufficient masters. Lastly, the solitary life which I lead (being compelled to keep at home) caused me be glad to find anything wherein to keep myself exercised for the benefit of my country.

But as concerning the book itself, if I had before I began it imagined half the pains and labour which it cost me, I would sooner have been persuaded to anything than to have taken in hand such a tedious piece of work, like unto a great sea, which the further I entered into the more I saw before me unpassed, so that at length, despairing ever to make an end (seeing that grow so big in mine hands which I thought to have shut up in two or three sheets of paper) I laid it aside in full determination to have proceeded no further, but to have left it off as shamefully as it was foolishly begun. But then, being admonished by some of my friends that it were pity to lose the fruits of the employment of so many good hours, and how justly I should be condemned of ignorant presumption in taking that in hand which I could not perform if I did not go forward, I resolved to endure whatsoever pain, labour, loss of time and expense and what not, rather than to leave that unbrought to an end in the which I was so far engulfed.

Taking, therefore, those precepts which being a child I learned, and laying them together in order, I began to compare them with some other of the same kind set down by some late writers. But then was I in a worse

case than before, for I found such diversity betwixt them that I knew not which part said truest or whom I might best believe. Then was I forced to run to the works of many, both strangers and Englishmen (whose labours, together with their names, had been buried with me in perpetual oblivion if it had not been for this occasion) for a solution and clearing of my doubt. But to my great grief then did I see the most part of mine own precepts false and easy to be confuted by the works of Taverner,[1] Fayrfax,[2] Cooper,[3] and infinite more, whose names it would be too tedious to set down in this place; but what labour it was to tumble, toss, and search so many books, and with what toil and weariness I was enforced to compare the parts for trying out the value of some notes (spending whole days, yea and many times weeks for the demonstration of one example which one would have thought might in a moment have been set down), I leave to thy discretion to consider, and none can fully under- stand but he who hath had or shall have occasion to do the like.

As for the method of the book, although it be not such as may in every part satisfy the curiosity of dichotomists, yet is it such as I thought most convenient for the capacity of the learner. And I have had an especial care that nothing should be set out of his own place, but that it which should serve to the understanding of that which followeth should be set first. And as for the definition, division, parts and kinds of music, I have omitted them as things only serving to content the learned and not for the instruction of the ignorant.[4]

Thus hast thou the reasons which moved me to take in hand and go forward with the book; the pains of making whereof, though they have been peculiar to me and only to me, yet will the profit redound to ? great number; and this much I may boldly affirm, that any of but mean capacity so that they can but truly sing their tunings, which we com- monly call the six notes, or Ut, Re, Mi, Fa, Sol, La, may, without any other help saving this book, perfectly learn to sing, make descant, and set parts well and formally together. But seeing in these latter days and doting age of the world there is nothing more subject to calumny and backbiting than that which is most true and right, and that as there be many who will enter into the reading of my book for their instruction, so I doubt not but divers also will read it, not so much for any pleasure or profit they look for in it, as to find something whereat to repine or take occasion of backbiting; such men I warn, that if in friendship they will (either publicly or privately) make me acquainted with anything in the book which either they like not or understand not, I will not only be content to give them a reason (and if I cannot, to turn to their opinion) but also think myself highly beholding to them. But if any man, either

[1] John Taverner (*c.* 1495–1545). [2] Robert Fayrfax (*d.* 1521).
[3] Or Robert Cowper (late fifteenth to early sixteenth century). [4] But see p. 100.

upon malice, or for ostentation of his own knowledge, or for ignorance (as who is more bold than blind Bayard), do either in hugger-mugger or openly calumniate that which either he understandeth not, or then maliciously wresteth to his own sense, he (as Augustus said by one who had spoken evil of him) shall find that I have a tongue also, and that 'me remorsurum petit,' he snarleth at one who will bite again, because I have said nothing without reason, or at least confirmed by the authorities of the best, both scholars and practitioners. There have also been some who (knowing their own insufficiency and not daring to disallow, nor being able to improve anything in the book) have nevertheless gone about to discredit both me and it another way, affirming that I have, by setting out thereof, maliciously gone about to take away the livings from a number of honest poor men who live (and that honestly) upon teaching not half of that which in this book may be found; but to answer those malicious caterpillars (who live upon the pains of other men) this book will be so far from the hindrance of any, that by the contrary it will cause those whom they allege to be thereby damnified to be more able to give reason for that which they do, whereas before they either did it at haphazard, or (for all reasons alleged) that they were so taught; so that if any at all owe me any thanks for the great pains which I have taken, they be, in my judgement, those who taught that which they knew not and may here, if they will, learn. But if the effect do not answer to my good meaning, and if many do not reap that benefit which I hoped, yet there will be no reason why I should be blamed, who have done what I could and given an occasion to others of better judgement and deeper skill than myself to do the like. And as for those ignorant Asses who take upon them to lead others, none being more blind than themselves, and yet without any reason, before they have seen their works, will condemn other men, I overpass them as being unworthy to be nominated, or that any man should vouchsafe to answer them, for they be indeed such as doing wickedly hate the light, for fear they should be espied.

And so (gentle Reader) hoping by thy favourable courtesy to avoid both the malice of the envious and the temerity of the ignorant, wishing thee the whole profit of the book and all perfection in thy studies, I rest,

Thine in all courtesy,

THO. MORLEY

THE FIRST PART

OF THE

INTRODUCTION TO MUSIC

Teaching to Sing

POLYMATHES PHILOMATHES MASTER

POLYMATHES. Stay, brother Philomathes, what haste? Whither go you so fast?

PHILOMATHES. To seek out an old friend of mine.

POL. But before you go I pray you repeat some of the discourses which you had yesternight at Master Sophobulus his banquet, for commonly he is not without both wise and learned guests.

PHI. It is true indeed, and yesternight there were a number of excellent scholars, both gentlemen and others, but all the propose[1] which then was discoursed upon was music.

POL. I trust you were contented to suffer others to speak of that matter.

PHI. I would that had been the worst, for I was compelled to discover mine own ignorance and confess that I knew nothing at all in it.

POL. How so?

PHI. Among the rest of the guests, by chance master Aphron came thither also, who, falling to discourse of music, was in an argument so quickly taken up and hotly pursued by Eudoxus and Calergus, two kinsmen of Sophobulus, as in his own art he was overthrown; but he still sticking in his opinion, the two gentlemen requested me to examine his reasons and confute them; but I refusing and pretending ignorance, the whole company condemned me of discourtesy, being fully persuaded that I had been as skilful in that art as they took me to be learned in others. But supper being ended and music books (according to the custom) being brought to the table, the mistress of the house presented me with a part earnestly requesting me to sing; but when, after many excuses, I protested unfeignedly that I could not, every one began to wonder; yea, some whispered to others demanding how I was brought up, so that upon shame of mine ignorance I go now to seek out mine old friend Master Gnorimus, to make myself his scholar.

[1] Probably from the French *propos* (subject).

POL. I am glad you are at length come to be of that mind, though I wished it sooner; therefore go, and I pray God send you such good success as you would wish to yourself. As for me I go to hear some mathematical lectures, so that I think about one time we may both meet at our lodging.

PHI. Farewell, for I sit upon thorns till I be gone, therefore I will make haste. But if I be not deceived I see him whom I seek sitting at yonder door. Out of doubt it is he, and it should seem he studieth upon some point of music; but I will drive him out of his dump.[1] Good morrow, sir.

MASTER. And you also, good master Philomathes, I am glad to see you, seeing it is so long ago since I saw you that I thought you had either been dead or then had vowed perpetually to keep your chamber and book to which you were so much addicted.

PHI. Indeed I have been well affected to my book. But how have you done since I saw you?

MA. My health since you saw me hath been so bad, as if it had been the pleasure of Him who may all things to have taken me out of the world I should have been very well contented, and have wished it more than once. But what business hath driven you to this end of the town?

PHI. My errand is to you, to make myself your scholar; and seeing I have found you at such convenient leisure, I am determined not to depart till I have one lesson in music.

MA. You tell me a wonder, for I have heard you so much speak against that art as to term it a corrupter of good manners and an allurement to vices, for which many of your companions termed you a Stoic.

PHI. It is true; but I am so far changed as of a Stoic I would willingly make a Pythagorean, and for that I am impatient of delay; I pray you begin even now.

MA. With a good will. But have you learned nothing at all in music before?

PHI. Nothing; therefore I pray begin at the very beginning and teach me as though I were a child.

MA. I will do so; and therefore behold, here is the Scale of Music, which we term the Gam. [*See table, page 11.*]

PHI. Indeed I see letters and syllables written here, but I do not understand them, nor their order.

MA. For the understanding of this Table you must begin at the lowest word Gam Ut and so go upwards to the end still ascending.

PHI. That I do understand. What is next?

MA. Then must you get it perfectly without book, to say it forwards and backwards. Secondly, you must learn to know wherein every key

[1] 'Reverie.'

Gamut table showing the hexachord deductions (solmization) for each key of the scale.

Keys[1] (sol-fa notes)		Prima sex vocum deductio[3]	Secunda deductio	Tertia deductio	Quarta ut prima	Quinta ut secunda	Sexta ut tertia	Septima ut prima[3]	
ee	e″							La	1 note[7]
dd	d″						La	Sol	2 notes
cc	c″						Sol	Fa	2 notes
bb	b′						Fa	♮Mi	2 notes, 2 clefs[4]
aa	a′					La	Mi	Re	3 notes
g	g′					Sol	Re	Ut 𝄞	3 notes
f	f′					Fa	Ut		2 notes
e	e′				La	Mi			2 notes
d	d′			La	Sol	Re			3 notes
c	c′			Sol	Fa	Ut 𝄡			3 notes
b	b			Fa	♮Mi[6]				2 notes, 2 clefs
a	a		La	Mi	Re				3 notes
G	g		Sol	Re	Ut				3 notes
F	f		Fa	Ut 𝄢					2 notes
E	e	La	Mi						2 notes
D	d	Sol	Re						2 notes
C	c	Fa	Ut						2 notes
²♮	B	Mi							1 note
A	A	Re							1 note
Γ	G	Ut							1 note

Bottom bracket groupings:
- Double or Treble Keys[1] (ee – e′)
- Mean Keys (d′ – f)
- Grave or Bass Keys (E – Γ)

¹ Keys = notes. In some early theoretical works it means clefs.
² The B can only be ♮ because Mi was always a major 3rd above Ut; it could only be Fa (B♭) if there was an F Ut below the G Ut (but see p. 16).
³ 'Prima sex vocum deductio' = the first note from which six others are deduced, etc. 'Quarta ut prima' = the fourth (deduction) as the first (deduction), etc.
⁴ See p. 12.
⁵ Helmholtz's notation; if in the text, brackets will be used, e.g. C sol fa (c′).
⁶ M. has '♭ Mi,' but 2nd edition has '♮ Mi,' which is correct (♮ square).
⁷ Note = sol-fa name.

standeth, that is, whether in line or in space. And thirdly, how many clefs and how many notes every key containeth.

PHI. What do you call a clef and what a note?

What a
Clef is. MA. A clef is a character set on a line at the beginning of a stave,[1] showing the height and lowness of every note standing on the same stave, or in space (although use hath taken it for a general rule never to set any clef in the space except the b clef [2]), and every space or line not having a clef set in it hath one understood, being only omitted for not pestering [3] the stave and saving of labour to the writer; [4] but here it is taken for a letter beginning the name of every key, and are they which you see here set at the beginning of every word.[5]

PHI. I take your meaning, so that every key hath but one clef, except b Fa b Mi.

MA. You have quickly and well conceived my meaning. The residue which you see written in syllables are the names of the notes.[6]

PHI. In this likewise I think I understand your meaning, but I see no reason why you should say the two bb be two several clefs, seeing they are but one twice named.

MA. The heralds shall answer that for me, for if you should ask them why two men of one name should not both give one Arms, they will straight answer you that they be of several houses, and therefore must give divers coats. So these two bb, though they be both comprehended under one name, yet they are in nature and character diverse.

PHI. This I do not understand.

MA. Nor cannot till you know all the clefs and the rising and falling of the voice for the true tuning of the notes.

PHI. I pray you then go forwards with the clefs; the definition of them I have heard before.

How many
Clefs there be. MA. There be in all seven clefs (as I told you before) as A, B, C, D, E, F, G; but in use in singing there be but four, that is to say the F fa ut (f), which is commonly in the bass or lowest part, being formed or The forms of made thus, 𝄢; the C sol fa ut (c') clef which is common to every part the usual
Clefs. and is made thus, 𝄡; the G sol re ut (g') clef which is commonly used in the treble or highest part and is made thus, 𝄞 [7]; and the b clef, which is common to every part, is made thus, ♭,[8] or thus, ♮, the one signifying the half note and flat singing, the other signifying the whole note or sharp singing.

[1] M. has 'verse,' here and elsewhere; in each case I have used 'stave.'

[2] e.g. 𝄬 [3] 'Crowding.' [4] Cf. p. 110–14.

[5] Second column in table. Γ—ee. [6] Ut, Re, Mi, etc.

[7] This is the form which M. uses throughout the book, but the modern form is given as early as 1537 in the *Compendium Musices* of Lampadius.

[8] M. uses an italic *b* throughout the book.

PHI. Now that you have told me the clefs, it followeth to speak of the tuning of the notes.

MA. It is so, and therefore be attentive and I will be brief. There be in music but six notes, which are called Ut, Re, Mi, Fa, Sol, La, and are commonly set down thus: The six notes in continual deduction.

PHI. In this I understand nothing, but that I see the F fa ut clef standing on the fourth line[1] from beneath.

MA. And do you not understand wherein the first note standeth?

PHI. Verily no.

MA. You must then reckon down from the clef as though the stave were the scale of music, assigning to every space and line a several key. How to know wherein every note standeth.

PHI. This is easy, and by this means I find that the first note standeth in Gam Ut (G) and the last in E la mi (e).

MA. You say true. Now sing them.

PHI. How shall I term the first note?

MA. If you remember that which before you told me you understood, you would resolve yourself of that doubt, but I pray you, in Gam ut how many clefs and how many notes?

PHI. One clef and one note. Oh, I cry you mercy, I was like a pot with a wide mouth that receiveth quickly and letteth out as quickly.

MA. Sing then after me till you can tune, for I will lead you in the tuning, and you shall name the notes yourself.

PHI. I can name them right till I come to C fa ut; now whether shall I term this Fa or Ut?

MA. Take this for a general rule, that in one deduction of the six notes you can have one name but once used, although indeed (if you could keep right tune) it were no matter how you named any note; but this we use commonly in singing, that except it be in the lowest note of the part we never use Ut. A note for singing of Ut.

PHI. How then, do you never sing Ut but in Gam ut?

MA. Not so, but if either Gam ut or C fa ut or F fa ut or G sol re ut be the lowest note of the part, then we may sing Ut there.

PHI. Now I conceive it.

MA. Then sing your six notes forward and backward.

PHI. Is this right?

ut re mi fa sol la la sol fa mi re ut

MA. Very well.

[1] M. has 'rule,' here and elsewhere; in each case I have used 'line.'

PHI. Now I pray you show me all the several keys wherein you may begin your six notes.

MA. Lo, here they be, set down at length.

PHI. Be these all the ways you may have these notes in the whole Gam?

MA. These and their octaves,[1] as what is done in Gam ut, may also be done in G sol re ut (*g*), and likewise in G sol re ut in alt (*g'*); and what in C fa ut (*c*), may be also in C sol fa ut (*c'*), and in C sol fa (*c"*); and what in F fa ut in bass (*f*), may also be done in F fa ut in alt (*f'*). But these be the three principal keys, containing the three natures or properties of singing.

PHI. Which be the three properties of singing?

The three properties of singing.

MA. B *quarre*, Properchant, and b *molle*.

PHI. What is b *quarre*?

MA. It is a property of singing wherein Mi is always sung in b fa ♮ mi, and is always when you sing Ut in Gam ut.

PHI. What is Properchant?

MA. It is a property of singing wherein you may sing either Fa or Mi in b fa ♮ mi, according as it shall be marked ♭ or thus ♮, and is when the Ut is in C fa ut.

PHI. What if there be no mark?

MA. There it is supposed to be sharp, ♮.

PHI. What is b *molle*?

MA. It is a property of singing wherein Fa must always be sung in b fa ♮ mi, and is when the Ut is in F fa ut.[2]

PHI. Now I think I understand all the clefs, and that you can hardly show me any note but that I can tell wherein it standeth.

MA. Then wherein doth the eighth note stand in this example?

PHI. In G sol re ut.

MA. How knew you?

PHI. By my proof.

MA. How do you prove it?

[1] M. has 'eights'; I have used 'octaves' here and elsewhere.

[2] The Hexachord system is based on the first six notes of the *major* scale; thus B is always ♮ when G is the keynote (b *quarre*), and always ♭ when F is the keynote (b *molle*). C may be the keynote with or without a ♭ in the signature (Properchant), for in this case the alteration of the B does not affect the essential feature of solmization, namely the Mi-Fa relationship. If, for instance, G is the keynote in a signature of one ♭ it will be called 'sol' or 're,' not 'ut.'

PHI. From the clef which is F fa ut, for the next key above F fa ut is G sol re ut. How to prove where a note standeth.

MA. Now sing this example:

PHI. . But now I am out of my bias,[1] for I know not what is above La.

MA. Wherein standeth the note whereof you doubt?

PHI. In F fa ut.

MA. And I pray you, F fa ut, how many clefs and how many notes?

PHI. One clef and two notes.

MA. Which be the two notes?

PHI. Fa and Ut.

MA. Now if you remember what I told you before concerning the singing of Ut you may not sing it in this place, so that of force you must sing Fa. What to be sung above La.

PHI. You say true, and I see that by this I should have a very good wit, for I have but a bad memory; but now I will sing forward.

MA. Do so then.

PHI. . But once again I know not how to go any further.

MA. Why?

PHI. Because I know not what to sing above this La.

MA. Wherein standeth the note?

PHI. In b fa ♮ mi.

MA. And what b hath it before it?

PHI. None.

MA. How then must you sing it when there is no sign?

PHI. I cry you mercy, it must be sharp, but I had forgotten the rule you gave me, and therefore I pray you set me another example to see if I have forgotten any more.

MA. Here is one; sing it.

PHI.

[1] 'Set course.' M. gives 'byas.'

MA. This is well sung. Now sing this other:

PHI.

ut re mi fa sol la mi fa sol la

MA. This is right; but could you sing it no otherwise?

PHI. No otherwise in tune, though I might alter the names of the notes.

MA. Of which, and how?

The three first notes may be altered in name though not in tune.

PHI. Of the three first thus &c. and so forth of their octaves.[1]

fa sol la

MA. You do well. Now for the last trial of your singing in continual deduction sing this perfectly, and I will say you understand plainsong well enough.

PHI. I know not how to begin.

MA. Why?

PHI. Because beneath Gam ut there is nothing, and the first note standeth beneath Gam ut.

Music is included in no certain bounds.

MA. Whereas you say there is nothing beneath Gam ut you deceive yourself, for music is included in no certain bounds, though the musicians do include their songs within a certain compass; and as you philosophers say that no number can be given so great but that you may give a greater, and no point so small but that you may give a smaller, so there can be no note given so high but you may give a higher, and none so low but that you may give a lower; and therefore call to mind that which I told you concerning the keys and their octaves, for if mathematically you consider it, it is true as well without the compass of the scale as within, and so may be continued infinitely.

PHI. Why then was your scale devised of twenty notes and no more?

MA. Because that compass was the reach of most voices, so that under Gam ut the voice seemed as a kind of humming, and above E la (e″) a kind of constrained shrieking. But we go from the purpose, and therefore proceed to the singing of your example.

What is to be sung under Gam ut.

PHI. Then I perceive the first note standeth in F fa ut under Gam ut, and being the lowest note of the stave I may there sing Ut.

MA. Right, or Fa if you will, as you did in the octave above in the other stave before. But go forward.

[1] In other words, reckoning the c below the f as Ut, in which case the f becomes Fa.

PHI. Then though there be no Re in Gam ut, nor Mi in A re, nor Fa in ♮ mi, etc., yet because they be in their octaves I may sing them there also. But I pray you why do you set a ♭ in E la mi (e♭), seeing there is neither in it nor in E la mi in alt (e') nor in E la (e") any Fa, and the ♭ clef is only set to those keys wherein there is Fa?

MA. Because there is no note of itself either flat or sharp, but compared with another is sometime flat and sometime sharp, so that there is no note in the whole scale which is not both sharp and flat; and seeing you might sing La in D sol re (d), you might also (altering the tune a little) sing Fa in E la mi (e♭).[1] There be many other flats in music, as the ♭ in A la mi re (a'),[2] whereof I will not speak at this time, because I will not cloy your memory with unprofitable precepts, and it will be time enough for you to learn them when you come to practise prick[3] song.

Every note both sharp and flat.

PHI. This I will then think sufficient till that time, and therefore go forward to some other matter.

MA. Then seeing you understand continual deduction I will show you it disjunct or abrupt.

PHI. In good time.

MA. Here, sing this stave.

The notes in disjunct deduction.

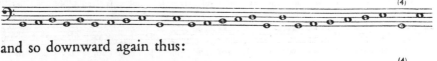

PHI. Here I know where all the notes stand, but I know not how to tune them by reason of their skipping.

MA. When you sing [music] imagine a note betwixt them thus, [music] and so leaving out the middle note, keeping the tune of the last note in your mind, you shall have the true tune; thus sing first Ut, Re, Mi, then sing Ut, Mi, and so the residue thus:

How to keep right tune in disjunct deduction.

(4)

and so downward again thus:

(4)

[1] If E la mi is sung as Fa (e♭) then Ut is B♭; but this B is always ♮ in the Guidonian scale, hence the 'tune' would have to be altered.

[2] See Part III, pp. 261–2. Also the examples on p. 18.

[3] 'Pricked' may either mean 'composed in measured notes as opposed to plainsong' (as here and on p. 40), or 'dotted' (i.e. a dotted minim.—Cf. p. 21, footnote 3.)

[4] Morley makes no comment on the leap of a major sixth though he must have been aware of the continental rule. This interval does not occur in the succeeding examples, but see p. 81, b. 84 and elsewhere.

PHI. Here is no difficulty but in the tuning, so that now I think I can keep tune and sing anything you can set down.

MA. Then sing this verse:

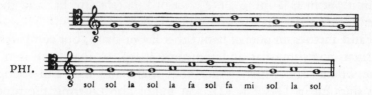

PHI.

MA. This is well sung. Now here be divers other examples of plain-song [1] which you may sing by yourself.

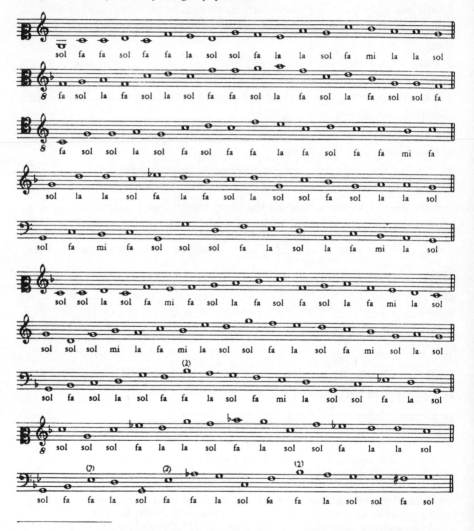

[1] i.e. simple tunes, not plainsong in the ecclesiastical sense.
[2] M. inserts a redundant ♭.

MA. Thus for the naming and tuning of the notes; it followeth to speak of the diversity of timing of them, for hitherto they have all been of one length or time, every note making up a whole stroke.[1]

PHI. What is stroke?

MA. It is a successive motion of the hand directing the quantity of every note and rest in the song with equal measure, according to the variety of signs and proportions; this they make threefold, More, Less, and Proportionate. The More stroke they call when the stroke comprehendeth the time of a breve; the Less when a time of a semibreve; and Proportionate where it comprehendeth three semibreves (as in a triple)[2] or three minims (as in the More Prolation); but this you cannot yet understand. Definition of strokes.
Division of strokes.

PHI. What is the timing of a note?

MA. It is a certain space or length wherein a note may be holden in singing. Definition of Time.

PHI. How is that known?

MA. By the form of the note and the Mood.

PHI. How many forms of notes be there?

MA. Eight, which be these: Usual forms of notes.

A Large A Long A Breve A Semibreve A Minim A Crotchet A Quaver A Semiquaver

PHI. What strokes be these set after every note?

MA. These be called rests or pauses, and what length the notes, Large, Long, breve, semibreve, or any other signified in sound, the same the rests or (as you call them) strokes doth in silence. But before we go any further we must speak of the ligatures. Rests.

PHI. What is a ligature?

MA. It is a combination or knitting together of two or more notes, altering (by their situation and order) the value of the same. What ligatures be.

PHI. And because we will in learning keep order, I pray speak of them according to their order, beginning at the first.

MA. I am contented; be then attentive and I will both be brief and plain. If your first note lack a tail, the second descending, it is a Long, as in this example:[3] First notes in ligatures without tails.

$$\begin{array}{cccccc} & 4\ 2\ 4 & 4 & 2 & 4\ 4 \end{array}$$

[1] Often called 'tactus.' [2] See example on p. 52, b. 4.

[3] Each note was given a number showing how many Less Strokes (by far the most common) were contained in each; thus Large = 8, Long = 4, breve = 2, semibreve = 1, minim = ½, etc. In succeeding footnotes, note values will be shown by italicized capitals, thus: Large (Maxima) = Mx, Long = L, breve = B, semibreve = S, minim = M, crotchet = C, quaver = Q, semiquaver = Sq.

PHI. But what if it have a tail?

MA. I pray you give me leave first to despatch those which lack tails, and then I will speak of them which have tails.

PHI. Go to, then. But what if the next note be ascending?

MA. Then is it a breve, thus:

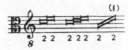

PHI. But interrupting your course of speech of ligatures, how many notes doth that character contain which you have set down last?

MA. Two.

PHI. Where do they stand? For I thought it should have been set

thus 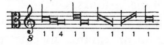 because it stretcheth from A la mi re to E la mi.

MA. The notes stand at the beginning and the end; as in this example aforesaid the first standeth in A la mi re, the last in E la mi.

PHI. Proceed then to the declaration of the tailed notes.

First notes with tails coming down.

MA. If the first note have a tail on the left side, hanging downward (the second ascending or descending), it is a breve.

First notes with tails ascending.

PHI. But how if the tail go upward?

MA. Then is it and the next immediately following (which I pray you keep well in mind) a semibreve.

PHI. How if the tail go both upward and downward?

MA. There is no note so formed as to have a tail of one side ⌐n go both upward and downward.

PHI. But how if it have a tail on the right side?

Every note having a tail on the right side is as though it were not in ligature.

MA. Then out of doubt it is as though it were not in ligature, and is a Long, thus:

and this is true as well in the last notes as in the first.

PHI. Now I think you have told me all that may be spoken of the first notes, I pray you proceed to the middle notes and their nature.

[1] Cf. p. 21, footnote 2.

MA. Their nature is easily known, for every note standing between two others is a breve, as thus:

A general rule for middle notes in ligatures.

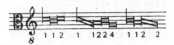

but if it follow immediately after another which had a tail going up, then is it a semibreve, as I told you before and you may see here in this:

Exception.

PHI. So; now go to the final or last notes.

MA. Every final note of a ligature descending, being a square note,[1] is a Long:

Final notes in ligatures.

PHI. But how if it be a hanging or long note?

MA. Then is it always breve, except it follow a note which hath the tail upward, as here:

But if the note be ascending, be it either square or long, it is always a breve, if it lack a tail, as thus:

There be also ligatures with dots,[3] whereof the first is three minims and the last likewise three minims, thus: 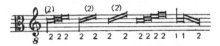 . And also others,

Dotted notes in ligature.

[1] i.e. provided it is not a 'hanging or long note.'

[2] In his *The Notation of Polyphonic Music, 900–1600* (p. 90), W. Apel (following Tinctoris) gives ▱ = *L B*, whereas M. (presumably following Gafurius) gives *B B*. Apel gives ▱ = *B B*, M. likewise (whereas Gafurius gives *L B*); thus M. gives the same values to both forms (on what authority he does not state), and though he must have known of the two conflicting views expressed by Tinctoris and Gafurius respectively, he does not fully subscribe to either.

In the footnote on p. 90 Apel describes the two ligatures given above as 'exceedingly rare,' it is therefore rather odd that M. should not only place them alongside the more usual forms, but actually include ▱ in the example on p. 39 in both Cantus and Bassus parts.

The following are not specifically given in Apel, though their values tally with his rules: ▱ ▱. ▱ is given on p. 313 under Franconian Notation, with a remark that it did not survive after 1300!

[3] M. has 'prick' here and elsewhere, which I have modernized to 'dot.'

whereof the first is three semibreves and the last two thus:

There be likewise other ligatures which I have seen but never used by any approved author, whereof I will cease to speak further, setting them only down with figures signifying their value of semibreves, whereof if you find one directly to be set over another, the lowest is always first sung:

PHI. Now have you fully declared the ligatures, all which I persuade myself I understand well enough, but because you speak of a dotted ligature, I do not understand that yet perfectly, therefore I pray you say what dots or points signify in singing.

Dots and their signification. MA. For the better instruction here is an example of the notes with a dot following every one of them:

A Dot of Augmentation. And as your rests signified the whole length of the notes in silence, so doth the dot the half of the note going before to be holden out in voice, not doubled, as (mark me) U-ut, Re-e, Mi-i, Fa-a, So-ol, La-a; and this dot is called a Dot of Augmentation.

PHI. What, be there any other dots?

MA. Yes, there be other dots, whereof we will speak in their own place.

PHI. Having learned the forms and value of the notes, rests, and dots by themselves, it followeth to speak of the Moods, and therefore I pray you to proceed to the declaration of them.

MA. Those who within these three hundred years have written the art of music, have set down the Moods otherwise than they either have been, or are taught now in England.

PHI. What have been the occasion of that?

MA. Although it be hard to assign the cause, yet may we conjecture that although the great music masters who excelled in foretime no doubt were wonderfully seen [1] in the knowledge thereof, as well in speculation as practice, yet since their death the knowledge of the art is decayed, and a more slight or superficial knowledge come instead thereof, so that it is come nowadays to that, that if they know the Common Mood [2] and some Triples, they seek no further.

PHI. Seeing that it is always commendable to know all, I pray you first to declare them as they were set down by others, and then as they are used nowadays.

[1] 'Skilled' (Shakespeare). [2] Imperfect of the Less Prolation (c) (see p. 31).

MA. I will, and therefore be attentive.

PHI. I shall be so attentive that, except I find some great doubt, I will not dismember your discourse till the end.

MA. Those which we now call Moods, they termed Degrees of music; [1] The defini- the definition they gave thus: A Degree is a certain mean whereby the value of the principal notes is perceived by some sign set before them. Degrees of music they made three: Mood, Time, and Prolation.

(margin) The definition of a Degree. Three Degrees.

PHI. What did they term a Mood?

MA. The due measuring of Longs and Larges, and was either Greater or Lesser.

(margin) Moods.

PHI. What did they term the Great Mood?

MA. The due measuring of Larges by Longs, and was either Perfect or Imperfect.

(margin) Great Mood,

PHI. What did they term the Great Mood Perfect?

MA. That which gave to the Large three Longs, for in both Mood, Time, and Prolation, that they term perfect which goeth by three, as the Great Mood is Perfect when three Longs go to the Large; the Less Mood is Perfect when three breves go to the Long; and Time is Perfect when three semibreves go to the breve. And his sign is o3.

(margin) Franchinus, Glareanus, Lossius.[2]

PHI. Which Mood did they term the Great one Imperfect?

MA. That which gave to the Large but two Longs; his sign is thus, c3:

(margin) Franchinus, op. mus. it. trac. 3, cap. 2. Lossius, lib.2, cap. 4. Peter Aron,[3] 'Toscanello.'

PHI. What did they call the Lesser Mood?

MA. That Mood which measured the Longs by breves, and is either

[1] Ornithoparcus uses Degrees in this sense.

[2] Franchinus Gafurius (1451–1522) (M. consistently spells it 'Gaufurius'): *Theoricum opus armonicae disciplinae* (Naples, 1480); *Theorica Musicae* (Milan, 1492; 2nd edition); *Practica Musicae* (Milan, 1496); *Musicae utriusque Cantus practica* (Brescia, 1497; 2nd edition); *Practica musicae utriusque Cantus* (Brescia, 1502; 3rd edition); *Practica musicae utriusque Cantus* (Brescia, 1502; 3rd edition. Venice, 1512; 4th edition); *Angelicum ac divinum Opus Musicae* (Milan, 1496, 1508); *De Harmonia Musicorum Instrumentorum* (Milan, 1518); *Apologia Francini Gafuri . . .* (Turin, 1520). Henricus Glareanus (1488–1563); *Dodecachordon* (1547). Lucas Lossius (1508–82): *Erotemata musicae practicae* (1563).

[3] Pietro Aron (died *c.* 1544): *Libri tres de Institutione harmonica* (1516); *Toscanello de la musica* (1523); *Lucidario in musica . . .* (1545). Thus 'Toscanello' (which M. spells 'Tuscanello') is not the name of an author, as the above and elsewhere might lead a 'beginner' to think.

24 THE FIRST PART

Perfect or Imperfect. The Less Mood Perfect was when the Long contained three breves, and his sign is thus, o2.

The Less Mood Imperfect is when the Long containeth but two breves, and his sign is thus, c2.

PHI. What called they Time?

MA. The dimension of the breve by semibreves, and is likewise Perfect or Imperfect. Perfect Time is when the breve containeth three semibreves; his signs are these, o3, c3, o.

The Time Imperfect is when the breve containeth but two semibreves, whose signs are these, o2, c2, c.

PHI. What is Prolation?

MA. It is the measuring of semibreves by minims, and is either More or Less. The More Prolation is when the semibreve containeth three minims; his signs be these, ⊙, ℂ.

The Less Prolation is when the semibreve containeth but two minims, the sign whereof is the absence of the dot, thus: o, c.

So that you may gather that the number doth signify the Mood, the circle the Time,[2] and the presence or absence of the point the Prolation, I have thought good for your further knowledge to set down before you the examples of all the Moods,[3] joined to their Times and Prolations.

[1] M. has '2' instead of 'c.'
[2] This is not always the case.
[3] Actually, some of the Moods are omitted, as will be seen later.

To begin with, the Great Mood Perfect; here is his example following without any Prolation, because in this Mood it is always *Imperfect.[1]

The Great Mood Imperfect with Time Perfect is set down thus:[2]

The Lesser Mood Perfect and Imperfect may be gathered out of the former two.[3] It followeth to set down the Prolation in the Times Perfect and Imperfect. Prolation Perfect in the Time Perfect is thus:

(Where there is respect had to the Prolation, the Mood is left out; but

[1] Great and Less Moods Perfect, Time Perfect, Prolation Imperfect (see p. 122). A complete diagram can be obtained by adding two minims to each of the semibreves.
[2] Great and Less Moods Imperfect, Time Perfect, Prolation Imperfect. For the complete diagram, see p. 26 (second example).
[3] i.e. by omitting the Large in each of the two previous examples. M. has here omitted three examples which he gives in the table on p. 125, and I include them for the sake of completeness: (1) Great and Less Moods Perfect, Time Perfect, Prolation Perfect:

(2) Great Mood Imperfect, Less Mood Perfect, Time Imperfect, Prolation Perfect:

(3). Great Mood Imperfect, Less Mood Perfect, Time Imperfect, Prolation Imperfect:

yet to make a difference, when the Mood is shown it is set by the Large; when the Prolation is shown it is always within.) [1]

Great Mood Imperfect, Small Mood Imperfect, Time Imperfect and Prolation Perfect. Prolation Perfect in the Time Imperfect is set thus:

Both Moods Imperfect, Time Perfect and Prolation Imperfect. Prolation Imperfect in the Perfect Time is set down thus:

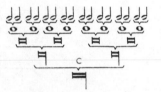

Both Moods, Time and Prolation Imperfect. The Imperfect Prolation in the Imperfect Time, thus:

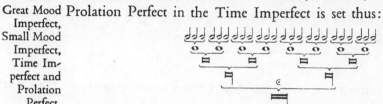

And because you may the better remember the value of every note according to every sign set before it, here is a table of them.

A Table containing the value of every Note, according to the value of the Moodes or signes.

½		⅔		·		⅔		⅔		⅔		1		1	
	2		2		2		2		2		2		3		3
1		1		1		1		1		1		3		3	
	3		3		2		2		3		2		3		2
3		3		2		2		3		2		9		6	
	3		2		3		2		2		2		2		2.
9		6		6		4		6		4		18		12	
	3		2		2		2		2		2		2		2
27		12		12		8		12		8		36		24	
	O3		C3		O2		C2		O		C		⊙		ℂ

[1] M. would seem to mean by this somewhat obscure afterthought that when both Moods are assumed to be Imperfect, as they are for the signs ⊙, ℂ, o, c (cf. p. 125), and it is only Time and Prolation which differ, then the signs, ⊙, ℂ, o, c are placed 'within' the diagram. But when the Moods themselves are specially indicated, as in the signs o3, c2, etc., then these signs are placed 'by the Large.'

PHI. I pray you explain this table, and declare the use thereof.

MA. In the table there is no difficulty if you consider it attentively, yet The use of the precedent Table. to take away all scruple I will show the use of it. In the lower part stand the signs, and just over them the notes, that if you doubt of the value of any note in any sign, seek out the sign in the lowest part of the table, and just over it you shall find the note; then at the left hand you shall see a number set even with it, showing the value or how many semibreves it containeth; over it you shall find how many of the next lesser notes belong to it in that sign, as for example, in the Great Mood Perfect you doubt how many breves the Long containeth; in the lowest part of the table on the left hand you find this sign, o3, which is the Mood you sought; just over that sign you find a Large, over that the number 3, and over that a Long; now having found your Long, you find hard by it on the left hand the number of 9, signifying that it is nine semibreves in that Mood, over it you find the figure of 3, signifying that there belong three breves to the Long in that Mood; and so forth with the rest.[1]

PHI. This is easy and very profitable, therefore seeing you have set down the ancient Moods (which hereafter may come in request, as the shotten-bellied doublet and the great breeches), I pray you come to the declaration of those which we use now.

MA. I will, but first you shall have an example [*see pages 28, 29*] of the use of your Moods in singing, where also you have an example of augmentation (of which we shall speak another time[2]) in the treble and Mean parts.[3] The tenor part expresseth the Lesser Mood Perfect, that is, three breves to the Long; the black Longs contain but two breves, but when a white

[1] This table (and the one on p. 125), the preceding diagrams, and succeeding examples do not make it clear that o3, o2, etc., are Proportional signs indicating Diminution, for they were only used in pieces written mainly in *M*'s or greater notes (cf. p. 28, tenor, and p. 53). On p. 43 M. states that Dupla Proportion is shown both by ¢ and o2 (amongst other signs), and that the *B* is always the tactus (the More stroke, cf. p. 19) when ¢ is placed at the beginning of a piece (p. 40); this *B* has the same value as a *S* in a piece governed by c. o3 is a sign for Tripla Proportion with the perfect *B* as tactus (the Proportionate stroke) which also has the same value as a *S* in c. Thus a piece governed by ¢, o3, etc., was always (theoretically) sung at a brisker tempo than if the same piece was governed by c or o. This distinction was by no means always made in England (cf. p. 40). The only signs in which the *S* is the tactus are ⊙, ¢ (the Proportionate stroke), and o, c (the Less stroke).

The purpose of the tables and diagrams was to demonstrate the various mensuration signs which were in use both before and during M.'s time, but by his day (as he says) only the last four were commonly employed, Proportions usually being shown by ¢, ɔ, etc., or numbers (cf. p. 43 et seq.).

[2] Cf. p. 42.

[3] The signs ø (Discantus and altus), o2 (tenor), and ø (bassus) all imply Diminution in Dupla Proportion (cf. footnote above and p. 43), but ø also implies Augmentation in relation to o2 and ø (cf. p. 42), so that in fact the note values of the upper parts are sung as written while those of the two lower parts are halved—a very clumsy arrangement on M.'s part.

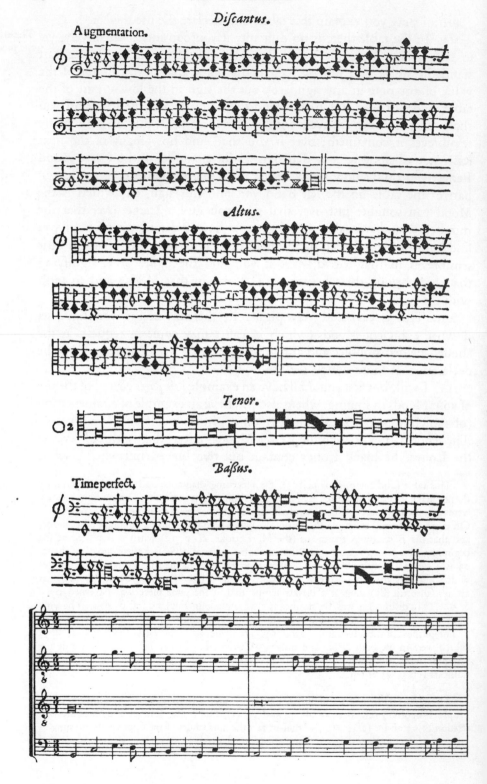

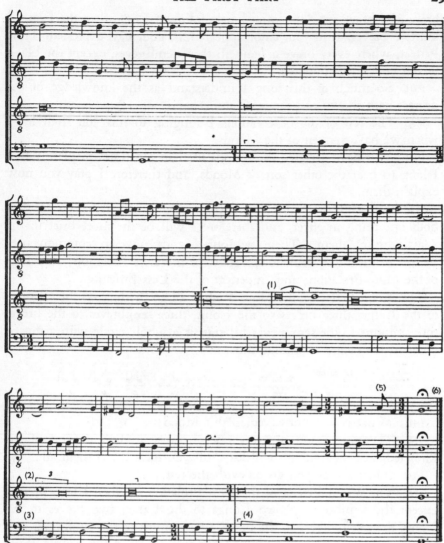

[1] Blackening or 'coloration' involves not only Imperfection but also a change of accent, hence the alteration to $\frac{2}{1}$ time. This ligature is wrong, as it means LB (transcribed BS); it should be the same as the second ligature, i.e. BB (transcribed SS).

[2] M. has D for the first note of this ligature, in error.

[3] Near octaves.

[4] If this ligature were white it would consist of two perfect B (= 3S each), but blackened (imperfected) the B = 2S each (1S in the transcription).

[5] Upward resolution of a 'consonant fourth' combined with Cambiata in the alto.

[6] The conventional last note of any part was a L, regardless of the length actually required; unless stated otherwise I have transcribed final notes as 𝄽 or 𝄼; the B in the Discantus is a misprint.

This is Im- breve or a breve rest doth immediately follow a Long, then the Long is
perfection, but two breves, as in your tenor appeareth. Your bass expresseth Time
whereof here-
after.[1] Perfect, where every breve containeth three semibreves, except the black
which containeth but two.

PHI. So much of this song I understand as the knowledge of the
degrees hath shown me, the rest I understand not.

MA. The rest of the observations belonging to this you shall learn
when we have spoken of the Moods.

PHI. You have declared the Moods used in old times so plainly that
I long to hear the other sort of Moods, and therefore I pray you now
explain them.

Exposition of MA. Although they differ in order of teaching and name, yet are they
the four usual both one thing in effect, and therefore I will be the more brief in the
Moods. explaining of them. There be four Moods now in common use:
Perfect of the More Prolation; Perfect of the Less Prolation; Imperfect
of the More Prolation; and Imperfect of the Less Prolation.

Perfect of the The Mood Perfect of the More is when all go by three, as three Longs
More. to the Large, three breves to the Long, three semibreves to the breve,
three minims to the semibreve; his sign is a whole circle with a dot or
point in the centre or middle thus ⊙.[2]

PHI. What is to be observed in this Mood?

MA. The observation of every one; because it doth depend of the
knowledge of them all we will leave till you have heard them all.

PHI. Then I pray you go on with the rest.

Perfect of MA. The Mood Perfect of the Less Prolation is when all go by two
the Less. except the semibreve, as two Longs to the Large, two breves to the
Long, three semibreves to the breve, two minims to the semibreve, and
his sign is a whole circle without any point or dot in the middle, thus:

PHI. Very well, proceed.

Imperfect of MA. The Mood Imperfect of the More Prolation is when all go by two
the More. except the minim which goeth by three, as two Longs to the Large, two
breves to the Long, two semibreves to the breve, and three minims to
the semibreve, so that though in this Mood the breve be but two

[1] Cf. p. 41.
[2] M. is here confounding theory with practice, for in the diagram on p. 25 and in the
tables on pp. 26 and 125 he gives ⊙ as denoting Great and Less Moods *Imperfect*. ⊙3 is the
correct sign for the above diagram, not ⊙.

semibreves, yet you must understand that he is six minims, and every semibreve three minims; his sign is a half circle set at the beginning of the song with a dot in the middle, thus:

The Mood Imperfect of the Less Prolation is when all go by two, as *Imperfect of* two Longs to the Large, two breves to the Long, two semibreves to the *the Less.* breve, and two minims to the semibreve, two crotchets to the minim, etc. His sign is a half circle without a dot or point set by him, as thus:[1]

This Mood is in such use as whensoever there is no Mood set at the beginning of the song, it is always imagined to be this, and in respect of it all the rest are esteemed as strangers.[2]

PHI. This is well. Now I pray you show me what is to be observed in every one of the Moods.

MA. The particular observations, because they are best conceived by examples, I will set you down one of every several Mood; and to begin with the Perfect of the More, take this example of a Duo.

Cantus.

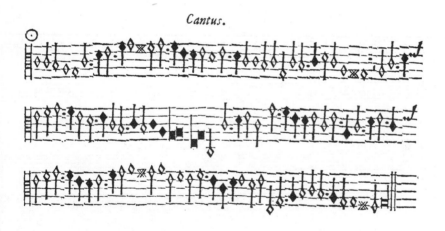

[1] The Mood Perfect of the Less Prolation is a misnomer, as M. points out in his Annotations (p. 123), for both the Great and Less Moods are in fact Imperfect, only the Time being Perfect.

[2] M. is thinking here of fifteenth-century practice or early sixteenth-century theory in which c was a more common sign than the others; he is not thinking of contemporary Italian practice where c denotes *note nere*, as the examples in this book clearly show (cf. p. 40, footnote 2).

Baſſus.

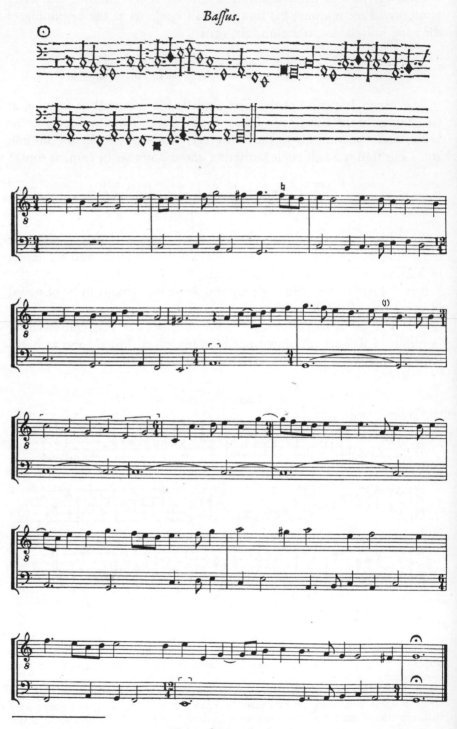

[1] Jumped *M* passing note.

PHI. Now I pray you begin and show me how I may keep right time in this example.

MA. In this Cantus there is no difficulty if you sing your semibreves three minims apiece[1] (the black excepted, which is always but two), your breves, nine, and your black breves, six; and whereas there is a breve rest in the beginning of the bass, that you must reckon nine minims. There is also in the bass a Long, which must be sung nine semibreves, which is twenty-seven minims. The value of some notes in this Mood.

PHI. A time for an Atlas or Typhoeus[2] to hold his breath, and not for me or any other man nowadays.

MA. True; but I did set it down of purpose, to make you understand the nature of the Mood.

PHI. You did well. But I pray you what is that which you have set at the end of the stave, thus:

MA. It is called an Index or Director, for look in what place it standeth, in that place doth the first note of the next stave stand. A Director and the use thereof.

PHI. But is there no other thing to be observed in this Mood?

MA. Yes, for though in this Mood (and likewise in the other of this Prolation) every semibreve be three minims, yet if an odd minim come immediately either after or before (but most commonly after) a semibreve, then is the semibreve sung but for two minims, and that other minim maketh up the number for the stroke; but to the intent that the singer may the more easily perceive when the minim is to be taken in with the semibreve and when it is to be left out, the masters have devised a certain dot, called a Dot of Division,[3] which being set betwixt a semibreve and A Dot of Division

a minim thus : showeth that the semibreve is perfect, with the nature and use thereof.

and that the minim next following doth belong to another stroke; likewise if the Dot of Division come betwixt two minims thus:

it signifieth that the semibreve going before is imperfect, and that the minim following it must be joined with it to make up the stroke.

PHI. Now I think you have sufficiently declared the nature of this Mood; I pray you therefore go forward to the next, or Perfect Mood of the Less Prolation.

[1] The Proportionate stroke, for each *S* contains three *M* (see p. 19).

[2] A giant of Greek mythology, father of the winds.

[3] The Dot of Division is placed well above or below the note, thus distinguishing it from other dots (cf. Bassus part of the Duo).

MA. Here is an example; peruse it.

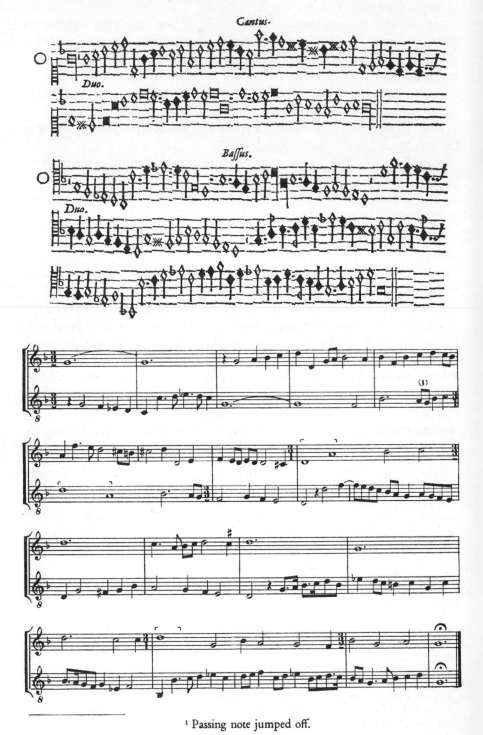

¹ Passing note jumped off.

PHI. In this last also I pray you begin with your stroke and time.

MA. In this Mood every semibreve is two minims, or one full stroke,[1] every breve three semibreves except it be black, in which case it is but two; every Long is six semibreves except it be black, and then it is but four, or have a semibreve following it noted with a Dot of Division thus:

<div style="float:right">The value of the notes in this Mood.</div>

, and then it is five, and the other semibreve maketh up the full time of six; and though this hath been received by the composers, yet have they but small reason to allow of it, for of Josquin they had it, in the tenor part of the Gloria of his Mass 'Ave Maris Stella';[2] but Josquin in that place used it for an extremity, because after the Long came two semibreves and then a breve, so that if the first semibreve had not been taken in for one belonging to the Long, the second must have been sung in the time of two semibreves and noted with a Dot of Alteration,[3] as in these his notes you may see:[4]

<div style="float:right">The value of a Long having a semibreve with a Dot of Division after it.</div>

And though (as I said) he used it upon an extremity, yet find I it so used of many others without any necessity, and, amongst the rest, Master Taverner, in his Kyries and Alleluias,[6] and therefore I have set it down

[1] The Less stroke (see p. 19).

[2] Josquin des Prés (c. 1445–1521). 'Ave Maris Stella'—*Second Book of Masses* (1512). The passage is as follows:

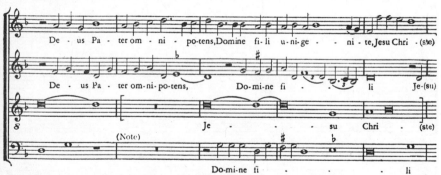

Note: The original only gives two S rests.

[3] See p. 37.

[4] In this Mood the S is the stroke, and the $L = 2B = 6S$. If the Dot of Division were absent the note values would be $L = 6S$, $S = S$, $SB = 3S$ (cf. p. 41), making 10 strokes (indivisible by 3). If the Dot of Division is included, the note values would be $LS = 6S$, $SB = 3S$, making 9 strokes. If the second S had a Dot of Alteration after it (cf. p. 37) the result would be $L = 6S$, $SS = 3S$, $B = 3S$, making 12 strokes; this, though divisible by 3, does not fit in with the other parts.

[5] In the original the dot comes next to the note thus: ○.

[6] There are no examples of this in the two Tudor Church Music volumes.

C

in this place because you should not be ignorant how to sing such an example if you should find any hereafter in other songs.

It followeth to speak of the third Mood, which is the Imperfect of the More Prolation, of which let this be an example:

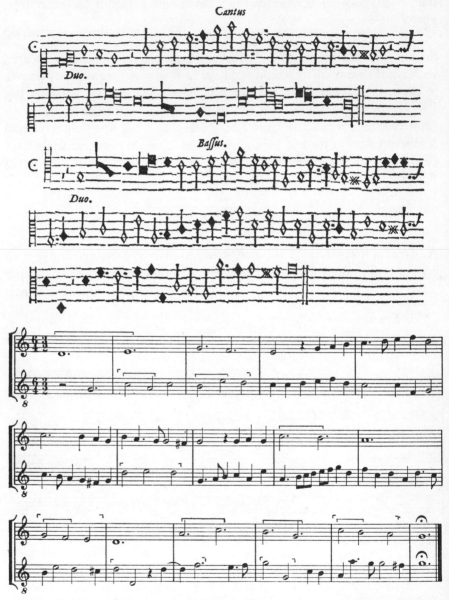

And as we did in the others, so begin with your stroke and time, strike and sing every one of these breves six minims,[1] and every one of the semibreves (except the last) three.

[1] This is misleading as the S is the stroke (cf. p. 37).

PHI. And why not the last also?

MA. If you remember that which I told you in the observations of the Perfect Mood of this Prolation,[1] you would not ask me that question, for what I told you there concerning a minim following a semibreve in the More Prolation is as well to be understood of a minim rest as of a minim itself.

PHI. I cry you mercy, for indeed if I had remembered the rule of the minim, I had not doubted of the rest; but I pray you proceed.

MA. You see the minim in D la sol marked with a dot, and if you consider the timing of the song you shall find that the minim going before that beginneth the stroke, so that those two minims must make up a full stroke; you must then know that if you find a dot so following A Dot of a minim in this Mood, it doubleth the value thereof and maketh it two Alteration. minims, and then is the dot called a Dot of Alteration. The black semibreve is always two minims in this Mood, and the black breve twice so much, which is four minims; and this is all to be observed in this Mood.

PHI. All that I think I understand, therefore I pray you come to the declaration of the fourth and last.

MA. The last, which is termed the Imperfect of the Less Prolation, is when all go by two, as two Longs to the Large, two breves to the Long, two semibreves to the breve, two minims to the semibreve, two crotchets to the minim, two quavers to the crotchet, and two semiquavers to the quaver, and so forth. Example:

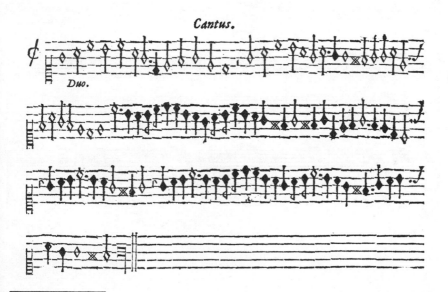

[1] See p. 33.

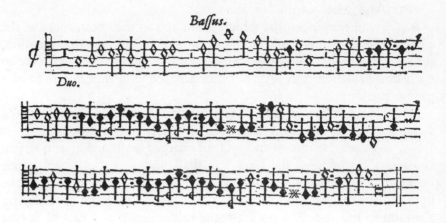

Baſſus.

Duo.

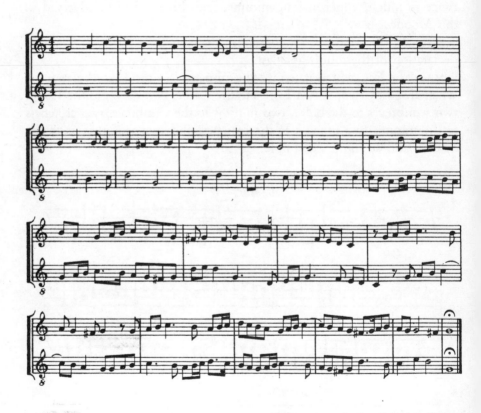

Cantus.

Baßus.

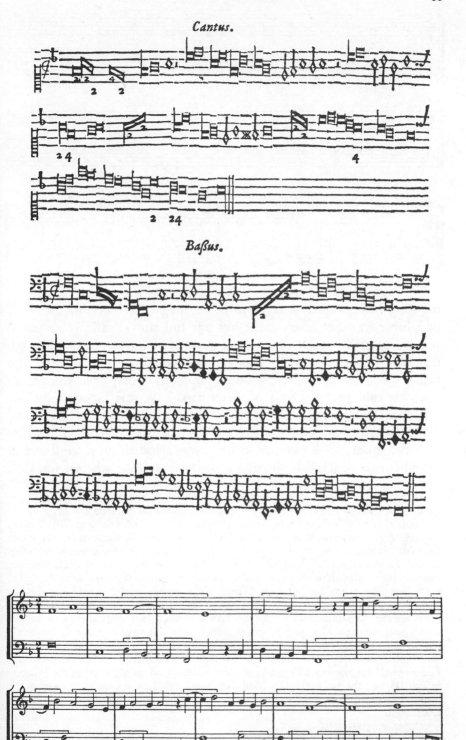

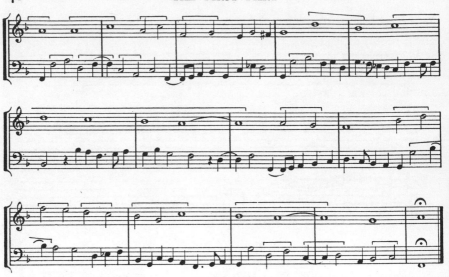

The sign of this Mood, set with a stroke parting it thus, ¢, causeth the song before which it is set to be so sung as a breve, or the value of a breve in other notes, make but one full stroke,[1] and is proper to Motets, specially when the song is pricked in great notes,[2] although that rule be not so generally kept but that composers set the same sign before songs of the semibreve time;[3] but this I may give you for an infallible rule, that if a song of many parts have this Mood of the Imperfect of the Less Prolation set in one part with a stroke through it, and in another part without the stroke, then is that part which hath the sign with the stroke, so diminished as one breve standeth for a semibreve of the other part which hath the sign without the stroke,[4] whereof you shall

Zacconi,[5]
Beurhusius [6]
cum aliis.

[1] i.e. a S. [2] M. inserts the example on p. 39 here.

[3] Prior to c. 1475 ¢ and ∅ had only a Proportional significance, i.e. Diminution (cf. p. 43), but from c. 1475 ¢ (and to a lesser extent ∅) was used as a 'time signature' in all parts, implying $\frac{4}{2}$ time with the B as 'tactus,' and the great majority of sixteenth-century music (especially sacred) employed this signature, thus destroying its Proportional meaning. During the earlier part of this period c and o fell into disuse. About 1545, however, composers of secular music began to write in shorter note values (note nere), using the sign c, the S being the 'tactus' and implying $\frac{4}{4}$ time. The change began in Italy and the two forms of notation existed side by side throughout the sixteenth century, but English composers did not differentiate between the two (as the most casual perusal of their works will show), and although M. inveighs against this abuse of the signs c and ¢ he frequently misuses them himself, placing c at the beginning of a piece in which the 'tactus' is clearly the B, and ¢ when the 'tactus' is the S; in fact the only examples in this book in which c is used correctly are the 6th Duo on p. 96, the Aria a 3 on p. 98, some of the 'Closes' in Part III, and the two Canzonets 'Ard' ogn hora' and 'Perche tormi' at the end of the book. Of course when ¢ occurs in relation to c or other signs during a piece it implies Diminution.

[4] Dupla Proportion (cf. p. 47).

[5] Ludovico Zacconi (1555–1627). Prattica di Musica . . ., Part I, Books 1 and 2 (1592).

[6] Friedrich Beurhusius (1536–1609). Erotematum musicae . . . (1573).

see an evident example after that we have spoken of the Proportions.[1]
But if the sign be crossed thus, ₵, then is the song so noted so diminished
in his notes as four semibreves are sung but for one,[2] which you shall
more clearly perceive hereafter when we come to speak of Diminution.
The other sort of setting the Mood thus, c, belongeth to Madrigals,
Canzonets, and such like.

This much for the Moods by themselves; but before I proceed to the
declaration of the altering of them, I must give you an observation to
be kept in Perfect Moods.

PHI. What is that?

MA. It is commonly called Imperfection. Imperfection.

PHI. What is Imperfection?

MA. It is the taking away of the third part of a perfect note's value,
and is done three manner of ways—by note, rest, or colour. Imper-
fection by note is when before or after any [normally perfect] note there
cometh a note of the next less value, as thus:

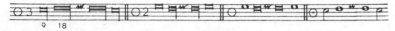

By rest, when after any [normally perfect] note there cometh a rest of
the next less value, as thus:

Imperfection by colour is when notes perfect are pricked black, which
taketh away the third part of their value, thus:

the example whereof you had in your tenor part of the song set next
after the former Moods.[3] But the examples of perfection and imper-
fection are so common, specially in the Moods of Perfect Time and
More Prolation, that it would be superfluous to set them down.

There is also another observation akin to this, to be observed likewise
in Moods Perfect,[4] and is termed Alteration. Alteration.

PHI. What is Alteration?

MA. It is the doubling of the value of any note for the observation of
the odd number, and that is it which I told you of in the example of the

[1] Cf. the example on pp. 61–2.
[2] Diminution of Diminution (cf. p. 43).
[3] See the example on p. 28.
[4] M. uses the word 'Mood' very loosely (as he himself admits in his Annotations), for
by the phrase 'Moods Perfect' he really means both Perfect Time and Prolation.

Mood Perfect of the More Prolation,[1] so that the note which is to be altered is commonly marked with a Dot of Alteration.

PHI. Now I pray you proceed to the alteration of the Moods.

MA. Of the altering of the Moods proceedeth Augmentation or Augmenta- Diminution. Augmentation proceedeth of setting the sign of the More tion. Prolation [2] in one part of the song only and not in others, and is an increasing of the value of the notes above their common and essential value, which cometh to them by signs set before them, or Moods set over them,[3] or numbers set by them. Augmentation by numbers is when proportions of the less inequality are set down, meaning that every note and rest following are so often to be multiplied in themselves as the lower number containeth the higher thus, $\frac{1}{2}$, $\frac{1}{3}$, $\frac{1}{4}$, etc., that is the minim to be a semibreve, the semibreve a breve, etc.; but by reason that this is better conceived by deed than word, here is an example of Augmentation in the tenor part.[4]

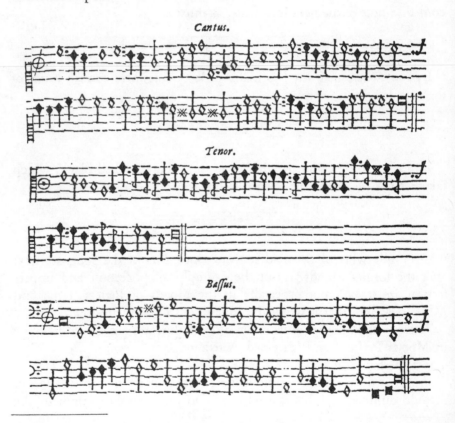

Cantus.

Tenor.

Baſſus.

[1] See p. 37. [2] ⊙.

[3] 'Signs set before them' presumably means an actual written indication as in the example on p. 28; 'Moods set over them' means ⊙ or ₵.

[4] The tenor is in Augmentation with respect to ∅, but the latter sign implies a brisk tempo for the whole piece.

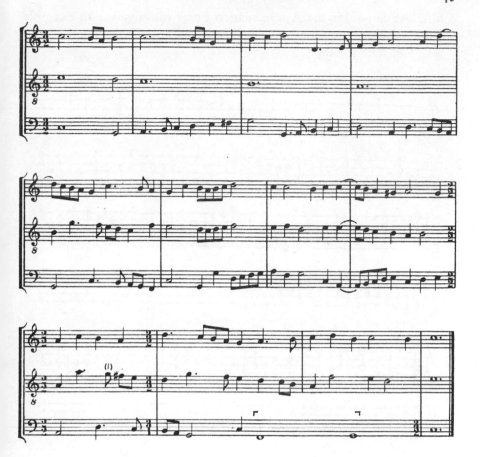

PHI. I can you thank for this example, for indeed without it I had hardly conceived your words; but now proceed to Diminution.

MA. Diminution is a certain lessening or decreasing of the essential Diminution. value of the notes and rests by certain signs or rules; by signs when you find a stroke cutting a whole circle or semicircle thus, ⊘, ¢, ⊘, ¢.[2] But when (as I told you before) a circle or half circle is crossed thus, ⊗, ⊗, it signifieth Diminution of Diminution, so that whereas a note of the sign once parted was the half of his own value, here it is but the quarter; by a number added to a circle or semicircle thus, O2, C2, ⊙2, C2; also by proportionate numbers as thus, $\frac{2}{1}$ dupla, $\frac{3}{1}$ tripla, $\frac{4}{1}$ quadrupla, etc.; by a semicircle inverted thus ↄ, ↄ, and this is the most usual sign of Diminution, diminishing still the one half of the note; but if it be dashed thus ↄ, ↄ it is double diminished.

[1] C resolution on to a discord ($\frac{6}{4}$).
[2] M. omits the dot.

*C

PHI. As you did in the Augmentation I pray you give me an example
of Diminution.

MA. Lo, here is one.

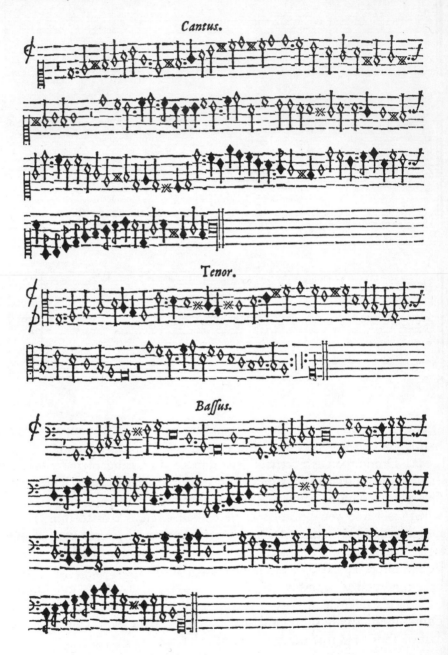

Cantus.

Tenor.

Baſſus.

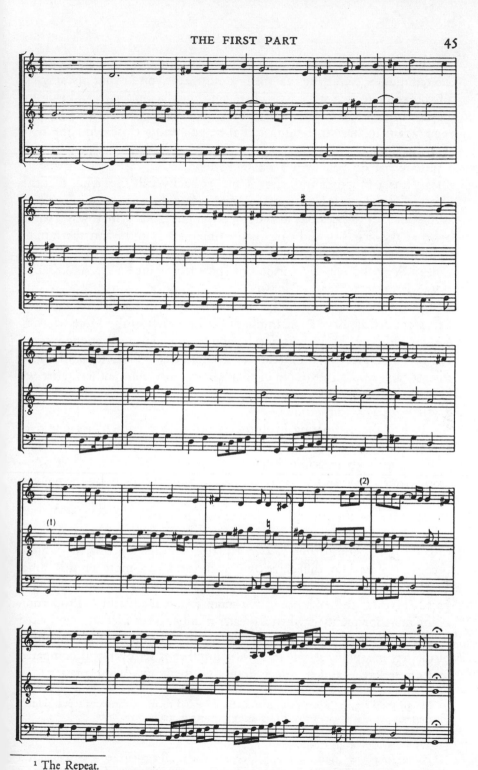

¹ The Repeat.
² Weak C approached by a leap. The breach of the so-called 'high note' law occurs fairly frequently throughout this book.

Where you see two Moods set to one part, the one thus, ₵, the other retorted thus, ₱, signifying that the first must serve you in your first singing till you come to this sign, :||:, where you must begin again and sing by the retort in half time (that is as round again as you did before) till you come again to the same sign, and then you must close with the note after the sign.[1]

A Retort. PHI. What do you term a retorted Mood?

MA. It is a Mood of Imperfect Time set backward, signifying that the notes before which it is set must be sung as fast again as they were before; as in your former example, at the second singing, that which was a semi-breve at the first you did sing in the time of a minim, and the minim in the time of a crotchet.[2]

PHI. Why did you say a Mood of Imperfect Time?

MA. Because a Mood of Perfect Time cannot be retorted.[3]

PHI. Of the Less Prolation I have had an example before, therefore I pray you let me have an example of the Imperfect of the More retorted.

MA. Although by your former example you may well enough com-prehend and perceive the nature of a retort, yet will I, to satisfy your request, give you an example of that Mood with many others, after we have spoken of the Proportions.[4]

PHI. What is Proportion?

Proportion. MA. It is the comparing of numbers placed perpendicularly one over another.

PHI. This I knew before, but what is that to music?

MA. Indeed we do not in music consider the numbers by themselves, but set them for a sign to signify the altering of our notes in the time.

PHI. Proceed then to the declaration of Proportion.

MA. Proportion is either of equality or inequality. Proportion of equality is the comparing of two equal quantities together, in which, because there is no difference, we will speak no more at this time. Proportion of inequality is when two things of unequal quantity are com-Proportion pared together, and is either of the more or less inequality. Proportion of the more of the more inequality is when a greater number is set over and compared inequality doth in music to a lesser, and in music doth always signify Diminution. Proportion always signify of the less inequality is where a lesser number is set over and compared Diminution. to a greater, as $\frac{2}{3}$, and in music doth always signify Augmentation.

[1] Strictly speaking, each part should be diminished and therefore the tenor repeat doubly diminished, but it is obvious that M. is using ₵ conventionally here.

[2] In other words, a retorted (or reversed) Mood (strictly speaking, the *sign* for the Mood) reduces a note to half its face value.

[3] For the simple reason that you cannot reverse a circle. If a composer wanted to quarter the value of a note in Perfect Time he would have to write this sign, ₴, making a perfect *B* into a *M*.

[4] Cf. p. 65 (5th stave), p. 66 (4th stave, Bassus).

PHI. How many kinds of Proportions do you commonly use in music? For I am persuaded it is a matter impossible to sing them all, especially those which be termed Superpartients.[1]

MA. You say true, although there be no proportion so hard but might be made in music, but the hardness of singing them hath caused them to be left out, and therefore there be but five in most common use with us: Dupla, Tripla, Quadrupla, Sesquialtera, and Sesquitertia.

PHI. What is Dupla Proportion in music?

MA. It is that which taketh half the value of every note and rest from *Dupla.* it, so that two notes of one kind do but answer to the value of one, and it is known when the upper number containeth the lower twice thus, $\frac{2}{1}, \frac{4}{2}, \frac{6}{3}, \frac{8}{4}, \frac{12}{6}$, etc. But by the way you must note that time out [of] mind we have termed that Dupla where we set two minims to the semi‑breve,[2] which if it were true there should be few songs but you should have Dupla, Quadrupla and Octupla in it, and then by consequent, must cease to be Dupla.[3] But if they think that not inconvenient, I pray them how will they answer that which from time to time hath been *A confuta‑* set down for a general rule amongst all musicians, that Proportions of *tion of* the greater inequality do always signify Diminution? And if their *Dupla in the* minims be diminished I pray you how shall two of them make up the *Minim.* time of a full stroke? For in all Proportions the upper number signifieth the semibreve and the lower number the stroke, so that as the upper number is to the lower so is the semibreve to the stroke. Thus if a man would go seek to refute their inveterate opinions it were much labour spent in vain; but this one thing I will add, that they have not their opinion confirmed by the testimony of any, either musician or writer, whereas on the other side, all who have been of any name in music have used the other Dupla and set it down in their works, as you may see in the example following, confirmed by the authorities of Peter Aron, Franchinus, Jordanus,[4] and (now of late days) learned Glareanus, Lossius, Listenius,[5] Beurhusius, and a great number more, all whom it were too tedious to nominate; true it is that I was taught the contrary myself and have seen many old written books to the same end, but yet

[1] Cf. p. 127 et seq.

[2] The origin of our modern Alla Breve sign ¢, for as it originally indicated that the *B* should be sung at the speed of a 'moderate' *S*, so now it indicates that the *S* should be sung at the speed of a moderate *M*. (Dupla Proportion was called 'Alla Breve' by sixteenth‑century Italian theorists.)

[3] If two *M* to a *S* is Dupla Proportion, then four *C* and eight *Q* to a *S* will be Quadrupla and Octupla respectively, and hence true Dupla cannot be present (see p. 172).

[4] Nemorarius Jordanus (*fl.* 1230). *Elementa Arithmetica*, included in the *Elementa Musicalia* of Stapulensis (cf. p. 206).

[5] Magister Nikolaus Listenius (born *c.* 1500). *Rudimenta musica* . . . (1533). M. gives 'Joannes' as the Christian name in the list of authors at the end of the book.

have I not seen any published under any man's name. But if their opinion had been true I marvel that none amongst so many good musicians have either gone about to prove the goodness of their own way or refute the opinions of others, from time to time by general consent and approbation taking new strength; therefore let no man cavil at my doing in that I have changed my opinion and set down the Proportions otherwise than I was taught them, for I assure them that if any man will give me stronger reason to the contrary than those which I have brought for my defence, I will not only change this opinion but acknow-ledge myself debt-bound to him, as he that hath brought me out of an error to the way of truth.

PHI. I doubt not but your Master who taught you would think it as lawful for you to go from his opinion as it was for Aristotle to disallow the opinion of Plato with this reason, that Socrates was his friend, Plato was his friend, but verity was his greater friend.

MA. Yet will I (to content others) set down the Proportions at the end of this treatise as they are commonly pricked now, to let you see that in the matter there is no difference betwixt us except only in form of pricking, which they do in great notes and we in small,[1] and to the end that if any man like his own way better than this he may use his own discretion.

But we go too far, and therefore peruse your example.

Cantus

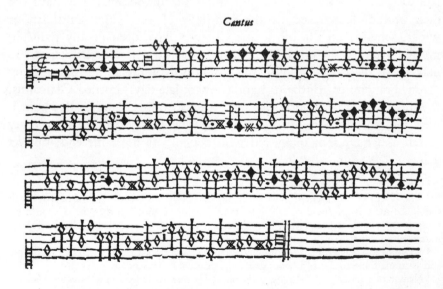

[1] Cf. example on pp. 63–77.

Tenor.

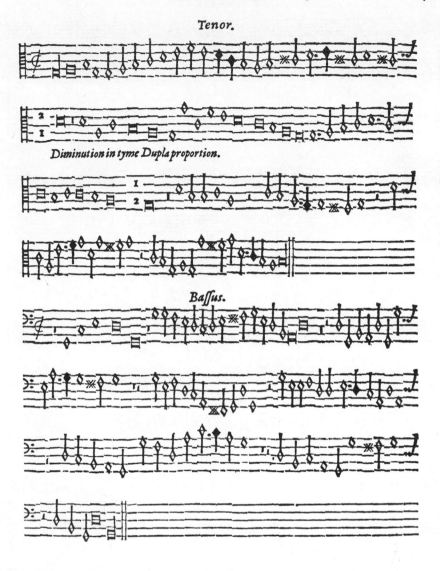

Diminution in tyme Dupla proportion.

Baſſus.

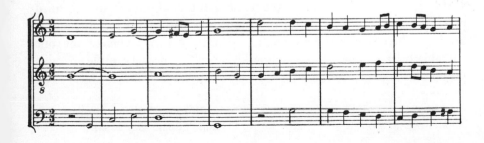

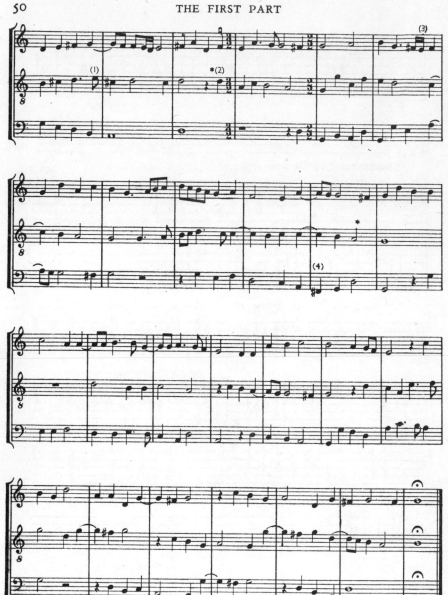

PHI. What is Tripla Proportion in music?

Tripla.　MA. It is that which diminisheth the value of the notes to one third part; for three breves are set for one, and three semibreves for one, and is known when two numbers are set before the song whereof the one containeth the other thrice, thus, $\frac{3}{1}$, $\frac{6}{2}$, $\frac{9}{3}$. For example of this proportion take this following.

[1] *Échappée.*
[3] M. has C in error.

[2] Asterisks show the passage in Dupla Proportion.
[4] Diminished fifth progression.

Cantus

Tenor.

Baßus,

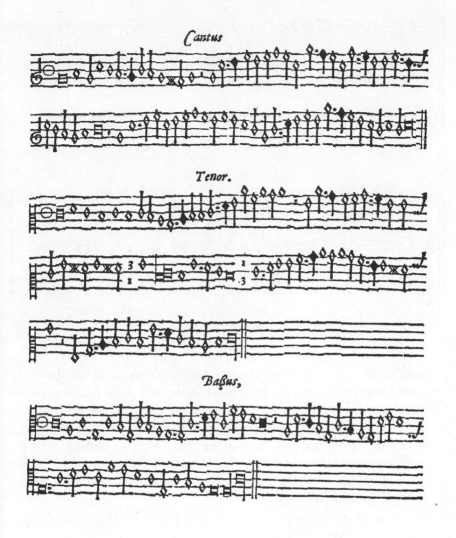

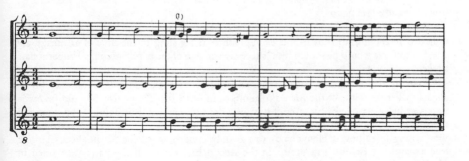

[1] C resolution.

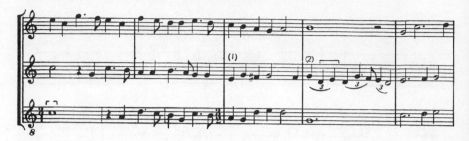

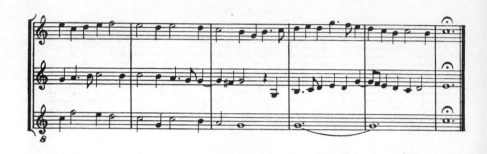

Here is likewise another example wherein Tripla is in all the parts
together,[3] which, if you prick all in black notes, will make that proportion
which the musicians falsely termed Hemiolia, when indeed it is nothing
else but a round Tripla; for Hemiolia doth signify that which the Latins
term Sesquipla or Sesquialtera, but the good monks, finding it to go
somewhat rounder than common Tripla, gave it that name of Hemiolia
for lack of another; but for their labour they were roundly taken up by
Glareanus, Lossius, and others.[4]

A confuta-
tion of
Hemiolia.

[1] Near fifths.

[2] This bar is in Tripla Proportion, and the stroke becomes Proportionate accordingly,
hence the name (see p. 19).

[3] When a Proportion is in all the parts, the stroke is a purely mental concept, for it is not
indicated in the music; thus in this example three *S* are sung in the time of an imaginary
one, but this one would be shown by a 'successive motion of the hand,' giving a Proportionate
stroke.

[4] Actually if this passage were written all in black notes the 'Mood' would have to be
altered to Perfect Time of the *More* Prolation, ⊙, in order that the perfect *S* could be made
imperfect by being black; but even if this were done it would still be Tripla Proportion, for
three black *S* would still be sung in the time of an imaginary one; thus the 'good monks'
were wrong in calling it Hemiolia as this is only another word for Sesquialtera ($\frac{3}{2}$). A
true example of Sesquialtera occurs in the second bar, where all the parts are written in
black *B* each equalling two *S*, and whereas before and after we get six *S* (or their equivalent)
divided 3 + 3, making up two strokes, in the second bar we get three imperfect *B* (six *S*)
divided 2 + 2 + 2, giving three against two. (Hemiolia is Greek for $1\frac{1}{2}$.)

Cantus.

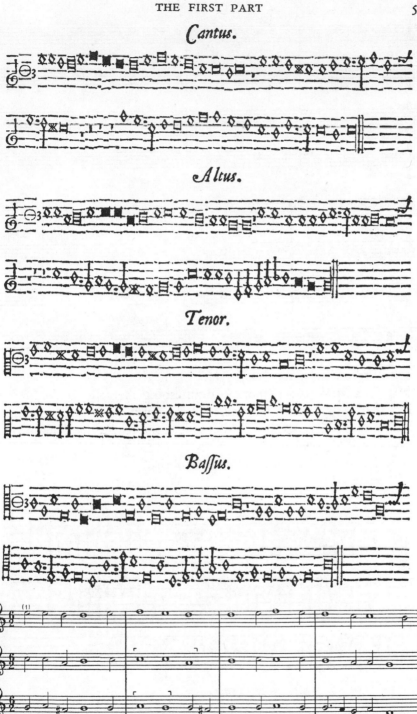

Altus.

Tenor.

Bassus.

[1] This should be sung at a quicker tempo than perhaps the note values imply.

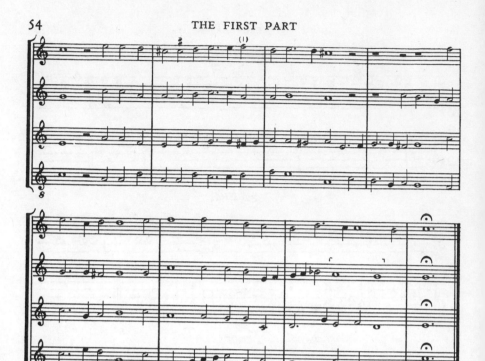

PHI. Proceed now to Quadrupla.

MA. Quadrupla is a proportion diminishing the value of the notes to the quarter of that which they were before, and it is perceived in singing when a number is set before the song comprehending another four times, as $\frac{4}{1}$, $\frac{8}{2}$, $\frac{16}{4}$, etc.

PHI. I pray you give me an example of that.

MA. Here is one.

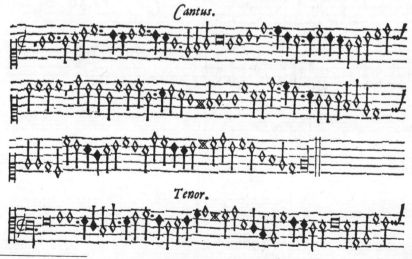

[1] Simultaneous false relation, succeeded by a discord.

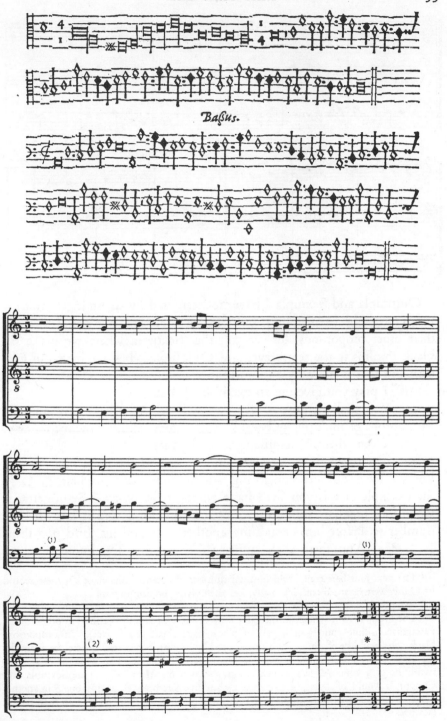

Baßus.

¹ Upward resolution on to a discord.
² The asterisks denote the passage in Quadrupla Proportion.

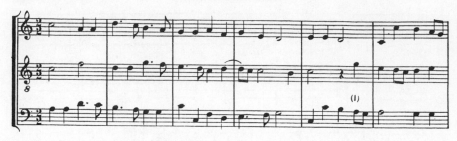

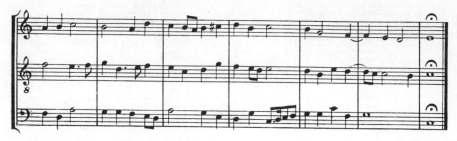

Quintupla and Sextupla I have not seen used by any stranger [2] in their songs (so far as I remember), but here we use them, but not as they use their other proportions, for we call that Sextupla where we make six black minims to the semibreve, and Quintupla when we have but five, etc.; but that is more by custom than reason.[3]

PHI. I pray you give me an example of that.

MA. You shall hereafter.[4] But we will cease to speak any more of Proportions of multiplicity because a man may consider them infinitely.

PHI. Come then to Sesquialtera; what is it?

Sesqui- MA. It is when three notes are sung to two of the same kind, and is
altera. known by a number containing another once and his half, $\frac{3}{2}, \frac{6}{4}, \frac{9}{6}$; the example of this you shall have amongst the others. Sesquitertia is when four notes are sung to three of the same kind, and is known by a number set before him containing another once and his third part thus, $\frac{4}{3}, \frac{8}{6}, \frac{12}{9}$. And these shall suffice at this time, for knowing these

[1] The next four bars contain an unusual number of accented dissonant Q; these would be C if ¢ were regarded conventionally, i.e. as implying no diminution.

[2] 'Foreigner.'

[3] The black *M* was written in the same way as the *C*, but only occurred in proportional passages consisting entirely or largely of black notes (black *S*, *B*, etc.). In Proportions black notes could be of almost any value as used by English composers, as here, for example, the black *M* equals one-third of a white *M*, six of them making two white *M* or a *S*; or two-fifths of a white *M*, five of them making two white *M* or a *S*. True Sextupla and Quintupla would, of course, be written as six and five *S* respectively against one *S* in another part. Thus the English Sextupla and Quintupla were based more on custom than reason (see pp. 171–2).

[4] Cf. p. 65 (5th stave et seq.), transcription, p. 80, b. 60 (Sextupla); p. 68 (6th stave et seq.—Tenor), transcription, p. 83, b. 104, and p. 69 (5th stave et seq.—Bassus), transcription, p. 83, b. 102 (Quintupla).

the rest are easily learned; but if a man would engulf himself to learn to sing and set down all them which Franchinus Gafurius hath set down in his book *De Proportionibus Musicis*, he should find it a matter not only hard but almost impossible. But if you think you would be curious in Proportions and exercise yourself in them at your leisure, here is a Table where you may learn them at full.[1]

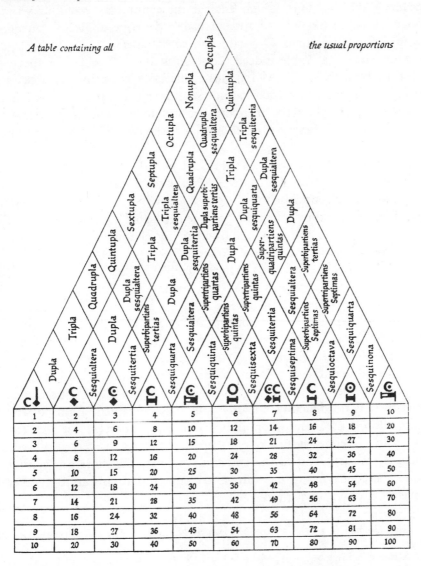

1	2	3	4	5	6	7	8	9	10
2	4	6	8	10	12	14	16	18	20
3	6	9	12	15	18	21	24	27	30
4	8	12	16	20	24	28	32	36	40
5	10	15	20	25	30	35	40	45	50
6	12	18	24	30	36	42	48	54	60
7	14	21	28	35	42	49	56	63	70
8	16	24	32	40	48	56	64	72	80
9	18	27	36	45	54	63	72	81	90
10	20	30	40	50	60	70	80	90	100

[1] The table is a copy, not a facsimile. M. has '14' in the first column, fourth line down, and '44' in the third column, eighth line down. The notes in the bottom row triangles contain the number of minims given in the top row of numerals; for instance, in the seventh triangle the S in Greater Prolation (ȼ) = 3 M, and the B in Imperfect Time and Lesser Prolation (c) = 4 M, making a total of 7 M.

As for the use of this Table, when you would know what proportion any one number hath to another, find out the two numbers in the Table, then look upward to the triangle enclosing those numbers, and in the angle of concourse (that is where your two lines meet together) there is the proportion of your two numbers written. As, for example, let your two numbers be 18 and 24, look upward, and in the top of the triangle covering the two lines which enclose those numbers you find written Sesquitertia; so likewise 24 and 42 you find in the angle of concourse written Supertripartiens Quartas; and so of others.

PHI. Here is a Table indeed, containing more than ever I mean to beat my brains about. As for music, the principal thing we seek in it is to delight the ear, which cannot so perfectly be done in these hard proportions as otherwise, therefore proceed to the rest of your music, specially to the example of those proportions which you promised before.

MA. I will; but before I give it you I will show you two others, the one out of the works of Giulio Renaldi,[1] the other out of Alessandro Striggio,[2] which, because they be short and will help you for the under\ standing of the other I thought good to set before you.

PHI. I pray you show me the true singing of this first, because every part hath a several Mood and Prolation.

Explanation of the example next ensuing. MA. The treble containeth Augmentation of the More Prolation in the Subdupla Proportion, so that every semibreve lacking an odd minim following, it is three; but if it have a minim following it, the semibreve itself is two semibreves and the minim one. The altus and Quintus be of the Less Prolation so that betwixt them there is no difference, saving that in the Quintus the Time is Perfect and by that mean every breve three semibreves. Your tenor is the common Mood of the Imperfect of the Less Prolation diminished in Dupla Proportion, so that in it there is no difficulty. Lastly your bass containeth Diminution of Diminution, or Diminution in Quadrupla Proportion, of that (as I showed you before) every Long is but a semibreve and every semibreve is but a crotchet. And to the end that you may the more easily under\ stand the contriving of the parts and their proportion one to another I have set it down in partition.

[1] Giulio Renaldi (c. 1500–c. 1570). *Madrigals and Neapolitans to Five Voices* (1576), 'Diverse lingue.'

[2] Alessandro Striggio (c. 1535–87). *Second Book of Madrigals of Six Parts* (1571), 'All' acqua sagra.'

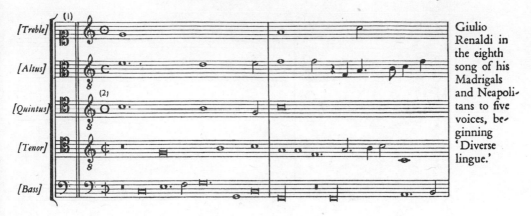

Giulio Renaldi in the eighth song of his Madrigals and Neapolitans to five voices, beginning 'Diverse lingue.'

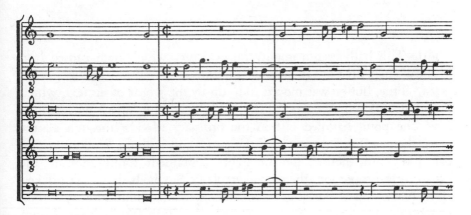

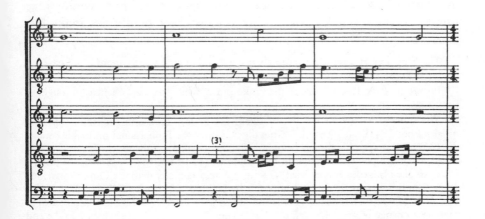

[1] Owing to errors in M. I have not included a facsimile but a corrected 'copy.' This applies to the next example also.

[2] M. gives c ɔ at the beginning instead of o, as in the original.

[3] M. gives a S rest here.

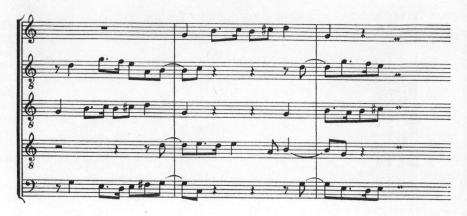

PHI. This hath been a mighty musical fury which hath caused him to show such diversity in so small bounds.

MA. True, but he was moved so to do by the words of his text, which reason also moved Alessandro Striggio to make this other,[1] wherein you have one point handled first in the ordinary Mood[2] through all the parts, then in Tripla through all the parts, and lastly in Proportions, no part like unto another, for the treble containeth Diminution in the Quadrupla Proportion, the second treble or Sextus hath Tripla pricked all in black notes, your altus or Mean containeth Diminution in Dupla Proportion, the tenor goeth through with his Tripla (which was begun before) to the end,[3] the Quintus is Sesquialtera to the breve, which hath this sign $\mathbb{¢}^3_2$ set before it, but if the sign were away then would three minims make a whole stroke, whereas now three semibreves make but

[1] The Striggio text means 'he(?) can change into a thousand strange forms.' I have been unable to consult the Renaldi original.

[2] Imperfect of the Less (c), hence the stroke is a S which remains unaltered throughout the piece.

[3] The number 3 by itself usually indicated: (1) Perfect Time and Prolation. (2) Sesquialtera not Tripla. (3) That the M not the S became the Proportional unit; this contradicts M.'s rule on p. 47 and must be regarded as a convention of the times.

All the above points are shown in this example: (1) In bb. 3–6 the S. must be perfect, otherwise the blackened (imperfected) S in b. 5 would not tally with the Quintus part; the white S in this section are rendered imperfect by position, i.e. they are followed or preceded by a M or M rest. The two notes at the end of b. 3 are a black S and a black M, inserted to indicate a change of stress, for ♩♩♩♩♩♩ (³⁄₁) but ♩♩♩♩ (⁶⁄₂). (2) In b. 7 to the end the tenor notes move at the same speed as in bb. 3–6; in b. 7 onwards the tenor sings three M against two in the bass (the bass having here reverted to the original time signature (c), hence each S equals the stroke); the Medius sings one ♩. (= perfect ○ = 3♩) to one ○ (=2♩) in the bass, which is therefore also Sesquialtera. (3) The explanations in (1) and (2) should make this point clear.

one stroke; [1] the bass is the ordinary Mood wherein is no difficulty as you may see.

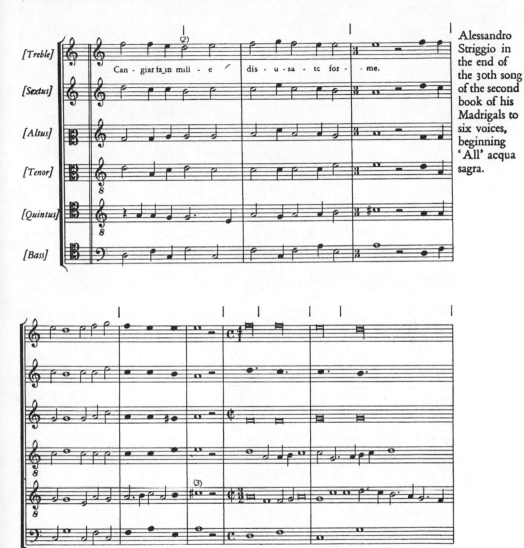

Alessandro Striggio in the end of the 30th song of the second book of his Madrigals to six voices, beginning 'All' acqua sagra.

[1] Quintus. The sign ¢ means that the B and S are imperfect and are sung as S and M respectively, hence the six written S become six M or three S when sung, thus making true Sesquialtera with the bass, as the sign $\frac{3}{2}$ indicates. It will be noticed that Striggio uses Proportions in this example to vary the note values of each voice (thus illustrating the text) while keeping the same general melodic pattern and harmonic sequence. The variations in the last section are in this case largely visual, for in performance the treble, altus and bass parts sing exactly the same note values while the tenor, Quintus, and Sextus are all in $\frac{6}{4}$ time.

[2] These short vertical strokes show M.'s barring.

[3] ♯ not given in the original edition of 1571.

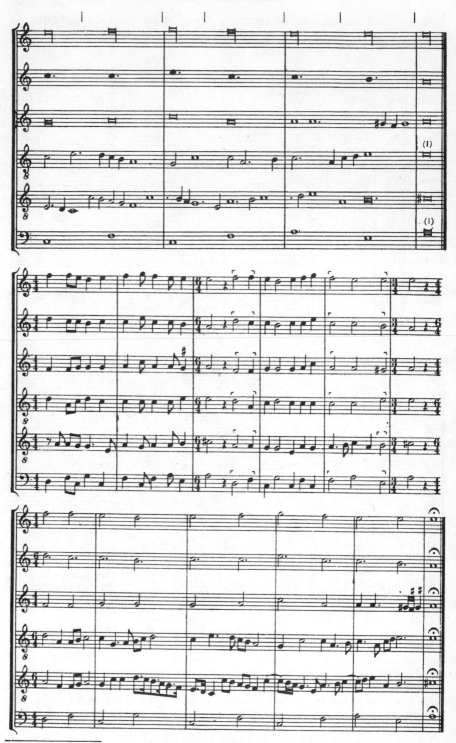

¹ Original has *L.*

PHI. Now I think you may proceed to the examples of your other Proportions.

MA. You say well, and therefore take this song, peruse it, and sing it perfectly, and I doubt not but you may sing any reasonable hard prick song that may come to your sight.[1]

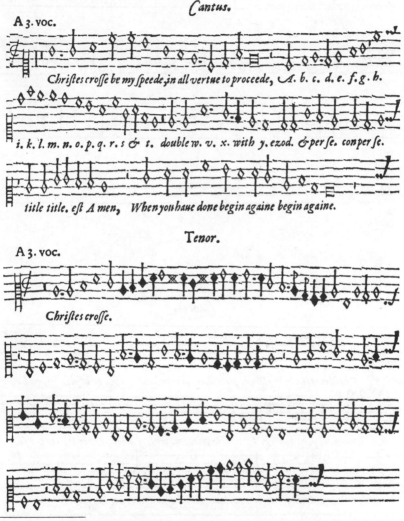

[1] The following note concerning the words of the ensuing example may be of interest. The practice of adding frivolous words to musical examples as an aid to beginners in singing was not new, for the monks used this method of old, and so did Glareanus. 'God and St. Nicholas be my speed' was a customary ejaculation of young Catholic scholars, St. Nicholas being the scholars' patron. The alphabet was often called the Criss Cross (Christ's Cross Row) because of a cross placed before the letter A which directed the child to cross itself before it began its lesson. (Hawkins, p. 490.) I have not listed all the variant readings between the two versions of 'Christ's Cross.' Coloration signs have been omitted; ligature signs refer to the 'English' version. In the original the music is so arranged that the singers can read their parts simultaneously.

Ba∬us.

A 3. voc.

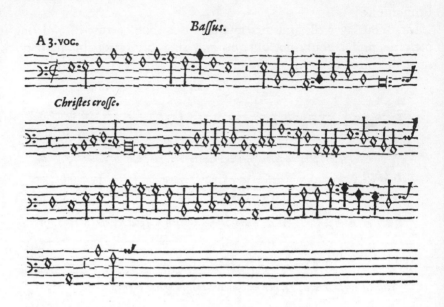

Chri∫tes cro∬e.

Cantus.

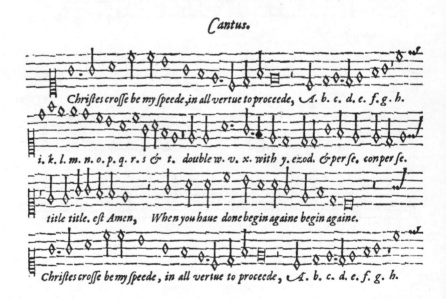

Chri∫tes cro∬e be my ∫peede, in all vertue to proceede, A. b. c. d. e. f. g. h.

i. k. l. m. n. o. p. q. r. s & t. double w. v. x. with y. ezod. & per ∫e. con per ∫e.

title title. e∫t Amen, When you haue done begin againe begin againe.

Chri∫tes cro∬e be my ∫peede, in all vertue to proceede, A. b. c. d. e. f. g. h.

Tenor.

Baßus.

32

Cantus.

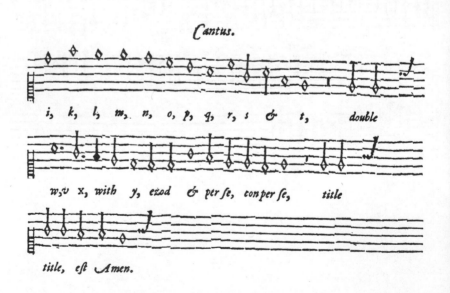

i, k, l, m, n, o, p, q, r, s & t, double

w,v x, with y, ezod & per se, con per se, title

title, est Amen.

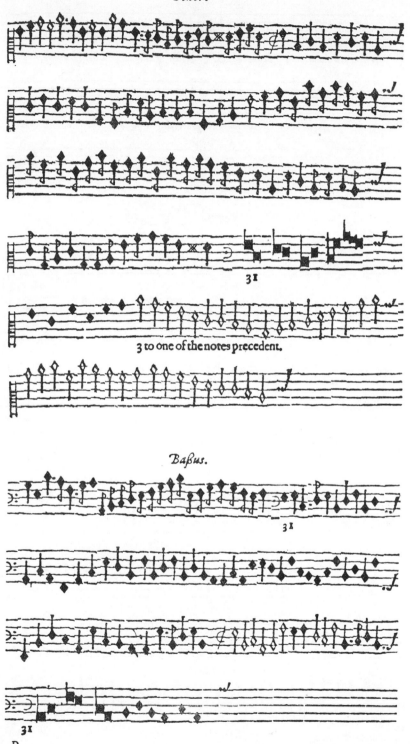

Cantus.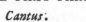

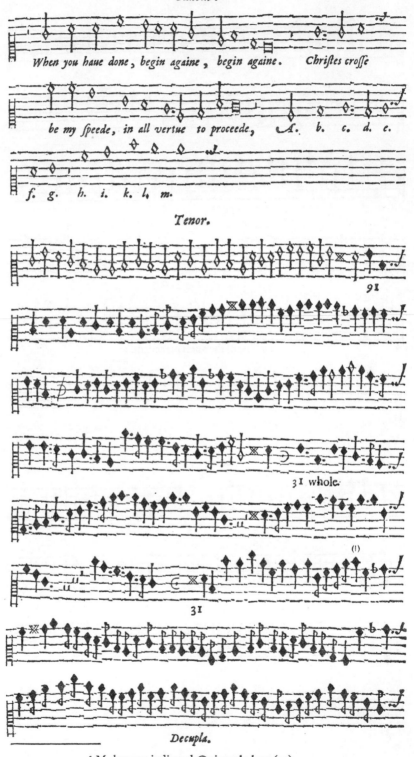

When you haue done, begin againe, begin againe. Chriſtes croſſe

be my ſpeede, in all vertue to proceede, A. b. c. d. e.

f. g. h. i. k. l, m.

Tenor.

91

31 whole.

(¹)

31

Decupla.

¹ M. has not indicated Quintupla here (51).

Baßus.

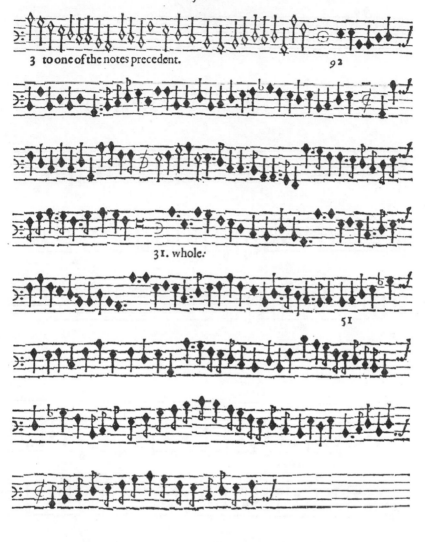

3 to one of the notes precedent. 92

31. whole: 51

Cantus.

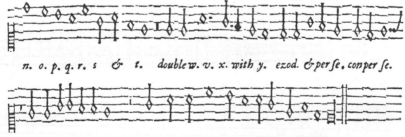

n. o. p. q. r. s & t. double w. v. x. with y. ezod. & per ſe. con per ſe.

title title. eſt A men, When you haue done begin againe begin againe.

Tenor.

Baßus.

And this is our usual manner of pricking and setting down of the Proportions generally received amongst our musicians; but if Glareanus, Ornithoparcus,[1] Peter Aron, Zarlino,[2] or any of the great musicians of Italy or Germany had had this example, he would have set it down thus as followeth.

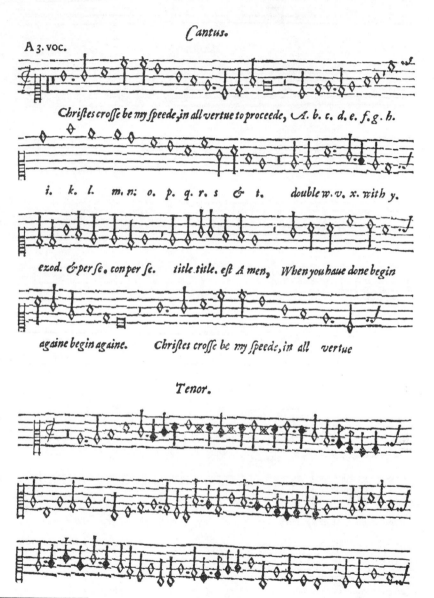

Cantus.

A 3. voc.

Chriftes croffe be my fpeede, in all vertue to proceede, A. b. c. d. e. f. g. h.

i. k. l. m. n: o. p. q. r. s & t. double w. v. x. with y.

ezod. & per fe. con per fe. title title. eft A men, When you haue done begin

againe begin againe. Chriftes croffe be my fpeede, in all vertue

Tenor.

[1] Andreas Ornithoparcus (Vogelsang) (late fifteenth to early sixteenth century). _Musicae activae micrologus_ (1517).

[2] Gioseffe Zarlino (1517–90). _Istitutioni armoniche_ (1558); _Dimostrationi armoniche_ (1571); _Sopplimenti musicali_ (1588). Complete edition (1589).

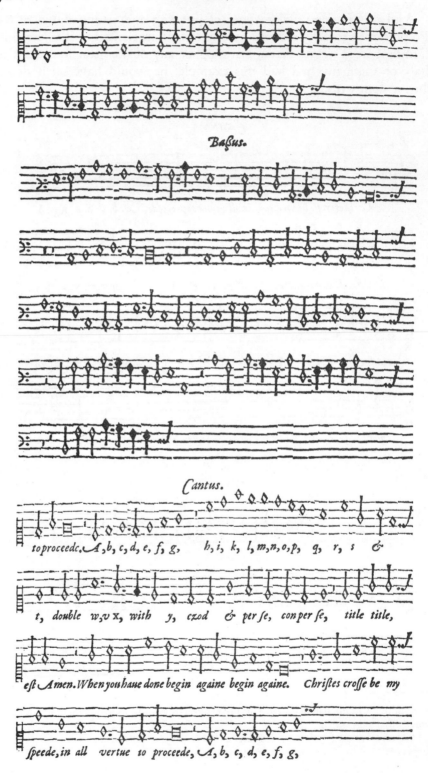

Baßus.

Cantus.

to proceede. A, b, c, d, e, f, g, h, i, k, l, m, n, o, p, q, r, s &

t, double w, v x, with y, czod & per se, con per se, title title,

est Amen. When you haue done begin againe begin againe. Christes crosse be my

speede, in all vertue to proceede, A, b, c, d, e, f, g,

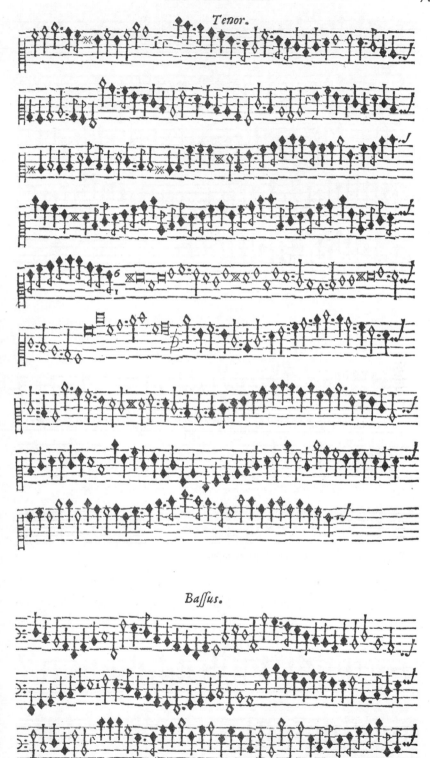

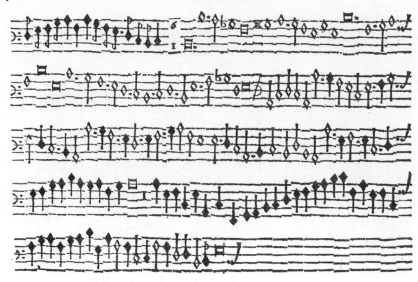

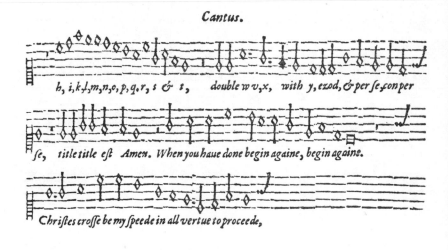

Cantus.

h, i, k, l, m, n, o, p, q. r, s & t, double w v, x, with y, ezod, & per se, con per

se, title title eſt Amen. When you haue done begin againe, begin againe.

Chriſtes croſſe be my ſpeede in all vertue to proceede,

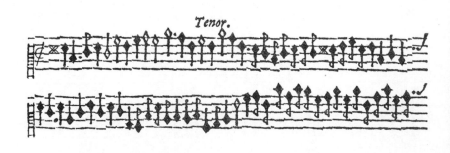

Tenor.

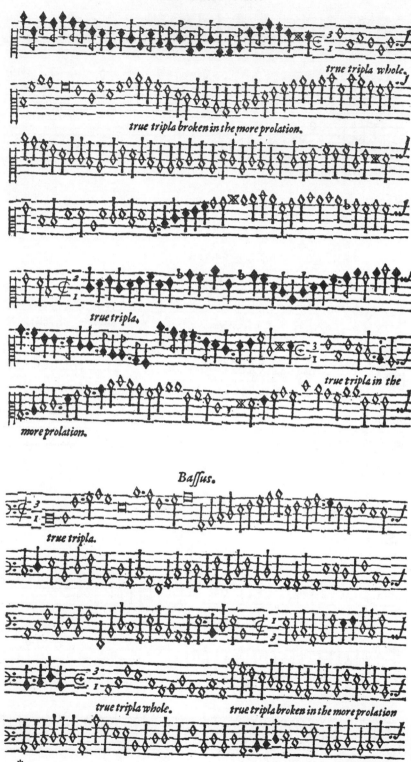

true tripla whole.

true tripla broken in the more prolation.

true tripla.

true tripla in the more prolation.

Baſſus.

true tripla.

true tripla whole. *true tripla broken in the more prolation*

*D

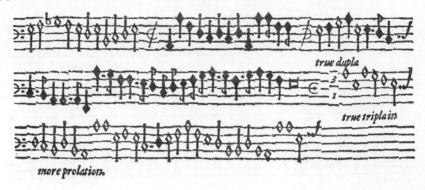

true dupla

true triplain

more prolation.

Cantus.

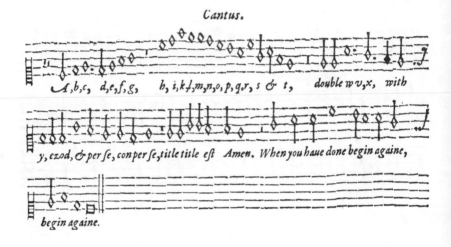

A, b, c, d, e, f, g, h, i, k, l, m, n, o, p, q, r, s & t, double w v, x, with

y, ezod, & per se, con per se, title title eſt Amen. When you haue done begin againe,

begin againe.

Tenor.

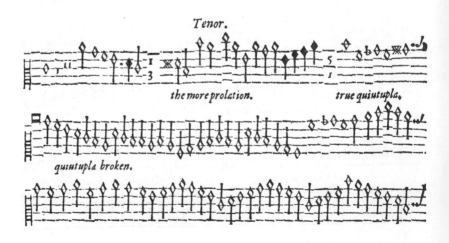

the more prolation. *true quiutupla.*

quiutupla broken.

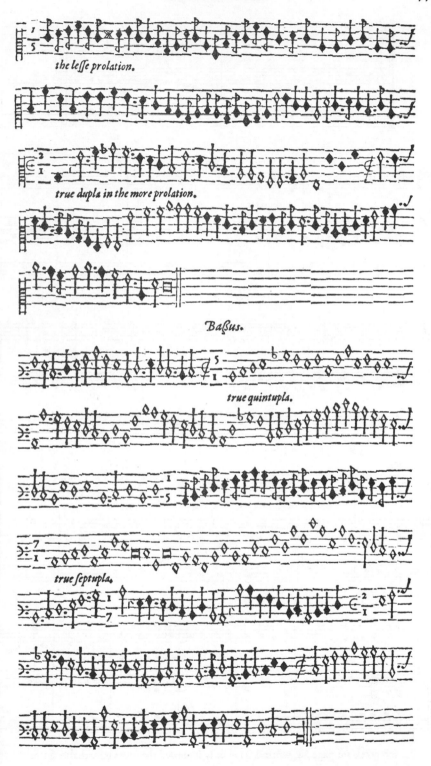

the le*ſſe* prolation.

true dupla in the more prolation.

Ba*ſſ*us.

true quintupla.

true *ſ*eptupla.

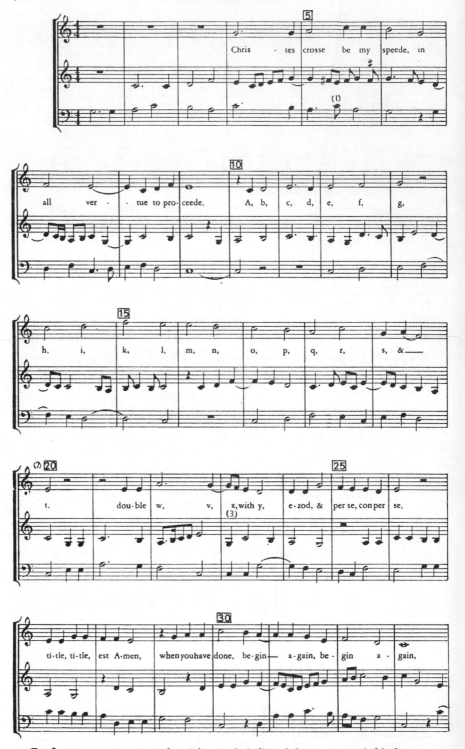

For footnotes, see page 84, where I have only indicated the more remarkable features.

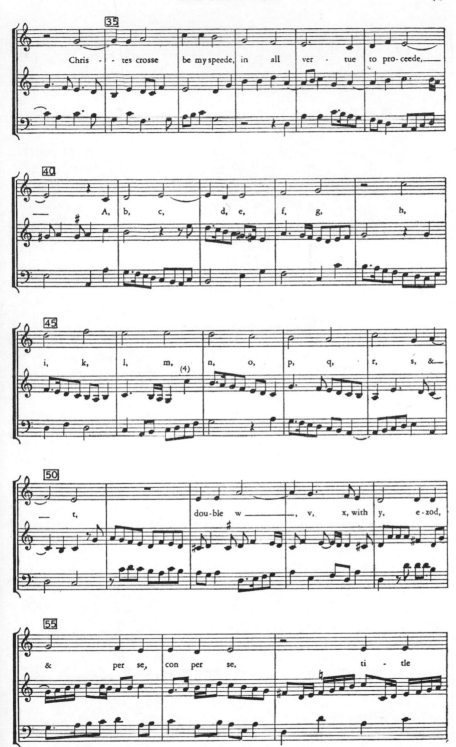

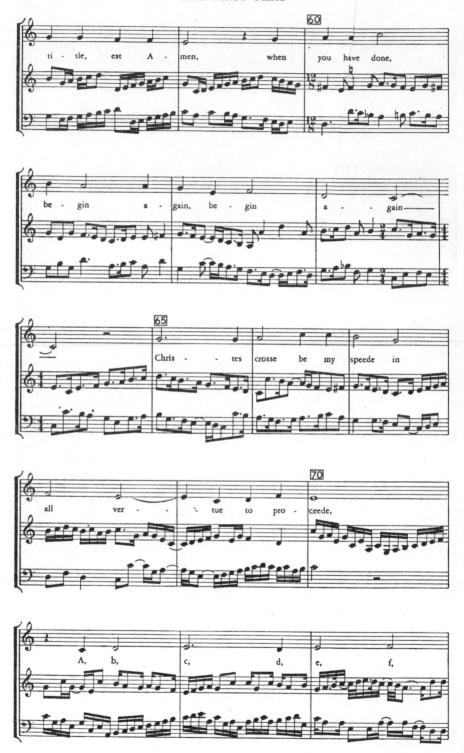

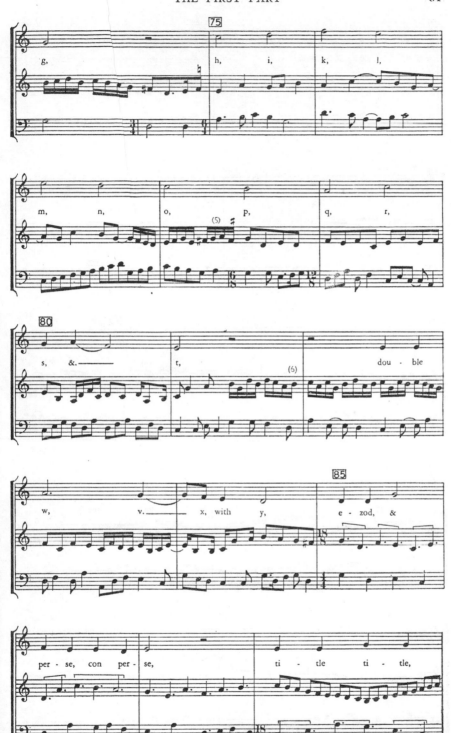

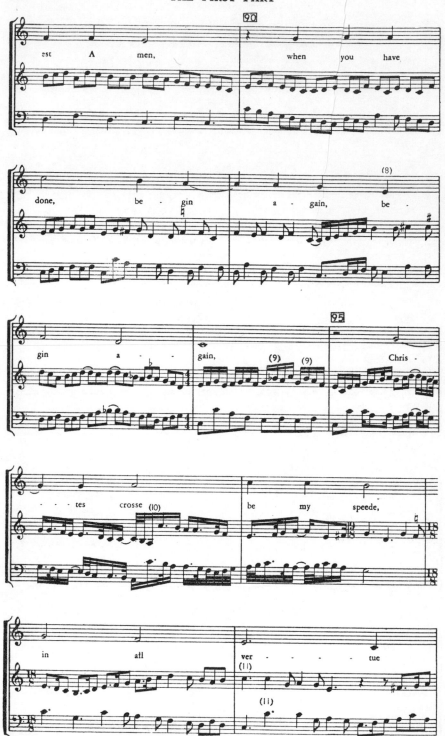

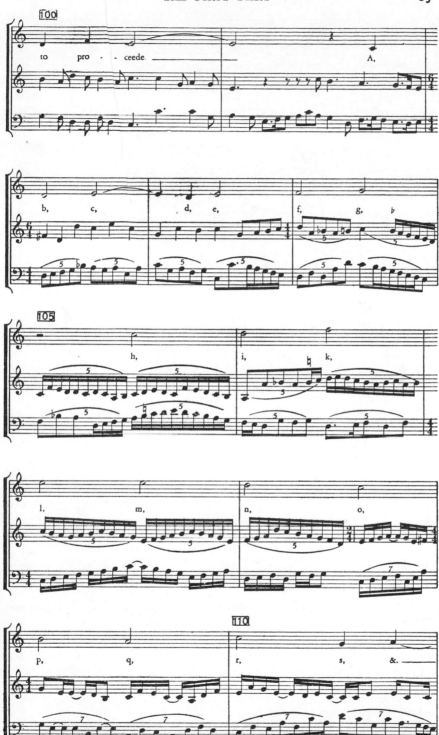

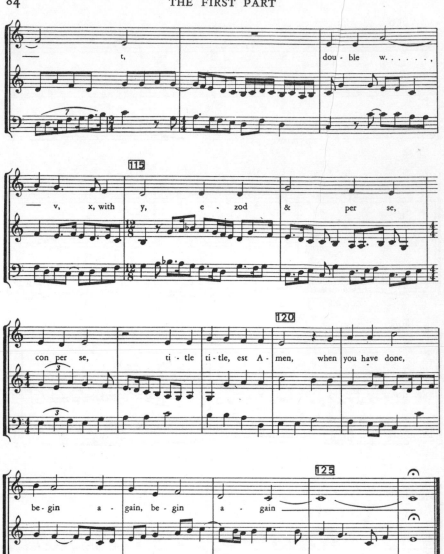

[1] Weak C approached by a leap.　　There are many succeeding instances which have not been indicated.

[2] 'Landini Sixth.'

[3] Downward leap of a major sixth.

[4] Upward leap of an eleventh.

[5] Consecutive sevenths.

[6] Near consecutive fifths.

[7] Consecutive octaves.

[8] Passing notes approached by a leap.

[9] Upward leap of a minor tenth in alto and bass.

[10] Quotation of folksong, 'The Woods so wild.'

And to the end that you may see how every thing hangeth upon another and how the Proportions follow others, I will show you particu-larly every one. The first change which cometh after the Proportion of equality is commonly called Sextupla, or six to one, signified by the More Prolation retorted thus: [musical example].[1] But if we consider rightly, that which we call Sextupla is but true Tripla pricked in black notes; but because I made it to express Sextupla I have set it down in semibreves, allowing six for a stroke and taking away the retorted Mood.[2]

The next Proportion is true Dupla, signified by the Time Imperfect of the Less Prolation retorted thus: [musical example] which manner of marking Dupla cannot be disallowed; but if the Proportion next before had been signified by any Mood, then might not this Dupla have been signified by the retort, but by proportionate numbers.[3]

Thirdly cometh the Less Prolation in the Mean part, and that [with] ordinary Tripla [4] of three [5] black minims to a stroke in the bass; and because those three black minims be sung in the time of two white minims they were marked thus, ℂ32, signifying three minims to two minims.[6] But if the sign of the Prolation had been left out and all been pricked

[1] M. has Q (D) instead of C.

[2] It must be remembered all through this song that the note values of the soprano part are diminished by half, as indicated by ¢ at the beginning. In this passage, if the sign had been ℭ it would have meant that the notes were sung at their face value, for this sign would cancel out the previous ¢, so that in order to diminish the note values by half (like the soprano) the sign is retorted (see p. 46). In this 'Mood' the white S = three M; therefore a black S = two M, the C being a black M, of which there are six to each S in the soprano, hence so-called Sextupla; but these six black M make up three black or imperfect S, so that the Proportion is really Tripla. In the second version Morley has written true Sextupla, or six S to one, indicating it by numbers. The retorted sign is unnecessary, for the previous ¢ still holds.

[3] The soprano is diminished, so to express Dupla the other parts must be doubly diminished, hence ⌀ (see p. 46). If the previous Proportion is shown by any other sign than ℭ or ¢, then you must not use the retort but proportionate numbers, i.e. ⁴⁄₁. Actually M. does not adhere strictly to this rule.

[4] 'Ordinary' in England but not on the Continent.

[5] M. has 'the.'

[6] Strictly speaking, all signs in the alto and bass parts should be diminished (e.g. ¢ or ⊃) whatever the proportion is, in order to correspond with the soprano, in which ¢ operates all through. M., however, uses the ordinary signs when Sesquialtera occurs but the diminished signs when Dupla, Tripla, or greater Proportions occur. Thus p. 65 (5th stave) shows the English Sextupla, hence ⊃ used; p. 65 (7th stave) shows Dupla, hence ⌀ used; p. 75 (Bassus, 1st stave) shows Tripla, and ¢ is used. But when Sesquialtera occurs he uses the ordinary sign, which implies no diminution. The note form ♩ is a black M; the ♪ and smaller note values were invariable as regards colour and took their values from higher note values in Proportional passages, thus ♪ here equals ½ black M.

in white notes, then had it been true thus: 𝄢 ♩ ♩ ♩ ♩ ♩ , and in this manner most commonly do the Italians signify their three minims to a stroke, or Tripla of three minims, which is indeed true Sesquialtera; but because we would here express true Tripla I have set it down thus: 𝄢 .♩ ♩ ♩ [1]. Therefore to destroy the Proportion follow these proportionate numbers at the sign of [the] degree thus: $\phi\frac{1}{3}$, which maketh the Common Time Imperfect of the Less Prolation.[2]

Then followeth true Tripla [3] which they [4] call Tripla to the semibreve; but because it is afterwards broken [5] I thought it better to prick it white than black; but the matter is come so far nowadays that some will have all semibreves in Proportion pricked black, else (say they) the Proportion will not be known. But that is false as being grounded neither upon reason nor authority. The Tripla broken in the More Prolation maketh nine minims for one stroke which is our common Nonupla,[6] but in one place of the broken Tripla where a semibreve and a minim come successively, that they marked with these numbers '92,' [7] which is the sign of Quadrupla Sesquialtera if the numbers were perpendicularly placed; but if that were true, why should not the rest also which were before be so noted, seeing nine of them were sung to two minims of the treble? [8]

Then followeth true Dupla, but for the reason before said, I signified it with numbers and not by the retort; [9] but in the bass, because the sign of the Less Prolation went immediately before, I could not with reason

[1] p. 75 (Bassus, 1st stave).

[2] p. 75 (Bassus, 4th stave). This is Subtripla. M. does not mention another Proportion which occurs in the bass (p. 67. 1st stave); this has the More Prolation retorted (ↄ), with the numbers 31 underneath. This is true Tripla, i.e. three black S to one in the soprano.

[3] p. 67 (Tenor, 4th stave), p. 75 (Tenor, 1st stave), p. 67 (Bassus, 4th stave), p. 75 (Bassus, 4th stave).

[4] The Italians.

[5] Split up into notes of less value. p. 67 (Tenor, 5th stave), p. 75 (Tenor, 2nd stave), p. 69 (Bassus, 1st stave), p. 75 (Bassus, 4th stave).

[6] The English composers were at least consistent in their misapplication of Proportions, for just as they called 3 and 6 M to a S Tripla and Sextupla, so 9 M to a S was Nonupla. The passage, however, is still Tripla, i.e. 3 Perfect S against 1 Imperfect in the soprano.

[7] p. 68 (Tenor, 1st stave—M. has '91' in error), p. 69 (Bassus, 1st stave).

[8] Just as the number 3 indicated Sesquialtera rather than Tripla (cf. p. 60, footnote 3) and made the M the Proportional unit, so did true Tripla (in the More Prolation) when written in M, for in this Tripla 3 Perfect S = 1 Imperfect S (stroke) or 2 M; when the 3 Perfect S are 'broken' into minims the result is 9 M = 2 M (stroke), which is 'conventional' Quadrupla Sesquialtera; true Quadrupla Sesquialtera is, of course, 9 S against 2 S.

[9] p. 75 (Tenor, 5th stave). In the first version M. has used the retorted sign wrongly, for the previous sign was ϕ, but in the second version he correctly puts $\phi\frac{2}{1}$, for the previous sign was ₵ and the retort can only be used if c or ϕ is the previous sign. (Cf. p. 85, footnote 3).

alter it, and therefore I suffered the retort to stand still, because I thought it as good as the proportionate numbers in that place.[1]

Then again followeth true Tripla in the More Prolation;[2] afterward, the contrary numbers $\frac{1}{3}$ of Subtripla destroying the Proportion,[3] the More Prolation remaineth, to which the bass singeth Quintupla, being

pricked thus: 𝄢♩♩♩♩♩♭ .[4] Such was our manner of pricking, without any reason or almost common sense, to make five crotchets be Quintupla to a semibreve, seeing four of them are but the proper value of one semibreve; but if they would make five crotchets to one semi‑breve then must they set down Sesquiquarta Proportions thus, $\frac{5}{4}$, wherein five semibreves (or their value) make up the time of four semibreves or strokes. But I am almost out of my purpose, and to return to our matter, I have altered those crotchets into semibreves, expressing true Quintupla.[5]

Then cometh Quintupla broken,[6] which is our common Decupla.[7] But if the other were Quintupla then is this likewise Quintupla because there goeth but the value of five semibreves for a stroke, and I think none of us but would think a man out of his wits who would confess that two testers [8] make a shilling and deny that six pieces of twopence apiece or twelve single pence do likewise make a shilling; yet we will confess that five semibreves to one is Quintupla, but we will not confess that ten minims, being the value of five semibreves, compared to one semi‑breve is likewise Quintupla; and so in Quadrupla, Sextupla, Septupla, and others.

Then cometh the common measure or the Less Prolation [9] (the sign of Subquintupla thus $\frac{1}{5}$, destroying the Proportion [10]), for which the bass singeth Septupla; but as it is set down in the first way it is, as it were, not Septupla but Supertripartiens Quartas or $\frac{7}{4}$; [11] therefore I set ·them all down in semibreves, allowing seven of them to a stroke; [12] which ended, cometh equality; [13] after which followeth true Dupla in the

[1] p. 76 (Bassus, 1st stave).　The retort can be used here as the previous sign is ₵.

[2] p. 75 (Tenor, 6th stave), p. 76 (Bassus, 2nd stave).　In the first version M. has followed the English custom of writing proportionate passages in black notes, hence he has dotted the black S in order to make them perfect, as they should be in the More Prolation.　The second version shows the clearer and more obvious method.

[3] p. 76 (Tenor, 1st stave).

[4] p. 69 (Bassus, 5th stave).

[5] p. 77 (Bassus, 1st stave).

[6] p. 76 (Tenor, 2nd stave).

[7] p. 68 (Tenor, 8th stave).　　　　[8] Sixpences (Shakespeare).

[9] p. 69 (Bassus, 8th stave), p. 70 (Tenor, 1st stave).

[10] p. 77 (Tenor, 1st stave), p. 77 (Bassus, 3rd stave).

[11] p. 70 (Bassus, 1st stave).　　　　　　　　[12] p. 77 (Bassus, 4th stave).

[13] p. 70 (Bassus, 2nd stave), p. 77 (Bassus, 5th stave).

More Prolation,[1] which we sometime call Sextupla and sometime Tripla;[2] after which, and last of all, cometh equality.[3]

And let this suffice for your instruction in singing, for I am persuaded that, except practice, you lack nothing to make you a perfect and sure singer.[4]

PHI. I pray you then, give me some songs wherein to exercise myself at convenient leisure.

MA. Here be some following of two parts which I have made of purpose, that when you have any friend to sing with you, you may practise together, which will sooner make you perfect than if you should study never so much by yourself.[5]

PHI. Sir, I thank you, and mean so diligently to practise till our next meeting, that then I think I shall be able to render you a full account of all which you have told me; till which time I wish you such contentment of mind and ease of body as you desire to yourself, or mothers use to wish to their children.

MA. I thank you, and assure yourself it will not be the smallest part of my contentment to see my scholars go towardly forward in their studies, which I doubt not but you will do, if you take but reasonable pains in practice.

[1] p. 70 (Tenor, 3rd stave; Bassus, 3rd stave), p. 77 (Tenor, 3rd stave; Bassus, 5th stave). The first version uses the retorted sign because the previous sign is ₵; the second version uses proportionate numbers because the Proportion immediately before is indicated by numbers; the use of proportionate numbers does not affect the diminishing power of the sign ₵ which, in the second version, operates on p. 77 (Bassus, 1st stave to end of 5th stave), and from p. 76 (Tenor, 1st stave—M. has omitted the sign before ⅔) to p. 77 (end of 2nd stave).

[2] Sextupla if they counted six black M to a white S, but Tripla if they counted three black S to a white S.

[3] p. 70 (Tenor, 4th stave; Bassus, 4th stave), p. 77 (Tenor, 3rd stave; Bassus, 6th stave).

[4] This remark, together with the foregoing example, gives an insight into the high standard of singing in Elizabethan England. It has been suggested that the Example is more a theoretical than a practical exercise, but although, in the two lower parts, bars 70-73, 80-84, 94-96, and 109-110 are more typical of contemporary instrumental style than of vocal, the rest of the piece, except for bars 102-108, contains passages that are hardly more difficult than some found in the motets and Masses of the late fifteenth century, and even bars 102-108 can be parallelled in some late fourteenth century chansons. In the first version the first two words of the text are give in both the lower parts, but this does not necessarily mean that they must be sung (the underlaying would present great difficulties albeit distinctly humorous possibilities), and an effective method of performance would be for viols to play the Tenor and Bass parts.

[5] There are six twopart songs and one threepart, all without words, so they were presumably sung to solfa syllables (cf. 'fa la' refrain in many balletts). The top part in each case is entitled Cantus and the lower Tenor, regardless of clef or range; in the threepart song the order is Cantus, Tenor, Bassus. M. writes out the repeats in full, except in the threepart song.

The First.

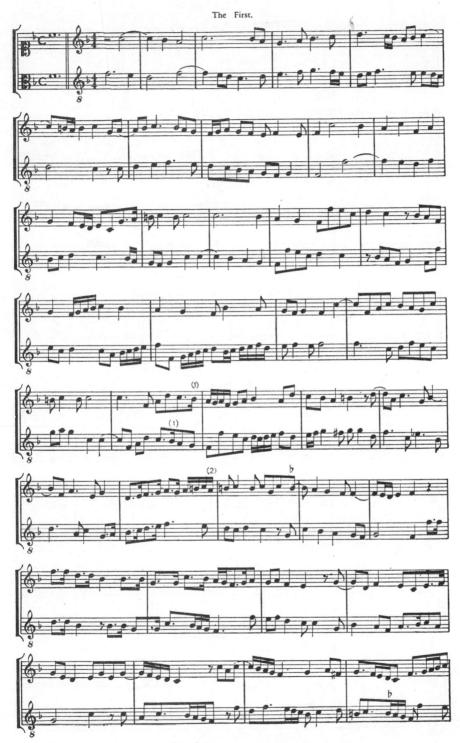

For footnotes, see page 99.

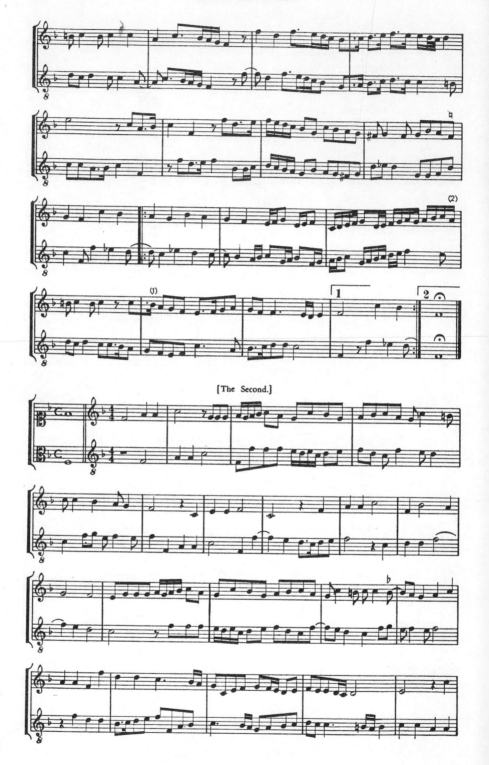

[The Second.]

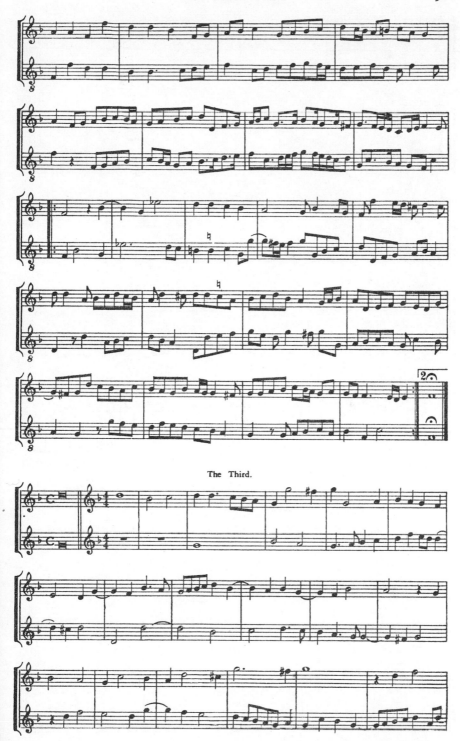

The Third.

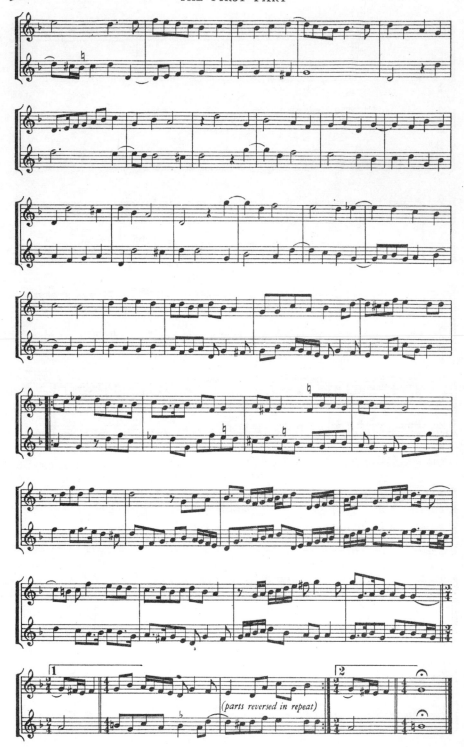

(parts reversed in repeat)

The Fourth.

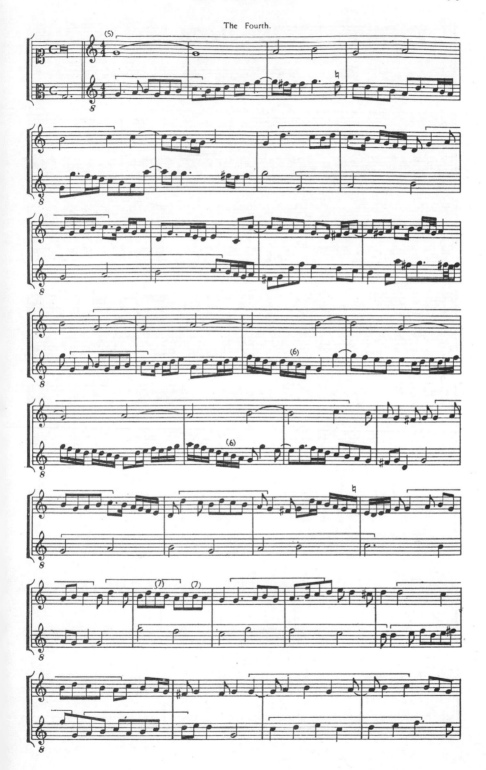

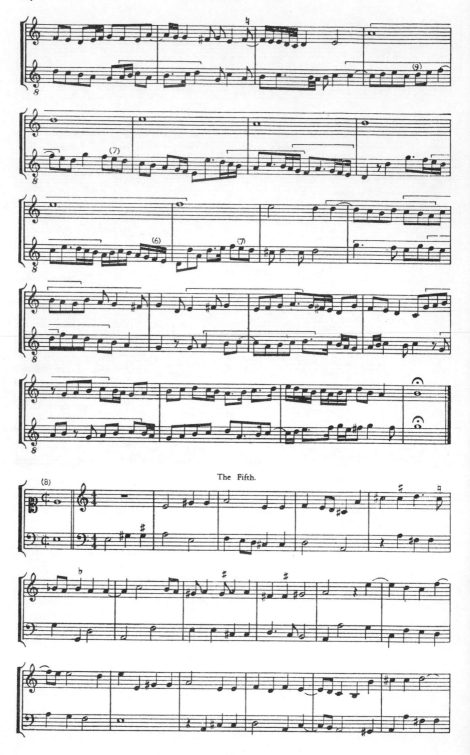

The Fifth.

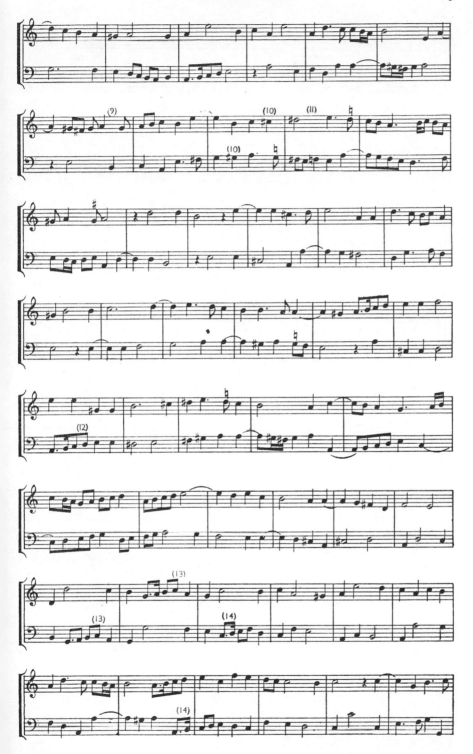

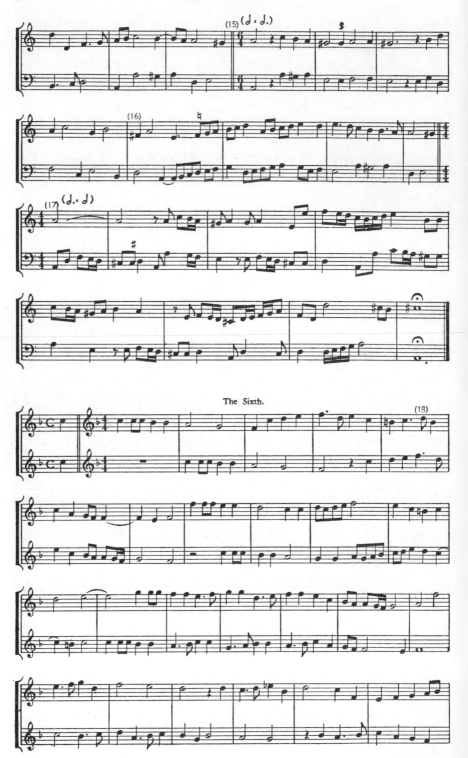

The Sixth.

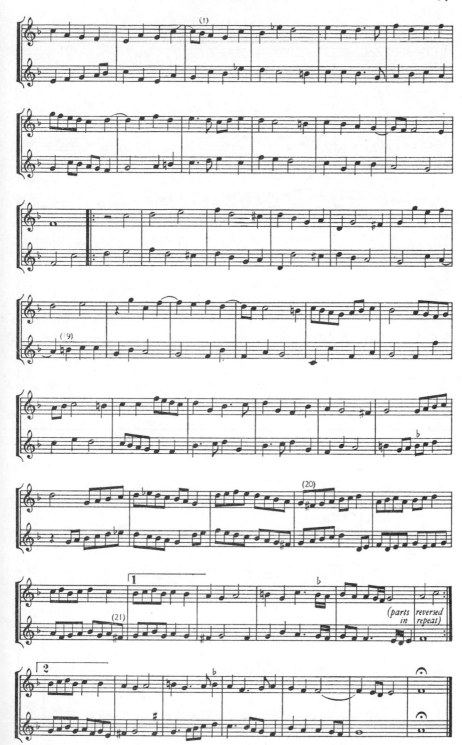

[CANZONET]
Aria a 3 voices

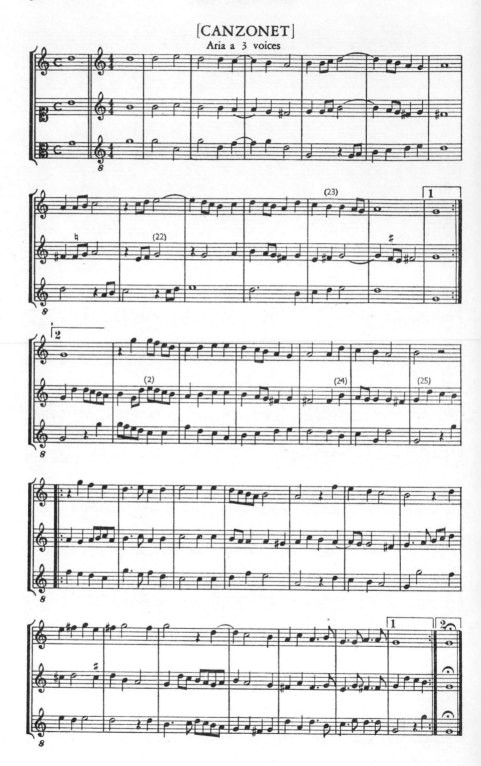

When you see this sign :‖: of repetition you must begin again, making the note next before the sign (be it minim, crotchet, or whatsoever) a semibreve in the first singing; * at the second time you must sing it as it standeth, going forward without any respect to the close. When you come to the end and find the sign of repetition before the final close, you must sing the note before the sign as it standeth, and then begin again at the place where the stroke † parteth all the lines and so sing to the final close. But if you find any song of this kind without the stroke so parting all the lines, you must begin at the first sign of repetition and so sing to the end, for in this manner (for saving of labour in pricking them at length) do they ‡ prick all their Ayres and Villanelles.

* In this song the soprano I has *S*, soprano II *C*, and the tenor *M*.
† The bar line mentioned in footnote 25.
‡ The Italians.

[1] Quaver resolution. [2] Jumped passing note.
[5] This Duo is remarkable in being entirely constructed from the opening motif, and I have indicated its construction by brackets. There is a similar piece in the *Cantiones sine textu* (No. 11) of Lassus (1577), but it is less subtle than M.'s.
[6] An unusual form of accented dissonant quaver.
[7] Accented dissonant *C*. [8] The Cantus has c in error.
[9] An unusual form (in two-part writing) of the Consonant Fourth cadence.
[10] A note chromatically sharpened within a phrase. M. may have had his eye on an example in Zacconi's *Prattica Musica* (Book II, chap. 49), where five instances occur (cf. Grove, vol. i, p. 741).
[11] A very unusual example of an augmented sixth. There are two instances in the above-mentioned example from Zacconi, one in Byrd's *Psalms, Sonnets, and Songs*, 1588 (No. 4, p. 22), two in the *Cantiones Sacrae*, 1589 (Nos. 6–7, p. 46; Nos. 20–21, p. 160), two in the 1591 book (Nos. 10–11, pp. 71 and 78), and two in *Musica Transalpina* (1588) (No. 41). Some scholars have questioned the ♭ before the F in the lower voice, claiming on the clear evidence of at least six copies that the ♭ was a misprint, corrected to a ♮ by a downward ink stroke, this being the easiest way of showing that the F was still F♭. This correction appears to be in the same ink used elsewhere in these copies for correcting a number of errors not included in the errata list and probably amended therefore in Short's office before the books were sold. All these ink corrections, with the exception of the one under discussion, were incorporated in the revised second edition of 1608. This Duo is clearly an attempt by M. to emulate Italian chromaticism (it is certainly more chromatic than any of his published work), and I suggest that the ♭ was not a misprint but a deliberate example of 'modernism' which he rejected on second thoughts.
[12] M. gives two Q. [13] *Échappée.*
[14] M. gives two C, but see the previous soprano phrase.
[15] M. writes this section thus:

He gives ∅ instead of ¢, which latter makes the *B* and *S* perfect, hence when black they become imperfect while the stroke halves their value. '32' means that three *S* in this section equal two in the previous section ($○ = ○·$).
[16] A leap from B to F♯ which M. condemns on p. 176.
[17] M. gives ¢ in both parts. [18] Jumped resolution.
[19] M. gives B♭ when this note occurs in the soprano I part; upward resolution.
[20] M. gives F♮ when this note occurs in the soprano II part.
[21] M. gives F♮ when this note occurs in the soprano I part. [22] M. gives C.
[23] B minor chord.
[24] A leap from F♯ to B which M. condemns on p. 176.
[25] M. inserts a bar line here, indicating the beginning of the section which is repeated.

E

ANNOTATIONS

Wherein the verity of some of the precepts is proved,
and some arguments, which to the contrary might be
objected, are refuted.

TO THE READER

WHEN I had ended my book and shown it (to be perused) to some of
better skill in letters than myself, I was by them requested to give some
contentment to the learned, both by setting down a reason why I had
disagreed from the opinion of others, as also to explain something which
in the book itself might seem obscure. I have therefore thought it best
to set down in Annotations such things as in the text could not so
commodiously be handled, for interrupting of the continual course of
the matter, that both the young beginner should not be overloaded with
those things which at the first would be too hard for him to conceive,
and also that they who were more skilful might have a reason for my
proceedings. I would therefore counsel the young scholar in music not
to entangle himself in the reading of these notes till he have perfectly
learned the book itself, or at least the first part thereof, for without the
knowledge of the book, by reading of them he shall run into such con-
fusion as he shall not know where to begin or where to leave. But thou
(learned reader) if thou find anything which shall not be to thy liking,
in friendship advertise me, that I may either mend it or scrape it out.
And so I end, protesting that 'Errare possum haereticus esse nolo.' [1]

Page 10, line 35, ' the Scale of Music.'

I have omitted the definition and division of music, because the greatest
part of those for whose sake the book was taken in hand and who chiefly
are to use it, be either altogether unlearned or then have not so far pro-
ceeded in learning as to understand the reason of a definition, and also
because amongst so many who have written of music I knew not whom
to follow in the definition, and therefore I have left it to the discretion
of the reader to take which he list of all these which I shall set down;

[1] 'I can make mistakes and have no wish to be unorthodox.'

the most ancient of which is by Plato, set out in his *Theages* thus:
'Music,' saith he, 'is a knowledge' (for so I interpret the word σοφία
which in that place he useth), 'whereby we may rule a company of
singers or singers in companies' (or 'choir,' for so the word χορός signifieth).
But in his *Banquet* he giveth this definition: 'Music,' saith he, 'is a
science of love matters occupied in harmony and rhythm.'

Boethius [1] distinguisheth, and theoretical or speculative music he
defineth, in the first chapter of the fifth book of his *Music*: 'Facultas
differentias acutorum & gravium sonorum sensu ac ratione perpendens'
('a faculty considering the difference of high and low sounds by sense
and reason').

Augustine defineth practical music (which is that which we have
now in hand): 'Recte modulandi scientia' ('a science of well-doing by
time, tune, or number'),[2] for in all these three is 'modulandi peritia'
occupied.

Franchinus Gafurius thus: 'Musica est proportionabilium sonorum
concinnis intervallis disjunctorum dispositio sensu ac ratione conso-
nantiam monstrans' ('a disposition of proportionable sounds divided by
apt distances, showing by sense and reason the agreement in sound').[3]
Those who have been since his time have done it thus: 'Rite & bene
canendi scientia' ('a science of duly and well singing,' 'a science of
singing well in tune and number'). 'Ars bene canendi' ('an art of
well singing'). Now I say, let every man follow what definition
he list.

As for the division, music is either speculative or practical. Specu-
lative is that kind of music which, by mathematical helps, seeketh out
the causes, properties, and natures of sounds, by themselves and com-
pared with others, proceeding no further, but content with the only con-
templation of the art. Practical is that which teacheth all that may be
known in songs, either for the understanding of other men's, or making
of one's own, and is of three kinds: Diatonicum, Chromaticum, and
Enharmonicum.

Diatonicum is that which is now in use, and riseth throughout the
scale by a whole note, a whole note, and a less half note [4] (a whole note
is that which the Latins call 'integer tonus,' and is that distance which is
betwixt any two notes except Mi and Fa, for betwixt Mi and Fa is not a

[1] Anicius Manlius Torquatus Severinus Boethius (c. 480–524). *De Institutione Musica*.
Glareanus published the manuscript dealing with music with comments of his own in 1570.
[2] The usual medieval definition was 'Musica est scientia bene modulandi.' 'Modulatio'
refers to the rhythmical and melodic structure of a composition.
[3] *Harmonia Instrumentorum* (Book I, f. 2ro).
[4] In the diagram on p. 106, however, all the diatessarons (the fundamental unit of
Greek music) are constructed in the reverse order of this, i.e. semitone, tone, tone.

full half note, but is less than half a note by a 'comma,'[1] and therefore called the less half note) in this manner:

Chromaticum is that which riseth by 'semitonium minus' (or the less half note), the greater half note, and three half notes,[3] thus:

(the greater half note is that distance which is betwixt Fa and Mi in b Fa ♮ mi).[5]

Enharmonicum is that which riseth by diesis, diesis (diesis is the half of the less half note [6]), and ditonus; but in our music I can give no example of it because we have no half of a less 'semitonium,' but

those who would show it set down this example: of

Enharmonicum and mark the diesis thus, '✕,' as it were the half of the apotome or greater half note which is marked thus, '✗.'[9] This sign of

[1] M. is here describing what he understood to be the Greek 'Diatonic genus' in which all the whole tones were equal and of ratio $9 : 8$ and the semitones of ratio $256 : 243$ (the Pythagorean Limma, cf. the diagram on p. 106). If we assume that by 'comma' he means that of Didymus (ratio $81 : 80$), then by 'half a note' he must mean the semitone in Just Intonation (ratio $16 : 15$), for the difference between a Just semitone and a Pythagorean Limma is a comma $\left(\dfrac{16}{15} \times \dfrac{243}{256} = \dfrac{81}{80} \right)$. M.'s description of the three Genera (Diatonic, Chromatic, and Enharmonic) are all based on the Pythagorean scale shown on p. 106. In this scale the leading note interval (Mi–Fa) is less than half a whole tone, whereas in Mean-Tone tuning Mi–Fa is more than half a whole tone.

[2] The D and A are redundant.

[3] These were regarded as a composite interval; M. does not mean three semitones of ratio $16 : 15$ or $256 : 243$.

[4] M. gives D (middle line).

[5] i.e. the interval between B♭ and B♮, also called the 'apotome.' This interval plus the Pythagorean Limma makes a whole tone. Thus in the 'natural' scale the 'less half note' is the interval between Mi and Fa (e.g. E–F, C♯–D, A–B♭, etc., depending on the position of the Ut), and the 'greater half note' is the interval between a note and its sharp (e.g. C–C♯) or a flattened note and its natural (e.g. B♭–B♮). Thus a passage such as this would not

sound so dissonant sung as it does when played on the piano: , but an

augmented sixth, on the other hand, would sound more dissonant.

[6] Therefore slightly less than a quarter tone.

[7] M. gives the usual sharp sign, i.e. '✗' instead of '✕.'

[8] M. gives D. The initial A is redundant.

[9] Half in the sense of one cross (✕), not two (✗), but not half the *interval* of the apotome, for the diesis has just been defined as half the less half note.

the more half note we nowadays confound with our b square or sign of Mi in b fa ♮ mi, and with good reason, for when Mi is sung in b fa ♮ mi it is in that habitude to A la mi re as the double diesis maketh F fa ut sharp to E la mi, for in both places the distance is a whole note.[1]

But of this enough, and by this which is already set down it may evidently appear that this kind of music which is usual nowadays is not fully and in every respect the ancient Diatonicum, for if you begin any four notes singing Ut, Re, Mi, Fa, you shall not find either a flat in E la mi or a sharp in F fa ut, so that it must needs follow that it is neither just Diatonicum nor right Chromaticum.[2] Likewise, by that which

is said, it appeareth this point which our organists use, ,

is not right Chromatica, but a bastard point patched up of half Chromatic and half Diatonic. Lastly it appeareth, by that which is said, that those virginals which our unlearned musicians call Chromatica (and some also Grammatica [3]), be not right Chromatica but half Enharmonica,[4] and that all the Chromatica may be expressed upon our

common virginals except this, , for if you would think that the

sharp in G sol re ut would serve that turn, by experiment you shall find that it is more than half a quarter of a note too low.[5]

But let this suffice for the kinds of music. Now to the parts practical.

[1] In other words they used the sharp sign (𝕏) to make a flattened note natural, for B♮ is in the same relationship (habitude) to A (i.e. a whole tone) as F♯ is to E. 'Double diesis' refers to the sign 𝕏 and does not mean that F♯ is two dieses above F, for F-F♯ is a *greater* semitone (apotome), while two dieses equal a *lesser* semitone.

[2] This is a little misleading, for the scales on C, F, and G are Diatonic and a Chromatic scale can be constructed on A (A, B♭, B♮, D), as both B♭ and B♮ are in the scale on p. 11. But for a Diatonic scale on D F♯ is needed, and for a Chromatic, E♭. A Chromatic on E also needs F♯, while a Diatonic needs F♯ and G♯.

[3] 'Theoretical,' having no practical use. Another pun! It might also mean that M. was leg-pulling those 'unlearned musicians' who, not knowing the real meaning of 'Chromatica,' misspelt it as 'Grammatica.'

[4] Chromatic virginals and organs in the sixteenth century could play notes not included on the 'common virginals' (or our modern pianos); for instance, the Italians had organs with a note between G♯ and A and C♯ and D, and Salinas mentions an archicymbalum in which each tone was divided into five parts; this system was called 'Systema Participato,' and as it used intervals which M. would call dieses it was not, as he says, Chromatic but half Enharmonic.

[5] In the Pythagorean scale the interval G–G♯ is greater than G–A♭, hence the first was called the greater half note and the second the less half note, but keyboard instruments were tuned in something approximating to Mean-Tone temperament in which the interval G–G♯ is less than G–A♭ by 1·9 commas; if by 'note' we take M. to imply a 'mean tone' (9 commas) then an eighth of this is 1·125 commas, so that G♯ would be ·775 of a comma, 'more than half a quarter of a note too low.' These figures would of course be beyond M., but the 'more' is the important word and shows the astonishing accuracy of sixteenth-century theoreticians.

Music is divided into two parts; the first may be called Elementary or Rudimental, teaching to know the quality and quantity of notes, and everything else belonging to songs of what manner or kind soever. The second may be called Syntactical, Poetical, or Effective, treating of sounds, concords, and discords, and generally of everything serving for the formal and apt setting together of parts or sounds for producing of harmony, either upon a ground or voluntary.[1]

Page 10, line 36 : ' which we call the Gam.'

That which we call the Scale of Music or the Gam, others call the Scale of Guido, for Guido Aretinus, a monk of the Order of St. Benet or Benedict, about the year of our Lord 960,[2] changed the Greek scale (which consisted only of fifteen keys, beginning at A re (*A*) and ending at A la mi re (*a'*)), thinking it a thing too tedious to say such long words as Proslambanomenos, Hypate hypaton, and such like, and turned them into A re, B mi, C fa ut, etc.;[3] and to the intent his invention might the longer remain and the more easily be learned of children, he framed and applied his scale to the hand, setting upon every joint a several key, beginning at the thumb's end and descending on the inside, then orderly through the lowest joints of every finger, ascending on the little finger, and then upon the tops of the rest, still going about, setting his last key E la (*e''*) upon the upper joint of the middle finger on the outside.[4] But to the end that every one might know from whence he had the art he set this Greek letter Γ Gamma to the beginning of his scale, serving for a diapason to his seventh letter G;[5] and whereas before him the whole scale consisted of four tetrachorda or fourths, so disposed as the highest note of the lower was the lowest of the next, except that of Mese (as we shall know more largely hereafter), he added a fifth tetrachordon, including in the scale (but not with such art and reason as the Greeks did[6]) seven hexachords or deductions of his six notes, causing that

[1] i.e. a C.F., either sacred or secular, which was used as the basis of a composition, or an entirely original piece.

[2] Guido d'Arezzo (*c.* 995–1050). *Micrologus. Argumentum novi Cantus inveniendi.*

[3] M. is here following Zarlino (*Harmonical Institutions*, Book II, chap. 30), who is quite incorrect, as the Greek names were replaced by the Latin letters before Guido's time, e.g. in the *Dialogus* attributed to Odo of Cluny (*d.* 942) and *Musica Enchiriadis* (ninth century).

[4] This Guidonian Hand is the usual one, differing from the one given in Grove. M. may have taken it from Zacconi's *Prattica Musica* or the tract in the Cotton MS. beginning 'Pro aliquali notitia de musica habenda.' (Hawkins, p. 233.)

[5] Another reason usually given was that Γ was the first letter of his own name. M. implies that Guido was the first to use this letter, but it is to be found in Odo's *Dialogus.*

[6] Presumably because the Greeks had *four* tetrachords while Guido had *seven* hexachords, and while each tetrachord began on the last note of the previous tetrachord (except the Diezeugmenon) Guido's hexachords overlapped unevenly.

which before contained but fifteen notes contain twenty, and so fill up both the reach of most voices and the joints of the hand. Some after him (or he himself) altered his scale in form of organ pipes, as you see set down in the beginning of the book.[1] But the Greek scale was thus: [*See page 106.*]

For understanding of which there be three things to be considered; the names, the numbers, and the distances. As for the names you must note that they be all nouns adjectives, the substantive of which is 'chorda,' or 'a string.' 'Proslambanomene' signifieth a string assumed, or taken in, the reason whereof we shall straight know.

All the scale was divided into four tetrachords, or fourths, the lowest of which four was called Tetrachordon Hypaton—the Fourth of Princi-pals. The second, Tetrachordon Meson—the Fourth of Middle or Means. The third, Tetrachordon Diezeugmenon—the Fourth of strings Disjoined or Disjunct. The fourth and last, Tetrachordon Hyperboleon —the Fourth of strings Exceeding. The lowest string, Proslambanomene, is called assumed, because it is not accounted for one of any tetrachord, but was taken in to be a diapason to the Mese, or middle string.[2] The Tetrachord of Principals, or Hypaton, beginneth in the distance of one note above the assumed string, containing four strings or notes, the last of which is Hypate Meson. The Tetrachord of Meson or Means be-ginneth where the other ended (so that one string is both the end of the former and the beginning of the next), and containeth likewise four, the last whereof is Mese. But the third tetrachord was of two manner of dispositions, for either it was in the natural kind of singing, and then was it called Tetrachordon Dìezeugmenon because the middle string, or Mese, was separated from the lowest string of that tetrachord by a whole note,[3] and was not accounted for any of the four belonging to it, as you may see in the scale; or then in the flat kind of singing, in which case it was called Tetrachordon Synezeugmenon or Synemmenon, because the Mese was the lowest note of that tetrachord, all being named thus: Mese, Trite Synemmenon (or Synezeugmenon), Paranete Synezeugmenon, and Nete Synezeugmenon.[4] But lest these strange names seem fitter to conjure a spirit than to express the art, I have thought good to give the names in English.

[1] M. is here probably referring to a manuscript which contained, among other tracts, the *Micrologus* of Guido and a commentary on it by one Johannes Wylde, the latter of which may have contained the organ pipe diagram.

[2] See the table on p. 107.

[3] This tetrachord consists of the notes B, C, D, E, and was called 'natural' in that no accidental was required.

[4] This tetrachord consists of the notes A, B♭, C, D, and was called 'flat' because the B had to be flattened in order to make the construction of the tetrachord conform to the others, i.e. semitone, tone, tone.

Syſtema harmonicum quindecim chordarum [1]
in genere diatonico.

2304		Nete hyperbolæon
2592	tonus	Paranete hyperbolæon
2916	ton	Trite hyperbolæon
3072	fem.	Nete diezeugmenon
3456	tonus	Paranete diezeugmenon
3888	tonus	Trite diezeugmenon
4096	fem.	Parameſe
4608	tonus	Meſe [3]
5184	tonus	Lychanos meſon [4]
5832	tonus	Parhypate meſon
6144	fem.	Hypate meſon [5]
6912	tonus	Lychanos hypaton
7776	tonus	Parhypate hypaton
8192	femitoniū minus	Hypate hypaton
9216	conus	Proſlambanomene

Arc labels: diateſſaron, diateſſaron, diapason, diapente, diapente, ratio ſeſquitertia, diateſſaron, diapente ratio ſeſquialtera, Diapaſon ratio dupla, Diſdiapaſon maximum Syſtema ratio quadrupla.

[1] M. probably based this diagram on the one in Zarlino's *Harmonical Institutions* (Book II, chap. 28, p. 122). There is a similar one without numbers in Gafurius's *Theorica Musice* (Book V, chap. 3).

[2] Nete (chorda) was the lowest of three strings but the highest in pitch.

[3] M. has not included the number for Trite Synezeugmenon (B♭), which is 4374, making a ratio with Mese (A) (4608) of 256 : 243—the diesis or limma of Pythagoras.

[4] M. spells 'Lichanos' with a 'y' instead of an 'i.' 'Lichanos chorda' means the string struck with the forefinger. In the following table M. translates it as 'index' in the sense of 'indicating' or 'pointing out' the tetrachord of which it is the first.

[5] Hypate (chorda) was the highest of three strings but the lowest in pitch. The usual explanation of this inverted nomenclature is that the Greek lyre player tilted his instrument in such a way that the high-pitched strings were in a low position, and vice versa. (But cf. Reese, *Music in the Middle Ages*, p. 22.)

ALL THE NAMES OF THE SCALE IN ENGLISH

	tetrachord	Greek name	tet. synez.	Synezeugmenon	English	
A re		Proslambanomene				A [1]
B mi	tet. hypaton	Hypate hypaton			Principal of principals	B
C fa ut		Parhypate hypaton			Subprincipal of principals	c
D sol re		Lichanos hypaton			Index of principals	d
E la mi	tet. meson	Hypate meson			Principal of means	e
F fa ut		Parhypate meson			Subprincipal of means	f
G sol re ut		Lichanos meson			Index of means [2]	g
A la mi re		Mese		Mese [3]	Middle	a
B fa X [4] mi	tet. diezeug.	Paramese	tet. synez.	Trite synezeug-menon	Next the middle	b♭, b♮
C sol fa ut		Trite diezeugmenon		Paranete synezeug-menon	Third of disjunct	c'
D la sol re		Paranete diezeug-menon		Nete synezeug-menon	Penult of disjunct	d'
la mi	tet. hyperboleon	Nete diezeugmenon			Last of disjunct	e'
fa ut		Trite hyperboleon			Third of exceeding or treble	f'
sol re ut		Paranete hyper-boleon			Penult of trebles	g'
la mi re		Nete hyperboleon			Last of trebles	a'

So much for the names. The numbers set on the left side declare the habitude (which we call proportion) of one sound to another, as, for example, the number set at the lowest note Proslambanomene is Sesqui-octave [5] to that which is set before the next, and Sesquitertia [6] to that which is set at Lichanos Hypaton; and so by consideration of these numbers may be gathered the distance of the sound of the one from the other; as Sesquioctave produceth one whole note, then betwixt Proslam-banomene and Hypate Hypaton is the distance of one whole note; likewise Sesquitertia produceth a fourth, therefore Proslambanomene and Lichanos Hypaton are a fourth, and so of others. But lest it might seem tedious to divide so many numbers and seek out the common divisors for so many fractions, both the distance is set down betwixt

[1] Helmholtz's notation.
[2] M. reverses the positions of 'Index of means' and 'Middle.'
[3] M. displaces this tetrachord, placing Mese opposite Parhypate meson.
[4] An instance of the sharp sign (sign of the apotome) being 'confounded' with the 'natural' (cf. pp. 102-3 and 110).
[5] 9 : 8. [6] 4 : 3.

* E

every two notes, and the consonants[1] are drawn on the right side of the Scale.[2]

Thus much for the explanation of the table, but what use it had, or how they did sing is uncertain; only it appeareth by the names that they termed the keys of their scale after the strings of some instrument, which I doubt not is the harp. And though the Friar Zacconi out of Franchinus[3] affirm that the Greeks did sing by certain letters, signifying both the time that the note is to be holden in length and also the height and lowness of the same, yet because I find no such matter in Franchinus his *Harmonia instrumentorum* (for his *Theorica* nor *Practica* I have not seen, nor understand not his arguments) I know not what to say to it. Yet thus much I will say, that such characters as Boethius setteth down to signify the strings do not signify any time, for it is a great controversy amongst the learned if the ancient musicians had any diversity of notes, but only the sign of the chord[4] being set over the word, the quantity or length was known by that of the syllable which it served to express.

But to return to Guido's invention, it hath hitherto been so usual as the old is gone quite out of men's memory; and as for the Gam, many have upon it devised such fantastical imaginations as it were ridiculous to write, as (forsooth) A re is silver, B mi quicksilver, etc., for it were too long to set down all; but it should seem that he who wrote it was either an alchemist or an alchemist's friend. Before an old treatise of music written in vellum above an hundred years ago called *Regulae Franconis cum additionibus Roberti de Handlo*,[5] there is a Gam set down thus:

[1] i.e. the fourth, fifth, and octave.

[2] The whole of the preceding passage dealing with the three genera and intervals is typical of the confusion which reigned in the medieval theorists' camp concerning Greek music, although M. has tried to be as concise as possible. The numbers in the diagram on p. 106 give the semitonic ratio as 256 : 243 and the whole tones as 9 : 8. This agrees with Ptolemy's 'Ditonic' Diatonic genera but not with Zarlino, who maintained that Ptolemy's 'Intense' or 'Syntonus' Diatonic genera was the only valid one (semitone 16 : 15, whole tones 9 : 8 and 10 : 9). M.'s Chromatic genera, however, does not agree with those of Ptolemy, Aristoxenos, Didymus, Eratosthenes, or Archytas. The Enharmonic is very nearly the same as that of Aristoxenos.

[3] The passage M. is referring to comes in *Prattica di Musica*, Book I, chap. 15, and although there is no specific reference to Franchinus Gafurius, Zacconi probably had his eye on the former's *Practica Musicae utriusque Cantus*, Book II, chap. 2, but here Franchinus specifically states that the Greek letters only signified pitch and that length of note was indicated by certain characters, which he does not give but which actually occur in Boethius, Book IV, chap. 3. (Hawkins, p. 283.)

[4] 'Note.'

[5] Robert de Handlo, *Regulae cum maximis Magistri Franconis, cum additionibus aliorum musicorum* (1326). The copy that M. consulted was almost certainly that included in the 'Tiberius B. ix' manuscript in the Cottonian Library, and later destroyed by fire in 1731. M. presumably knew the date, and it is therefore surprising that he places it only 'above an hundred years ago.' This manuscript also contains the *Quatuor Principalia*

Γ ut	G¹	Terra	E la mi	e¹	Saturnus
A re	A	Luna	F fa ut	f	Jupiter
B mi	B	Mercurius	G sol re ut	g	Mars
C fa ut	c	Venus	A la mi re	a	Sol
D sol re	d	Sol	B fa X mi	bb or b♮	Venus
E la mi	e	Jupiter	C sol fa ut	c'	Mercurius
F fa ut	f	Saturnus	D la sol re	d'	Luna
G sol re ut	g	Coelum			Boethius²

And at the end thereof these words [of] Marcus Tullius,³ pointing (as I take it) to that most excellent discourse in the dream of Scipio where the motions and sounds of all the spheres are most sweetly set down,⁴ which whoso listeth to read, let him also peruse the notes of Erasmus⁵ upon that place, where he taketh up Gaza⁶ roundly for his Greek translation of it, for there Tullius doth affirm that it is impossible that so great motions may be moved without sound, and, according to their nearness to the earth, giveth he every one a sound, the lower body the lower sound.⁷ But Glareanus, one of the most learned of our time, maketh two arguments to contrary effects, gathered out of their opinion who deny the sound of the spheres:⁸ 'the greatest bodies,' saith he, 'make the greatest sounds; the higher celestial bodies are the greatest bodies; therefore the highest bodies make the greatest sounds.'⁹ The other proveth the contrary thus: 'that which moveth swiftest giveth the highest sound; the higher bodies move swiftest; therefore the highest bodies give the highest sound.'

(cf. p. 112). The Handlo treatise mentions Jacobus de Navernia (cf. p. 116), which M. misspells 'Naverina'; he also spells Handlo 'Haudlo' or 'Haulo.'

¹ Helmholtz's notation.

² This table could not possibly have been taken from Boethius, as the insertion of his name here suggests, as the Gam was not invented in his time; the table given on p. 110, however, is almost certainly based on Boethius; I suggest therefore that the name has been misplaced.

³ Cicero.

⁴ 'Dream of Scipio,' Cicero (De Republica, Book VI). Cicero maintains that the higher bodies, being those which move with the greatest velocity, make the highest sounds (cf. p. 110).

⁵ Erasmus (1466–1536).

⁶ Gaza (1398–1478). An Italian and a great Latin scholar, who translated 'The Dream of Scipio' from Latin into Greek.

⁷ Musica mundana.

⁸ This sentence is a little ambiguous, but what is meant is that the succeeding statements have been taken by Glareanus from the writings of those who deny the existence of musica mundana and who have quoted these two conflicting theories in order to refute the whole idea. Boethius was the chief exponent of musica mundana (first formulated by Pythagoras), but by the end of the fourteenth century it was almost completely discredited.

⁹ 'Great' in the vibrational sense, hence lowness of pitch.

The Greeks have made another comparison of the Tunes, Keys, Muses, and Planets, thus:

Urania [1]	Mese [2]			Hypermixolydius	Coelum stellatum [3]
Polymnia	Lichanos Meson			Mixolydius	Saturnus
Euterpe	Parhypate Meson			Lydius	Jupiter
Erato	Hypate Meson		Thalia	Phrygius	Mars
Melpomene	Lichanos Hypaton			Dorius	Sol
Terpsichore	Parhypate Hypaton			Hypolydius	Venus
Calliope	Hypate Hypaton			Hypophrygius	Mercurius
Clio	Proslambanomene			Hypodorius	Luna

Thalia

Terra

and not without reason, though in many other things it hath been called justly 'mendax' and 'nugatrix Graecia.' Some also (whom I might name if I would) have affirmed that the scale is called Gam ut from 'Gam,' which signifieth in Greek 'grave' or 'ancient'; as for me I find no such Greek in my lexicon; if they can prove it they shall have it.

Page 12, line 18 : ' but one twice named.'

It should seem that at the first the round 'b' was written as now it is, thus, 'b,' and the square 'b' thus, 'h'; but for haste, men not being careful to see the strokes meet just at right-angles, it degenerated into this figure, 'h,' and at length came to be confounded with the sign of the apotome or 'semitonium majus' which is this, 'X,' and some falsely term diesis, for diesis is the half of 'semitonium minus,' whose sign was made thus, '×.' But at length the sign by ignorance was called by the name of the thing signified, and so the other sign, being like unto it, was called by the same name also.

Page 12, line 30 : 'but in use in singing.'

These be commonly called 'claves signatae,' or 'signed clefs,' because they be signs for all songs, and use hath received it for a general rule not to set them in the space because no clef can be so formed as to stand in a

[1] M. gives 'Urama' and 'Polymma.'

[2] This column should be placed the other way up, Proslambanomene being the same as Hypermixolydius, etc. I have not corrected this error in the text as it was a common one, and even occurs in Grove (vol. iii, p. 476).

[3] The order of the planets from earth to heaven is the same as the Pythagorean; the linking of the planets with actual sounds occurs in the Waltham Holy Cross tract entitled *De octo Tonis . . .* and agrees with that given by M.

space and touch no line except the B clef; [1] and therefore, lest any should doubt of their true standing (as, for example, the G clef, if it stood in space and touched a line, one might justly doubt whether the author meant G sol re ut in bass which standeth in space or G sol re ut in alto which standeth on the line [2]), it hath been thought best by all the musicians to set them in line. Indeed I cannot deny but that I have seen some A re clefs and others in the space, [3] but 'una hirundo non facit ver.'

Page 13, line 10 : ' *as though the stave were the scale.*'

So it is, and though no usual stave comprehend the whole scale yet doth it a part thereof, for if you put any two staves together you shall have the whole Gam thus:

Page 14, line 9 : ' *the three natures of singing.*'

A property of singing is nothing else but the difference of plainsongs caused by the note in B fa ✗ mi, having the half note either above or below it; [4] and it may plainly be seen that those three properties have not been devised for pricked song, [5] for you shall find no song included in so small bounds as to touch no B. And therefore these plainsongs which were so contained were called 'natural' because every key of their six notes stood invariable the one to the other however the notes were named, as from D sol re to E la mi was always a whole note whether one did sing Sol la or Re mi, and so forth of others. [6] If the b had the semitonium under it, then was it noted ♭ and was termed b *molle* or soft; if above it, then was it noted thus, ♮, and termed b *quadratum* or b *quarre*. In an

[1] i.e. ♭. [2] Top space bass clef and top line alto clef.
[3] The Waltham Holy Cross MS. (a collection based on Guido's *Micrologus* and other writings—Brit. Mus. Lansdowne MS. 763) contains a tract by one Wylde, *Hunc librum vocitatum Musicam Guidonis,* in chap. 19 of which he censures the practice of some musical scribes who used other 'keys' (clefs) than those given above and mentions, among others, an A clef below middle C (cf. Hawkins, p. 242). M. himself uses another clef (dd) in the diagram on p. 142, which is also given in Lossius's *Erotemata.* Taverner also uses a 'd' clef, and in the *Mulliner Book* are two examples of an F clef denoting the eleventh above middle C (Nos. 48 and 113).
[4] B♮–C or B♭–A.
[5] 'Measured' song as opposed to plainsong.
[6] The 'natural' plainsong was one with a range from C to A, for these notes were invariable no matter how they were termed. If, however, a plainsong contained a B it was sung either as Fa or Mi (♭ or ♮), and hence B fa b mi to C sol fa ut could be either a whole tone (B fa–C sol) or a semitone (B mi–C fa).

old treatise called *Tractatus quatuor principalium*[1] I find these rules and
verses: 'Omne Ut incipiens in C cantatur per naturam, in F per b molle,
in G per ♮ quadratum,' that is, 'every Ut beginning in C is sung by
Properchant, in F by b *molle* or flat, in G by the square ♮ or sharp.'
The verses be these:

> C naturam dat F b molle nunc tibi signat,
> G quoque b durum tu semper habes caniturum.

which if they were no truer in substance than they be fine in words and
right in quantity of syllables, were not much worth. As for the three
themselves, their names bear manifest witness that music hath come to
us from the French,[2] for if we had had it from any other, I see no reason
why we might not as well have said the 'square b' as 'b *quarre*' or '*carre*,'
the signification being all one. In the treatise of the Four Principals I
found a table containing all the notes in the scale, and by what property
of singing every one is sung, which I thought good to communicate
unto thee in English. [*See diagram on p. 113*].

But for the understanding of it I must show you what is meant by
mutation or change: mutation is the leaving of one name of a note and
taking another in the same sound, and is done (sayeth the author of
Quatuor principalia) either by reason of property or by reason of the voice.
By reason of the property as when you change the Sol in G sol re ut in
Ut by the ♮, and in Re by the ♭, and such like.[3] By reason of the voice
when the name is changed for the ascension or descension's sake, as, for
example, in C fa ut, if you take the note Fa you may rise to the third
and fall to the fourth, in the due order of the six notes, if the property
let not; but if you would ascend to the fourth, then of force must you
change your Fa into Ut, if you will not sing improperly, because no man
can ascend above La nor descend under Ut properly, for if he descend
he must call Ut, Fa.[4] Now in those keys wherein there is but one note
there is no change, where two there is double change, where three is
sextupla; but all this must be understood where those three or two notes
be all in one sound, for if they be not of one sound they fall not under

[1] Cf. p. 108. The full title is *Quatuor principalia totius artis musicae* (1351). It is in dia-
logue form between Franco and de Handlo and other occasional interlocutors.

[2] M. is probably thinking here of the Ars Nova and Philippe de Vitry whom he mentions
later on. It is interesting to compare this sentence (especially when we remember that in
M.'s day Italy was the predominant influence) with the following: 'Almost all the innova-
tions that originated in Italy go back to French sources.' (Láng, *Music in Western Civiliza-
tion*, chap. 8, 'The Ars Nova,' p. 151.)

[3] See p. 114, footnote 3.

[4] If you sing C as Fa you may rise to E singing Sol (D) and La (E), provided that the
property of singing does not prevent ('let') you, for if the E were flat then you would have
to sing Fa and not La (see pp. 17–18). If you want to sing higher than E then you must
sing C as Ut, which will take you up to A (La); and similarly with descending passages.

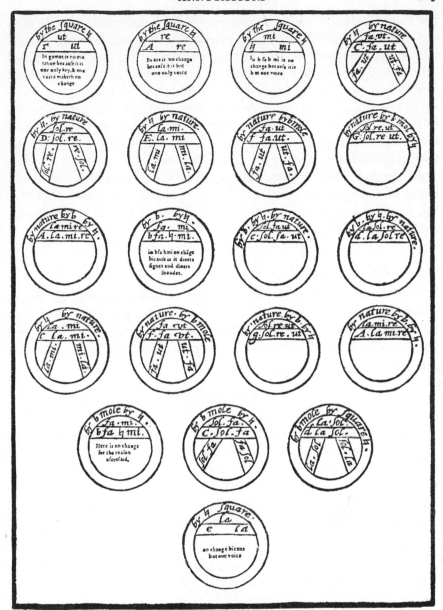

In the third diagram, 'b fa b mi' is incorrect, for there is no 'b fa' in the first B of the scale (cf. p. 11), only 'b mi' should therefore be written in this diagram.

In the fourth and following diagrams 'by nature' means 'sung in Properchant,' in other words, either B♭ or B♮ can be used (cf. p. 14, footnote 2).

In the tenth diagram, 'no change because in it divers signs and divers sounds' means that b fa(♭) can be sung to many notes, e.g. E♭ and A♭, and the same applies to b mi (♮ or ✗), which is assumed (if not written) whenever Mi is sung; hence these two signs do not change in themselves, in fact they are the invariables which decide what changes shall take place in the other notes. Thus in G sol re ut you must sing Ut if the B above is natural and Re if the B is flat (for if G is Re then F is Ut and B is always flat in this scale); similarly E♭ would be sung Fa (with B♭ the assumed Ut), but E♮ would be sung Mi (with C as Ut).

this rule, for they be directed by signs set by them.[1] But all mutation ending in Ut, Re, Mi is called ascending, because they may ascend further than descend, and all change ending in Fa, Sol, La is called descending, because they may descend further than ascend, and thereof came this verse: 'Ut Re Mi scandunt, descendunt Fa quoque Sol La.'

But though, as I said, these three properties be found in plainsong, yet in pricked song they be but two, that is either sharp or flat, for where nature is, there no ♭ is touched.[2] But if you would know whereby any note singeth (that is whether it sing by Properchant, ♮ *quarre*, or b *molle*), name the note and so come downward to Ut. Example: you would know whereby Sol in G sol re ut singeth; come down thus—Sol, Fa, Mi, Re, Ut, so you find Ut in C fa ut, which is the property whereby the Sol in G sol re ut singeth, and so by others.[3]

Page 19, line 17 : ' By the form of the note.'

There were in old time four manners of pricking; one, all black, which they termed 'black full'; another, which we use now, which they called 'black void'; the third, all red, which they called 'red full'; the fourth, red as ours is black, which they called 'red void'; all which you may perceive thus:

But if a white note (which they called 'black void') happened amongst black full, it was diminished of half the value, so that a minim was but a crotchet, and a semibreve a minim, etc. If a 'red full' note were found in black pricking, it was diminished of a fourth part, so that a semibreve was but three crotchets, and a red minim was but a crotchet;[5] and thus you may perceive that they used their red pricking in all respects

[1] You can only change La to Sol, or Sol to Re, or La to Re (and vice versa) if La, Sol, and Re are all names for the same note, i.e. D la sol re, and the above rule does not apply unless this is so. But if you want to sing E la mi as Fa then you would have to set the 'sign' of a flat before it.

[2] In composed (pricked) song B is never sung flat in Properchant ('nature'); thus the scale of C, which in plainsong could have either B♭ or B♮ sung above La (cf. p. 14), always had B♮, hence there were only two properties of singing in composed song, sharp (which includes the natural sign) and flat, or as M. would put it, by b *quarre* or b *molle*.

[3] This paragraph gives the clue to the diagrams on p. 113. Take, for example, G sol re ut; if you sing G as Sol then C is Ut and the B above may be either ♭ or ♮ ('by nature'); if G is Re then F is Ut and the B must be ♭ ('by b *molle*'); if G is Ut then the B must be ♮ ('by ♮'); and likewise with the others except B fa ♮ mi.

[4] Red notation.

[5] The *M* was halved and not reduced by a quarter because theoretically a dotted *C* did not exist, but in actual practice it did, of course, e.g. a dotted *S* in Quadrupla Proportion. For an example of red notation see the motet 'Domine fac mecum' on p. 310.

as we use our black nowadays.[1] But that order of pricking is gone out of use now, so that we use the black voids as they used their 'black fulls,' and the black fulls as they used the 'red fulls.' The red is gone almost quite out of memory, so that none use it and few know what it meaneth; [2] nor do we prick any black notes amongst white except a semibreve thus, 𝄞, in which case the semibreve so black is a minim and a dot (though some would have it sung in tripla manner and stand for 2/3 of a semibreve) and the black minim a crotchet, as indeed it is. If more black semibreves or breves be together, then is there some Proportion, and most commonly either Tripla or Hemiolia, which is nothing but a round common Tripla or Sesquialtera.[3]

As for the number of the forms of notes, there were, within these two hundred years, but four known or used of the musicians; those were the Long, breve, semibreve, and minim.[4] The minim they esteemed the least or shortest note singable, and therefore indivisible. Their Long was in three manners, that is either simple, double, or triple; a simple Long was a square form having a tail on the right side hanging down or ascending; a double Long was so formed as some at this day frame their

[1] This paragraph only applies to imperfect notes, for perfect notes when blackened lose a third of their value. For examples of the former, see p. 119.

[2] 'Red full' in 'black full' notation was used in three ways:

 (a) In Perfect Mood, Time, or Prolation when red L, B, or S lost one-third of their value (and thus became imperfect) and red M half of their value.

 (b) In Imperfect Prolation, when red S lost a quarter of their value and hence equalled the dotted black M (\downarrow.), and red M half of their value.

 (c) In perfect Prolation, when red M added half their value and hence equalled the dotted black M.

M. does not mention (a) or (c), though (a) was by far the most commonly used and, in fact, the only example he gives ('Domine fac mecum,' p. 310) uses red notation in this way; (b) was extremely rare and may have been an exclusively English manner of writing, for Apel, while stating that in white (normal) notation and Imperfect Prolation often equalled (which M. mentions in the next sentence), does not give these values for red notation, except, when discussing a passage in the Old Hall 'Patrem omnipotentem,' he suggests that four red S equal the value of three black S, which gives M.'s value. (*Notation of Polyphonic Music, 900–1600*, p. 435.)

M. does not give the values of 'red void' notation; Apel states that it usually served to introduce binary groups into Perfect Prolation, and hence gives the value of a 'red void' S as half a black S and a 'red void' M as three-quarters of a black M (op. cit., p. 407), but the only example M. gives ('Domine fac mecum,' p. 311, Cantus, 3rd stave) makes the 'red void' M equal a quarter of a black M.

For examples of 'black void' in 'black full' writing see example on p. 124, and the 'Agnus Dei' (p. 312).

[3] Passages written in black notes were usually either true Tripla or Hemiolia, the latter being the common English Tripla which, as we have seen earlier, is really Sesquialtera (cf. p. 86).

[4] Ornithoparcus gives five, adding the Mx to the above (*Micrologus*, Book II, chap. 2).

Larges, that is, as it were, compact of two Longs; the triple was bigger in quantity than the double;[1] of their value we shall speak hereafter.[2] The semibreve was at the first framed like a triangle thus ◄,[3] as it were the half of a breve divided by a diameter thus ▱, but that figure not being comely nor easy to make, it grew afterward to the figure of a rhomb or lozenge thus ◆, which form it still retaineth.[4] The minim was formed as it is now, but the tail of it they ever made ascending and called it *signum minimitatis* in their Ciceronian Latin.[5] The invention of the minim they ascribe to a certain priest (or who he was I know not) in Navarre, or what country else it was which they termed Navernia,[6] but the first who used it was one Philippus de Vitriaco,[7] whose motets for some time were of all others best esteemed and most used in the Church.

Who invented the crotchet, quaver, and semiquaver is uncertain;[8] some attribute the invention of the crotchet to the aforenamed Philip, but it is not to be found in his works,[9] and before the said Philip the smallest note used was a semibreve, which the authors of that time made of two sorts, more or less, for one Franco[10] divided the breve either in three equal parts (terming them semibreves) or in two unequal parts, the greater whereof was called the 'more' semibreve (and was in value equal to the imperfect breve), the other was called the 'less' semibreve, as being but half of the other aforesaid.

[1] Handlo in his *Regulae* . . . gives L with as many as nine divisions, the 'triple' being formed thus, ▱▱—a purely theoretical symbol.

[2] Actually M. makes no further reference to the subject. [3] M. gives ▼.

[4] This description of the S was probably taken from Ornithoparcus' *Micrologus*, Book II, chap. 2.

[5] M. does not mention this form of the M (◄) which was used.

[6] See p. 108, footnote 5. In an anonymous tract in the Waltham Holy Cross MS. entitled *De Origne et Effectu Musicae*, which derives from certain chapters in the *Quatuor Principalia*, occurs this sentence, which may also have confused M.: 'Then [came] Philippus Vitriaco who invented that figure called the Least Prolation, in Navarre' (cf. footnote 9).

[7] Philippe de Vitry (*c.* 1290–1361). *Ars Nova. Ars Perfecta. Liber musicalium. Ars contra-punctis.*

[8] There is no mention of how the B was formed. Vicentino gives a very ingenious account of how all the notes were formed in his *L'Antica Musica Ridotta* . . . (1555), suggesting that they were evolved from the ♭ and ♮ signs. M. (somewhat surprisingly) was not acquainted with this work it seems.

[9] With reference to the M and C, M. probably had the following passage in mind from the *Quatuor Principalia*: 'The figure of a minim is an oblong body after the style of a lozenge, bearing a stem straight up above its head, which stem is called a sign of diminishing as thus: ♩ ♩ ♩. But concerning the minim Magister Franco makes no mention in his work, but only of Longs, breves, and semibreves. The minim however had been found in Naverina and according to Philippe de Vitry, who was a Master, it was approved and used by musicians of the whole world. Those however who say that the aforementioned Philippe invented the crotchet, semi-minim or *dragma*, or that he had handed it down to them are in error, as clearly appears in his notes.' (Trans. from Hawkins, p. 221.)

[10] Franco of Cologne (*fl. c.* 1250–after 1280). *Ars Cantus Mensurabilis* (*post* 1280).

This Franco is the most ancient of all those whose works of practical music have come to my hands. One Robert de Handlo hath made, as it were, commentaries upon his rules and termed them Additions.[1] Amongst the rest, when Franco setteth down that a square body having a tail coming down on the right side is a Long, he saith thus: 'Si tractum habeat a parte dextra ascendentem erecta vocatur ut hic: ponuntur enim istae longae erectae ad differentiam longarum quae sunt rectae, & vocantur erecta quod ubicunque inveniuntur per semitonium eriguntur.' That is, 'if it have a tail on the right side going upward,[2a]

(2)

it is called erect or raised thus: , for these raised Longs be put for difference from others which be right, and are raised, because wheresoever they be found they be raised half a note higher,' a thing which (I believe) neither he himself nor any other ever saw in practice. The like observation he giveth of the breve, if it have a tail on the left side going upward.

The Large, Long, breve, semibreve, and minim (saith Glareanus) have these seventy years been in use, so that reckoning downward from Glareanus his time, which was about fifty years ago, we shall find that the greatest antiquity of our pricked song is not above 130 years old.[3]

Page 19, line 17 : ' and the Mood.'

By the name of Mood were signified many things in music. First, those which the learned call Moods, which afterward were termed by the name of 'tunes.'[4] Secondly, a certain form of disposition of the Church plainsongs in Longs and breves; example: if a plainsong consisted all of Longs it was called the first Mood, if of a Long and a breve successively it was called the second Mood, etc.[5] Thirdly, for one of the degrees of music, as when we say Mood is the dimension of Larges and Longs; and lastly for all the degrees of music, in which sense it is

[1] It is not known whether de Handlo's commentaries were based on Franco of Cologne or Franco of Paris (early thirteenth century).

[2] M. has the middle Long on the second line up.

[2a] Thurston Dart has drawn my attention to Bodley MS 384, f.1 where there are examples of "raised Longs" indicating sharpened breves."

[3] M. has obviously reckoned from the date of publication of the *Dodecachordon* (1547), exactly fifty years before his own work was published. Thus Glareanus believed that the M, etc., had only been in use since *c.* 1470 (130 years before M.'s time), hence M. must have thought that de Vitry lived about 150 years later than he is now known to have lived.

[4] Ecclesiastical Modes.

[5] There were five Franconian Rhythmic Modes but their numbering varied. M. probably based the above on those given in de Handlo's *Regulae . . .*, the other three of which are a L and two B, two B and L, B and S mixed. In the third and fourth Modes the second B is double the first. The above numbering differs from that given in Reese's *Music in the Middle Ages* (p. 272).

commonly though falsely taught to all the young scholars in music of
our time, for those signs which we use do not signify any Mood at all
but stretch no further than Time, so that more properly they might call
them *Time* Perfect of the More Prolation, etc., than *Mood* Perfect of the
More Prolation.[1]

Page 19, line 21 : ' the rests.'

Rests are of two kinds, that is either to be told [2] or not to be told.
Those which are not to be told be always set before the song, for what
purpose we shall know hereafter.[3] Those which are to be told for two
causes chiefly were invented; first, to give some leisure to the singer to
take breath; the second that the points might follow in imitation one upon
another at the more ease, and to show the singer how far he might let
the other go before him before he began to follow. Some rests also (as
the minim and crotchet rests) were devised to avoid the harshness of some
discord or the following of two perfect concords together.[4]

But it is to be noted that the Long rest was not always of one form, for
when the Long contained three breves then did the Long rest reach over
three spaces, but when the Long was imperfect then the Long rest
reached but over two spaces, as they now use them.

Page 19, line 24 : ' ligatures.'

Ligatures were devised for the ditty's sake, so that how many notes
served for one syllable, so many notes were tied together. Afterwards
they were used in songs having no ditty,[5] but only for brevity of writing.
But nowadays, our songs consisting of so small notes, few ligatures be
therein used, for minims and figures in time shorter than minims cannot
be tied or enter in ligature; but that defect might be supplied by dashing
the sign of the degree either with one stroke or two,[6] and so cause the
ligable figures serve to any small quantity of time we list. But because
in the book I have spoken nothing of black or half black ligatures, I
thought it not amiss to set down such as I have found used by other
authors and collected by Friar Zacconi in the 45th chapter of the first
book of *Practice of Music*, with the resolution of the same in other common
notes.

[1] The signs referred to are those which were commonly used, e.g. ⊙, ℭ, o, c, which indicate
only Time and Prolation, not Mood.
[2] Counted as rests in the modern sense.
[3] Cf. pp. 121–2.
[4] M. condemns this practice on p. 156. (cf. the example from Byrd given there).
[5] Instrumental pieces.
[6] e.g. ₵ or ₭.

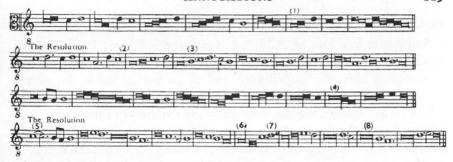

And by these few the diligent reader may easily collect the value of any other, wherefore I thought it superfluous to set down any more, though infinite more might be found.

Page 22, line 9: 'Dots.'

A dot is a kind of ligature, so that if you would tie a semibreve and a minim together you may set a dot after the semibreve, and so you shall bind them. But it is to be understood that it must be done in notes standing both in one key,[9] else will not the dot augment the value of the note set before it; but if you would tie a semibreve and a minim, or two minims, together which stand not both in one key, then must you use the form of some note ligable (for as I told you before, the minim and smaller figures than it be not ligable), and mark the sign of degree with what diminution is fittest for your purpose. Example: there be two minims, the one standing in A la mi re (a), the other in E la mi (e); if you must needs have them sung for one syllable, or be tied together, then may you set them down thus: 𝄞 , as though they were semibreves, but dashing the sign of the time with a stroke of diminution to make them minims; but if you think that would not be perceived, then may you set down numbers before them thus $\frac{2}{1}$, which would have the same effect; but if that pleased you no more than the other, then might you set them in tied breves with this 𝄍 or this $\frac{4}{1}$ sign before them,[10] which were all one matter with the former.

[1] First *B* is black in M. [2] Bar line missing in M.

[3] Zacconi has second note as *B*.

[4] No tail in Zacconi. The presence or absence of a tail makes no difference to this note value in ligature.

[5] Tie missing in M. and Zacconi.

[6] M. has ♮, Zacconi ♯. [7] M. omits dot.

[8] M. and Zacconi omit tail. There is also a redundant *L* on B at the end of the bar in M.

[9] i.e. on the same line or space.

[10] e.g. 𝄞 or 𝄞 .

Page 22, line 15: ' A Dot of Augmentation.'

Some term it a Dot of Addition, some also a Dot of Perfection not much amiss; but that which now is called of our musicians a Dot of Perfection is altogether superfluous and of no use in music, for after a semibreve in the More Prolation they set a dot, though another semibreve follow it, but though the dot were away the semibreve of itself is perfect. The author of the treatise *De quatuor principalibus* saith thus: 'Take it for certain that the point or dot is set in pricksong for two causes, that is either for perfection or division's sake, although some have falsely put the point for other causes, that is, for imperfection's and alteration's sake, which is an absurdity to speak. But the dot following a note will make it perfect though of the own nature it be imperfect; also the point is put to divide, when by it the perfections (so he termeth the number of three) be distinguished, and for any other cause the point in music is not set down.' So that by these his words it evidently appeareth that in those days (that is about two hundred years ago [1]) music was not so far degenerate from theoretical reasons as it is now; but those who came after not only made four kinds of dots but also added the fifth thus: there be (say they) in all, five kinds of dots: a Dot of Addition, a Dot of Augmentation, a Dot of Perfection, a Dot of Division, and a Dot of Alteration.

A Dot of Augmentation they define: that which being set after a note maketh it half as much longer as it was before.

The Dot of Addition they define: that which being set after a semi⁄breve in the More Prolation, if a minim follow, it causeth the semibreve to be three white minims.

A Dot of Perfection they define: that which being set after a semi⁄breve in the More Prolation, if another semibreve follow, it causeth the first to be perfect.

The Dot of Division and Alteration they define as they be in my book.

But if we consider rightly, both the Dot of Addition, of Augmenta⁄tion, and that of Alteration are contained under that of Perfection, for in the Less Prolation, when a semibreve is two minims, if it have a dot and be three then must it be perfect; and in the More Prolation when two minims come betwixt two semibreves (or in Time Perfect when two semibreves come betwixt two breves which be perfect) the last of the two minims is marked with a dot and so is altered to the time of two minims (and the last of the two semibreves is likewise marked with a dot and is sung in the time of two semibreves) which is only done for perfection's sake that the ternary number may be observed; [2] yet in such cases of

[1] This would make c. 1400 the date of the treatise instead of the correct date 1351.
[2] See p. 35.

alteration some call that a Point of Division, for if you divide the last semibreve in Time Perfect from the breve following, either must you make it two semibreves or then perfection decays, so that the Point of Alteration may either be termed a Point of Perfection or of Division. But others, who would seem very expert in music, have set down the points or dots thus: this dot (say they) doth perfect—c◗·; now this dot standing in this place—o·◗ doth imperfect; now the dot standing in this place—o◗ takes away the third part; and another dot, which standeth under the note, takes away the one half, as here—◗; and like in all notes. But to refute this man's opinion (for what or who he is I know not) I need no more than his own words, 'for,' saith he, 'if the dot stand thus—o·◗ it imperfecteth, if thus—o◗ it taketh away the third part of the value.' Now I pray him what difference he maketh betwixt taking away the third part of the value and imperfection? If he say (as he must needs say) that taking away the third part of the value is to make imperfect, then I say he hath done amiss to make one point of imperfection and another of taking away the third part of a note's value.

Again, 'all imperfection is made either by a note, rest, or colour, but no imperfection is made by a dot'; therefore our monk (or whatsoever he were) hath erred in making a Point of Imperfection.

And lastly, 'all diminution is signified either by the dashing of the sign of the degree, or by proportionate numbers, or by a number set to the sign, or else by ascription of the canon.' But none of these is a dot, therefore no diminution (for taking away half of the note is diminution) is signified by a dot; and therefore none of his rules be true saving the first, which is that a dot following a black breve perfecteth it.

Page 22, line 22: ' *Those who.*'

That is Franchinus Gafurius, Peter Aron, Glareanus, and, at a word, all who ever wrote of the art of music. And though they all agree in the number and form of degrees, yet shall you hardly find two of them tell one tale for the signs to know them. For Time and Prolation there is no controversy, the difficulty resteth in the Moods; but to the end that you may the more easily understand their nature, I have collected such rules as were requisite for that purpose and yet could not so well be handled in the book.

The Mood, therefore, was signified two manner of ways; one by numeral figures, another by pauses or rests. That way by numbers I have handled in my book; it resteth to set down that way of showing the Mood by pauses. When they would signify the Great Mood Perfect they did set down three Long rests together; if the Less Mood were likewise Perfect then did every one of those Long rests take up three

spaces thus: [mood sign] ;[1] but if the Great Mood were Perfect and the Less Mood Imperfect then did they likewise set down three Long rests, but imperfect, in this manner: [mood sign]; and though this way be agreeable both to experience and reason, yet hath Franchinus Gafurius set down the sign of the Great Mood Perfect thus: [mood sign] ; of the Great Mood Imperfect he setteth no sign, except one would say that this is it: [mood sign], for when he sets down that Mood,[2] there is such a dash before it touching all the five lines, but one may justly doubt if that be the sign of the Mood or some stroke set at the beginning of the lines. But that sign which he maketh of the Great Mood Perfect, that doth Peter Aron set for the Great Mood Imperfect if the Less Mood be Perfect. But (saith he) this is not of necessity, but according as the composition shall fall to be, the Less Mood Perfect not being joined with the Great Mood Imperfect,[3] so that when both Moods be Imperfect then is the sign thus: [mood sign]. And thus much for the Great Mood. The Less Mood is often con‑ sidered and the Great Mood left out, in which case if the Small Mood be Perfect it is signified thus: [mood sign]; if it be Imperfect then is there no pause at all set before the song nor yet any cipher, and that betokeneth both Moods Imperfect;[4] so that it is most manifest that our common signs which we use have no respect to the Moods but are contained within the bounds of Time and Prolation.[5]

Page 25, line 2: ‘ in this Mood it is always Imperfect.’

That is not of necessity, for if you put a point in the centre of the circle then will the Prolation be Perfect, and the Large be worth eighty‑one minims, and the Long twenty‑seven, the breve nine, and the semibreve three, so that Moods Great and Small, Time and Prolation will altogether be Perfect.[6]

[1] The sign ⊙ is inserted in order to make it clear that the rests are ‘modal,’ i.e. indicating a Mood; thus this example shows Great and Less Mood, Time, and Prolation all Perfect.

[2] ‘When he writes an actual piece of music in that Mood.’

[3] If there were no *Mx* in the song the Great Mood was often omitted from the sign at the beginning; similarly if there were no *L* only the Time and Prolation were indicated; hence Aron says that this sign, [mood sign], is only valid if the Great Mood is shown in the notation of the song, and he gives a different sign when only the Less Mood Perfect is implicated (see further).

[4] Thus the usual way of showing the Moods by rests is as follows: both Moods Per‑ fect, [mood sign]; Great Mood Perfect, Less Mood Imperfect, [mood sign]; Great Mood Imperfect, Less Mood Perfect, [mood sign]; both Moods Imperfect, [mood sign].

[5] i.e. ⊙, ₵, ○, c

[6] See p. 25, footnote 3.

Page 30, line 13 : ' Perfect of the More.'

This (as I said before) ought rather to be termed Time Perfect of the More Prolation than Mood Perfect, and yet hath it been received by consent of our English practitioners to make the Long in it three breves, and the Large thrice so much, but to this day could I never see in the works of any, either strangers or Englishmen, a Long set for three breves with that sign,[1] except it had either a figure of three, or then modal rests set before it. (Zar. vol. 1, part 3, cap. 67. Zacc. lib. 2, cap. 14.)

But to the end that you may know when the rests be to be told, and when they stand only for the sign of the Mood, you must mark if they be set thus, ⊞⊖, in which case they are not to be told, or thus, ⊖⊞, and then they are to be numbered. Likewise you must make no account whether they be set thus, ⊞, or thus, ⊞, for both those be one thing, signifying both Moods Perfect.

Page 30, line 21 : ' The Perfect of the Less.'

This first caused me to doubt of the certainty of those rules which, being a child, I had learned, for whereas in this sign I was taught that every Large was three Longs and every Long three breves, I find neither reason nor experience to prove it true; for reason (I am sure) they can allege none, except they will under this sign o comprehend both Mood and Time, which they can never prove. Yet do they so stick to their opinions that when I told some of them (who had so set it down in their books) of their error, they stood stiffly to the defence thereof, with no other argument than that it was true.[2] But if they will reason by experience and regard how it hath been used by others, let them look in the Mass of Mr. Taverner called 'Gloria tibi trinitas,' where they shall find examples enough to refute their opinion and confirm mine. But if they think Master Taverner partial, let them look in the works of our English Doctors of Music, as Dr. Fayrfax, Dr. Newton, Dr. Cooper, Dr. Kirbye, Dr. Tye, and divers other excellent men as Redford, Cornyshe, Pigott, Whyte, and Mr. Tallis.[3] But if they will trust none of all these,

[1] The sign referred to is ⊙, which M. uses in the text on p. 30 ; but before the diagram of this Mood which follows he places the correct sign, ⊙3.

[2] Byrd, in the Errata of his 1588 publication, calls this sign (∅) 'Perfect of the Less,' but reckons the *Mx* and *L* as Imperfect.

[3] Newton (?), George Kirbye (*d.* 1634), Christopher Tye (*c.* 1500–*c.* 1572), Robert Whyte (*c.* 1530–74), John Redford (*c.*1485–*c.*1547), Richard Pigott (*d.* after 1549), William Cornyshe (*c.* 1465–1523), Thomas Tallis (*c.* 1505–85).

here is one example which was made before any of the aforenamed were born.[1]

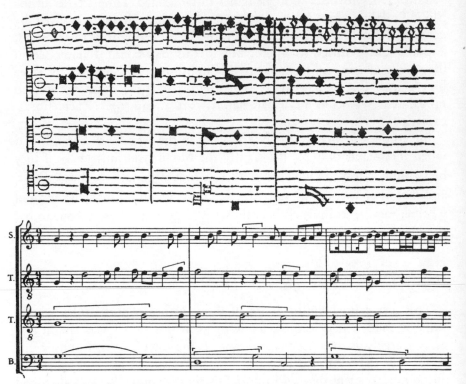

And this shall suffice at this time for the understanding of the contro‑verted Moods, but to the end thou mayest see how many ways the Moods may be diversely joined, I have thought good to show thee a Table used by two good musicians in Germany [2] and approved by Friar Ludovico [3] Zacconi in the 57th chapter of his second book of *Practice of Music*.[4]

[1] This is not a Proportional passage but is an example of 'full black' writing which M. mentions on pp. 114–15; hence each black note can be treated as if it were a white note, and the white notes as if they were black, i.e. imperfect. The purport of the example is to show that the sign o stands for Perfect Time but *Imperfect* Mood (both Great and Less), and this it does, for unless the B is regarded as perfect and the L imperfect the parts do not fit. In the transcription the note values have been quartered. This example is the opening of the 'Gloria' from the anonymous Mass *Veterem hominem* (see R. T. Dart, 'A Footnote for Morley's "Plain and Easy Introduction"' in *Music and Letters,* vol. 35, p. 183). The only known text is Trent MS 88 (D.T.O. vol. VII) where it is written in white notation. It is likely that Morley's source was earlier than the Trent MS, and most probable that the Mass is English.

[2] Father Johann Lengenbrunner, *Musices haud vulgare compendium* . . . (1559); Sebald Heyden (1498–1561), *Musicae Στοιχείωσις* (1532).

[3] M. gives 'Lowyes.'

[4] p. 132.

| Prolation | Time | Mood | | Strokes, that is, measures [1] | | | | | |
		Small	Great						
Perfect	Perfect	Perfect	Perfect	⊙3	81	27	9	3	1
Perfect	Perfect	Imperfect	Imperfect	¢3	36	18	9	3	1
Imperfect	Perfect	Perfect	Perfect	o3	27	9	3	1	½²
Imperfect	Perfect	Imperfect	Imperfect	c3	12	6	3	1	½
Perfect	Imperfect	Perfect	Imperfect	⊙2	36	18	6	3	1
Perfect	Imperfect	Imperfect	Imperfect	¢2	24	12	6	3	1
Imperfect	Imperfect	Perfect	Imperfect	o2	12	6	2³	1	½
Imperfect	Imperfect	Imperfect	Imperfect	c2	8	4	2	1	½
Perfect	Perfect	Imperfect	Imperfect	⊙	36	18	9	3	1
Perfect	Imperfect	Imperfect	Imperfect	¢	24	12	6	3	1
Imperfect	Perfect	Imperfect	Imperfect	o	12	6	3	1	½
Imperfect	Imperfect	Imperfect	Imperfect	c	8	4	2	1	½

But by the way you must note that in all Moods (or rather signs) of the More Prolation he setteth a minim for a whole stroke, and proveth it by examples out of the Mass of Palestrina called 'L'homme armé.' [4]

[1] This table is not identical with that of Zacconi or of Heyden, in whose 1532 publication a similar one occurs. I append the Zacconi table (excluding the strokes or measures which agree almost exactly with M.) in order that a comparison may be made. Initials in brackets show where Heyden differs from Zacconi. After o2 the table agrees with M.

| Prolation | Time | Mood | | |
		Small	Great	
P	P	I	P	⊙3
P	I (P)	I	P (I)	¢3
I	P	I	P	o3
I	I (P)	I	P (I)	c3
P	P (I)	P	I	⊙2
P	I	I	I	¢2
I	P (I)	P	I	o2

Heyden gives one more column than Zacconi representing C fractions, but these are only inserted for ⊙3, ¢3, o3, and o. On the other hand, Heyden gives no M fractions for o3, c3, o2, or c2.

[2] Zacconi has ²⁄₁ instead of ½ all through the table. [3] Zacconi has 3 but Heyden 2.
[4] Giovanni Pierluigi da Palestrina (1525/6–94). *Third Book of Masses* (1570). The passage occurs in Zacconi's *Prattica di Musica* (Book II, chap. 38). M. gives 'Palestin,' a corruption of 'Palestina' which appeared in many collections of madrigals, e.g. *Musica Transalpina* (1588).

There is also another way of setting down the degrees which, because I had not seen practised by any musician, I was determined to have passed in silence; but because some of my friends affirmed to me that they had seen them so set down, I thought it best to show the meaning of them. The ancient musicians, who grounded all their practice upon speculation, did commonly set down a particular sign for every degree of music in the song, so that they having no more degrees than three, that is, the two Moods and Time (Prolation not being yet invented), set down three signs for them; so that if the Great Mood were Perfect it was signified by a whole circle which is a perfect figure; if it were Imperfect it was marked with a half circle. Therefore wheresoever these signs, ○33,[1] were set before any song, there was the Great Mood Perfect signified by the circle, the Small Mood Perfect signified by the first figure of three, and Time Perfect signified by the last figure of three. If the song were marked thus, c33, then was the Great Mood Imperfect and the Small Mood and Time Perfect. But if the first figure was a figure of two thus, c23, then were both Moods Imperfect and Time Perfect; but if it were thus, c22, then were all Imperfect. But if in all the song there were no Large, then did they set down the signs of such notes as were in the song, so that if the circle or semicircle were set before one only cipher as ○2, then did it signify the Less Mood, and by that reason, that circle now last set down with the binary cipher following it signified the Less Mood Perfect and Time Imperfect; if thus, c3, then was the Less Mood Imperfect and Time Perfect; if thus, c2, then was both the Less Mood and Time Imperfect, and so of others. But since the Prolation was invented they have set a point in the circle or half circle to show the More Prolation, which, notwithstanding, altereth nothing in the Mood nor Time. But because (as Peter Aron saith) these are little used now at this present I will speak no more of it, for this will suffice for the understanding of any song which shall be so marked, and whosoever perfectly understandeth and keepeth that which is already spoken will find nothing pertaining to the Moods to be hard for him to perceive.

Page 42, line 4: 'Augmentation.'

If the More Prolation be in one part with this sign ☉, and the Less in the other with this ○, then is every perfect semibreve of the More Prolation worth three of the Less, and every Imperfect semibreve (that is, if it have a minim following it) worth two, and the minim one.[2] But if the Less Prolation be in the other parts with this sign ¢, every perfect semibreve of the More Prolation is worth six of the Less, and the imperfect

[1] M. has ☉33 in error. [2] Cf. pp. 58, 59, treble (○), Quintus (○).

semibreve worth four, and every minim two, as in the example of Giulio Renaldi set at the end of the first part of the book after the Proportions may be perceived.[1]

Page 46, line 21: 'What is Proportion.'

When any two things of one kind, as two numbers, two lines, or such like are compared together, each of those two things so compared is of the Greeks called ὄρος, which Boethius interpreteth in Latin 'terminus'; in English we have no proper word to signify it, but some keep the Latin and call it 'term.' And that comparison of those two things is called of the Greeks λόγος καὶ σχέσις, that is, as the Latins say, 'ratio & habitudo'; in English we have no word to express those two, but hitherto we have abusively taken the word 'Proportion' in that sense. What Proportion is we shall know hereafter, but with what English word soever we express those 'ratio & habitudo,' they signify this: how one term is in quantity to another; as if you compare 3 and 6 together and consider how they are to another, there will be two terms, the first three and the latter six, and that comparison and, as it were, respect of the one unto the other is that 'ratio' and 'habitudo' which we spake of.

Now these things which are compared together are either equal one to another, as five to five, an ell to an ell, an acre to an acre, etc., and then is it called 'aequalitatis ratio'—'respect of equality' which we falsely term 'proportion of equality,' or then unequal, as three to six, a handbreadth to a foot, etc., in which case it is called 'inaequalis' or 'inaequalitatis ratio.' Now this respect of equality is simple, and always one, but that of inequality is manifold, wherefore it is divided into many kinds, of which some the Greeks term προλόγα and other some ὑπολόγα.[2] Those kinds they term προλόγα, wherein the greater term is compared to the less, as six to three, which of the late barbarous writers is termed 'proportion of the greater inequality'; and by the contrary those kinds they term ὑπολόγα where the less term is compared to the greater, as four to six, which they term 'the less inequality.' Of each of these two kinds there be found five species or forms, three simple and two compound. The simple 'prologa' are *multiplex, superparticular,* and *superpartient.* Compound 'prologa' are *multiplex superparticular,* and *multiplex superpartient.*

Multiplex ratio[3] is when the greater term doth so contain the less as nothing wanteth or aboundeth, as ten and five, for ten doth twice con-tain five precisely and no more nor less, of which kind there be many

[1] Ibid., tenor (¢). [2] 'Prologa' and 'hypologa.'
[3] This ratio and those following also apply to 'hypologa,' thus 5 : 10 is also *multiplex ratio,* and would be called Subdupla ratio or Proportion (hypo = sub).

forms, for when the greater containeth the less twice then is it called 'Dupla ratio,' if thrice 'Tripla,' if four times 'Quadrupla,' and so infinitely.

Superparticularis ratio, which the Greeks call ἐπιμόριος, is when the greater term containeth the less once with some one part over, which one part, if it be half of the lesser term, then is the respect of the greater to the lesser called 'Sesquiplex' and 'Sesquialtera ratio,' as three to two; if it be the third part it is called 'Sesquitertia,' as four to three; if it be the fourth part it is called 'Sesquiquarta,' as five to four, and so of others.

Superpartiens, which the learned call ἐπιμέρης λόγος, is when the greater term containeth the less once and some parts besides, as five doth comprehend three once and, moreover, two third parts of three, which are two unities, for the unity is the third part of three; and ten compre-hendeth six once, and besides two third parts of six, for two is the third part of six, in which case it is called 'ratio superbipartiens tertias'; and so of others according to the number and names of the parts which it containeth.

Multiplex superparticular is when the greater term comprehendeth the less *more* than once, and besides some one part of it, as nine to four is 'Dupla sesquiquarta' because it containeth it twice and, moreover, one fourth part of it; likewise seven is to two 'Tripla sesquialtera,' that is, *multiplex* because it containeth two often, that is, thrice, and *super-particular* because it hath also a half of two, that is, one; and so of others, for of this kind there be as many forms as of the simple kinds *multiplex* and *superparticular.*

Multiplex superpartiens is easily known by the name; example: fourteen to five is *multiplex superpartiens*; *multiplex* because it containeth five twice, and *superpartiens* because it hath four fifth parts more, and so fourteen to five is 'Dupla superquadripartiens quintas,' for of this kind there be so many forms as of *multiplex* and *superpartiens.*

Thus you see that two terms compared together contain 'ratio,' 'habitudo,' 'respect,' or how else you list to term it. But if the terms be more than two and betwixt them one respect or more, then do the Greeks by the same word λόγος term it ἀναλογία; the Latins call it 'proportio' and define it thus: 'Proportio est rationum similitudo,' and Aristotle in the fifth book of his *Morals (ad Nichomachum)* defineth it 'Rationum aequalitas,' as for example let there be three numbers whereof the first hath double respect to the second, and the second double respect to the third thus: 12, 6, 3; these, or any such like, make 'proportion' or 'analogie.'

The arithmeticians set down in their books many kinds of proportions, but we will touch but those three which are so common everywhere in the works of those chief philosophers Plato and Aristotle, and be these, Geometrical, Arithmetical, and Harmonical.

Geometrical proportion (which properly *is* proportion) is that which two or more equal 'habitudes' do make (as I showed you even now), and is either 'conjunct' or 'disjunct.' Conjunct proportion is when the middle term is twice taken thus: as 16 : 8 so are 8 : 4, and 4 : 2 and 2 : 1, for here is everywhere double 'habitude.' Disjunct proportion is when the middle terms be but once taken, thus, as 16 : 8, so 6 : 3.

Arithmetical proportion is when between two or more terms is the same, not 'habitude,' but difference, as it is in the natural disposition of numbers thus, 1, 2, 3, 4, 5, for here every term passeth other by one only, or thus, 2, 4, 6, 8, 10, 12, where every number passeth other by two; or any such like.

But Harmonical proportion is that which neither is made of equal 'habitudes' nor of the like differences, but when the greatest of three terms is so to the least, as the differences of the greatest and middle terms is to the difference of the middle and least. Example: here be three numbers, 6, 4, 3, whereof the first two are in Sesquialtera 'habitude' and the latter two are in Sesquitertia; you see, here is neither like 'habitude' nor the same differences, for 4 is more than 3 by 1, and 6 is more than 4 by

2; but take the difference betwixt 6 and 4, which is 2, and the difference of 4 and 3, which is 1, and compare the differences to-gether, you shall find 2 : 1 as 6 : 3, that is, Dupla 'habitude,' and this is called Harmonical proportion, because it containeth the 'habitudes' of the con-sonants amongst themselves; as let there be three lines taken for as many strings or organ pipes, let the first be six foot long, the second four, the third three; that of six will be a Diapason or octave to that of three, and that of four will be a Diapente or fifth above that of six, thus: [*See diagram.*]

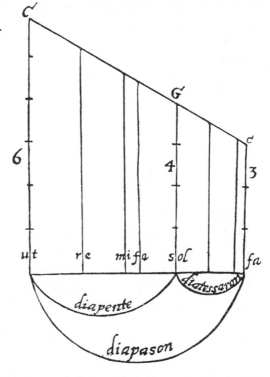

Thus you see what Proportion is, and that Proportion is not properly taken in that sense wherein it is used in the book, yet was I constrained to use that word for lack of a better.

One whose book came lately from the press, called the *Pathway to Music*,[1] setting down the Proportions, calleth them a 'great proportion of inequality' and a 'less proportion of inequality'; and a little after, treating of Dupla, he setteth down words which he hath translated out of Lossius his *Music*, but it seemeth he hath not understood too well, 'for (saith he) Dupla is that which taketh from all notes and rests the half value,' etc., and giveth this example:

But if he had understood what he said he would never have set down this for an example, or else he hath not known what a minim or a crotchet is. But if I might, I would ask him of what length he maketh every note of the plainsong? I know he will answer 'of a semibreve time'; then if your plainsong be of a semibreve time how will two minims, being diminished, make up the time of a whole semibreve, a minim in Dupla Proportion being but a crotchet? 'O but (saith he) the plain-song note is likewise diminished, and so the diminished minims will make up the time of a diminished semibreve.' But then how will one bar of your partition make up a full stroke, seeing in the Less Prolation a minim is never taken for a whole stroke? Again, no diminution is ever known but where the signs of diminution be set by the notes, and except you set the numbers in both parts, diminution will not be in both parts.

But to conclude, he who set down that example either knew not what Dupla was, or then understood not what he himself said, which appeareth in many other places of his book, as, for example, in the tenth page (leaving out the leaf of the title), 'A perfect second (saith he) containeth a distance of two perfect sounds.' What would he say by this? In mine opinion he would say, 'a perfect second containeth a distance of two perfect sounds'; yet I know not what he meaneth by a 'perfect sound,' for any sound is perfect not compared to another, and though it were compared to another yet is the *sound* perfect, though it be not a perfect *consonant* to the other. But our master who shows such 'Pathways to Music' would say this, 'a perfect second containeth a whole note (or, as the Latins term it, 'integer tonus'), as from Ut to Re is a whole note, etc.' In the beginning of the next page he saith, 'an imperfect second [is] a sound and a half.' But I pray you good Mr. 'Guide of the Pathway,' how can you make that a sound (for so you interpret the

[1] *The Guide of the Pathway to Music,* printed by William Barley (1596). Author unknown.

word 'tonus') and a half, which is not full a half sound, or half a 'tonus'? But if you had understood what you said you would have said thus, 'an imperfect second containeth but a less half note, as is ever betwixt Mi and Fa.'

Also, defining what Diatessaron, or a fourth is, he saith, 'a fourth is the distance of the voice by a fourth.' And likewise, 'a fifth the distance of the voice by a fifth.' Notable definitions: as in the play, the page asking his master what a poet was, he, after a great pause and long study answered that it was 'a poet.' Likewise, giving the definition of a note, he saith, 'it is a sign showing the loudness or stillness of the voice.' But these be light faults to those which follow after, for the Ligatures are set down false, and coming to speak of the Moods, or degrees of music, he maketh no mention at all of the Less Mood. And defining Time he saith, 'it is a formal quantity of semibreves, measuring them by three or by two'; and Prolation he calleth 'a formal quantity of minims and semibreves'; and showing Time Perfect of the Less Prolation he setteth it down thus:

And in the Imperfect of the More Prolation he maketh two minims to the semibreve.

But I am almost out of my purpose following one 'quem vincere inglorium & a quo atteri sordidum.'[1] for if you read his book you may say by it as a great poet of our time said by another's, 'Vix est in toto pagina sana libro.'[2] What, said I 'vix'? Take away two or three scales which are filched out of Beurhusius and fill up the three first pages of the book, you shall not find one side in all the book without some gross error or other; for as he setteth down his Dupla so doth he all his other Proportions, giving true definitions and false examples, the example still importing the contrary to that which was said in the definition. But this is the world; every one will take upon him to write and teach others, none having more need of teaching than himself. And as for him of whom we have spoken so much, one part of his book he stole out of Beurhusius, another out of Lossius, perverting the sense of Lossius his words, and giving examples flat to the contrary of that which Lossius saith; and the last part of his book, treating of Descant, he took verbatim out of an old written book which I have. But it should seem that whatsoever or whosoever he was that gave it to the press was not the author of it himself, else would he have set his name to it, or then he was ashamed of his labour.

[1] 'To conquer whom is no glory and to be conquered by whom is a disgrace.'
[2] 'There is scarcely a page that makes sense in the whole book.'

F

Page 47, line 9: ' Dupla.'

I cannot imagine how the teachers (which these thirty or forty years past have taught) should so far have strayed from the truth as, for no reason, to call that common sort of music which is in the Time Imperfect of the Less Prolation, Dupla, or that it is in Dupla Proportion, except they would say that any two to one is Dupla, which none (at least who is in his right wits) will affirm, for when Proportion is, then must the things compared be of one kind, as one acre to two acres is in Subdupla Pro, portion, etc.; so when you see Dupla set down you must sing every note so fast again as it was before. Glareanus giveth this example of Dupla out of Franchinus,[1] which, because it hath some difficulty, I thought good to set down and explain in this place.

The sign at the beginning showeth Time Perfect, so that every breve not having a semibreve after it is three semibreves, and so, being diminished of half their value in Dupla Proportion, are but three minims apiece; those breves which in Dupla have a semibreve following them, are sung but in time of one semibreve; the sign of Imperfect Time coming in after the Proportion, destroyeth it, but these numbers $\frac{4}{2}$, being the notes of Dupla 'habitude,' following within four notes, make up the Proportion again; but in the latter Dupla you must mark that the diminished breve is less by a whole minim than it was in the former because the first followed Time Perfect, and the half of a breve in Time Perfect is three

[1] *Dodecachordon* (Book III, chap. 12, p. 229). Version II is a modern transcription.

[2] M. gives |◻· ○ ◻·|, but Glareanus as above. The dot after the D is a 'Dot of Division,' showing that the preceding S E belongs to the B D, making the latter imperfect; the B F is therefore perfect. M.'s version, however, is clearer.

[3] M. gives an undotted S in error, for this would not equal half of the perfect B in the soprano.

[4] Glareanus does not give this sharp. [5] M. gives B but Glareanus L in both parts.

minims; the latter followed Time Imperfect and the half of a breve in Time Imperfect is a semibreve or two minims. Likewise you must note that when Dupla or any other Proportion is in all the parts alike then can it not be called Proportion, seeing there is no comparison of notes together according to any imparity of numbers.

Page 50, line 2: ' Tripla.'

This is the common hackney horse of all the composers, which is of so many kinds as there be manners of pricking; sometimes all in black notes, sometimes all in white notes, sometimes mingled, sometimes in breves, sometimes in semibreves, and yet all one measure. But one thing I mislike (though it be in common use with us all), that is when we call that Tripla wherein all the voices go together in one time with the stroke of Sesquialtera time or three minims for a stroke, for that is no Tripla but, as it were, a Sesquialtera compared to a Sesquialtera, and whereas we commonly make Tripla with three minims for a stroke we confound it with Sesquialtera.[1] Lastly, true Tripla maketh three semibreves (or their value in other notes) to the time of one semibreve, whereof Glareanus giveth this example out of Cochlaeus.[2]

But this Tripla is double as swift in stroke as our common Tripla of three minims,[3] which though I have used and still do use yet am not I able to defend it by reason, so that if any man would change before me I would likewise willingly change, but of myself I am loath to break a received custom. But, one may ask me, if our common Tripla be not a Proportion what it is? I will answer out of Glareanus, that it seemeth

[1] In other words, when all the parts are singing three *M* to a previous (or assumed) *S* stroke they are each singing in Sesquialtera, therefore the Proportion is Sesquialtera compared to a Sesquialtera.

[2] Johannes Cochlaeus (1479–1552). *Tetrachordum musices* (1511). This example is from *Dodecachordon* (Book III, chap. 12, p. 230) and *Tetrachordum* (chap. 20). In the latter the four middle *S* and the next *B* in the tenor part are written in ligature. Version II is a modern transcription.

[3] By this M. means that whereas in the English so-called Tripla three *M* are sung for one stroke, in true Tripla six *M* are sung for one stroke, hence they are sung twice as quickly.

to be a kind of perfection flourished by art, and different from the ancient and first kind of order because in it both imperfection and alteration have place.

And by this, which in Dupla and Tripla is spoken, may all other things concerning Proportions of Multiplicity be easily understood, therefore one word of Sesquialtera and then an end of this first part.

Page 56, line 9: ' Sesquialtera.'

Sesquialtera is a musical Proportion wherein thrêe notes are sung in the time of two of the same kind, or rather thus: Sesquialtera is a kind of musical diminution wherein three semibreves (or their value in other notes) are sung for two strokes. But you may object and say if that be true Sesquialtera what difference do you make betwixt it and the More Prolation? Only this, that in the More Prolation a perfect semibreve maketh up a whole stroke and likewise the value of a semibreve, but in Sesquialtera the value of a semibreve and a half do but make one stroke, and a semibreve of itself never maketh a stroke. And by this it appeareth that our common Tripla of three minims is false, which is confounded both with the More Prolation and Sesquialtera; therefore take that for a sure and infallible rule which I have set down in my book, that *in all musical Proportions the upper number signifieth the semibreve and the lower the stroke*; so that if the Proportion be noted thus, $\frac{3}{2}$, three semibreves (or the value of three semibreves) must go to two strokes; but if thus, $\frac{2}{3}$, then must two semibreves (or their value) make three whole strokes.[1]

And let this suffice for the Proportions. As for Sesquitertia, Sesqui-quarta, and such like, it were folly to make many words of them, seeing they be altogether out of use, and it is a matter almost impossible to make sweet music in that kind. Yet is Sesquitertia one of the hardest Pro-portions which can be used, and carrieth much more difficulty than Sesquiquarta, because it is easier to divide a semibreve into four equal parts than into three;[2] nor have I ever seen an example of true Sesqui-tertia saving one, which Lossius giveth for an example and pricketh it

[1] Sesquialtera and Subsesquialtera respectively.

[2] M. is here really referring to Subsesquitertia and Subsesquiquarta ($\frac{3}{4}$ and $\frac{4}{5}$), which imply Augmentation, and not Sesquitertia and Sesquiquarta ($\frac{4}{3}$ and $\frac{5}{4}$), which imply Diminution, for in the following examples each S in the soprano is equal to $\frac{3}{4}$ and $\frac{4}{5}$ respectively of each S 'stroke' in the bass, thus Sesquitertia is easier as the soprano divides each S into four C and sings three of them, instead of having to divide the S into five and sing four of them:

in Longs, making them but three strokes apiece, and the breves one and
a half; [1] in semibreves it is very hard and almost impossible to use it,

In Subsesquitertia, however, the soprano has to divide each *S* into three parts and sing
four of them, while in Subsesquiquarta the *S* has to be divided into four parts and five of
them sung, a much easier thing to do.

[1] *Erotemata Musicae* . . . (1563; chap. 12). The example M. mentions is given below
(Version I). Version II is a transcription. M. gives an example of his own on p. 172.

but according to our manner of singing, if one part sing Sesquialtera in crotchets, and another sing quavers in the Less Prolation (whereof eight go to a stroke), then would we say that they were eight to six, which is Sesquitertia.

But if I should go about to say all that may be spoken of the Proportions I might be accounted one who knew not how to employ my time, and therefore I will conclude with one word, that Proportions of Multiplicity [1] might be had and used in any kind without great scruple or offence, but those Superparticulars and Superpartients [2] carry great difficulty, and have crept into music I know not how; but it should seem that it was by means of the Descanters who, striving to sing harder ways upon a plainsong than their fellows, brought in that which neither could please the ears of other men, nor could by themselves be defended by reason.[3]

Here was I determined to have made an end, but some more curious than discreet compelled me to speak some words more, and to give a reason why, after the Proportions, I have said nothing of the Inductions, and therefore to be brief, I say that all which they can say of these Inductions is nothing but mere foolishness, and 'commenta otiosorum hominum qui nihil aliud agunt nisi ut inveniant quomodo in otio negotiosi videantur.' [4] Yet I marvel that a thing which neither is of any use, nor yet can be proved by any reason, should so much be stood upon by them who take upon them to teach the youth nowadays, but yet to refute it I need no other argument than this, that not any one of them who teach it delivereth it as another doth. But to be plain, those Inductions be no other thing (as I said in my book, p. 172, line 13) but that number which any greater notes broken in smaller do make, as for example (though their opinions be false) Sesquialtera or dotted semibreve is the Induction to their Tripla, for sing your Sesquialtera in minims and you shall find three of them to a stroke. Likewise break either your Tripla of three minims or your dotted semibreve into crotchets, and so shall the dotted semibreve be the Induction to Sextupla, as they say. But this is so false as what is falsest, for in whatsoever notes you sing Sesquialtera it is always Sesquialtera, because the value of a semibreve and a half doth

[1] e.g. 2 : 1, 3 : 1, 4 : 1, etc.

[2] e.g. 3 : 2, 4 : 3, etc., and 5 : 2, 7 : 4, etc., respectively (cf. pp. 127-8).

[3] By the 'Descanters' M. is probably referring to that class of singer who in the fourteenth century provoked the famous decree of Pope John XXII, of which the following is an extract: 'They chop up the melodies by *ochete*, mollify them by *discantus* and *triplum* so that they [the melodies] rush around ceaselessly, intoxicating the ear without quieting it, falsify the expression and disturb devotion instead of evoking it.' (Láng, *Music in Western Civilization*, p. 139.)

[4] 'The fancies of idle men who do nothing else except to discover how they can appear busy in their idleness.'

always make a full stroke. Break true Tripla in minims, it will make their Sextupla; make it in crotchets, it will make their Duodecupla; and this is it which they call their Inductions, which it shall be enough for the scholar to understand when he heareth them named, for no musician (if he can but break a note) can miss the true use of them.

It resteth now to give a reason why I have placed that Table of Proportions in my book,[1] seeing it belongeth no more to music than any other part of arithmetic doth (arithmetic you must not take here in that sense as it is commonly, for the art of calculation, but as it is taken by Euclid, Nichomachus, Boethius, and others), but the reason why I set it there was to help the understanding of many young practitioners who, though they see a song marked with numbers (as thus $\frac{8}{3}$ for example), yet do they not know what Proportion that is, and therefore if they do but look upon the numbers and mark the concourse of the lines enclosing them, they shall there plainly find set down what relation one of those numbers hath to another.

[1] p. 57.

THE SECOND PART

OF THE

INTRODUCTION TO MUSIC

Treating of Descant

[MASTER] [PHILOMATHES]

MASTER. Whom do I see afar off? Is it not my scholar Philomathes? Out of doubt it is he, and therefore I will salute him. Good morrow, scholar.

PHILOMATHES. God give you good morrow and a hundred. But I marvel not a little to see you so early, not only stirring but out of doors also.

MA. It is no marvel to see a snail after a rain to creep out of his shell and wander all about seeking the moisture.

PHI. I pray you talk not so darkly but let me understand your comparison plainly.

MA. Then in plain terms, being overwearied with study and taking the opportunity of the fair morning I am come to this place to snatch a mouthful of this wholesome air, which gently breathing upon these sweet smelling flowers and making a whispering noise amongst these tender leaves, delighteth with refreshing and refresheth with delight my over-wearied senses.

But tell me I pray you the cause of your hither coming; have you not forgotten some part of that which I showed you at our last being together?

PHI. No verily, but by the contrary I am become such a singer as you would wonder to hear me.

MA. How came that to pass?

PHI. Be silent and I will show you. I have a brother, a great scholar and a reasonable musician for singing. He, at my first coming to you, conceived an opinion (I know not upon what reason grounded) that I should never come to any mean knowledge in music, and therefore when he heard me practise alone he would continually mock me, indeed not without reason, for many times I would sing half a note too high, otherwhile as much too low, so that he could not contain himself from

laughing; yet now and then he would set me right, more to let me see that he could do it than that he meant any way to instruct me, which caused me so diligently to apply my pricksong book that in a manner I did no other thing but sing, practising to skip from one key to another, from flat to sharp, from sharp to flat, from any one place in the scale to another, so that there was no song so hard but I would venture upon it, no Mood nor Proportion so strange but I would go through and sing perfectly before I left it; and in the end I came to such perfection that I might have been my brother's master, for although he had a little more practice to sing at first sight than I had, yet for the Moods, Ligatures, and other such things I might set him to school.

MA. What then was the cause of your coming hither at this time?

PHI. Desire to learn, as before.

MA. What would you now learn?

PHI. Being this last day upon occasion of some business at one of my friends' houses we had some songs sung. Afterwards, falling to discourse of music and musicians, one of the company naming a friend of his own termed him the best Descanter that was to be found. Now, sir, I am at this time come to know what Descant is and to learn the same.

MA. I thought you had only sought to know pricksong, whereby to recreate yourself being weary of other studies.

PHI. Indeed when I came to you first I was of that mind, but the common proverb is in me verified that 'much would have more,' and seeing I have so far set foot in music I do not mean to go back till I have gone quite through all; therefore I pray you now (seeing the time and place fitteth so well) to discourse to me what Descant is, what parts and how many it hath, and the rest.

MA. The heat increaseth and that which you demand requireth longer discourse than you look for, let us therefore go and sit in yonder shady arbour to avoid the vehementness of the sun.

Exposition of the name of Descant. The name of Descant is usurped of the musicians in divers significations; sometime they take it for the whole harmony of many voices;[1] others sometime for one of the voices or parts, and that is when the whole song is not passing three voices;[2] last of all they take it for singing a part extempore upon a plainsong, in which sense we commonly use it; so that when a man talketh of a Descanter it must be understood of one that can, extempore, sing a part upon a plainsong.

PHI. What is the mean to sing upon a plainsong?

[1] 'English Discant.'

[2] i.e. the top part of a three-part piece was called Discantus, the lower two being Tenor and Contratenor. Oddly enough, the only time M. uses Discantus is as the top voice of a four-part composition! (cf. p. 28).

MA. To know the distances both concords [1] and discords.

PHI. What is a concord?

MA. It is a mixed sound compact of divers voices, entering with delight in the ear, and is either perfect or imperfect.

What a concord is.

PHI. What is a perfect consonant?

MA. It is that which may stand by itself and of itself maketh a perfect harmony without the mixture of any other.

What a perfect consonant is.

PHI. Which distances make a concord or consonant harmony?

MA. A third, a fifth, a sixth, and an octave.

How many concords there be.

PHI. Which be perfect and which imperfect?

MA. Perfect—an unison, a fifth, and their octaves.

PHI. What do you mean by 'their octaves'?

MA. Those notes which are distant from them eight notes, as from an unison, an octave; from a fifth, a twelfth.

PHI. I pray you make me understand that for in common sense it appeareth against reason, for put eight to one and all will be nine, put eight to five and all will be thirteen.

MA. I see you do not conceive my meaning in reckoning your distances for you understood me exclusively and I mean inclusively, as for example from Gam ut to B mi is a third, for both the extremes are taken, so from Gam ut to G sol re ut is an octave, and from Gam ut to D la sol re is a twelfth, although it seem in common sense but an eleventh.

PHI. Go forward with your discourse for I understand you now.

MA. Then, I say, a unison, a fifth, an octave, a twelfth, a fifteenth, a nineteenth, and so forth *in infinitum* be perfect chords.

PHI. What is an imperfect concord?

MA. It is that which maketh not a full sound and needeth the following of a perfect concord to make it stand in the harmony.

PHI. Which distances do make imperfect consonants?

MA. A third, a sixth, and their octaves, a tenth, a thirteenth, etc.

What an imperfect concord is.

PHI. What is a discord?

MA. It is a mixed sound compact of divers sounds naturally offending the ear and therefore commonly excluded from music.

How many imperfect chords there be.

PHI. Which distances make discord or dissonant sounds?

What a discord is.

MA. All such as do not make concords, as a second, a fourth,[2] a seventh, and their octaves, a ninth, an eleventh, a fourteenth, etc. And to the end that what I have showed you concerning concords perfect and imperfect and discords also may the more strongly stick to your memory, here is a table of them all which will not a little help you.

[1] M. has 'of concords,' but this is corrected in the Errata (see also p. 205, footnote 3).
[2] Cf. p. 205.

| | Concords | | | Discords | | |
| perfect | imperfect | perfect | imperfect | | | |

dd

19 20 18 21

17 16

G 15

(1) 𝄡[1] 12 13 14

10 11

F 8 9

(2) ♮[2]

(3) Γ[3]

an unison. a third. a fifth. a sixth. a second. a fourth. a seventh.

Or thus more briefly:

$$\text{From} \begin{Bmatrix} 7 \\ 6 \\ 5 \\ 4 \\ 3 \\ 2 \\ 1 \end{Bmatrix} \text{ariseth} \begin{Bmatrix} 14 \\ 13 \\ 12 \\ 11 \\ 10 \\ 9 \\ 8 \end{Bmatrix} \qquad \text{And from} \begin{Bmatrix} 14 \\ 13 \\ 12 \\ 11 \\ 10 \\ 9 \\ 8 \end{Bmatrix} \text{ariseth} \begin{Bmatrix} 21 \\ 20 \\ 19 \\ 18 \\ 17 \\ 16 \\ 15 \end{Bmatrix}$$

PHI. I pray you show me the use of those chords.

MA. The first way wherein we show the use of the chords is called Counterpoint, that is when to a note of the plainsong there goeth but one note of descant. Therefore when you would sing upon a plainsong look where the first note of it stands and then sing another for it which may be distant from it three, five, or eight notes, and so forth with others, but with a sixth we seldom begin or end.

PHI. Be there no other rules to be observed in singing on a plainsong than this?

MA. Yes.

[1] M. has 𝄐—an old form. [2] B square (B♮). [3] Gamma (G).

PHI. Which be they?

MA. If you be in the unison, fifth, or octave from your bass or plain-song, if the bass rise or fall you must not rise and fall just as many notes as your bass did.

PHI. I pray you explain that by an example.

MA. Here is one wherein the unisons, fifths, and octaves be severally set down.

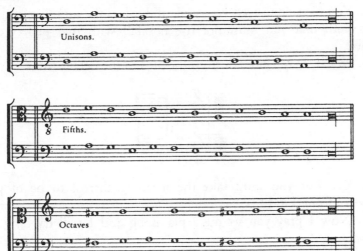

Consequence
of perfect
concords of
one kind
condemned.[1]

PHI. This is easy to be discerned as it is set down now but it will not be so easy to be perceived when they be mingled with other notes, there-fore I pray you show me how they may be perceived amongst other chords.

MA. There is no way to discern them but by diligent marking wherein every note standeth, which you cannot do but by continual practice, and so by marking where the notes stand and how far every one is from the next before you shall easily know both what chords they be and also what chord cometh next.

PHI. I pray you explain this likewise by an example.

MA. Here is one wherein there be equal number of true and false notes, therefore (if you can) show me now what concord every note is and which be the true notes and which false.

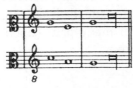

[1] This well-known rule appears as early as the fourteenth century in a tract by Torkesey entitled *Declaratio Trianguli* in the Waltham Holy Cross MS. Anonymus XIII (late thirteenth century?) prohibits consecutive fifths and octaves against the tenor.

PHI. The first note of the bass standeth in C sol fa ut and the first of the treble in G sol re ut so that they two make a fifth and therefore the first note is true. The second note of the bass standeth in A la mi re and the second of the treble in E la mi, which two make also a fifth and were true if the bass did not fall two notes and the treble likewise two notes from the place where they were before. The third note is true and the last false.

MA. You have conceived very well, and this is the meaning of the rule which saith that you must not rise nor fall with two perfect chords together.

Consequence
of perfect
concords of
divers kinds
allowed. PHI. What, may I not fall from the fifth to the octave thus?

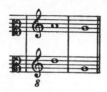

MA. Yes, but you must take the meaning thereof to be of perfect concords of one kind.[1]

PHI. Now I pray you set me a plainsong and I will try how I can sing upon it.

MA. Set down any you list yourself.

PHI. Then here is one; how like you this?

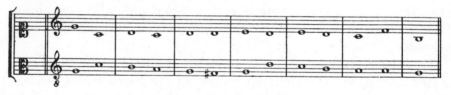

Falling from
the octave to
the unison
condemned.

Falling from
a sixth to a
unison con-
demned in
two parts. MA. This is well, being your first proof, but it is not good to fall so from the octave to the unison as you have done in your first two notes, for admit I should, for my pleasure, descend in the plainsong from G sol re ut to C fa ut, then would your descant be two octaves; and whereas in your seventh and eighth notes you fall from a sixth to an unison, it is indeed true but not allowed in two parts either ascending or descending, but worse ascending than descending, for descending it cometh to an octave which is much better and hath far more fullness of sound than the unison hath; indeed in many parts (upon an extremity, or for the point or imitation's[2] sake thus:

[1] Fifth to octave is allowed descending but not ascending (cf. p 152).

[2] M. has 'fugue' here and elsewhere; in each case I have substituted the word 'imitation,' which is all he means.

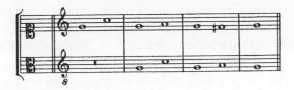

or in canon) it were tolerable, but most chiefly in canon, the reason whereof you shall know hereafter when you have learned what a canon is; in the meantime let us go forward with the rest of your lesson.

In your last two notes the coming from a sixth to a third is altogether not to be suffered in this place, but if it were in the middle of a song and then your B fa b mi being flat it were not only sufferable but commendable, but to come from F fa ut (which of his nature is always flat) to B fa b mi sharp, it is against nature; but if you would in this place make a flat close to your last note and so think to avoid the fault, that could no more be suffered than the other, for no close may be flat; but if you had made your way thus it had been much better: *Falling from [a] sixth to a third, both parts descending, disallowed.*

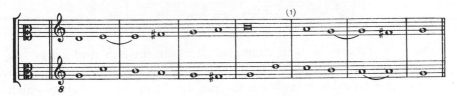

for the fewer parts your song is, of the more exquisite should your descant be and of most choice chords, especially sixths and tenths; perfect chords are not so much to be used in two parts except passing (that is when one part descendeth and another ascendeth) or at a close or beginning.

PHI. Indeed methinks this filleth mine ears better than mine own did; but I pray you how do you make your last note saving two to stand in the harmony, seeing it is a discord?

MA. Discords mingled with concords not only are tolerable but make the descant more pleasing if they be well taken; moreover there is no coming to a close, specially with a cadence, without a discord, and that most commonly a seventh bound in with a sixth when your plainsong descendeth as it doth in that example I showed you before. *Discords well taken allowed in music.*

PHI. What do you term a Cadence?

MA. A Cadence we call that when, coming to a close, two notes are bound together and the following note descendeth thus: *What a Cadence is.*

or in any other key after the same manner.

¹ The barring is irregular here in M., in fact it is barred differently in the various states and editions.

PHI. I pray you then show me some ways of taking a discord well, and also some where they are not well taken, that comparing the good with the bad I may the more easily conceive the nature of both.

MA. Here be all the ways which this plainsong will allow wherein a discord may be taken with a cadence in counterpoint.

Examples of well taking a discord with a Cadence.

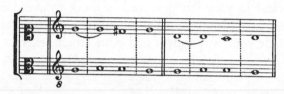

And whereas in the first of these examples you begin to bind upon the sixth, the like you might have done upon the octave or in the fifth, if your plainsong had risen thus:

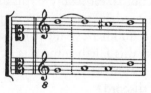

PHI. The second of these examples closeth in the fifth, and I pray you do you esteem that good?

MA. It is tolerable though not so good in the ear as that before which closeth in the octave, or that which next followeth it; but if the last note of the plainsong ascended to D la sol re thus:

it had been good and the best way of closing.

PHI. Now I pray you give me some examples where the discord is not well taken.

MA. Here is one; peruse it.

PHI. I pray you show me a reason why the discord is evil taken here.

MA. Because after the discord we do not set a perfect concord, for the perfect concords do not so well bear out the discords as the imperfect do,

and the reason is this: when a discord is taken it is to cause the note following be the more pleasing to the ear; now the perfect concords of themselves being sufficiently pleasing need no help to make them more agreeable, because they can be no more than of themselves they were before.[1]

PHI. Let us now come again to our example from which we have much digressed.

MA. We will, and therefore as I have told you of the good and bad taking of a discord upon these notes, it followeth to speak of a formal closing without a discord or cadence, and here be some ways formally to end in that manner.

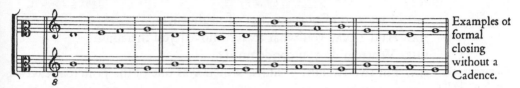

Examples of formal closing without a Cadence.

PHI. The first and last ways I like very well, but the second way, closing in the fifth, offendeth mine ears.

MA. Though it be unpleasant yet is it true; and if it be true closing in the octave why should it not be true in the fifth also? But if you like it not there be (as the proverb sayeth) 'more ways to the wood than one.'

PHI. You say true, but I have had so many observations that I pray God I may keep them all in mind.

MA. The best means to keep them in mind is continually to be practising, and therefore let me see what you can do on the same plainsong again.

PHI. Here is a way; how like you it?

The scholar's second lesson of counter-point.

MA. Peruse it and see how you like it yourself.

PHI. I like it so well as I think you shall not find many faults in it.

MA. You live in a good opinion of yourself. But let us examine your example. This is indeed better than your first, but mark wherein I con- Faults in this demn it. In the first and second notes you rise as though it were a close, lesson. causing a great informality of closing when you should but begin. Your third note is good; your fourth note is tolerable, but in that you go from it to the twelfth it maketh it unpleasing, and that we commonly call

[1] An ingenious reason!

What 'hitting the octave on the face' is. 'hitting the octave on the face' when we come to an octave and skip up from it again to another perfect concord, but if it had been meeting one another, the plainsong ascending and the descant descending, it had been very good, thus:

But I pray you where was your memory when you set down this sixth note?

PHI. I set it so of purpose, not of negligence.

MA. And I pray you what reason moved you thereunto?

PHI. Wherein do you condemn it?

Consequence of imperfect fifths no more to be used than of perfect.

MA. For two twelfths or fifths, which was one of the principal caveats I gave you to be avoided.

PHI. But they be not two fifths.

MA. No? What reason have you to the contrary?

PHI. Because in singing I was taught that the sharp clef taketh away half of his sound so that it cannot be properly called a fifth.

MA. That is a new opinion; but I trust you will not say it is a fourth.

PHI. No.

MA. Why?

PHI. Because it hath half a note more than any fourth hath.

MA. And I hope you will not term it a sixth.

PHI. No.

MA. Then if it be no fourth because it is more than a fourth, nor a sixth because it is less than a sixth, what name will you give it?

PHI. I cannot tell.

Alfonso in his song 'Sich 'io mi cred 'ho mai,' being the twentieth song of his second book of Madrigals of five voices [1587], at the very close be- tween canto and alto.[1]

MA. A woman's reason, to maintain an opinion and then if she be asked why she doth so will answer 'because I do so.' Indeed I have seen the like committed by Master Alfonso, a great musician, famous and admired for his works amongst the best, but his fault was only in pricking, for breaking a note in division, not looking to the rest of the parts, made three fifths in the same order as you did; but yours came of ignorance, his of jollity. And I myself have committed the like fault

Alfonso Ferrabosco (senior) (1543–88).

in my first work of three parts,[1] yet if any one should reason with me I were not able to defend it, but (no shame to confess) my fault came by negligence; but if I had seen it before it came to the press it should not have passed so for I do utterly condemn it as being expressly against the principles of our art. But of this another time at more length.[2]

In the Third Part.

And as for the rest of your lesson, though the chords be true yet I much mislike the form, for falling down so in tenths so long together is odious seeing you have so much shift[3] otherwise. Likewise in your penult and antepenult notes you stand still with your descant, the plainsong standing still, which is a fault not to be suffered in so few as two parts, especially in octaves. But in descanting you must not only seek true chords but formality also, that is to make your descant carry some form of relation to the plainsong, as thus for example:

Standing with the plainsong condemned. *What formality is.*

PHI. You sing two plainsong notes for one in the descant which I thought you might not have done except at a close.

MA. That is the best kind of descant, so it be not too much used in one song, and it is commonly called 'binding descant.' But to instruct you somewhat more in formality, the chiefest point in it is singing with a Point or Imitation.

Binding descant.

PHI. What is Imitation?

MA. We call that Imitation when one part beginneth and the other singeth the same for some number of notes which the first did sing, as thus for example:

Imitation.

PHI. If I might play the Zoilus[5] with you in this example I might find much matter to cavil at.

[1] *Canzonets for 2 and 3 Voices*, No. 20, 'Arise get up,' p. 102 (cf. also p. 237, footnote 15).

[2] p. 254. [3] 'Scope.'

[4] M. probably intended B here.
[5] A bitter, unjust, and envious Greek critic. (See also the verse by I. W., p. 4.)

MA. I pray you let me hear what you can say against any part of it, for I would be glad that you could not only spy an oversight but that you could make one much better.

PHI. First of all you let the plainsong sing two whole notes for which you sing nothing. Secondly you begin on a sixth.

MA. You have the eyes of a lynx in spying faults in my lesson and I pray God you may be so circumspect in your own; but one answer solveth both these objections which you lay against me, and first for the rest; there can be no point or imitation taken without a rest, and in this place it is impossible in counterpoint sooner to come in with the point in the octave; and as for the beginning upon a sixth the point likewise compelled me to do so, although I could have made the descant begin it otherwise, as thus:

No imitation can be brought in without a rest.

Beginning upon a sixth in imitation tolerable.

for avoiding of the sixth, altering the leading part, but then would not your point have gone through to the end answering to every note of the plainsong, for that the ninth note of force must be a fourth as you see. But if you would sing the descant part fifteen notes lower, then will it go well in the octave below the plainsong, and that note which above was a fourth will fall to be a fifth under the plainsong, thus:

The point likewise doth excuse all the rest of the faults which might be objected against me except it be for false descant, that is, two perfect chords of a kind together, or such like.

PHI. You have given me a competent reason, and therefore I pray you show me in what and how many distances you may begin your point.

MA. In the unison, fourth, fifth, sixth, and octave;[1] but this you must mark by the way, that when we speak of imitation or canon in the unison, fifth, or octave, it is to be understood from the first note of the leading part, as my lesson may be called 'two parts in one in the octave' although I did begin upon a sixth.

Distances whereupon imitation may be begun.

How those distances are reckoned.

[1] These are the intervals at which *imitation* may occur; they do not refer to canon, which can be at any interval (cf. pp. 179–185). Imitation at the sixth was rare.

PHI. Well then, seeing by your words I conceive the formality of following a point with a plainsong, I will try upon the same plainsong what I can do for the maintenance of this imitation. But now that I have seen it I think it impossible to find any other way than that which you already have set down on these notes.

MA. Yes, there is another way if you can find it out.

PHI. I shall never leave breaking my brains till I find it. And lo, here is a way which, although it do not drive the point quite through as yours did, yet I think it formal.

MA. You have rightly conceived the way which I meant. But why did you prick it of so much compass?

PHI. For avoiding the unison in the beginning.

MA. It is well, and very hard and almost impossible to do more for the bringing in of this point above the plainsong than you have done, wherefore I commend you in that you have studied so earnestly for it; but can you do it no otherwise?

PHI. No, in truth, for while I studied to do that I did, I thought I should have gone mad with casting and devising, so that I think it impossible to set any other way.

MA. Take the descant of your own way, which was in the eleventh or fourth above, and sing it as you did begin, but in the fifth below under the plainsong, and it will in a manner go through to the end, whereas yours did keep report [1] but for five notes.

PHI. This riseth five notes and the plainsong riseth but four.

MA. So did you in your example before, although you could perceive it in mine and not in your own; but although it rise five notes yet is it the point, for if it were in canon we might not rise one note higher nor descend one note lower than the plainsong did, but in imitations we are not so straitly bound. But there is a worse fault in it which you have

[1] 'Relation' or 'connection' (Fr. *rapport*); the term is fairly often used in seventeenth-century England for 'imitation.'

Rising from
the fifth to
the octave
disallowed
in music. not espied, which is the rising from the fifth to the octave in the
seventh and eighth notes, but the point excuseth it although it be not
allowed for any of the best in two parts, but in more parts it might be
suffered.

PHI. I would not have thought there had been such variety to be used
upon so few notes.

MA. There be many things which happen contrary to men's expecta-
tions, therefore yet once again try what you can do upon this plainsong,
though not with a point yet with some formality or meaning in your
way.

PHI. You use me as those who ride the great horses, for having first
ridden them in a small compass of ground they bring them out and ride
them abroad at pleasure. But lo, here is an example upon the same
notes.

MA. This is well enough, although if I peruse mine own first lesson
of imitation I shall find you a robber, for behold here be all your own
notes in black pricking, the rest which be white be mine, for though
you close in the octave below yet is the descant all one.

PHI. In truth I did not willingly rob you although by chance I fell
into your chords.

MA. I like it all the better. But I would counsel you that you accustom
not yourself to put in pieces of other men's doings amongst your own,
for by that means the diversity of veins will appear and you be laughed
to scorn of the skilful for your pains.

PHI. You say true and I will take heed of it hereafter. But I think
myself now reasonably instructed in counterpoint, I pray you therefore
go forward to some other matter.

MA. There remaineth some things in counterpoint which you must
Short and
Long. know before you go any further. The first is called 'Short and Long'
when we make one note alone and then two of the same kind bound
together and then another alone as you see in this lesson:

Long and short [. . .]

PHI. Nay, by your leave, I will make one of every sort, and therefore
I pray you proceed no further till I have made one of these.

MA. If you think it worth the making do so, for if you can otherwise
do anything upon a plainsong this will not be hard for you, but to do it
twice or thrice upon one plainsong in several ways will be somewhat
harder because that in these ways there is little shift.

PHI. 'Somewhat,' said you? I had rather have made twenty lessons
of counterpoint than have made this one miserable way which not-
withstanding is not to my contentment; but I pray you peruse it.

MA. This is well done.

PHI. The rising to the twelfth or fifth I do mislike in the seventh
note, but except I should have taken your descant I had none other
shift.

MA. Let it go. 'Long and short' is when we make two notes tied Long and
together and then another of the same kind alone, contrary to the other Short.
example before, thus:

(1)

PHI. Seeing I made one of the other sort I will try if I can make
one of this also.

MA. You will find as little shift in this as in the other.

PHI. Here is a way, but I was fain either to begin upon the sixth or
else to have taken your beginning, for here I may not rest.

¹ M. has overlooked this as a result of barring automatically—the example should be
barred as ³⁄₁; even so the S dissonance is probably a slip.

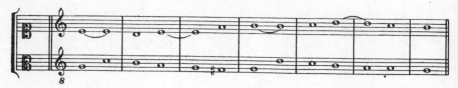

MA. Necessity hath no law and therefore a small fault in this place. But let this suffice for counterpoint.

PHI. What followeth next to be spoken of?

Descant commonly called Dupla.
AM. The making of two or more notes for one of the plainsong which (as I told you before) is falsely termed Dupla[1] and is when [for] a semi-breve or note of the plainsong we make two minims.

PHI. May you not now and then intermingle some crotchets?

MA. Yes, as many as you list so you do not make all crotchets.

PHI. Then I think it is no more Dupla.

MA. You say true, although it should seem that this kind of Dupla is derived from the true Dupla,[2] and the common Quadrupla out of this; but to talk of these Proportions is in this place out of purpose, therefore we will leave them and return to the matter we have in hand.

PHI. I pray you then set me down the general rules of this kind of descant that so soon as may be I may put them in practice.

MA. The rules of your chords, beginning, formality, and such like, are the same which you had in counterpoint, yet by the way one caveat
A discord not to be taken for the first part of a note except in binding wise.
more I must give you to be observed here, that is that you take not a discord for the first part of your note except it be in binding manner, but for the last part you may.

PHI. I pray you make me understand that by an example.

MA. Here briefly you may see that upon these notes you may sing thus:

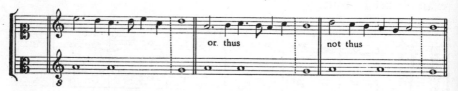

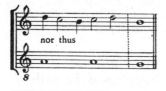

[1] p. 47.

[2] Descanters were fond of singing in Proportions (cf. p. 136), and as a descant written in S in Dupla Proportion would actually be sung in M, a descant written in M and sung against a plainsong in S (without any Proportion) would naturally, but inaccurately, be given the same name—Dupla.

But in binding descant you may take a discord for the first part of the note
thus:

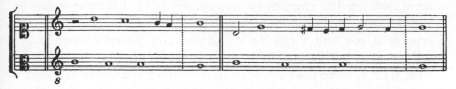

PHI. I will remember this, therefore I pray you set me a lesson in this
kind of descant whereby I may strive to imitate you with another of the
same kind.

MA. Here is one; mark it and then make one of your own like it.

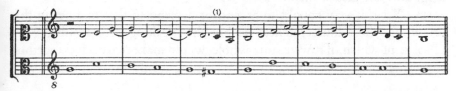

PHI. I perceive by this that it is an easy matter for one that is well
seen in counterpoint to attain in short time to the knowledge of this kind.

MA. It is so. But there be many things which at the first sight seem
easy which in practice are found harder than one would think. But
thus much I will show you, that he who hath this kind of descanting
perfectly may, with small trouble, quickly become a good musician.

PHI. You would then conclude that the more pains are to be taken
in it. But here is my way; how do you like it?

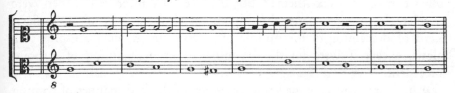

MA. Well for the first trial of your understanding in this kind of
descant. But let us examine particularly every note, that you, seeing
the faults, may avoid them hereafter.

PHI. I pray you do so and leave nothing untouched which any way
may be objected.

MA. The first, second, and third notes[2] of your lesson are tolerable, but
your fourth note is not to be suffered because that and the next note
following are two octaves.

PHI. The second part of the note is a discord and therefore it cannot
be two octaves, seeing they are not both together.

[1] M., curiously, does not point out this typical cadential figure.
[2] 'Note' (in this context) means 'semibreve,' here and elsewhere.

MA. Though they be not both together yet is there no concord between
them; and this you must mark, that a discord coming between two
octaves doth not let [1] them to be two octaves still. Likewise if you set
a discord between two fifths it letteth. them not to be two fifths still.
Therefore if you will avoid the consequence of perfect chords of one
kind you must put betwixt them other concords and not discords.

A discord coming between two perfect concords of one kind taketh not away the faulty consequence.

PHI. This is more than I would have believed if another had told it
me; but I pray you go on with the rest of the faults.

MA. Your seventh and eighth notes have a fault cousin german [2] to
that which the others had, though it be not the same.

PHI. I am sure you cannot say that they be two octaves, for there is a
tenth after the first of them.

MA. Yet it is very naught to ascend or descend in that manner to the
octave, for those four crotchets be but the breaking of a semibreve in
G sol re ut which, if it were sung whole, would make two octaves together
ascending, or if he who singeth the plainsong would break it thus:

Ascending or descending to the octave condemned.

Zarlino, Inst. Mus., part terza, cap. 48.

(which is a thing in common use amongst the singers) it would make
five octaves together, and as it is it ought not to be used, especially in two
parts, for it is a gross fault. Your ninth and tenth notes are two octaves
with the plainsong, for a minim rest set betwixt two octaves keepeth them
not from being two octaves because (as I said before) there cometh no
other concord betwixt them; [3] but if it were a semibreve rest then were
it tolerable in more parts, though not in two, for it is an unartificial
kind of descanting in the middle of a lesson to let the plainsong sing
alone, except it were for the bringing in or maintaining of a point
precedent.

A minim rest put betwixt two perfect chords of one kind hindreth not their faulty consequence.

PHI. I pray you give me some examples of the bad manner of coming
to octaves, fifths, or unisons, that by them I may in time learn to find out
more, for without examples I shall many times fall into one and the
selfsame error.

[1] 'Prevent.' [2] M. has 'germaine,' here and on p. 211.

[3] The following example of this 'fault' occurs in Byrd's *Songs of Sundry Natures* (1589),

No. 2, 'Right blest are they,' p. 12: M. is also guilty of

it himself. (See instances noted in examples on pp. 229-40, also in his published
works.) .

MA. That is true, and therefore here be the grossest faults; others, by my instruction and your own observations, you may learn at your leisure. And because they may hereafter serve you when you come to practise Bass descant I have set them down first above the plainsong and then under it.

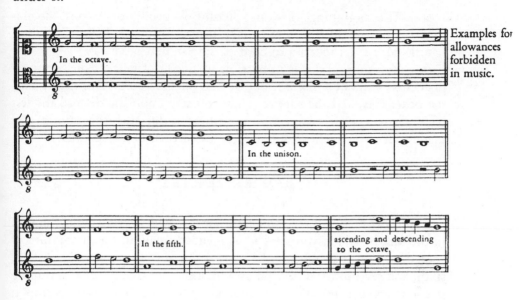

Examples for allowances forbidden in music.

PHI. These I will diligently keep in mind; but I pray you how might I have avoided those faults which I have committed in my lesson?

MA. Many ways, and principally by altering the note going before that wherein the fault is committed.

PHI. Then I pray you set down my lesson corrected after your manner.

MA. Here it is with your faults amended and that of yours which was good retained.

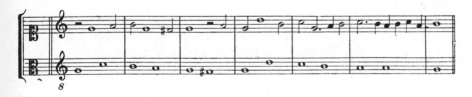

PHI. This is well; but I will make another, that all my faults may come out at the first and so I may have the more time to mend them.

MA. Do so, for the rules and practice joined together will make you both certain and quick in your sight.

PHI. Here is one; and as you did in the other I pray you show me the faults at length.

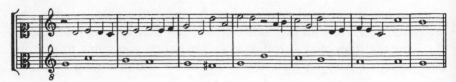

MA. The beginning of your descant is good, the second note is tolerable but might have been made better.

PHI. May I not touch a discord passing in that order?

An observa- MA. You may, and it is impossible to ascend or descend in continual
tion for deduction without a discord, but the less offence you give in the discord
passing notes. the better it is, and the shorter while you stay upon the discord the less
offence you give; therefore if you had set a dot after the minim and
made your two crotchets two quavers it had been better, as thus:

Your next note had the same fault for that you stayed a whole minim
in the fourth, which you see I have mended, making the last minim of
your third note a crotchet and setting a dot after the first.[1] Your fifth,
Wild sixth, and seventh notes be wild and informal, for that informal skipping
skipping is condemned in this kind of singing; but if you had made it thus it
condemned had been good and formal.
in descant.

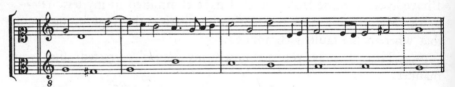

PHI. Wherein did you mislike my close, for I see you have altered it also?

Staying MA. Because you have stayed in the note before it a whole semibreve
before the together, for if your descant should be stirring in any place it should be
close in the note before the close; as for this way, if a musician should see it
condemned.

[1] M. is only condemning the accented dissonant crotchet (D) because it not only comes in two-part writing but also forms a major second with the plainsong (C); in the first example on p. 165, b. 4, the accented dissonant crotchet A is a minor seventh from the plainsong G and hence is less harsh; this figure, ♩ ♩ ♩, in which the first ♩ is dissonant, was a common-place in sixteenth-century writing. The harmonic unit in this example is the M, in the *Canzonets for Two Voices* (1595) the C is the unit, and in these songs there is no instance of an accented dissonant Q. The unaccented dissonant M is condemned also because it occurs in two-part writing, for in songs of four or more parts, where the M is the unit, unaccented dissonant M are quite common in the English school (cf. examples in Part III).

he would say it hangeth too much in the close. Also you have risen to the octave, which is all one as if you had closed below in the note from whence you fled.

PHI. I pray you before you go any further to set me some ways of discords passing, ascending and descending, and how they may be allowable and how disallowable.

MA. Although you might by the example which I showed you before conceive the nature of a passing note, yet to satisfy your desire I will set down such as might occur upon this plainsong, but in form of an imitation, that you may perceive how it is allowable or disallowable in imitation. And because we will have the best last I will show you two ways which, though others have used them, yet are no way tolerable, for it is impossible to take a discord worse than in them you may here see set down, which I have of purpose sought out for you that you may shun them and such like hereafter. Yet some (more upon their own opinion than any reason) have not spared to praise them for excellent, but if they or any man else can devise to make them falser then will I yield to them, and be content to be esteemed ignorant in my profession. But I pray you peruse them.

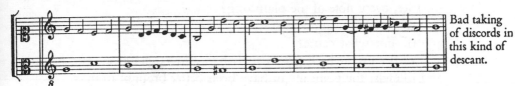

Bad taking of discords in this kind of descant.

PHI. It may be there is art in this which I cannot perceive but I think it goeth but unpleasingly to the ear, specially in the two notes next before the close.

MA. I find no more art in it than you perceived pleasure to the ear, and I doubt not if you yourself should examine it you would find matter enough without a tutor to condemn it. As for the first, there are four notes that might be easily amended with a dot, altering some of their length by the observation which I gave you before. But as for the place which you have already censured, if all the masters and scholars in the world should lay their heads together it were impossible to make it worse; but if it had been thus it had been tolerable:

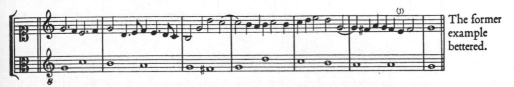

The former example bettered.

[1] M. has a ♯ before the E instead of the previous F.

and you may see with what little alteration it is made better from the beginning to the end, not taking away any of the former notes except that informal close which no man's ears could have endured, yet (as I told you before) the best manner of closing is in cadence.

PHI. In cadence there is little shift or variety, and therefore it should seem not so often to be used for avoiding of tediousness.

MA. I find no better word to say after a good prayer than 'Amen,' nor no better close to set after a good piece of descant than a cadence, yet if you think you will not say as most voices do, you may use your discretion and say 'so be it' for variety.

Here is also another way which for badness will give place to none other.

Other examples of discord evil taken.

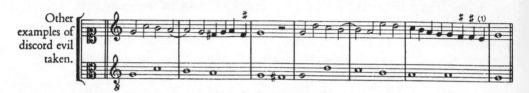

PHI. What, will not the imitation excuse this seeing it singeth, in a manner, every note of the plainsong?

MA. No.

PHI. For what cause?

MA. Because it both taketh such bad allowances as are not permitted and likewise the point might have been better brought in thus:

Examples of discord well taken, wherein all the allow-ances be contained.

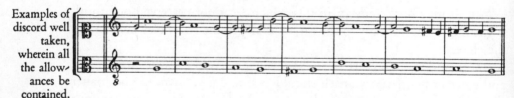

But it were better to leave the point and follow none at all than for the point's sake to make such harsh unpleasant music, for music was devised to content and not offend the ear.

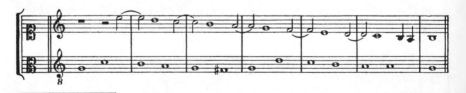

[1] This is the so-called 'Landini Sixth' cadence and can be found in sixteenth-century works fairly frequently, though very rarely at final cadences (see also the 'Tripla in the minim' example, p. 170). The two G crotchets can be regarded as a form of the consonant 7th suspension.

And as for the other two, as there is no means of evil taking of discords which you have not in them (and therefore, because I think I have some authority over you, I will have you altogether to abstain from the use of them) so in these other two there is no way of well taking a discord lacking, both for imitation and for binding descant, in that it is impossible to take them truly on this plainsong otherwise than I have set them down for you, for in them be all the allowances, and besides the first of them singeth every note of the plainsong.

PHI. I thank you heartily for them and I mean by the grace of God to keep them so in memory that whensoever I have any use of them I may have them ready.

MA. Try then to make another way formal without imitation.

PHI. Here is one, although I be doubtful how to think of it myself, and therefore I long to hear your opinion.

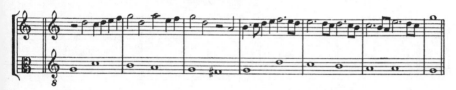

MA. My opinion is that the half of it is tolerable, the other half I mislike.

PHI. I suspected so much before that the latter half would please you though the first half did not.

MA. You are deceived, for the first half liketh me better than the latter.

PHI. How can that be seeing the latter keepeth point in some sort with the plainsong?

MA. But you fall as the plainsong doth, still telling one tale without variety. But if you would maintain a point you must go to work thus:

Falling down with the plainsong disallowed.

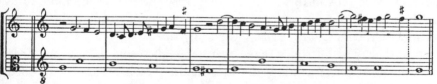

But withal you must take this caveat, that you take not above one minim rest (or three upon the greatest extremity of your point) in two parts, for that in long resting the harmony seemeth bare, and the odd rest giveth an unspeakable grace to the point (as for an even number of rests, few or none use them in this kind of descanting); but it is supposed that when a man keepeth long silence and then beginneth to speak he will speak to the purpose, so in resting you let the other go before that you may the better follow him at your ease and pleasure.

An odd rest the most artificial kind of bringing in a point.

PHI. Here is a way which I have beaten out wherein I have done what I could to maintain the point.

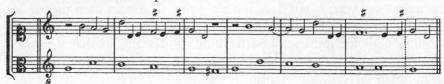

MA. You have maintained your point indeed but after such a manner as nobody will commend, for the latter half of your lesson is the same that your first was without any alteration, saving that to make it fill up the whole time of the plainsong (which hath two notes more than were before) you have set it down in longer notes; but by casting away those two notes from the plainsong you may sing your first half twice after one manner, as in this example you may see:

One thing twice sung in one lesson condemned.

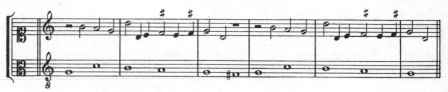

And therefore, though this way be true, yet would I have you to abstain from the use of it, because in so small bounds and short space it is odious to repeat one thing twice.

PHI. Well then, I will remember not to take the same descant twice in one lesson, but when I made it I did not look into it so narrowly; yet I think by these ways I do well enough understand the nature of this kind of descant, therefore proceed to that which you think most meet to be learned next.

MA. Before you proceed to any other thing I would have you make some more lessons in this kind that you may thereby be the more ready in the practice of your precepts, for that this way of maintaining a point or imitation cometh as much by use as by rule.

PHI. I may at all times make ways enough seeing I have the order how to do them and know the most faults which are to be shunned, therefore, if you please, I pray proceed to some other matter which you think most requisite.

MA. Now seeing (as you say) you understand this kind of descant and know how to follow or maintain a point, it followeth to learn how to revert it.

PHI. What do you call the reverting of a point?

What a Revert is.

MA. The reverting of a point (which also we term 'a revert') is when a point is made rising or falling and then turned to go the contrary way as many notes as it did the first.

PHI. That would be better understood by an example than by words and therefore I pray you give me one.

MA. Here is one; mark it well and study to imitate it.

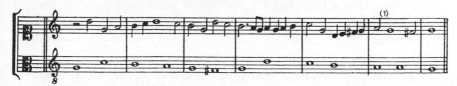

PHI. This way argueth mastery, and in my opinion he who can do it at the first sight needeth not to stand telling his chords.

MA. That is true indeed; but do you see how the point is reverted?

PHI. Yes, very well, for from your first note till the middle of your fifth your point is contained, and then in the middle of your fifth note you revert it, causing it ascend as many notes as it descended before and so descend where it ascended before.

MA. You have well perceived the true making of this way; but I pray make one of your own, that your practice may stretch as far as your speculation.

PHI. Lo, here is one; how do you like it?

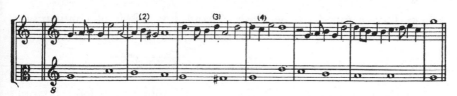

MA. I think it is fatal to you to have these wild points of informal skippings, which I pray you learn to leave, otherways your first five notes be tolerable. In your fifth note you begin your revert well, but in your seventh and eighth notes you fall from the thirteenth (or sixth) to the octave (or unison), which was one of the faults I condemned in your first lesson of counterpoint; the rest of your descant is passable. But I must admonish you that in making reverts you choose such points as may be easily driven through to the end, without wresting, changing of notes or points in harsh chords, which cannot be done perfectly well without great foresight of the notes which are to come after; therefore I would wish you, before you set down any point, diligently to consider

Falling from the sixth to the octave condemned.

[1] A rarely used variation (in two parts) of the cadential formula seen at the end of the second example on p. 160.

[2] A rather advanced resolution for a pupil to write unaided!

[3] A very unusual C group, yet M. commends it.

[4] Dissonant C quitted by a leap up.

G

your plainsong to see what points will aptliest agree with the nature of it, for that upon one ground or plainsong innumerable ways may be made, but many better than other.

PHI. Then for a trial that I have rightly conceived your meaning I will make another way reverted, that then we may go forward with other matters.

MA. Do so, but take heed of forgetting your rules.

PHI. I am in a better opinion of the goodness of mine own memory than to do so; but I pray you peruse this way; if there be in it any sensible gross fault, show it me.

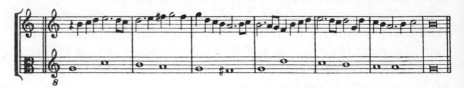

MA. All this is sufferable except your seventh and eighth notes wherein you fall from B fa b mi to F fa ut and so informally to B fa b mi back

Falling from
B fa b mi
sharp to F fa ut
condemned.

again thus: ♫ , which, though it be better than that which I condemned in the close of your first lesson of counterpoint, yet is it of the same nature and naught; but you may in continual deduction ascend from Mi to Fa thus: ♫ . I know you will make the point your excuse, but (as I told you before) I would rather have begun again and taken a new point than I would have committed so gross a fault. As for the rest of your lesson, it is tolerable.

Now I hope by the precepts which I have already given you in your examples going before you may conceive the nature of Treble descant; it followeth to show you how to make Bass descant.

PHI. What is Bass descant?

Bass descant.

MA. It is that kind of descanting where your sight of taking and using your chords must be under the plainsong.

PHI. What rules are to be observed in Bass descant?

A caveat
for the
sight of
chords under
the plainsong.

MA. The same which were in Treble descant; but you must take heed that your chords deceive you not, for that which above your plainsong was a third will be under your plainsong a sixth, and that which above your plainsong was a fourth will be under your plainsong a fifth, and which above was a fifth will under the plainsong be a fourth, and lastly that which above your plainsong was a sixth will under it be a third; and so likewise in your discords, that which above your plainsong was a

second will be under it a seventh, and that which above the plainsong was a seventh will be under the plainsong a second.

PHI. But in descanting I was taught to reckon my chords from the plainsong or ground.

MA. That is true, but in Bass descant the bass is the ground although we are bound to see it upon the plainsong, for your plainsong is as it were your theme, and your descant (either Bass or Treble) as it were your declamation, and either you may reckon your chords from your bass upwards or from the plainsong downward, which you list, for as it is twenty miles by account from London to Ware so is it twenty from Ware to London.

PHI. I pray you set me an example of Bass descant.

MA. Here is one.

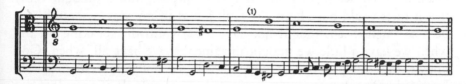

PHI. I think it shall be no hard matter for me to imitate this.

MA. Set down your way and then I will tell you how well you have done.

PHI. Here it is, and I think it shall need but little correction.

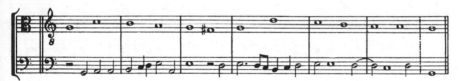

MA. Conceit of their own sufficiency hath overthrown many who otherwise would have proved excellent, therefore in any case never think so well of yourself, but let other men praise you (if you be praiseworthy), then may you justly take it to yourself, so it be done with moderation and without arrogancy.

PHI. I will; but wherein do you condemn my way?

MA. In those things wherein I did not think you should have erred, for in the beginning of your fourth note you take a discord for the first part and not in binding wise; your other faults are not so gross and yet must they be told.

PHI. In what notes be they?

MA. In the four notes going before the close, for there your descant

A discord taken for the first part of a note, not i binding w. condemne

[1] Compare this with the second half of the first bar in the first example, and the footnote, on p. 158.

would have been more stirring, and by reason it hangs so much I do not nor cannot greatly commend it, although it be true in the chords.

 PHI. What, is not that binding descant good?

Binding
with con-
cords not
so good as
that with
discords. MA. That kind of binding with concords is not so good as those bindings which are mixed with discords; but here is your own way, with a little alteration, much better.

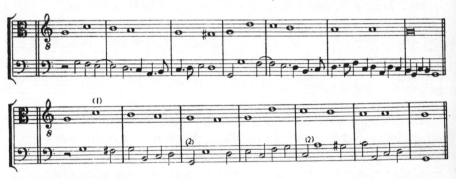

 PHI. This is the course of the world, that where we think ourselves surest there are we furthest off from our purpose, and I thought verily that if there could have been any fault found in my way it should have been so small that it should not have been worth the speaking of; but when we have a little we straight imagine that we have all, when, God knows, the least part of that which we know not is more than all we know; therefore I pray you set me another example that, considering it with your other, I may more clearly perceive the artificial composition of them both.

 MA. Here be two; choose which of them you think best and imitate it.

 PHI. It is not for me to judge or censure your works, for I was so far dashed in my last way (which I thought so exceeding good) that I dare never credit mine own judgement hereafter; but yet I pray you why have you left out the sharp clef before your sixth note in the plainsong of your second way?

The ear the
most just
judge of all
music. MA. Although the descant be true if the sharp clef were there, yea and passable with many, yet let your ear be judge how far different the air of the descant (the plainsong being flat) is from itself when the

[1] Bare fourth resolving on to a diminished fifth, in two parts.
[2] Leap of a major sixth.

plainsong is sharp, and therefore because I thought it better flat than sharp
I have set it flat; but if any man like the other way better let him use
his discretion.

PHI. It is not for me to disallow your opinion. But what rests for me
to do next?

MA. By working we become workmen, therefore once again set down
a way of this kind of descant.

PHI. That was my intended purpose before and therefore here is one,
and I pray you censure it without any flattery.

MA. This is very well, and now I see you begin to conceive the nature
of Bass descant, wherefore here is yet another way of which kind I would
have you make one.

PHI. This is a point reverted and (to be plain) I despair for ever doing
the like.

MA. Yet try, and I doubt not but with labour you may overcome greater
difficulties.

PHI. Here is a way; I pray you how like you it?

MA. I perceive by this way that if you will be careful and practise,
censuring your own doings with judgement, you need few more instruc-
tions for these ways; therefore my counsel is that when you have made
anything you peruse it and correct it the second and third time before
you leave it.

But now, seeing you know the rules of singing one part above or under

[1] Unusual accented dissonant C (cf. p. 183, fifth example).
[2] Cf. p. 163, footnote 4.

the plainsong, it followeth to show you how to make more parts. But
before we come to that I must show you those things which of old were
taught before they came to sing two parts; and it shall be enough to set
you a way of every one of them that you may see the manner of making
of them, for the allowances and descanting be the same which were
before, so that he who can do that which you have already done may
easily do them all.

The first is called 'crotchet, minim, and crotchet, crotchet, minim, and
crotchet,' because the notes were disposed so, as you may see in this
example.

Crotchet,
minim, and
crotchet.

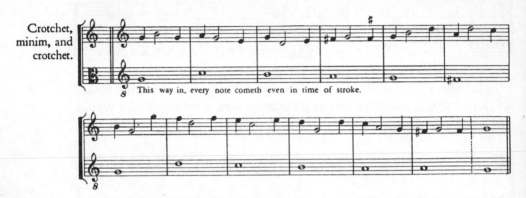

This way in, every note cometh even in time of stroke.

The second is called 'minim and crotchet' because there come a minim
and a crotchet successively through to the end; this, after two notes,
cometh even in the stroke and in the third likewise, and so in course
again to the end as here you may see.

Minim,
crotchet, and
minim.

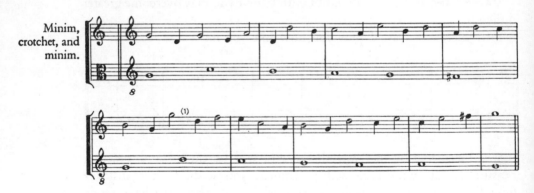

The third is a driving [2] way in two crotchets and a minim, but odded
by a rest, so that it never cometh even till the close, thus:

[1] Ornamental ('jumped') resolution.
[2] A note 'driven' over to the strong accent or beat.

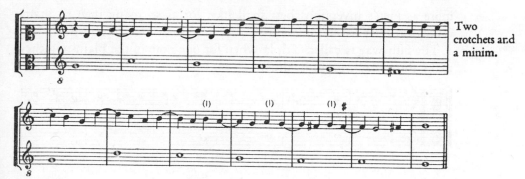

Two
crotchets and
a minim.

The fourth way driveth a crotchet rest throughout a whole lesson all
of minims, so that it never cometh even till the end, thus:

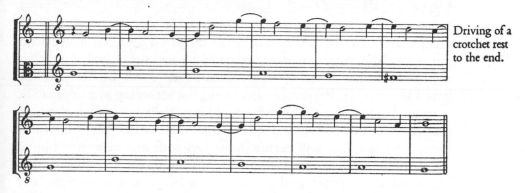

Driving of a
crotchet rest
to the end.

And in these ways you may make infinite variety, altering some note,
or driving it through others, or by some rest driven, or making your
plainsong figuration.

PHI. What is Figuration?

MA. When you sing one note of the plainsong long and another short Figuration.
and yet both pricked in one form;[2] or making your plainsong as your
descant notes and so making upon it;[3] or then driving some note or rest
through your plainsong, making it two long, three long, etc., or three
minims, five minims, or so forth, two minims and a crotchet, three
minims and a crotchet, five minims and a crotchet, etc.,[4] with infinite

[1] Unusual accented dissonant *C*.

[2] e.g. two *S* would be written, but one would be sung as a *B* and the other as a *S* (third
Rhythmic Mode).

[3] i.e. 'breaking' the plainsong into the same note values as the descant, as in the Parsley
example on pp. 178–9.

[4] This passage is somewhat obscure, and I suggest that M. is here briefly indicating a
sixteenth-century practice based on the medieval system of 'ordines' in which the plainsong
was split up into various rhythmic patterns. The examples below show the plainsong
'figuration' in the various patterns given by M. The original 'ordines' were written in
L and *B*. 'Two long, three long, etc.,' means patterns consisting of two, three, or more
notes, and 'three *M*,' etc., are merely reductions in note values from the original *L* and

more as men's inventions best shall like, for as so many men so many
minds, so their inventions will be divers and diversely inclined.

The fifth way is called Tripla when for one note of the plainsong they
make three black minims, thus:

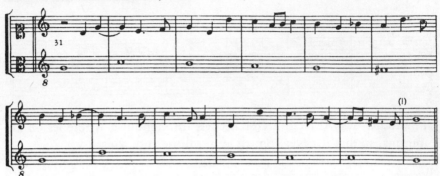

Tripla in
the minim.
though (as I told you before) this be not the true Tripla, yet have I set it
down unto you in this place that you might know not only that which is
right but also that which others esteemed right. And therefore likewise
have I set down the Proportions following, not according as it ought to be
in reason but to content wranglers who I know will at every little oversight
take occasion to backbite and detract from that which they cannot dis-
prove. I know they will excuse themselves with that new invention of
Tripla to the semibreve and Tripla to the minim, and that that kind of
Tripla which is Tripla to the minim must be pricked in minims, and
the other in semibreves. But in that invention they overshoot themselves,
seeing it is grounded upon custom and not upon reason. They will
reply and say the Italians have used it. That I grant, but not in that
order as we do, for when they mark Tripla of three minims for a stroke

B. (The early thirteenth-century *L*, as a matter of fact, was roughly equal in value to
the sixteenth-century *M*.)

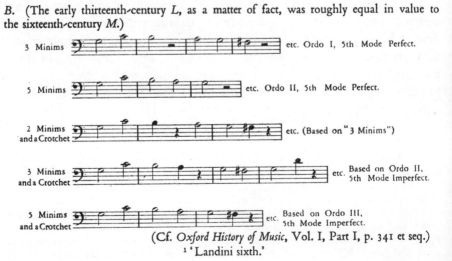

(Cf. *Oxford History of Music*, Vol. I, Part I, p. 341 et seq.)
[1] 'Landini sixth.'

they do most usually set these numbers before it $\frac{3}{2}$, which is the true marking of Sesquialtera, and these three minims are true Sesquialtera itself. But you shall never find in any of their works a minim set down for the time of a black semibreve and a crotchet,[1] or three black minims, which all our composers, both for voices and instruments, do most commonly use. It is true that Zacconi in the second book and 38th chapter of *Practice of Music* doth allow a minim for a stroke in the More Prolation and proveth it out of Palestrina, but that is not when the song is marked with Proportionate numbers but when all the parts have the Less Prolation and one only part hath the More, in which case the part so marked containeth Augmentation, as I said before, and so is every minim of the More Prolation worth a semibreve of the Less.

In the First Part.[2]

But let every one use his discretion; it is enough for me to let you see that I have said nothing without reason, and that it hath been no small toil for me to seek out the authorities of so many famous and excellent men for the confirmation of that which some will think scarce worth the making mention of.

Quadrupla and Quintupla they denominated after the number of black minims set for a note of the plainsong, as in these examples you may see.

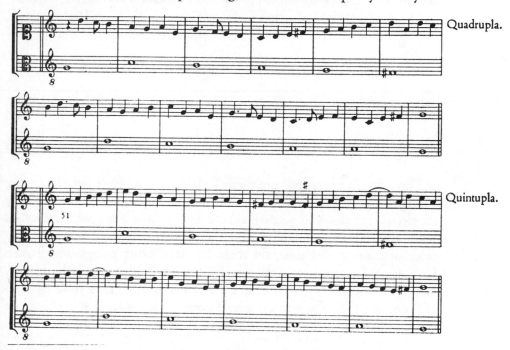

Quadrupla.

Quintupla.

[1] By 'crotchet' M. means a black *M*, for their form was identical. A black *S* in Proportional passages was equal to two black *M* (cf. example on p. 170), which with the 'crotchet' makes three black *M*. Alternatively, if the passage was not Proportional a black *S* = dotted *M*, the succeeding *C* making up the full value (cf. p. 115).

[2] pp. 42, 58, 126.

And so forth, Sextupla, Septupla, and infinite more which it will be superfluous to set down in this place; but if you think you would consider of them also you may find them in my 'Christ's Cross' set down before.

Sesquialtera and Sesquitertia they denominated after the number of black semibreves set for one note of the plainsong, as in these two following.

Sesquialtera.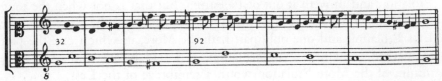

Here they set down certain observations which they termed Inductions, as here you see in the first two bars Sesquialtera perfect, that they called the Induction to nine to two, which is Quadrupla Sesquialtera; in the third bar you have broken Sesquialtera, and the rest to the end is Quadrupla Sesquialtera or, as they termed it, nine to two. And every Proportion whole is called the Induction to that which it maketh being broken, as Tripla being broken in the More Prolation will make Nonupla, and so is Tripla the Induction to Nonupla; or in the Less Prolation will make Sextupla, and so is the Induction to Sextupla. But let this suffice.

It followeth to show you Sesquitertia, whereof here is an example.

Sesquitertia.

There be many other Proportions (whereof you have examples in my 'Christ's Cross' before) which here be not set down, and many you may see elsewhere; also you yourself may devise infinite more which may be both artificial and delightful and therefore I will leave to speak any more of them at this time, for there be many other things which men have devised upon these ways which, if one would particularly deduce, he might write all his life time and never make an end, as John Spataro of Bologna did,[1] who wrote a whole great book containing nothing else but the manner of singing Sesquialtera Proportion.[2]

[1] Giovanni Spataro (c. 1458–1541). *Tractato di musica di Giovanni Spataro musico bolognese nel quale si tracta de la perfectione sesquialtera producta in la musica mensurata exercitate* (1531).

[2] This is not entirely correct, for Spataro's book was an attack on Gafurius's ratios of the consonants and the form of some of the note values; hence Sesquialtera meant both Proportion and Ratio, i.e. the interval of the fifth.

But to return to our interrupted purpose of making more parts than one upon a plainsong, take any of the ways of Bass descant which you made and make another part which may serve for a treble to it above the plainsong, being true to both. Two parts upon a plainsong.

PHI. Yours be better and more formal than mine and therefore I will take one of yours.

MA. If you list do so.

PHI. Here is a way which I think is true.

MA. This is much, and so much as one shall hardly find any other way to be sung in this manner upon this ground, for I can see but one other way besides that, which is this:

But I did not mean that you should have made your treble in counterpoint but in descant manner as your Bass descant was, thus:

PHI. I did not conceive your meaning till now that you have explained it by an example, and therefore I will see what I can do to counterfeit it, although in my opinion it be hard to make.

MA. It is no hard matter, for you are not tied when your bass singeth
a semibreve (or any other note) to sing one of the same length, but you
may break your notes at your pleasure and sing what you list, so it be in
true chords to the other two parts, but especially fifths and thirds inter-
mingled with sixths, which of all other be the sweetest and most fit for
three parts; for in four or five parts you must have more scope because
there be more parts to be supplied and therefore the octave must of force
be the oftener used.

PHI. Well then, here is a way; correct it and show me the faults,
I pray you.

MA. This is well. But why did you stand so long before the close?

PHI. Because I saw none other way to come to it.

Hanging in MA. Yet there is shift enough; but why did you stand still with your
the close last note also seeing there was no necessity in that? For it had been
condemned. much better to have come down and closed in the third for that it is
Many per- tedious to close with so many perfect chords together, and not so good
fect chords in the air. But here is another example which I pray you mark and
together con- confer with my last going before, whereby you may learn to have some
demned. meaning in your parts to make them answer in imitation; for if you
examine well mine other going before you shall see how the beginning
of the treble leadeth the bass, and how in the third note the bass leadeth
the treble in the fourth note, and how the beginning of the ninth note
of the bass leadeth the treble in the same note and next following.

PHI. I perceive all that, and now will I examine this which you have
set down.

In your treble you follow the imitation of the plainsong; but I pray you what reason moved you to take a discord for the first part of your fourth note (which is the second of the treble) and then to take a sharp for the latter half, your note being flat?[1]

MA. As for the discord it is taken in binding manner, and as for the sharp in the bass for the flat in the treble, the bass being a cadence the nature thereof requireth a sharp, and let your ears (or whosoever else) be judge, sing it, and you will like the sharp much better than the flat in my opinion; yet this you must mark by the way, that though this be good in half a note (as here you see) yet is it intolerable in whole semibreves.

In what manner a sharp for a flat is allowable in the fifth.

PHI. This observation is necessary to be known; but as for the rest of your lesson I see how one part leadeth after another, therefore I will set down a way which I pray you censure.

MA. I do not use when I find any faults in your lessons to leave them untold, and therefore that protestation is needless.

PHI. Then here it is; peruse it.

MA. In this lesson, in the very beginning, I greatly mislike that rising from the fourth to the fifth between the plainsong and the treble; although they be both true to the bass yet you must have a regard that the parts be formal betwixt themselves as well as to the bass. Next, your standing in one place two whole semibreves together, that is in the latter end of the third note, all the fourth and half of the fifth. Thirdly, your causing the treble strike a sharp octave to the bass, which is a fault much offending the ear though not so much in sight, therefore hereafter take heed of ever touching a sharp octave except it be naturally in E la mi or B fa b mi (for these sharps in F fa ut, C sol fa ut and such like be wrested out of their properties, although they be true and may be suffered yet would I wish you to shun them as much as you may for that it is not altogether so pleasing in the ear as that which cometh in his

Going up from the fourth to the fifth, both parts ascending, condemned.

Long standing in a place condemned.

A sharp octave disallowed.

[1] i.e. the suspension in the second bar in which the bass resolves on to F♯, making a diminished fifth with the soprano C♮ ('flat').

[2] C resolution. [3] M. gives G.

own nature [1]), or at a close betwixt two middle parts, and seldom so. Fourthly, your going from F fa ut [sharp] to B fa b mi [sharp] in the eighth note, in which fault you have been now thrice taken.[2] Lastly your old fault, standing so long before the close. All these be gross faults; but here is your own way altered in those places which I told you did mislike me and which you yourself might have made much better if you had been attentive to your matter in hand; but such is the nature of you scholars that so you do much you care not how it be done, though it be better to make one point well than twenty naughty ones needing correction almost in every place.

(marginal notes:) g from it sharp fa b mi llowed.

PHI. You blamed my beginning yet have you altered it nothing saving that you have set it eight notes higher than it was before.

MA. I have indeed reserved your beginning to let you see that by altering but half a note in the plainsong it might have been made true as I have set it down.

PHI. What, may you alter the plainsong so at your pleasure?

MA. You may break the plainsong at your pleasure (as you shall know hereafter [3]) but in this place I altered that note because I would not dissolve your point which was good with the bass.

(marginal notes:) tter to k the song ssolve ooint.

PHI. But upon what considerations and in what order may you break the plainsong?

MA. It would be out of purpose to dispute that matter in this place but you shall know it afterward at full, when I shall set you down a rule of breaking any plainsong whatsoever.

PHI. I will then cease at this time to be more inquisitive thereof, but

[1] This is pure pedantry, for F♯ sounds exactly the same when it is the leading note of G as E does in F; what is important is whether it is the leading note at the place where it is doubled or only the major third of the chord; in the latter instance doubling was fairly common (cf. p. 226); here the F♯ is clearly the leading note of G and hence doubling should be avoided.

[2] This is incorrect, as on the two previous occasions Phi. wrote F♮ to B (cf. pp. 144 and 164). M. is possibly also thinking of the diminished fifth progressions on pp. 161 and 167 (third example), though he makes no comment at the time.

[3] Cf. p. 178.

I will see if I can make another way which may content you, seeing my last proved so bad; but now that I see it I think it impossible to find another way upon this bass, answering in imitation.

MA. No? Here is one wherein you have the point reverted.

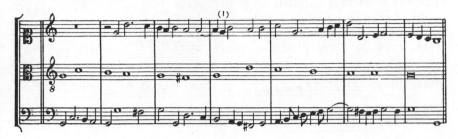

But in the end of the twelfth note I have set down a kind of closing (because of yourself you could not have discerned it) from which I would have you altogether abstain, for it is an unpleasant harsh music; and though it hath much pleased divers of our descanters in times past and been received as current amongst others of later time, yet hath it ever been condemned of the most skilful here in England [2] and scoffed at amongst strangers, for, as they say, there can be nothing falser, and their opinion seemeth to me to be grounded upon good reason however it contenteth others.

Meeting of the flat and sharp octave condemned.

It followeth now to speak of two parts in one.

PHI. What do you term 'two parts in one'?

MA. It is when two parts are so made as one singeth every note and rest in the same length and order which the leading part did sing before. But because I promised you to set down a way of breaking the plainsong, before I come to speak of two parts in one I will give you an example out of the works of Mr. Parsley [3] wherewith we will content ourselves at this present, because it had been a thing very tedious to have set down so many examples of this matter as are everywhere to be found in the works of Mr. Redford, Mr. Tallis, Preston, Hodges, Thorne, Selbye, [4] and divers others, where you shall find such variety of breaking of plainsongs as one not very well skilled in music should scant discern any plainsong at all, whereby you may learn to break any plainsong whatsoever.

Definition of two parts in one.

PHI. What general rules have you for that?

[1] C-resolution.

[2] This is not strictly true, for Byrd himself wrote many similar passages, e.g. *Cantiones Sacrae* (1575)), p. 223, b. 6, etc. (cf. pp. 54 and 272).

[3] Osbert Parsley (1511–85).

[4] John Thorne (*d.* 1573), William Selbye (Shelbye) (first half of the sixteenth century), Thomas Preston (late fifteenth or early sixteenth century), Hodges (organist of Hereford Cathedral, early sixteenth century).

MA. One rule, which is ever to keep the substance of the note of the plainsong.

PHI. What do you call keeping the substance of a note?

MA. When, in breaking it, you sing either your first or last note in the same key wherein it standeth, or in his octave.

PHI. I pray you explain that by an example.

MA. Here be three plainsong notes, ♩♩♩, which you may

break thus: ♩♩♩ ; thus: ♩♩♩ ;

or thus: ♩♩♩ ; and infinite more ways which you may

devise to fit your canon, for these I have only set down to show you what the keeping the substance of your note is.

PHI. I understand your meaning, and therefore I pray you set down that example which you promised.

MA. Here it is, set down in partition because you should the more easily perceive the conveyance of the parts.

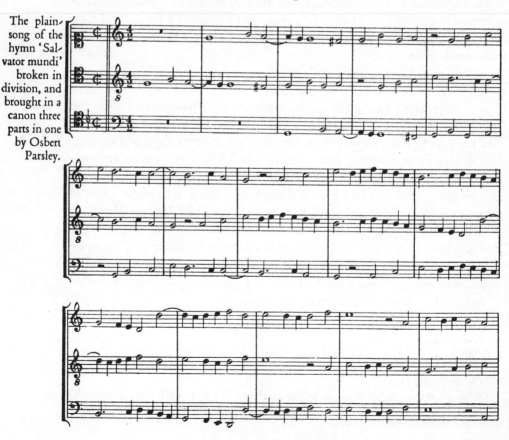

The plainsong of the hymn 'Salvator mundi' broken in division, and brought in a canon three parts in one by Osbert Parsley.

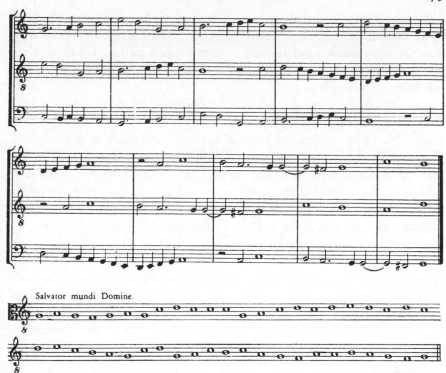

Salvator mundi Domine.

I have likewise set down the plainsong that you may perceive the breaking of every note and not that you should sing it for a part with the rest, for the rest are made out of it and not upon it. And as concerning the descanting, although I cannot commend it for the best to the ear yet is it praiseworthy; and though in some places it be harsh to the ear yet is it more tolerable in this way than in two parts in one upon a plainsong, because that upon a plainsong there is more shift than in this kind.[1]

 PHI. I perceive that this example will serve me to more purpose here-after (if I shall come to try masteries) than at this time to learn descant, therefore I will pass it and pray you to go forward with your begun purpose of two parts in one, the definition whereof I have had before.

 MA. Then it followeth to declare the kinds thereof, which we distin-guish no other ways than by the distance of the first note of the following part from the first of the leading which, if it be a fourth, the song or canon is called 'two parts in one in the fourth'; if a fifth, 'in the fifth,' and so forth in other distances. But if the canon be in the octave of these as in the tenth, twelfth, or so, then commonly is the plainsong in the middle betwixt the leading and following part; yet is not that rule so general

Great masteries upon a plainsong not the sweetest music.

[1] i.e. there is more scope ('shift') in writing a two-part canon above a S CF ('plain-song') than in a three-part canon like the Parsley example, and hence discords which are tolerable in the latter because of its greater difficulty are not permissible in the former.

but that you may set the plainsong either above or below at your pleasure. And because he who can perfectly make two parts upon a plainsong may the more easily bind himself to a rule when he list, I will only set you down an example of the most usual ways, that you may by yourself put them in practice.

PHI. What, be there no rules to be observed in the making of two parts in one upon a plainsong?

MA. No verily, in that the form of making the canons is so many and divers ways altered that no general rule may be gathered; yet in the *A note for* making of two parts in one in the fourth, if you would have your following *two parts* part in the way of counterpoint to follow within one note after the other, *in one in* you must not ascend two nor descend three;[1] but if you descend two *the fourth.* and ascend three it will be well, as in this example (which because you should the better conceive I have set down both plain and divided) you may see. This way some term a canon[2] in epidiatessaron, that is in the fourth above, but if the leading part were highest then would they call it in hypodiatessaron, which is the fourth beneath; and so likewise in the other distances, diapente (which is the fifth) and diapason (which is the octave).

Thus plain.

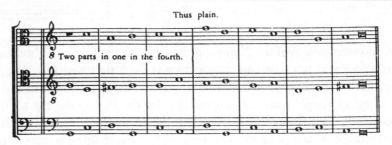

Thus divided.

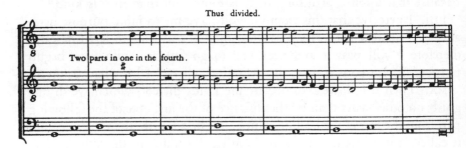

And by the contrary, in two parts in one in the fifth you may go as

[1] 'One note after' means 'one semibreve after.' If the first part begins C–E in *S* the second part enters on F, which clashes with the E. If the first part descends C–G the F entry of the second part will also clash. These rules only apply, of course, if the second part enters in the fourth *above*.

[2] M. has 'fugue.'

many down together as you will but not up;[1] and generally or most commonly that which was true in two parts in one in the fourth the contrary will be true in two parts in one in the fifth, an example whereof you have in this canon following, wherein also I have broken the plain-song of purpose and caused it to answer in imitation as a third part to the others, so that you may at your pleasure sing it broken or whole for both the ways.

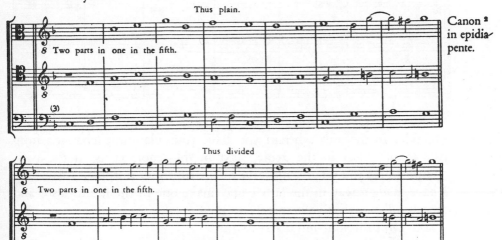

Thus plain.

Two parts in one in the fifth.

Canon[2] in epidiapente.

Thus divided

Two parts in one in the fifth.

PHI. I pray you (if I may be so bold as to interrupt your purpose)[4] that you will let me try what I could do to make two parts in one in the fifth in counterpoint.

MA. I am contented, for by making of that you shall prepare yourself to the better making of the rest.

PHI. Here is then a way, I pray peruse it; but I fear me you will condemn it because I have caused the treble part to lead, which in your example is contrary.

Canon[2] in hypodiapente.

[1] A very vague sentence, for although the leading part can descend more intervals than it can ascend (second, fourth, sixth, as opposed to third and fifth) without clashing with the first note of the following part, this is hardly going 'as many down together as you will.' Here again M. is referring to a canon in the fifth *above*.

[2] M. has 'fugue.' [3] No ♭ in the signature in M. [4] cf. p. 182.

MA. It is not material which part lead except you were enjoined to the contrary, and seeing you have done this so well plain let me see how you can divide it.

PHI. Thus, and I pray you peruse it that I may hear your opinion of it.

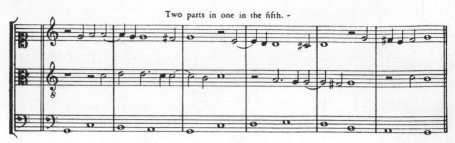

Two parts in one in the fifth.

MA. This is well broken. And now I will give you some other examples in the fifth wherein you have your plainsong changed from part to part, first in the treble, next in the tenor, lastly in the bass.

PHI. I pray you yet give me leave to interrupt your purpose,[1] that seeing I have made a way in the fifth I may make one in the fourth also, and then I will interrupt your speech no more.

MA. Do so if your mind serve you.

PHI. Here it is in descant wise without counterpoint, for I thought it too much trouble first to make it plain and then break it.

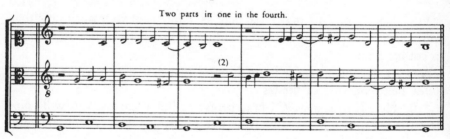

Two parts in one in the fourth.

(2)

MA. This way is so well as I perceive no sensible fault in it.

PHI. I am the better contented, and therefore (if you please) you may proceed to those ways which you would have set down before.

MA. Here they be. As for the other ways, because they be done by plainsight without rule I will set them down without speaking any more of them; only this, by the way, you must note, that if your canon be in the fourth and the lower part lead, if you sing the leading part an octave higher your canon will be in hypodiapente, which is the fifth below; and by the contrary, if your canon be in the fifth the lower part leading, if you sing the leading part an octave higher your canon will be in hypodia‚ tessaron, or in the fourth below.

[1] Fr. *propos*=‘discourse.’ [2] M. has overlooked these consecutive octaves (cf. p. 156).

Two parts in one in the fifth, the plainsong in the treble.

Another example in the fifth, the plainsong in the middlest.

Another example of two parts in one in the fifth, the plainsong in the bass.

Two parts in one in the sixth. (1)

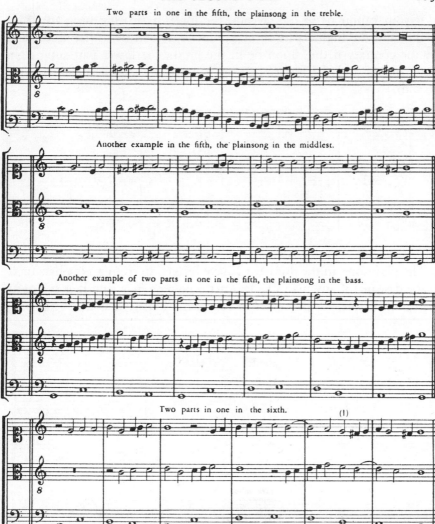

This way in the sixth, if you sing the lower part eight notes higher and the higher part eight notes lower, will be in the third or tenth; and by the contrary, if the canon be in the tenth, if you sing the lower part eight notes higher and the higher part eight notes lower, then will your canon be in the sixth, either above or below according as the leading part shall be.

Two parts in one in the seventh. (2) (3)

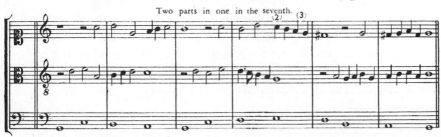

[1] Unprepared accented $\frac{6}{4}$.
[2] M. has overlooked the difference between the soprano and tenor parts.
[3] Cf. p. 167, footnote 1.

If your canon be in the seventh, the lower part being sung an octave
higher and the higher part an octave lower, it will be in the ninth; and
by the contrary if the canon be in the ninth, the lower part sung eight
notes higher and the higher part eight notes lower will make it in the
seventh.

Two parts in one in the octave.

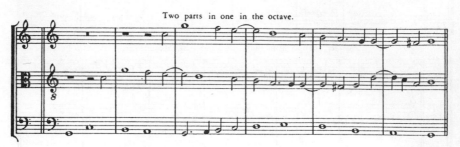

The plainsong in the third bar I have broken to shun a little harshness
in the descant; if any man like it better whole he may sing it as it was in
the canon before, for though it be somewhat harsh yet is it sufferable.

Two parts in one in the ninth.

Two parts in one in the tenth.

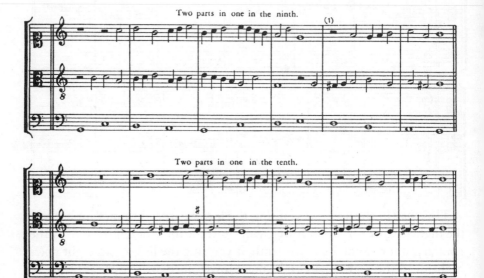

Here is also another way in the tenth which the masters call 'per arsin
& thesin,' that is 'by rising and falling,' for when the higher part ascendeth
the lower part descendeth, and when the lower part ascendeth the higher
part descendeth. And though I have here set it down in the tenth yet
may it be made in any other distance you please.

[1] This rest is omitted in M.

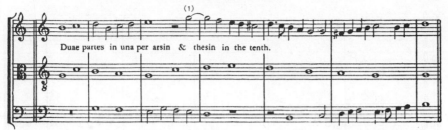

Duae partes in una per arsin & thesin in the tenth.

And because we are come to speak of two parts in one upon a plain-
song 'per arsin & thesin' I thought good to set down a way made by
Mr. Byrd,[2] which for difficulty in the composition is not inferior to any
which I have seen, for it is both made 'per arsin & thesin' and likewise
the point or canon [3] is reverted note for note, which thing how hard it
is to perform upon a plainsong none can perfectly know but he who hath
or shall go about to do the like. And to speak uprightly I take the
plainsong to be made with the descant for the more easy effecting of his
purpose. But in my opinion whosoever shall go about to make such
another upon any common known plainsong or hymn shall find more
difficulty than he looked for; and although he should essay twenty
several hymns or plainsongs for finding of one to his purpose I doubt
if he should any way go beyond the excellency of the composition of
this, and therefore I have set it down in partition.

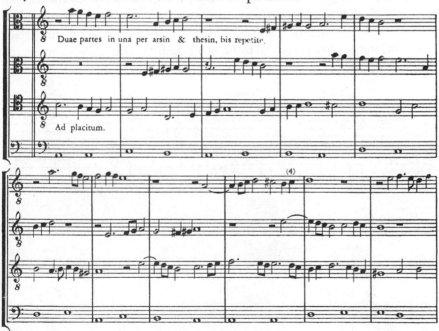

Duae partes in una per arsin & thesin, bis repetite.

Ad placitum.

<hr />

[1] M. does not give this tie, but see the bass part following.
[2] William Byrd (1542/3–1623). *Cantiones, Quae ab Argumento Sacrae Vocantur*(1575); *Psalms,
Sonnets, and Songs* (1588); *Songs of Sundry Natures* (1589); *Cantiones Sacrae*, Book I (1589),
Book II (1591). [3] M. has 'fugue.' [4] Simultaneous false relation.

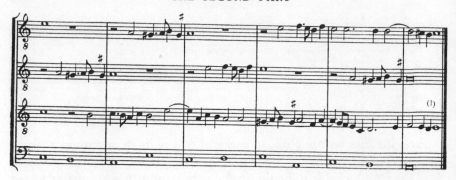

And thus much for canons of two parts in one, which though I have
set down at length in two several parts yet are they most commonly
pricked both in one, and here in England (for the most part) without
any sign at all where and when to begin the following part, which use
many times caused divers good musicians sit a whole day to find out the
following part of a canon, which being found (it might be) was scant
worth the hearing. But the Frenchmen and Italians have used a way
that though there were four or five parts in one, yet might it be perceived
A com- and sung at the first, and the manner thereof is this: of how many parts
pendious way the canon is so many clefs do they set at the beginning of the stave, still
of pricking causing that which standeth nearest unto the music serve for the leading
of canons. part, the next towards the left hand for the next following part, and so
consequently to the last. But if between any two clefs you find rests,
those belong to that part which the clef standing next unto them on the
left side signifieth.[2]

Example.

[1] M. gives B.
[2] Resolution:

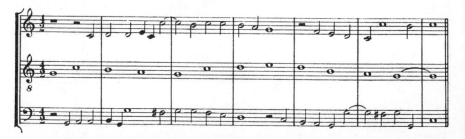

Here be two parts in the 'diapente cum diatessaron' or (as we term it) in the eleventh above, where you see first a C sol fa ut clef standing on the lowest line, and after it three minim rests. Then standeth the F fa ut clef on the fourth line from below, and because that standeth nearest to the notes the bass (which that clef representeth) must begin, resting a minim rest after the plainsong, and the treble three minim rests. And lest you should miss in reckoning your pauses or rests, the note where⁄ upon the following part must begin is marked with this sign : .⳽. It is true that one of those two, the sign or the rests, is superfluous, but the order of setting more clefs than one to one stave, being but of late devised, was not used when the sign was most common, but instead of them, over or under the song was written in what distance the following part was from the leading, and most commonly in this manner: canon in * or * Superiore or Inferiore;[1] but to shun the labour of writing those words the clefs and rests have been devised, showing the same thing. And to the intent you may the better conceive it, here is another example wherein the treble beginneth and the Mean followeth within a semibreve after in the hypodiapente or fifth below.[2]

And this I thought good to show you, not for any curiosity which is in it but for the easiness and commodity which it hath, because it is better than to prick so as to make one sit five or six hours beating his brains to find out the following part. But such hath been our manner in many other things heretofore, to do things blindly and to trouble the wits of practitioners, whereas by the contrary strangers have put all their care how to make things plain and easily understood. But of this enough.

[1] The asterisks denote where the interval of the canon should be inserted.

[2] Resolution. The last five notes should be ♩ ♪ ♪ ♩ ▯ in the original.

Double counterpoint.

There is also a manner of composition used amongst the Italians which they call 'Contrapunto doppio' or 'double counterpoint,' [1] and though it be no canon yet is it very near the nature of a canon, and therefore I thought it meetest to be handled in this place; and it is no other thing but a certain kind of composition which being sung after divers sorts by changing the parts, maketh divers manners of harmony, and is found to be of two sorts.

Division of double counterpoint.

The first is when the Principal (that is the thing as it is first made) and the Reply (that is it which the Principal, having the parts changed, doth make) are sung, changing the parts in such manner as the highest part may be made the lowest and the lowest part the highest, without any change of motion, that is, if they went upward at the first they go also upward when they are changed, and if they went downward at the first they go likewise downward being changed. And this is likewise of two sorts, for if they have the same motions, being changed they either keep the same names of the notes which were before, or alter them. If they keep the same names the Reply singeth the high part of the Principal a fifth lower and the lower part an octave higher; [2] and if it alter the names of the notes the higher part of the Principal is sung in the Reply a tenth lower and the lower part an octave higher. [3]

Rules to be observed in compositions of the first sort of the first kind of double counterpoint.

The second kind of double counterpoint is when the parts changed, the higher in the lower, go by contrary motions, that is if they both ascend before, being changed they descend, or if they descend before, they ascend being changed.

Therefore when we compose in the first manner (which keepeth the same motions and the same names) we may not put in the Principal a sixth because in the Reply it will make a discord; nor may we put the

[1] The examples and rules which follow are based on those in Zarlino's *Istitutioni armoniche*, Book III, chap. lvi (cf. p. 199). M.'s term is 'double descant' here and elsewhere.

[2] Double counterpoint at the twelfth.

[3] Double counterpoint at the seventeenth. By 'names of the notes' M. means Ut, Re, Mi, etc. The notes which are sung an octave higher obviously keep the same names; those that are sung a fifth lower can also be sung to the same names, e.g.:

C sol *fa ut* becomes F *fa ut*
D la *sol re* ,, G *sol re* ut
E *la mi* ,, A *la mi* re
F *fa* ut ,, B *fa* b mi, etc.

The B's in the lower part of the Reply should therefore, presumably, all be sung flat.

When the notes of the Principal are sung a tenth lower the names do not correspond, e.g.:

C sol fa ut becomes A la mi re
D la sol re ,, B fa b mi
E la mi ,, C sol fa ut
F fa ut ,, D la sol re, etc.

parts of the song so far asunder as to pass a twelfth;[1] nor may we ever cause the higher part come under the lower nor the lower above the higher, because both those notes which pass the twelfth and also those which make the lower part come above the higher in the Reply will make discords; we may not also put in the Principal a cadence wherein the seventh is taken because that in the Reply it will not do well;[2] we may very well use the cadence wherein the second or fourth is taken because in the Reply they will cause very good effects;[3] we must not also put in the Principal a flat tenth after which followeth an octave or twelfth (a flat tenth is when the highest note of the tenth is flat, as from D sol re to F fa ut in alt flat,[4] or from Gam ut to B fa b mi flat), nor a flat third before an unison or a fifth when the parts go by contrary motions, because if they be so put in the Principal there will follow 'tritonus' or false fourth in the Reply.[5] Note also that every twelfth in the Principal will be in the Reply an unison, and every fifth an octave. And all these rules must be exactly kept in the Principal else will not the Reply be without faults. Note also that if you will close with a cadence you must of necessity end either your Principal or Reply in the fifth or twelfth, which also happeneth in the cadences in what place soever of the song they be, and between the parts will be heard the relation of a 'tritonus' or false fourth, but that will be a small matter if the rest of the com-position be duly ordered, as you may perceive in this example.

[1] The thirteenth, fourteenth, and fifteenth are discords either in the Principal or the Reply, and a distance of more than two octaves was reckoned too great in a composition of two parts.

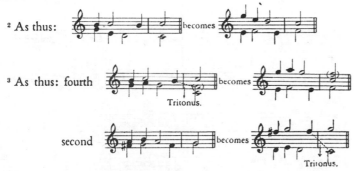

[2] As thus: becomes

[3] As thus: fourth becomes
 Tritonus.

 second becomes
 Tritonus.

[4] F♮.

[5] A flat tenth or third followed by an octave or unison results in a 'tritonus' between the parts in successive notes, which was regarded as harsh in two parts, thus:

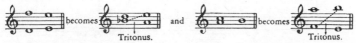

becomes Tritonus. and becomes Tritonus.

but it is not clear why M. bans the twelfth and fifth after the tenth and third, for in the Reply they become a unison and octave respectively.

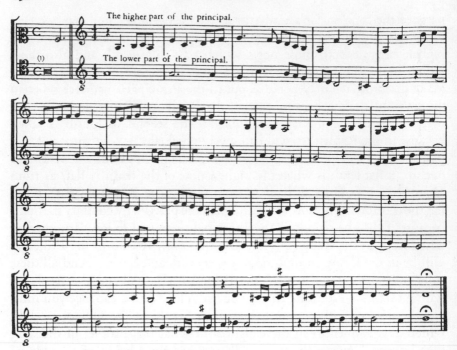

Now change the higher part, making it lower by a fifth, and the lower part higher by an octave, and so shall you have the Reply thus:

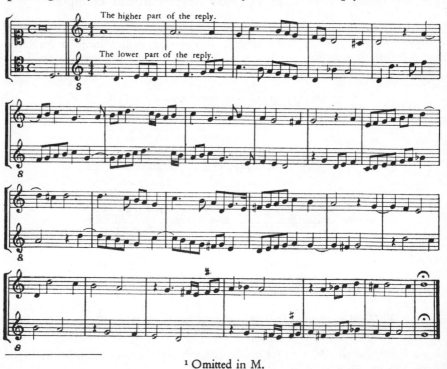

¹ Omitted in M.

And this is called double counterpoint in the twelfth.

But if we would compose in the second kind (that is in it which in the Reply keepeth the same motions but not the same names which were in the Principal) we must not put in any case two chords of one kind together in the Principal, as two thirds or two sixths and such like, although the one be great or sharp and the other small or flat;[1] nor may we put cadences with[2] a discord. The sixth likewise in this kind may be used[3] if (as I said before) you put not two of them together; also, if you list, the parts may one go through another, that is the lower may go above the higher and the higher under the lower, but with this caveat, that when they be so mingled you make them no further distant than a third because that when they remain in their own bounds they may be distant a nineteenth[4] one from another; indeed we might go further asunder but though we did make them so far distant yet might we not in any case put a thirteenth, for it will be false in the Reply,[5] therefore it is best not to pass the twelfth and to keep the rules which I have given, and likewise to cause the music (so far as possibly we may) proceed by degrees and shun that motion of leaping (because that leaping of the fourth and fifth may in some places of the Reply engender a discommodity[6]), which observations being exactly kept will cause our descant go well and formally in this manner:

Caveats for compositions in the second sort of the first kind of double counterpoint.

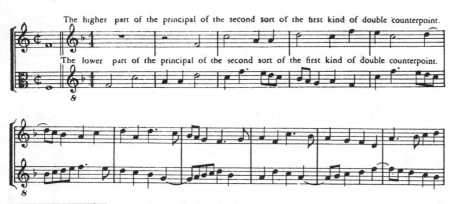

The higher part of the principal of the second sort of the first kind of double counterpoint.

The lower part of the principal of the second sort of the first kind of double counterpoint.

[1] Consecutive octaves and fifths result in the Reply.

[2] M. has 'without,' but this is obviously a misprint as experiment will show; the cadences in his example are all without discords.

[3] This implies that the sixth could be used in the previous kind of double descant, which is incorrect.

[4] M. has 'twelfth.'

[5] This can hardly mean that the high part of the Principal is a thirteenth below the low part, as in the Reply the parts would be three octaves distant. If it means that the high part of the Principal must not be a thirteenth above the low part then in the Reply they will be a fifth apart, which is not 'false.'

[6] e.g. in the high part a leap from A to D or D to A becomes in the Reply F to B or B to F.

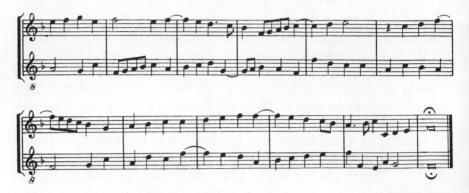

And changing the parts, that is setting the treble lower by a tenth and the lower part higher by an octave, we shall have the Reply thus:

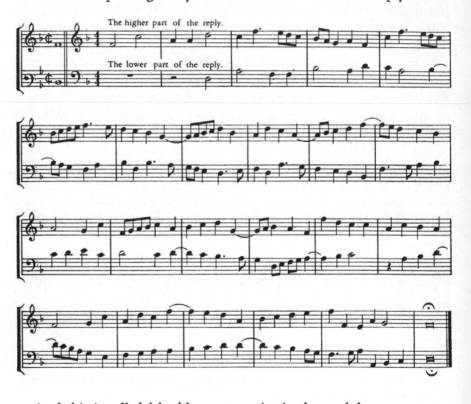

And this is called 'double counterpoint in the tenth.'

You may also make the treble part of the Principal an octave lower and the bass a tenth higher, which will do very well because the nature of the tune will so be better observed as here you may perceive:[1]

[1] In modern terms the tonality is F in this Reply as in the Principal, whereas in the first Reply it has a distinct D minor flavour.

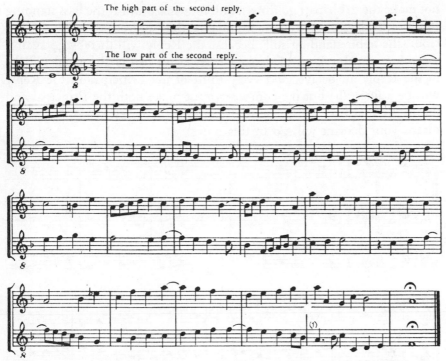

The high part of the second reply.

The low part of the second reply.

Also these compositions might be sung of three voices if you sing a part a tenth above the low part of the Principal, and in the Reply a seventeenth [2] under the high part.[3] It is true that the descant will not be so pure as it ought to be, and though it will be true from false descant yet will there be unisons and other allowances which in other music would scarce be sufferable. But because it is somewhat hard to compose in this kind and to have it come well in the Reply I will set you down the principal rules how to do it, leaving the less necessary observations to your own study.

You must not then, in any case, put a third or a tenth after an octave when the parts of the song descend together, and when the parts ascend you must not put a sixth after a fifth nor a tenth after a twelfth,[4] especially when the high part doth not proceed by degrees, which motion is a little more tolerable than that which is made by leaping. Likewise you must not go from an octave to a flat tenth, except when the high part moveth by a whole note and the lower part by a half note, nor yet from a third or fifth to a flat tenth by contrary motions. [5] Also you shall

Rules for singing a third part to other two in double counterpoint.

[1] M. has B♭.
[2] M. has 'seventh,' which is obviously incorrect, as his example shows.
[3] Or a tenth lower than its original pitch.
[4] All these produce octaves or fifths, approached by similar motion.
[5] Third to tenth gives consecutive octaves; fifth to tenth gives an octave approached by a major sixth, condemned by M. on p. 163.

not make the treble part go from a fifth to a sharp third (the bass standing
still) nor the bass to go from a fifth to a flat third or from a twelfth to a flat
tenth (the treble standing still) because the Reply will thereby go against
the rule.[1] In this kind of descant every tenth of the Principal will be
in the Reply an octave, and every third of the Principal in the Reply
will be a fifteenth; but the composer must make both the Principal and
the Reply together, and so he shall commit the fewest errors, by which
means your descant will go in this order:

By negligence
of not think-
ing upon a
third part
in the
composition
of the
Principal the
fault of too
much dis-
tance in the
Reply was
committed,
which other-
wise might
easily have
been avoided
and the
example
brought in
less compass.

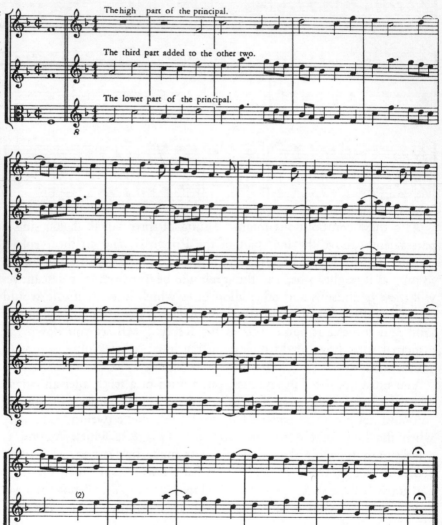

[1] These intervals all produce false relations in the Reply.
[2] M. has overlooked this.

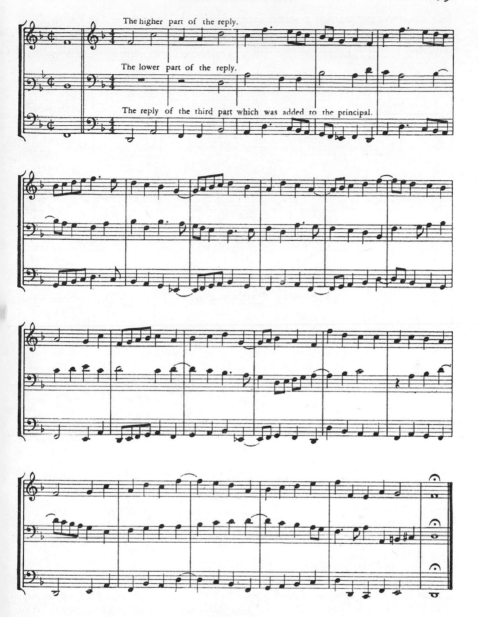

In the second kind of double counterpoint where the Reply hath contrary motions to those which were in the Principal, keeping in the parts the same distances, if you put any cadences in the Principal they must be without any discord, and then may you put them in what manner you list, but if they have any dissonance, in the Reply they will produce hard effects.[1] In this you may use the sixth in the Principal,

Notes to be observed in the second kind of double counterpoint.

[1] The discord will resolve upwards in the Reply.

H

but in any case set not a tenth immediately before an octave nor a third
before an unison when the parts descend together, because it will be
naught;[1] but observing the rules your descant will go well in this
manner:

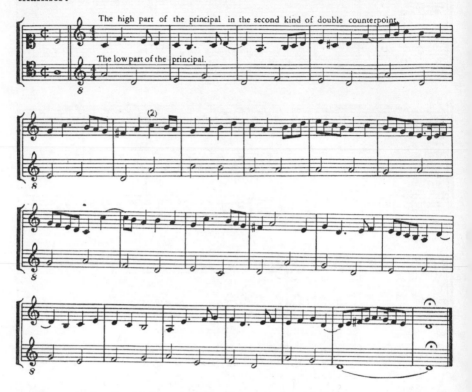

If you make the high part lower by a ninth and the low part higher by
a seventh you shall have the Reply thus:[3]

[1] In the Reply these become an octave and a fifteenth approached by a sixth and a
thirteenth respectively in similar motion, a progression to which M. has already objected
on p. 163.

[2] Diminished fifth progression.

[3] M. does not state which note in the Principal the inverted intervals are based on, but
actually it is found to be A, second space up (treble clef) for the high part, and top line
(bass clef) for the low part. In the inversion 'per arsin & thesin' given on p. 185, A is
again the governing note, though why this should be so in either case is not clear. The
following scales show how the notes of the inversion are obtained from the Principal, for
if the top scale represents the high part of the Principal then the bass scale gives the inversion
in the low part of the Reply; and if the bottom scale represents the low part of the Principal,
the treble scale gives the inversion in the high part of the Reply.

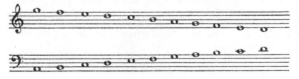

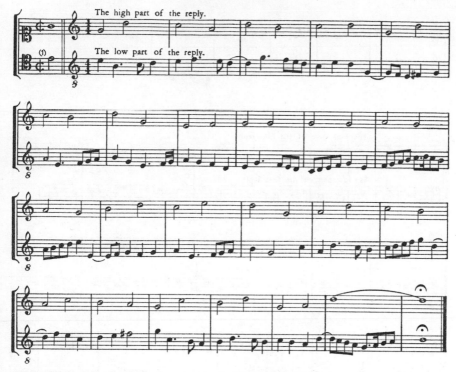

And if you compose in this manner the parts of the Principal may be set in what distance you will, yea though it were a fifteenth, because in the Reply it will do well; but yet ought we not to do so.[2] Likewise if you examine well the rules given before and have a care to leave out some things which in some of the former ways may be taken, you may make a composition in such sort as it may be sung all the three before-said ways with great variety of harmony, as in this Principal and Replies following you may perceive.

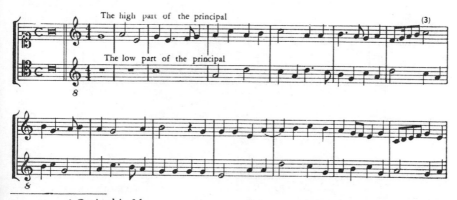

[1] Omitted in M.

[2] Because in the Reply the parts will be overlapping continuously.

[3] M. gives two *M* instead of one *S* (as in the Reply).

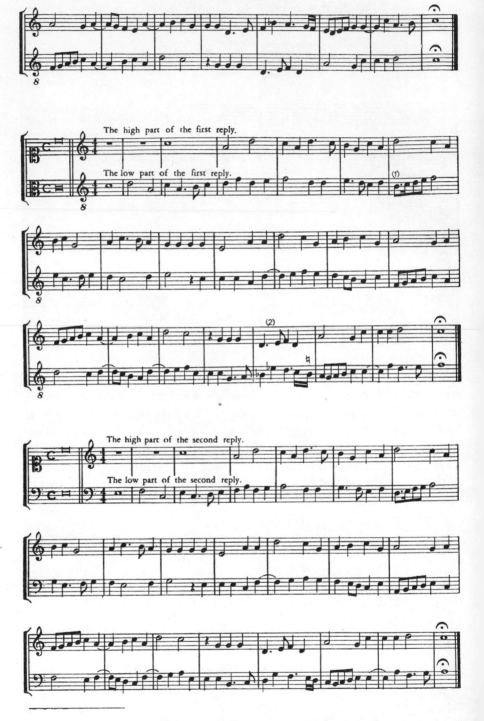

The high part of the first reply.

The low part of the first reply.

The high part of the second reply.

The low part of the second reply.

<hr>

¹ M. gives four C. The B should probably be flattened.
² M. has evidently overlooked this passage.

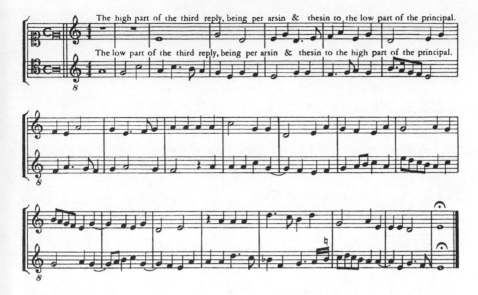

The high part of the third reply, being per arsin & thesin to the low part of the principal.

The low part of the third reply, being per arsin & thesin to the high part of the principal.

And that you may the more clearly perceive the great variety of this kind, if you join to the low part of the Principal or of the third Reply a high part distant from it a tenth or third, or if you make the low part higher by an octave and put to [it] a part lower than the high part by a tenth (because it will come better), every one of those ways may, by themselves, be sung of three voices, as you saw before in the example of the second way of the first kind of double counterpoint.[1]

There be also, besides those which I have shown you, many other ways of double counterpoint which it were too long and tedious to set down in this place, and you yourself may hereafter by your own study find out, therefore I will only let you see one way 'per arsin & thesin,' and so an end of double counterpoint.

If, therefore, you make a canon 'per arsin & thesin' without any discord in binding manner in it you shall have a composition in such

[1] The foregoing examples differ in some respects from those in Zarlino, as the following summary of the Replies will show:

	Z.			M.	
H.P. down fifth.	L.P. no change		H.P. down fifth.	L.P. up octave	
H.P. „ twelfth.	L.P. up sixth		H.P. „ octave.	L.P. „ tenth	
H.P. „ tenth.	L.P. „ octave		H.P. „ tenth.	L.P. „ octave	
H.P. „ ninth.	L.P. „ seventh (inversion)		H.P. „ ninth.	L.P. „ seventh (inversion)	
H.P. „ fifth.	L.P. „ octave (third part up tenth)		H.P. „ tenth.	L.P. „ octave (third part down nineteenth)	

The governing note is A in both the inversions.

sort as it may have a Reply wherein that which in the Principal was the
following part may be the leading, as here you see in this example:[1]

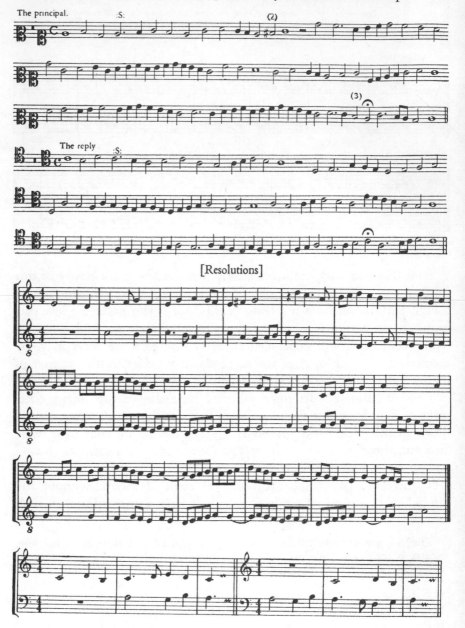

[Resolutions]

[1] There are four solutions to this canon, but only the two most satisfactory are fully
shown. The other two (of which only the initial bars are given) involve leaps of diminished
fifths and augmented fourths, and are interesting only in that they show the licence allowed
in such 'exercises.'

[2] This sharp only applies when the note is F.

[3] M. places this sign over the next note.

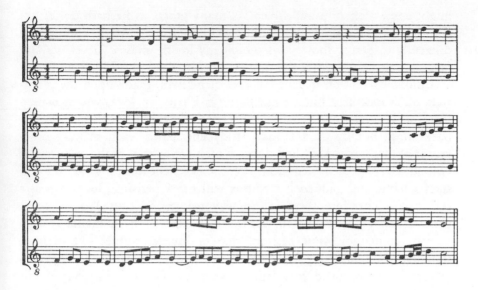

Thus you see that these ways of double counterpoint carry some difficulty and that the hardest of them all is the canon. But if the canon were made in that manner upon a plainsong (I mean a plainsong not made of purpose for the descant but a common plainsong or hymn such as heretofore have been used in churches) it would be much harder to do. But because these ways seem rather for curiosity than for your present in‑ struction I would counsel you to leave to practise them till you be perfect in your descant and in those plain ways of canon which I have set down, which will, as it were, lead you by the hand to a further knowledge; and when you can at the first sight sing two parts in one in those kinds upon a plainsong, then may you practise other hard ways, and specially those ' per arsin & thesin,' which of all other canons carry both most difficulty and most majesty, so that I think that whoso can, upon any plainsong whatsoever, make such another way as that of Mr. Byrd (which I showed you before) may with great reason be termed a great master in music; but whosoever can sing such a one at the first sight upon a ground may boldly undertake to make any canon which in music may be made; and for your further encouragement this much I may boldly affirm, that whosoever will exercise himself diligently in that kind may, in short time, become an excellent musician, because that he who in it is perfect may almost at the first sight see what may be done upon any plainsong.

And these few ways which you have already seen shall be sufficient at this time for your present instruction in two parts in one upon a plainsong, for if a man should think to set down every way and do nothing all his lifetime but daily invent variety he should lose his labour, for any other

might come after him and invent as many others as he hath done; but if you think to employ any time in making of those I would counsel you diligently to peruse those ways which my loving master (never without reverence to be named of the musicians) Mr. Byrd and Mr. Alfonso, in a virtuous contention in love betwixt themselves, made upon the plain, song of 'Miserere'; [1] but a contention (as I said) in love, which caused them strive every one to surmount another without malice, envy, or backbiting, but by great labour, study and pains, each making other censor of that which they had done; which contention of theirs (specially without envy) caused them both become excellent in that kind and win such a name and gain such credit as will never perish so long as music endureth. Therefore there is no way readier to cause you become perfect than to contend with someone or other, not in malice (for so is your contention your passion, not for love of virtue) but in love, showing your adversary your work and not scorning to be corrected of him, and to amend your fault if he speak with reason. But of this enough.

To return to Mr. Byrd and Mr. Alfonso, though either of them made to the number of forty ways and could have made infinite more at their pleasure, yet hath one man, my friend and fellow, Mr. George Water, house,[2] upon the same plainsong of 'Miserere' for variety surpassed all who ever laboured in that kind of study, for he hath already made a thousand ways (yea, and though I should talk of half as many more I should not be far wide of the truth) every one different and several from another; but because I do hope very shortly that the same shall be pub, lished for the benefit of the world and his own perpetual glory I will cease to speak any more of them, but only to admonish you that whoso will be excellent must both spend much time in practice and look over the doings of other men.[3] And as for those who stand so much in opinion of their own sufficiency as in respect of themselves they condemn all other men I will leave them to their foolish opinions, being assured that every man but of mean discretion will laugh them to scorn as fools imagining that all the gifts of God should die in themselves if they should be taken out of the world.

And as for four parts in two, six in three, and such like, you may hereafter make them upon a plainsong when you shall have learned to make them without it.

[1] Published by East in 1603 under the title *Medulla Musicke*. No copy is extant. John Farmer also published, in 1591, a book containing forty examples of two parts in one upon one plainsong.

[2] George Waterhouse (*d.* 1602).

[3] There are 1163 strict canons on the 'Miserere' plainsong in the manuscripts at Oxford and Cambridge (cf. p. 307).

PHI. I will then take my leave of you for this time till my next leisure, at which time I mean to learn of you that part of music which resteth. And now, because I think myself nothing inferior in knowledge to my brother, I mean to bring him with me to learn that which he hath not yet heard.

MA. At your pleasure; but I cannot cease to pray you diligently to practise, for that only is sufficient to make a perfect musician.

*H

ANNOTATIONS

Page 140, line 32: ' The name of Descant.'

This part is the second member of our division of practical music, which may be properly termed syntactical, poetical, or effective;[1] and though I dare not affirm that this part was in use with the musicians of the learned age of Ptolemaeus[2] or yet of that of Boethius, yet may I with some reason say that it is more ancient than prick song, and only by reason of the name, which is 'contrapunto,' an Italian word devised since the Goths did overrun Italy and changed the Latin tongue into that barbarism which they now use. As for the word itself it was at that time fit enough to express the thing signified, because (no diversity of notes being used) the musicians instead of notes did set down their music in plain pricks or points; but afterwards that custom being altered by the diversity of forms of notes, yet the name is retained amongst them in the former signification, though amongst us it be restrained from the generality to signify that species or kind which of all others is the most simple and plain, and instead of it we have usurped the name of descant. Also, by continuance of time, that name is also degenerated into another signification, and for it we use the word 'setting' or 'composing.'

But to leave setting and composing and come to the matter which now we are to entreat of, the word 'descant' signifieth, in our tongue, the form of setting together of sundry voices or concords for producing of harmony; and a musician, if he hear a song sung and mislike it, he will say the descant is naught. But in this signification it is seldom used; and the most common signification which it hath is the singing extempore upon a plainsong, in which sense there is none (who hath tasted the first elements of music) but understandeth it.

When descant did begin, by whom and where it was invented is uncertain, for it is a great controversy amongst the learned if it were known to the antiquity or no, and divers do bring arguments to prove and others to disprove the antiquity of it; and for disproving of it they say that in all the works of them who have written of music before Franchinus there is no mention of any more parts than one, and that if any did sing to the harp (which was their most usual instrument) they sung the same which

[1] Cf. p. 101. [2] Claudius Ptolemy (second century A.D.).

they played. But those who would affirm that the ancients knew it say that if they did not know it to what end served all those long and tedious discourses and disputations of the consonants wherein the most part of their works are consumed.[1] But whether they knew it or not this I will say, that they had it not in half that variety wherein we now have it, though we read of much more strange effects of their music than of ours.[2]

Page 141, line 1: Intervals, 'both concords and discords.' [3]

As for the consonants or concords, I do not think that any of those which we call imperfect chords were either in use or acknowledged for consonants in the time of those who professed music before Guido Aretinus or of Guido himself. Boethius, setting down the harmonical proportions and the consonants which arise of them, talketh of quadrupla, tripla, dupla, sesquialtera, and sesquitertia, which make disdiapason, diapente cum diapason, diapason, diapente, and diatessaron, or as we say a fifteenth, a twelfth, an octave, a fifth, and a fourth. But why they should make diatessaron a consonant, seeing it mightily offendeth the ear, I see no reason, except they would make that geometrical rule of parallel lines true in consonants of music—'Quae sunt uni & eidem parallelae, sunt etiam inter se parallelae,' and so make those sounds which to one and the selfsame are consonants to be likewise consonants amongst themselves,[4] i.e. as a fourth plus a fifth make an octave, then because the latter two are consonant (parallel) the fourth must also be consonant. But if any man would ask me a reason why some of those consonants which we use are called perfect and other some imperfect I can give him no reason, except that our age hath termed those consonants perfect which have been in continual use since music began; the others they term imperfect because they leave (in the mind of the skilful hearer) a desire of coming to a perfect chord; and it is a ridiculous reason which some have given that these be imperfect chords because you may not begin nor end upon them; but if one should ask why you may not begin nor end

[1] Those who affirmed that the Greeks knew and used harmony included Gafurius and Zarlino; those who contended the opposite included Glareanus, Salinas, and probably M. himself.

[2] M. is presumably thinking of the extraordinary effects which ancient music was supposed to have exerted on its hearers.

[3] M. inserts the following sentence, which I have omitted as the text is correct as it stands: 'The printer, not conceiving the words "concords" and "discords" to be adjectives, added the word "of," perverting the sense, but if you dash out that word the sense will be perfect.'

[4] Boethius ranked any interval as consonant which has a Multiplex or Superparticular ratio, but he realized that the fourth was in a class of its own, for when it is compounded with an octave (eleventh) its ratio is Superpartient (8 : 3), which he ranked as a dissonance; the ratio of the fifth, however, when so compounded becomes Multiplex (3 : 1). Cassiodorus (d. c. 560), on the other hand, regarded both the fourth and eleventh as consonants.

upon them I see no reason which might be given except this, that they be imperfect chords; so that in mine opinion it is a better reason to say you may not begin nor end upon them because they be imperfect chords than to say that they be imperfect because you may not begin nor end upon them. And if the custom of musicians should suffer it to come in practice to begin and end upon them should they then become perfect chords? No verily, for I can show many songs composed by excellent men, as Orlande de Lassus,[1] Mr. Whyte, and others, which begin upon the sixth; and as for the third, it was never counted any fault either to begin or end upon it, and yet will not any man say that the third is a perfect chord. But if mine opinion might pass for a reason I would say that all sounds contained in habitude of multiplicity or superparticularity were, of the old musicians, esteemed consonants, which was the cause that they made the diatessaron a consonant although it were harsh in the ear;[2] the tonus or whole note is indeed comprehended under superparticular habitude, that is sesquioctave, but it they counted the beginning of consonance and not a consonant itself. The sesquitonus, ditonus, semitonium cum diapente, and tonus cum diapente (that is our flat and sharp thirds and sixths) they did not esteem consonants because they were not in habitude of multiplicity or of superparticularity but under superpartients, the first and second between sesquitertia and sesquiquarta, the third and fourth between sesquialtera and dupla.[3] But of this matter enough in this place; if any desire more of it let him read the third book of Jacobus Faber Stapulensis [4] his *Music,* the second part of Zarlino his *Harmonical Institutions,* and Franchinus his *Harmonia Instrumentorum.*

As for singing upon a plainsong, it hath been in times past in England (as every man knoweth) and is at this day in other places the greatest part of the usual music which in any churches is sung, which indeed causeth me to marvel how men acquainted with music can delight to hear such confusion as of force must be amongst so many singing extempore. But some have stood in an opinion which to me seemeth not very probable, that is that men accustomed to descanting will sing together upon a plainsong without singing either false chords or forbidden descant one

[1] Orlande de Lassus (*c.* 1530–94).

[2] The fifteenth, twelfth, and octave are in multiplicity ratio, the fifth and fourth in superparticularity ratio. The eleventh was theoretically excluded because it is in Multiplex superpartient ratio (8 : 3).

[3] The ratios are as follows: minor third, 32 : 27; major third, 81 : 64; minor sixth, 27 : 16; major sixth, 128 : 81. The order that M. gives is not quite correct, as the following will show: $\frac{32}{27}, \frac{5}{4}, \frac{81}{64}, \frac{4}{3}, \frac{3}{2}, \frac{128}{81}, \frac{27}{16}, \frac{2}{1}$. These ratios are those of Pythagoras.

[4] Jacobus Faber Stapulensis (Jacques Lefèvre d'Éstaples) (*c.* 1455–1536). *Elementa Musicalia* (1496).

to another, which till I see I will ever think impossible, for though they should all be most excellent men and every one of their lessons by itself never so well framed for the ground, yet is it impossible for them to be true one to another except one man should cause all the rest sing the same which he sung before them, and so indeed (if he have studied the canon beforehand) they shall agree without errors, else shall they never do it.[1]

It is also to be understood that when they did sing upon their plain-songs, he who sung the ground would sing it a sixth under the true pitch, and sometimes would break some notes in division, which they did for the more formal coming to their closes; but every close (by the close in this place you must understand the note which served for the last syllable of every verse in their hymns) he must sing in that tune as it standeth, or then in the octave below;[2] and this kind of singing was called in Italy 'Falso bordone,' and in England a 'Fa burden,' whereof here is an example, first the plainsong and then the Fa burden.

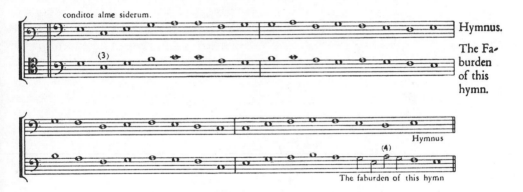

Hymnus.

The Fa-burden of this hymn.

Hymnus

The faburden of this hymn

And though this be pricked a third above the plainsong yet was it always sung under the plainsong.[5]

[1] M. is probably thinking here of a passage in an anonymous tract in the Cotton MS. beginning 'Pro aliquali notitia de musica habenda,' which gives rules for extempore singing on a plainsong at the fifth, eighth, and twelfth (Hawkins, p. 237).

[2] i.e. the 'descanting' voice must sing the same note (or its octave) as the plainsong at the end of each section, as in the example given.

[3] M. has C.

[4] This patently does not fit unless the penultimate D in the plainsong is sung as a B; such lengthening of the penultimate note in the tenor was customary.

[5] This description of Fauxbourdon is a little obscure, and I suggest the following explana-tion. The 'ground' is the added part or 'fa-burden,' and is the lowest part when sung; it is this part which 'breaks some notes in division' at the end of the above example, and is a 'false bass,' in that although 'pricked [written] a third above the plainsong,' it was in fact sung 'a sixth under the true pitch' of the plainsong; hence in the above example the Fa-burden would be sung an octave below its written pitch, making consecutive sixths with the plainsong.

This example is more allied to the continental Fauxbourdon (plainsong in the top part)

Other things handled in this part of the book are of themselves easily to be understood, therefore I will cease to speak any more of them and proceed to the explanation of other things as yet untouched.

than the earlier English Discant (plainsong in middle part), but both types implied three voices. It could also be regarded as a form of inverted Gymel, i.e. plainsong on top but consecutive sixths instead of thirds, a not unknown procedure.

Cf. also the treatise on Fauxbourdon from the Waltham Holy Cross MS., printed in *Speculum*, x, 3, pp. 235–69. Its editor, Sanford B. Meech, has sometimes been misled in his interpretation of the original text.

THE THIRD PART

OF THE

INTRODUCTION TO MUSIC

Treating of Composing or Setting of Songs

PHILOMATHES, THE SCHOLAR POLYMATHES [MASTER]

PHILOMATHES. What new and unaccustomed passion, what strange humour or mind-changing opinion took you this morning, brother Poly-mathes, causing you, without making me acquainted, so early to be gone out of your chamber? Was it some fit of a fever? Or (which I rather believe) was it the sight of some of those fair faces which you spied in your yesternight's walk which have banished all other thoughts out of your mind, causing you think the night long and wish the daylight, that thereby you might find some occasion of seeing your mistress? Or any-thing else? I pray you hide it not from me, for as hitherto I have been the secretary (as you say) of your very thoughts, so if you conceal this I must think that either your affection towards me doth decrease, or else you begin to suspect my secrecy.

POLYMATHES. You are too jealous, for I protest I never hid anything from you concerning either you or myself; and whereas you talk of passions and mind-changing humours those seldom trouble men of my constitu-tion; and as for a fever I know not what it is; and as for love, which you would seem to thrust upon me, I esteem it as a foolish passion entering in empty brains and nourished with idle thoughts, so as of all other things I most condemn it so do I esteem them the greatest fools who be there-with most troubled.

PHI. Soft, brother, you go too far; the purest complexions are soonest infected and the best wits soonest caught in love; and to leave out infinite examples of others, I could set before you those whom you esteemed chiefest in wisdom, Socrates, Plato, Aristotle, and the very dog [1] himself, all snared in love. But this is out of our purpose; show me the occasion of this your timely departure.

POL. I was informed yesternight that Master Polybius did, for his recreation, every morning privately in his own house read a lecture of

[1] The Cynic Diogenes was called 'the dog,' and it is possible that M. was referring to him.

209

Ptolemy his great *Construction*,[1] and remembering that this morning
(thinking the day farther spent than indeed it was) I hied me out, thinking
that if I had stayed for you I should have come short. But to my no small
grief I have learned at his house that he is gone to the university to
commence doctor in medicine.

PHI. I am sorry for that, but we will repair that damage another way.

POL. As how?

PHI. Employing those hours which we would have bestowed in
hearing of him in learning of music.

POL. A good motion, for you have so well profited in so short space
in that art that the world may see that both you have a good master and
a quick conceit.

PHI. If my wit were so quick as my master is skilful I should quickly
become excellent. But the day runneth away; shall we go?

POL. With a good will. What a goodly morning is this, how sweet
is this sunshine, clearing the air and banishing the vapours which
threatened rain.

PHI. You say true, but I fear me I have slept so long that my master
will either be gone about some business or then will be so troubled with
other scholars that we shall hardly have time to learn anything of
him. But in good time, I see him coming from home with a bundle
of papers in his bosom; I will salute him. Good morrow, master.

MA. Scholar Philomathes! God give you good morrow. I mar-
velled that since our last meeting (which was so long ago) I never heard
anything of you.

PHI. The precepts which at that time you gave me were so many and
diverse that they required long time to put them in practice and that hath
been the cause of my so long absence from you. But now I am come
to learn that which resteth and have brought my brother to be my
schoolfellow.

MA. He is heartily welcome. And now will I break off my intended
walk and return to the house with you. But hath your brother proceeded
so far as you have done?

PHI. I pray you ask himself, for I know not what he hath, but before
I knew what descant was I have heard him sing upon a plainsong.

POL. I could have both sung upon a plainsong and began to set three
or four parts, but to no purpose, because I was taken from it by other
studies so that I have forgotten those rules which I had given me for
setting, though I have not altogether forgotten my descant.

MA. Who taught you?

POL. One Master Bold.

[1] *Almagest.*

MA. I have heard much talk of that man, and because I would know the tree by the fruit I pray you let me hear you sing a lesson of descant.

POL. I will if it please you to give me a plainsong.

MA. Here is one; sing upon it.

POL.

PHI. Brother, if your descanting be no better than that you will gain but small credit by it.

POL. I was so taught, and this kind of descanting was by my master allowed and esteemed as the best of all descant.

PHI. Whoever gave him his name hath either foreknown his destiny or then hath well and perfectly read Plato his *Cratylus*.

POL. Why so?

PHI. Because there be such 'bold' taking of allowances as I durst not have taken if I had feared my master's displeasure.

MA. Why, wherein do you disallow them?

PHI. First of all in the second note is taken a discord for the first part of the note, and not in the best manner nor in binding; the like fault is in the fifth note; and as for the two notes before the close, the end of the first is a discord to the ground and the beginning of the next likewise a discord; but I remember when I was practising with you, you did set me a close thus: [2]

Two discords together condemned.

which you did so far condemn as that (as you said) there could not readily be a worse made; and though my brother's be not the very same yet is it cousin german to it, for this descendeth where his ascendeth and his descendeth where this ascendeth, that in effect they be both one.

POL. Do you then find fault with the first part of the second note?

PHI. Yea, and justly.

[1] M.'s printer placed a tie over the previous A–B in error. [2] p. 159, first example.

POL. It is the imitation of the plainsong and the point will excuse the harshness, and so likewise in the fifth note, for so my master taught me.

Harsh chords not to be taken for the point's sake. PHI. But I was taught otherwise, and rather than I would have committed so gross oversight I would have left out the point, although here both the point might have been brought in otherwise and those offences left out.

MA. I pray you good Master Polymathes, sing another lesson.

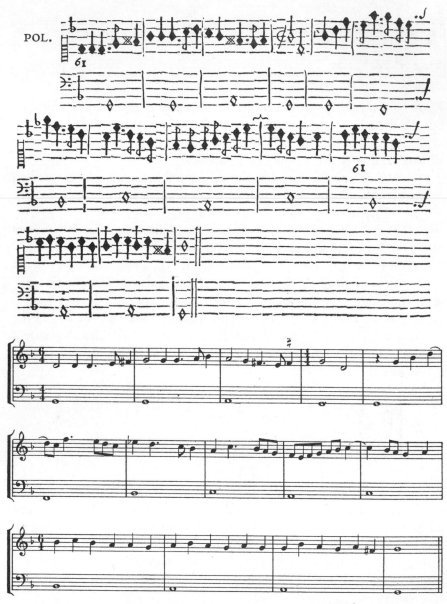

PHI. I promise you, brother, you are much beholding to 'Sellenger's

Round'[1] for that beginning of yours, and your ending you have taken 'sesquipaltry'[2] very right.

MA. You must not be so ready to condemn him for that seeing it was the fault of the time, not of his sufficiency, which causeth him to sing after that manner, for I myself, being a child, have heard him highly commended who could upon a plainsong sing hard Proportions, harsh allowances, and country dances; and he who could bring in maniest of them was counted the jolliest fellow. But I would fain see you (who have those Argus eyes in spying faults in others) make a way of your own, for perchance there might likewise be a hole (as they say) found in your own coat.

Proportions are not ridiculously to be taken.

PHI. I would be ashamed of that, specially having had so many good precepts and practising them so long.

POL. I pray you then set down one that we may see it.

PHI. Here it is, and I fear not your censure.

The point[3] of the first lesson brought in without bad allowances.

POL. You need not; but I pray you, Master, help me, for I can spy no fault in it.

MA. Nor I; and by this lesson, scholar Philomathes, I perceive that you have not been idle at home.

POL. Indeed, now that I have perused it, I cannot but commend it, for the point of the plainsong is every way maintained and without any taking of harsh chords.

MA. That is the best manner of descanting. But shall I hear you sing a lesson of Bass descant?

POL. As many as you list, so you will have them after my fashion.

MA. It was for that I requested it, therefore sing one.

POL.

MA. The first part of your lesson is tolerable and good, but the ending is not so good, for the end of your ninth note is a discord and upon

[1] A corruption of 'St. Leger's Round'; the tune is a well-known folk dance.
[2] This was presumably a derogatory word coined to describe passages which used Sesquialtera proportion to no purpose. On p. 215 occur two more such words, 'Sesquiblinda' and 'Sesquihearkenafter.' [3] M. has 'fugue.' [4] Omitted in M.

another discord you have begun the tenth, breaking Priscian's [1] head to

the very brain; but I know you will go about to excuse the beginning of your tenth note in that it is in binding wise, but though it be bound it is in fetters of rusty iron not in the chains of gold, for no ear hearing it but will at the first hearing loathe it, and though it be the point yet might the point have been as nearly followed in this place, not causing such offence to the ear. And to let you see with what little alteration you might have avoided so great an inconvenience here be all your own notes of the fifth bar in the very same substance as you had them, though altered somewhat in time and form: ; therefore if you mean to follow music any further I would wish you to leave those harsh allowances. But I pray you how did you become so ready in this kind of singing?

POL. It would require a long discourse to show you all.

MA. I pray you truss up that long discourse in so few words as you may and let us hear it.

POL. Be then attentive. When I learned descant of my master Bold he, seeing me so forward and willing to learn, ever had me in his company, and because he continually carried a plainsong book in his pocket he caused me to do the like, and so, walking in the fields, he would sing the plainsong and cause me sing the descant, and when I sung not to his contentment he would show me wherein I had erred. There was also another descanter, a companion of my master's, who never came in my

master's company (though they were much conversant together) but they fell to contention, striving who should bring in the point soonest and make hardest Proportions, so that they thought they had won great glory if they had brought in a point sooner or sung harder Proportions the one than the other. But it was a world to hear them wrangle, every one defending his own for the best. 'What?' saith one, 'you keep not time in your Proportions.' 'You sing them false,' saith the other. 'What Proportion is this?' saith he. 'Sesquipaltry,' saith the other. 'Nay,' would the other say, 'you sing you know not what; it should seem you came lately from a barber's shop where you had "Gregory Walker"* or a Curranta [3] played in the new Proportions by them lately

[1] A sixth-century Roman grammarian; breaking his head meant committing a gross grammatical fault.

[2] 'Gregory' was the name of a wig worn in the sixteenth century and said to have been invented by a barber named Gregory. In the sixteenth and early seventeenth centuries a lute, viol, or fiddle was part of the furniture of a barber's shop and his customers, presumably more 'genteel' than nowadays, while waiting for a hair cut or some minor operation, would amuse themselves on the instruments provided. The 'Quadrant' or 'Quadro' pavan was the newer form of passamezzo (the 'moderno') in the major key (b was therefore natural or 'square'). (Cf. Dart, 'Morley's Consort Lessons of 1599' in *R.M.A. Proceedings*, lxxiv.)

[3] Courante.

found out, called "Sesquiblinda" and "Sesquihearkenafter,'" so that if
one unacquainted with music had stood in a corner and heard them he
would have sworn they had been out of their wits so earnestly did they
wrangle for a trifle; and in truth I myself have thought sometime that
they would have gone to round buffets with the matter, for the descant
books were made angels [1] but yet fists were no visitors of ears, and there-
fore all parted friends. But to say the very truth this Polyphemus had a
very good sight, specially for treble descant, but very bad utterance, for
that his voice was the worst that ever I heard, and though of others he
were esteemed very good in that kind yet did none think better of him
than he did of himself, for if one had named and asked his opinion of
the best composers living at this time he would say in a vain glory of his
own sufficiency 'Tush, tush' (for these were his usual words), 'he is a
proper man but he is no descanter, he is no descanter; there is no stuff
in him; I will not give two pins for him except he hath descant.'

PHI. What, can a composer be without descant?

MA. No, but it should seem by his speech that except a man be so
drowned in descant that he can do nothing else in music but wrest and
wring in hard points upon a plainsong they would not esteem him a
descanter, but though that be the Cyclops his opinion, he must give us
leave to follow it if we list, for we must not think but he that can formally
and artificially put three, four, five, six, or more parts together may at his
ease sing one part upon a ground without great study, for that singing
extempore upon a plainsong is indeed a piece of cunning, and very
necessary to be perfectly practised of him who meaneth to be a composer
for bringing of a quick sight; yet is it a great absurdity so to seek for a sight
as to make it the end of our study, applying it to no other use, for as a
knife or other instrument, not being applied to the end for which it was
devised (as to cut), is unprofitable and of no use, even so is descant which,
being used as a help to bring ready sight in setting of parts is profitable,
but not being applied to that end is of itself like a puff of wind which,
being past, cometh not again, which hath been the reason that the
excellent musicians have discontinued it although it be impossible for
them to compose without it; but they rather employ their time in making
of songs which remain for the posterity than to sing descant which is no
longer known than the singer's mouth is open expressing it, and for the
most part cannot be twice repeated in one manner.

PHI. That is true. But I pray you, brother, proceed with the cause of
your singing of descant in that order.

POL. This Polyphemus carrying such name for descant, I thought it
best to imitate him so that every lesson which I made was a counterfeit of

[1] 'Flew about their ears as if they had wings.'

A course not to be disliked if it had been done with judgement. some of his, for at all times and at every occasion I would foist in some of his points which I had so perfectly in my head as my Pater Noster, and because my master himself did not dislike that course I continued still therein. But what said I? 'Dislike it?' He did so much like it as ever where he knew or found any such example he would write it out for me to imitate it.

MA. I pray you set down two or three of those examples.

POL. Here be some which he gave me as authorities wherewith to defend mine own.

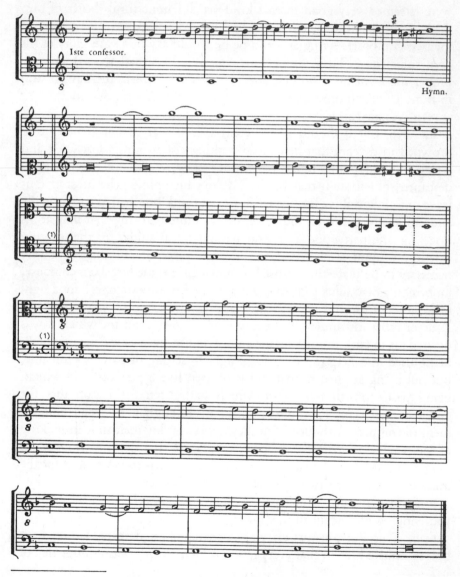

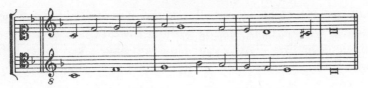

MA. Such lips, such lettuce, such authority, such imitation.[1] But is this Master Bold's own descant?

POL. The first is his own, the second he wrote out of a verse of two parts of an Agnus Dei of one Henry Risby [2] and recommended it to me for a singular good one, the third is one of one Pigott, but the two last I have forgotten whose they be, but I have heard them highly commended by many who bore the name of great descanters.

MA. The authors were skilful men for the time wherein they lived, but as for the examples he might have kept them all to himself for they be all of one mould and the best stark naught, therefore leave imitating of them and such like and in your music seek to please the ear as much as show *In music* cunning, although it be greater cunning both to please the ear and *both the* *ear is to be* express the point than to maintain the point alone with offence to the ear. *pleased and*

POL. That is true indeed; but seeing that such men's works are thus *art showed.* censured I cannot hope any good of mine own, and therefore before you proceed to any other purpose I must crave your judgement of a lesson of descant which I made long ago, and in my conceit at that time I thought it excellent, but now I fear it will be found scant passable.

PHI. I pray you let us hear it and then you shall quickly hear mine opinion of it.

POL. It was not your opinion which I craved but our master's judgement.

MA. Then show it me.

POL. Here it is, and I pray you declare all the faults which you find in it.

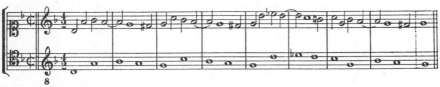

MA. First, that discord taken for the first part of the second note is not *Faults in* good ascending in that manner; secondly, the discord taken for the last *this lesson.* part of the fifth note and another discord for the beginning of the next is very harsh and naught; thirdly, the discord taken for the beginning of

[1] This is a variation on the proverb 'Like lips, like lettuce,' which is derived from a saying of M. Crassus when he saw an ass eating thistles ('Similem habent labra lactucam').
[2] Henry Risby (first half of the sixteenth century).

the tenth note is naught; it, and all the other notes following, are the same thing which were in the beginning without any difference saving that they are four notes higher; [1] lastly, your close you have taken thrice before in the same lesson, a gross fault, in sixteen notes, to sing one thing four times over.

PHI. I would not have used such ceremonies to anatomize every‚ thing particularly but, at a word, I would have flung it away and said it was stark naught.

POL. Soft swift, you who are so ready to find faults, I pray you let us see how you can mend them, maintaining the point in every note of the plainsong as I have done.

PHI. Many ways without imitation and with imitation easily, thus:

The former
lesson
bettered.

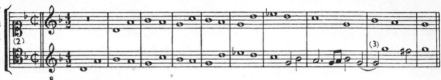

POL. But you have removed the plainsong into the treble and caused it rest two whole semibreves.

PHI. You cannot blame me for that seeing I have neither added to it nor pared from it, and I trust when I sing upon a plainsong I may choose whether I will sing Treble or Bass descant.

POL. You say true.

MA. But why have you made it in a manner all counterpoint seeing there was enough of other shift?

PHI. Because I saw none other way to express every note of the plainsong.

MA. But there is another way to express every note of the plainsong, breaking it but very little, and therefore find it out.

POL. If I can find it out before you I will think myself the better descanter.

PHI. Do so.

POL. Faith, I will leave further seeking for it for I cannot find it.

PHI. Nor I.

POL. I am glad of that for it would have grieved me if you should have found it out and not I.

PHI. You be like unto those who rejoice at the adversity of others though it do not anything profit themselves.

POL. Not so, but I am glad that you can see no further into a mill‚ stone than myself, and therefore I will pluck up my spirits (which before

[1] This is not entirely true as only six notes are repeated 'four notes higher.'

[2] M. places this clef on the top line. [3] These notes are not tied in M.

was so much dulled, not by mine own fault but by the fault of them who taught me) and 'audere aliquid brevibus Gyaris & carcere dignum' because I mean to be 'aliquid.' [1]

PHI. So you shall though you be a dunce perpetually.

POL. That I deny as impossible in that sense as it was spoken.

MA. These reasonings are not for this place and therefore again to your lesson of descant.

POL. We have both given it over as not to be found out by us, and thereupon grew our jar.

MA. Then here it is, though either of you might have found out a greater matter; and because you cavilled at his removing the plainsong to the treble here I have set it (as it was before) lowest:

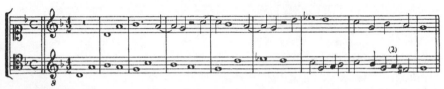

You may also upon this plainsong make a way wherein the descant may sing every note of the ground twice, which though it show some sight and mastery yet will not be so sweet in the ear as others.

PHI. I pray you, sir, satisfy my curiosity in that point and show it us.

MA. Here it is.

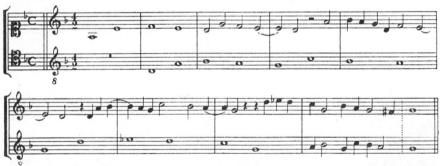

And though it go harsh in the ear yet be there not such allowances in taking of discords used in it as might any way offend, but the un-pleasantness of it cometh of the wresting in of the point, for seeking to repeat the plainsong again the music is altered in the air seeming as it were another song,[3] which doth disgrace it so far as nothing more; and though a man (conceiting himself in his own skill and glorying in that

[1] 'To venture something which may merit severe criticism' because I mean to be 'somebody.' This is a line from Juvenal (*Sat.* i. 73), which begins 'aude.'

[2] A rather unusual form of Cadence to teach a student.

[3] What M. is objecting to is the E♮ (bars 5–6) which, though tolerable in bars 3–4 gives, when repeated, a feeling of D minor tonality rather than G minor, hence divorcing it from the C. F. (cf. p. 249).

he can deceive the hearer) should at the first sight sing such a one as this· is, yet another standing by and perchance a better musician than he, not knowing his determination and hearing that unpleasantness of the music, might justly condemn it as offensive to the ear; then would the descanter allege for his defence that it were every note of the plainsong twice sung over, and this (or some such like) would they think a sufficient reason to move them to admit any harshness or inconvenience in music whatsoever, which hath been the cause that our music in times past hath never given such contentment to the auditor as that of latter time, because the composers of that age (making no account of the air nor of keeping their key) followed only that vein of wresting in such matter in small bounds, so that seeking to show cunning in following of points they missed the mark whereat every skilful musician doth chiefly shoot, which is to show cunning with delightfulness and pleasure.

You may also make a lesson of descant which may be sung to two plainsongs although the plainsongs do not agree one with another, which, although it seem very hard to be done at the first, yet having the rule of making it declared unto you it will seem as easy in the making as to sing a common way of descant, although to sing it at the first sight will be somewhat harder because the eye must be troubled with two plainsongs at once.

POL. That is strange, so to sing a part as to cause two other dissonant parts agree.

MA. You mistake my meaning, for both the plainsongs must not be sung at once; but I mean, if there be two plainsongs given, to make a lesson which will agree with either of them by themselves but not with both at once.

POL. I pray you give us an example of that.

MA. Here is the plainsong whereupon we sung with another under it taken at all·adventures.

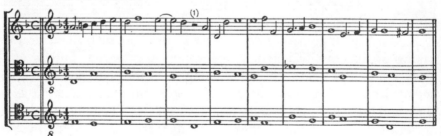

Now if you sing the descanting part it will be true to any one of them.

POL. This is pretty, therefore I pray you give us the rules which are to be observed in the making of it.

[1] Consecutive fifths between the Descant and lower plainsong avoided by a M rest, a procedure which M. condemns on p. 156.

MA. Having any two plainsongs given you you must consider what chord the one of them is to the other, so that if they be in an unison then may your descant be a third, fifth, sixth, eighth, tenth, twelfth, or fifteenth to the lowest of them; but if the plainsongs be distant by a second or ninth then must your descant be a sixth or a thirteenth to the lowest of them; moreover if your plainsongs stand still in seconds or ninths then of force must your descant stand still in sixths because there is no other shifts of concord to be had; [1] if your plainsongs be distant by a third then may your descant be a fifth, eighth, tenth, twelfth, or fifteenth to the lowest; and if your plainsongs be distant by a fourth then may your descant be a sixth, eighth, thirteenth, or fifteenth to the lowest of them; likewise if your plainsongs be a fifth one to another your descant may be a third or fifth to the lowest of them; but if your plainsongs be in the sixth then may your descant be an eighth, tenth, fifteenth, or seventeenth to the lowest of them; lastly, if your plainsongs be distant a seventh then may your descant be only a twelfth. Also you must note that if the plainsongs come from a fifth to a second, the lower part ascending two notes and the higher falling one (as you may see in the last note of the sixth bar and first of the seventh of the example) then of force must your descant fall from the tenth to the sixth with the lower plainsong and from the sixth to the fifth with the higher; and though that falling from the sixth to the fifth, both parts descending, be not tolerable in other music yet in this we must make a virtue of necessity and take such allowances as the rule will afford.

PHI. This is well. But our coming hither at this time was not for descant; and as for you, brother, it will be an easy matter for you to leave the use of such harsh discords in your descant, so you will but have a little more care not to take that which first cometh in your head.

POL. I will avoid them so much as I can hereafter. But I pray you, master, before we proceed to any other matter, shall I hear you sing a lesson of Bass descant?

MA. If it please you; sing the plainsong.

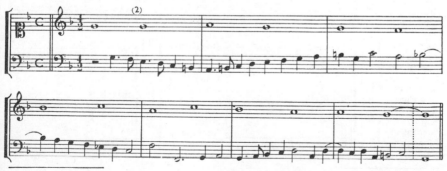

[1] This would mean consecutive fifths to the higher plainsong. [2] Bar line in M.

PHI. Here is an instruction for us, brother, to cause our Bass descant to be stirring.

POL. I would I could so easily imitate it as mark it.

PHI. But now, master, you have sufficiently examined my brother Polymathes and you see he hath sight enough, so that it will be needless to insist any longer in teaching him descant, therefore I pray you proceed to the declaration of the rules of setting.

MA. They be few and easy to them that have descant, for the same allowances are to be taken, and the same faults which are to be shunned in descant must be avoided in setting also. And because the setting of two parts is not very far distant from singing of descant we will leave to speak of it and go to three parts, and although these precepts of setting of three parts will be in a manner superfluous to you, Philomathes, because to make two parts upon a plainsong is more hard than to make three parts into voluntary, yet because your brother either hath not practised that kind of descant or perchance hath not been taught how to practise it, I will set down those rules which may serve him both for descant and voluntary. And therefore to be brief peruse this Table, wherein you may see all the ways whereby concords may be set together in three parts; and though I do in it talk of fifteenths and seventeenths yet are these chords seldom to be taken in three parts except of purpose you make your song of much compass and so you may take what distances you will, but the best manner of composing three voices (or how many soever) is to cause the parts go close.

A TABLE CONTAINING THE CHORDS WHICH ARE TO BE USED IN THE
COMPOSITION OF SONGS FOR THREE VOICES

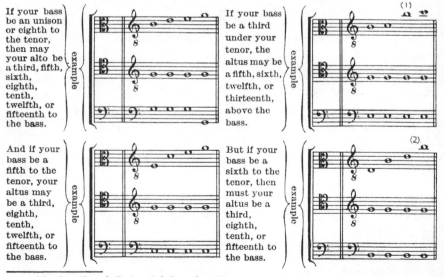

If your bass be an unison or eighth to the tenor, then may your alto be a third, fifth, sixth, eighth, tenth, twelfth, or fifteenth to the bass.

If your bass be a third under your tenor, the altus may be a fifth, sixth, twelfth, or thirteenth, above the bass.

And if your bass be a fifth to the tenor, your altus may be a third, eighth, tenth, twelfth, or fifteenth to the bass.

But if your bass be a sixth to the tenor, then must your altus be a third, eighth, tenth, or fifteenth to the bass.

[1] M. gives E and G, i.e. eighth and tenth. [2] M. gives G, i.e. a thirteenth.

POL. I pray you give me an example which I may imitate.

MA. Let this suffice for one at this time.

And when you come to practise, let the third, fifth, and sixth (sometimes also an octave) be your usual chords because they be the sweetest and bring most variety; the octave is, in three parts, seldom to be used except in passing manner or at a Close. And because of all other closes the cadence is the most usual (for without a cadence in some one of the parts, either with a discord or without it, it is impossible formally to close), if you carry your cadence in the tenor part you may close all these ways following and many others. And as for those ways which here you see marked with a star thus *, they be 'passing closes' which we commonly call 'false closes,' being devised to shun a final end and go on with some other purpose; and these passing closes be of two kinds in the bass part, that is either ascending or descending; if the passing close descend in the bass it cometh to the sixth, if it ascend it cometh to the tenth or third as in some of these examples you may see.

¹ Previous bar line omitted.

² The final note in each of these 'closes' should strictly speaking be M (halving M.'s S), but to give a more modern appearance I have retained the S.

³ Unaccented C approached by a leap up and quitted by a step down.

If you carry your cadence in the bass part you may close with any of these ways following, the mark still showing that which it did before. And as concerning the rule which I told you last before of passing closes, if your bass be a cadence (as your tenor was before, not going under the bass) then will the rule be contrary, for whereas before your bass in your false closing did descend to the sixth, now must your altus or tenor (because sometime the tenor is above the altus) ascend to the sixth or thirteenth and descend to the tenth or third, as here following you may perceive.

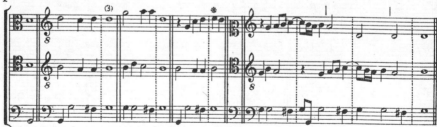

But if your cadence be in the alto, then may you choose any of these ways following for your end, the sign still showing the false close which

[1] These passing closes are not marked in M. (cf. p. 244, footnote 3).

[2] Unaccented C approached by a step up and quitted by a leap down.

[3] Cf. p. 223, footnote 2. M.'s original barring is shown by short vertical strokes.

may not be used at a final or full close. And though it hath been our use in times past to end upon the sixth with the bass in our songs and specially in our canons, yet it is not to be used but upon an extremity of canon, but by the contrary to be shunned as much as may be; and because it is almost everywhere out of use I will cease to speak any more against it at this time; but turn you to the perusing of these examples following.[1]

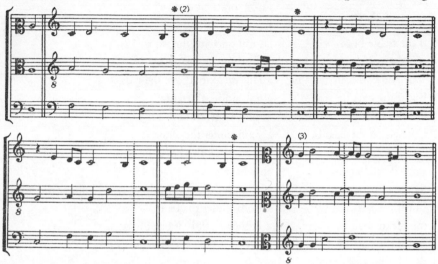

Thus much for the composition of three parts. It followeth to show you how to make four, therefore here be two parts, make in two other middle parts to them and make them four.

PHI. Nay, seeing you have given us a Table of three I pray you give us one of four also.

MA. Then (that I may discharge myself of giving you any more Tables) here is one which will serve you for the composition not only of four parts but of how many else it shall please you, for when you compose more than four parts you do not put to any other part but double some of those four, that is you either make two trebles or two Means or two tenors or two basses. And I have kept in the Table this order: first, to set down the chord which the treble maketh with the tenor; next, how far the bass may be distant from the tenor; so that these three parts being so ordained I set down what chords the alto must be to them to make up the harmony perfect. You must also note that sometimes you find set down for the alto more than one chord, in which case the chords may serve not only for the alto but also for such other parts as may be added to the four; nor shall you find the alto set in an unison or octave with any of the other parts except in four places, because that

[1] M. does not mark the three passing closes asterisked above, nor is the 'cadence' always in the alto, e.g. examples 2 and 3. [2] Cf. p. 223, footnote 2.

[3] This example is taken from A. Holborne's *Cittharn Schoole* (1597), Second Fantasia à 3.

226

THE THIRD PART

when the other parts have amongst themselves the fifth and third (or their octaves) of necessity such parts as shall be added to them (let them be never so many) must be in the octave or unison with some of the three aforenamed. Therefore take it and peruse it diligently.

A TABLE [1] CONTAINING THE USUAL CHORDS FOR THE COMPOSITION OF FOUR OR MORE PARTS

OF THE UNISON	
If the treble be	an unison with the tenor
and the bass	a third under the tenor
your alto or Mean shall be	a fifth or sixth above the bass.
But if the bass be	a fifth under the tenor,
the alto shall be	a third or tenth above the bass.
Likewise if the bass be	a sixth under the tenor,
then the alto may be	a third or tenth above the bass.
And if the bass be	an octave under the tenor,
the other parts may be	a third, fifth, sixth, tenth, or twelfth above the bass.
But if the bass be	a tenth under the tenor,
the Mean shall be	a fifth or twelfth above the bass.
But if the bass be	a twelfth under the tenor,
the alto may be made	a third or tenth above the bass.
Also the bass being	a fifteenth under the tenor,
the other parts may be	a third, fifth, sixth, tenth, twelfth, and thirteenth above the bass.
OF THE THIRD	
If the treble be	a third with the tenor
and the bass	a third under it,
the alto may be	an unison or octave with the parts.
If the bass be	a sixth under the tenor,[2]
the altus may be	a third or tenth above the bass.
But if the bass be	an octave under the tenor,
then the altus shall be	a fifth or sixth above the bass.
And the bass being	a tenth under the tenor,
then the parts may be	in the unison or octave to the tenor or bass.
OF THE FOURTH	
When the treble shall be	a fourth to the tenor,
and the bass	a fifth under the tenor,
then the Mean shall be	a third or tenth above the bass.
But if the bass be	a twelfth under the tenor,
the altus shall be	a tenth above the bass.

[1] Translated from Zarlino, *Istitutioni armoniche*, pp. 296–7.
[2] Major or minor 6/3 with the treble doubling the bass note.

	OF THE FIFTH
But if the treble shall be	a fifth above the tenor,
and the bass	an octave under it,
the alto may be	a third or tenth above the bass.
And if the bass be	a sixth under the tenor,
the altus shall be	an unison or octave with the parts.
	OF THE SIXTH
If the treble be	a sixth with the tenor,
and the bass	a fifth under the tenor,
the altus may be	an unison or octave with the parts.
But if the bass be	a third under the tenor,
the altus shall be	a fifth above the bass.
Likewise if the bass be	a tenth under the tenor,
the Mean likewise shall be	a fifth or twelfth above the bass.
	OF THE OCTAVE
If the treble be	an octave with the tenor,
and the bass	a third under the tenor,
the other parts shall be	a third, fifth, sixth, tenth, twelfth, thirteenth above the bass.
So also when the bass shall be	a fifth under the tenor,
the other parts may be	a third above the bass.
And if the bass be	an octave under the tenor,
the other parts shall be	a third, fifth, tenth, twelfth above the bass.
Lastly, if the bass be	a twelfth under the tenor,
the parts shall make	a tenth or seventeenth above the bass.

Here be also certain examples whereby you may perceive (your bass standing in any key) how the rest of the parts (being but four) may stand unto it, both going close and in wider distances.

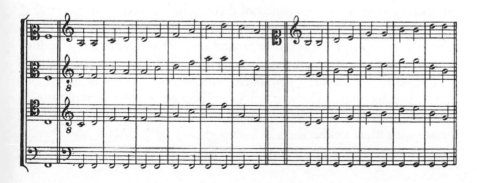

I

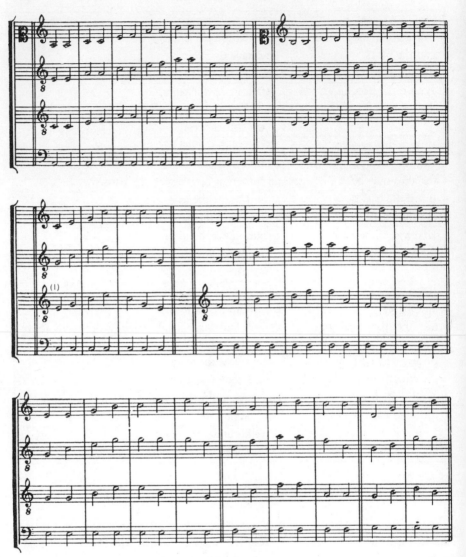

Lastly, here be examples of formal closes in four, five, and six parts, wherein you must note that such of them as be marked with this mark * serve for middle closes such as are commonly taken at the end of the first part of a song; the other be final closes, whereof such as be sudden closes belong properly to light music as Madrigals, Canzonets, Pavanes, and Galliards, wherein a semibreve will be enough to cadence upon; but if you list you may draw out your cadence or close to what length you will. As for the Motets and other grave music you must in them come with more deliberation in bindings and long notes to the close.

[1] M. has the C clef on the top line in error, making the tenor notes as follows: C, E, A, C, A, E, C.

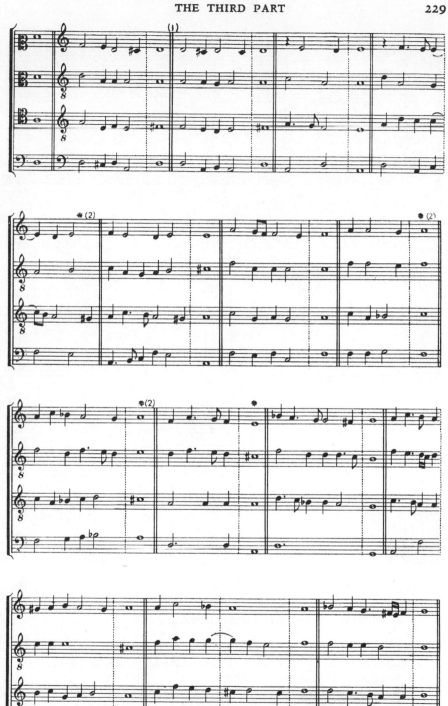

For footnotes, see page 240

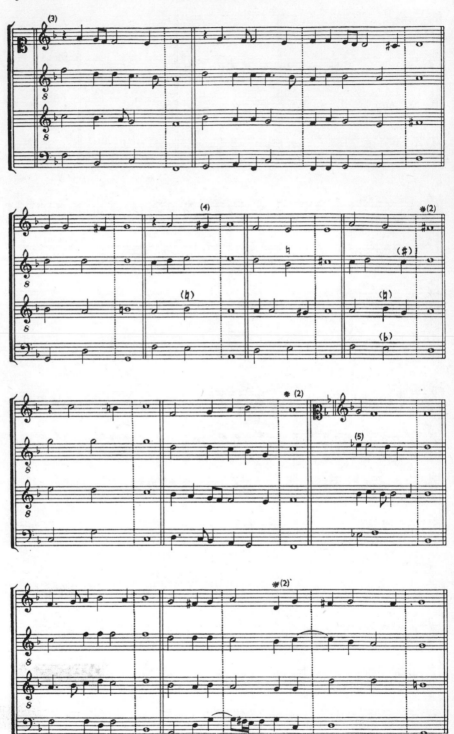

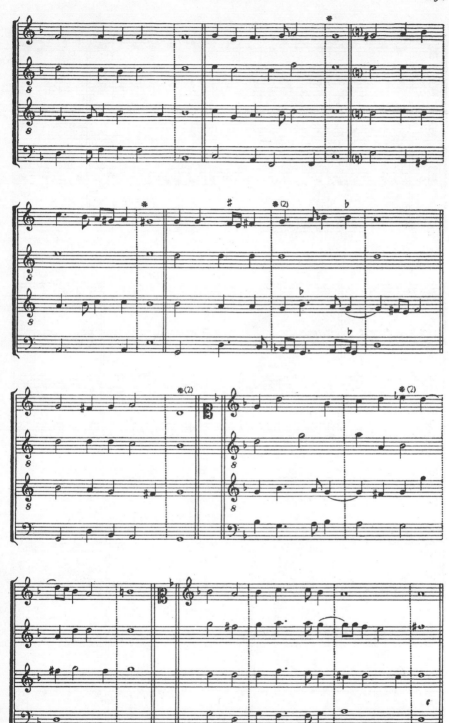

Closes of Five Voices

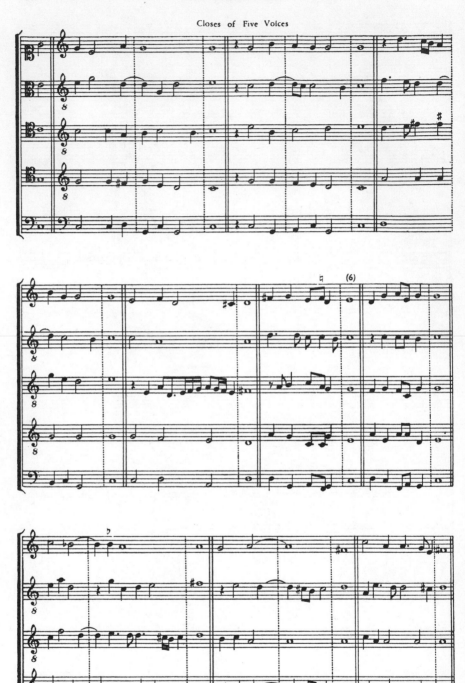

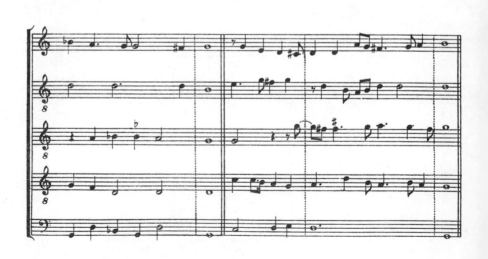

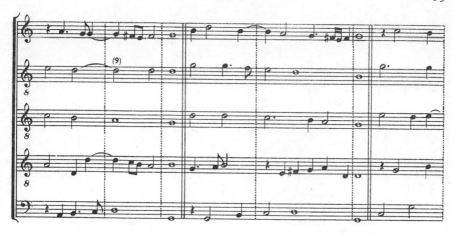

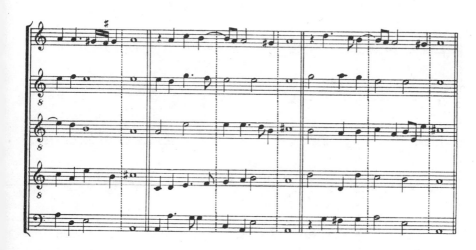

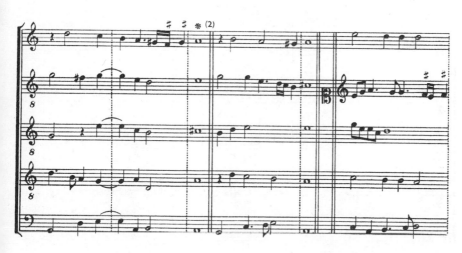

*1

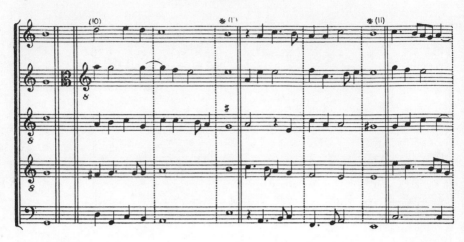

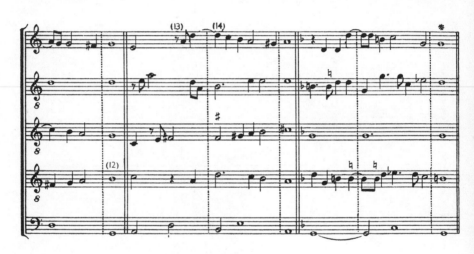

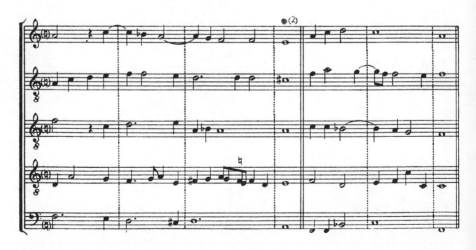

Closes of Six Voices

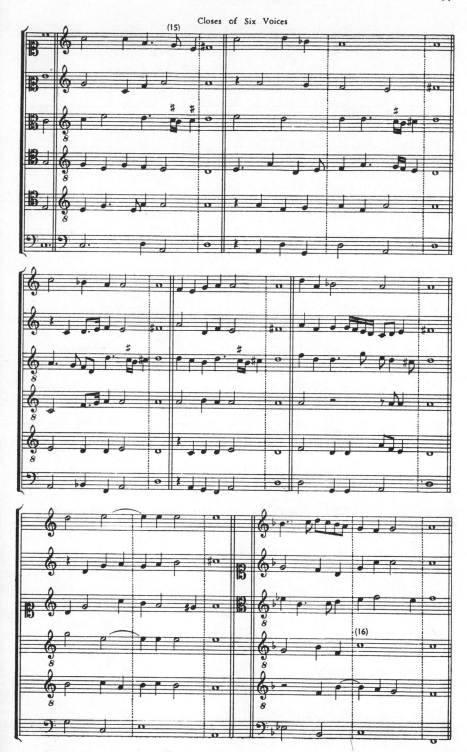

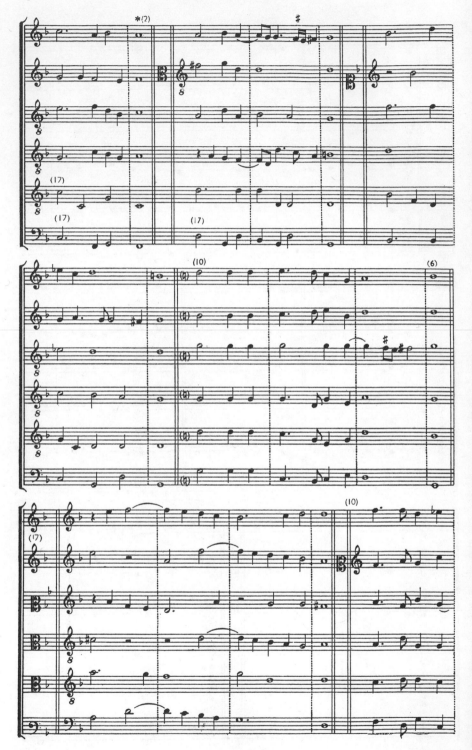

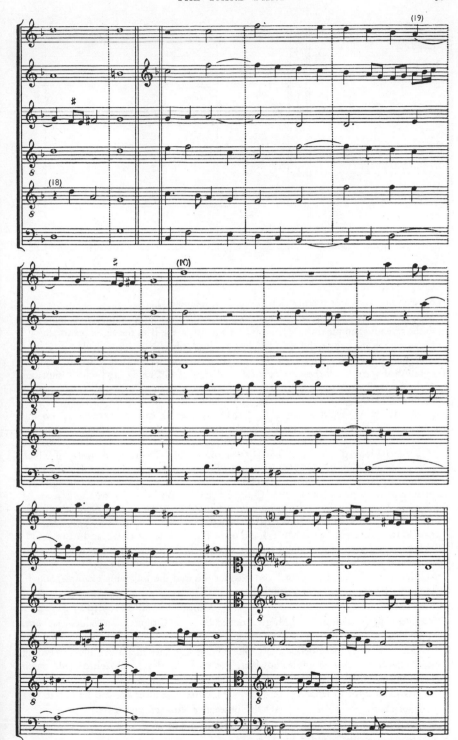

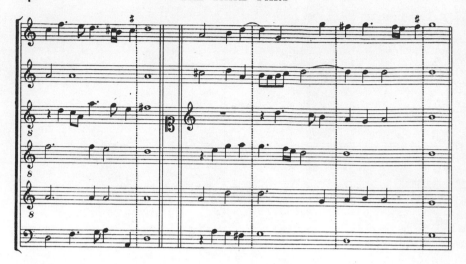

¹ Cf. p. 223, footnote 2.

² M. does not mark this passing close (cf. p. 244, footnote 3).

³ M. omits the B♭ signature in the soprano part for the next eight examples yet marks the B♮ in the seventh example thus (✗) and inserts a ♭ before the B in the eighth example.

⁴ I have placed the superscript ♮ in brackets because although as it stands this cadence is (I believe) unique for its period, there are four points to bear in mind: (1) In the whole of M.'s published vocal work there are only two instances of G♯ being used with a signature of one ♭—in both cases the G♯ is used as the leading note in a 'sectional' cadence in A (*Canzonets to Three Voices*, 1593, No. 14, p. 76, and *First Book of Madrigals to Four Voices*, 1594, No. 7, pp. 30–1); thus this close and the succeeding one are exceptional on this account alone. (2) The B in tenor II, apart from being flattened by the signature, is also 'supra la' which the B in tenor I of the succeeding example is not. (3) The chord E, B♭, G♯ can be looked upon as a logical extension of the 'chromatic clausula' of which M. gives an example on p. 280. (4) Even if the B♭–G♯ interval is accepted as being used, for instance, by Byrd in the Italian sixth chord in No. 4 of his 1588 volume (though even this is suspect by some scholars), the 'Quinta Falsa' E–B♭ between bass and tenor II flouts accepted practice; but in this connection it should be noted that in the next example but one there occurs another 'Quinta Falsa' between the same two parts! This latter can be resolved by either making the bass E♭ and tenor I C♮, or tenor II B♮ and tenor I C♯. Both closes sound well as they stand (which is, after all, M.'s criterion), but it is probable that he would have agreed to one or other of the superscript accidentals.

⁵ M. gives a 2♭ signature in tenor I and bass for this and the following example, and in the bass only for the next three examples.

⁶ Doubled third. ⁷ Consecutive fifths avoided by *M* rest.

⁸ M. gives G♯, A in error. ⁹ M. gives dotted B. ¹⁰ Original note values—*note nere*.

¹¹ The difference between this close and Nos. 3–5 on p. 233 is that the latter approach the final chord of E with more deliberation, thus giving a greater finality to the succeeding E major chord. In this example, however, the final chord is approached with much more movement, which destroys the sense of finality.

¹² M. has G in error in tenor III. ¹³ Consecutive fifths avoided by *C* rest.

¹⁴ B minor chord. ¹⁵ Consecutive fifths (cf. pp. 148–9).

¹⁶ M. has B♭. ¹⁷ No ♭ in signature in M.

¹⁸ Consecutive octaves avoided by *M* rest.

¹⁹ M. gives this ligature for the A and G: ♮ (cf. p. 119).

And though you have here some of every sort of closes, yet will not I say that here is the tenth part of those which either you yourself may devise hereafter or may find in the works of other men, when you shall come to peruse them; [1] for if a man would go about to set down every close

[1] There has been some dispute as to whether or no M. copied some or all of his examples of closes from Tigrini's *Compendio della Musica* (1588). Arkwright, in Grove (vol. iii, p. 520), dismisses the suggestion, stating that M.'s notation and arrangement are different from Tigrini's and that 'there is no reason to suppose that he ever saw Tigrini's book.' The latter statement is impossible to prove either way, but as to the notation and arrangement the subjoined table leaves no doubt. Arkwright's statement that the number of satisfactory closes is limited and that therefore some of the examples in both books are bound to be identical would be valid if there were not so many that are identical (53 out of 108).

With reference to the table the following points should be noted: (1) An asterisked number denotes the last example on a page. (2) The barring and clefs are identical in both books unless otherwise indicated. (3) 'Altered' in the Remarks column only means that M. has made the part writing a little more interesting, e.g. compare M.'s second example on p. 230 with Tigrini's ninth and tenth examples on p. 81:

MORLEY			TIGRINI (Book III, chap. xxvi)		
Page	*No.*	*Remarks*	*Page*	*No.*	*Remarks*
225	1		79	1	
	2 and 3	Two S beats omitted between the two examples		2	
	4 and 5			3	
229	2	Altered	80	2	
	3			3	
	13*	A. and T. altered	81	7	S. clef on bottom line. No F♯.
230	1	A. altered		8	
	2	Altered	9 and 10*		
	3	S. and T. altered		1	
	4			2	No ♭ in signature, therefore no B♮ in S. (fifth example).
	5			3	
	6			4	
	7			5	
232	1		82	1	
	2			2	

he might compose infinite volumes without hitting the mark which he shot at; but let these suffice for your present instruction, for that by these you may find out an infinity of other which may be particular to yourself.

PHI. Now seeing you have abundantly satisfied my desire in showing us such profitable Tables and closes, I pray you go forward with that discourse of yours which I interrupted.

General rules for setting. MA. Then (to go to the matter roundly without circumstances) here be two parts, make in two middle parts to them and make them four; and of all other chords leave not out the fifth, the octave, and the tenth, and look which of those two (that is the octave or the tenth) cometh next to the treble, that set uppermost.

MORLEY			TIGRINI		
Page	No.	Remarks	Page	No.	Remarks
	3			4	
	4			5	
	5		83	2	
	6			1	
	8*			3	
233	1			4	
	2			5*	
	3		84	1	
	4			2	
	5		85	1	
	6*		84	3	
234	1			4	
	2			5	
	3			6*	
	4		85	2	
	5		86	1	
	6			2	
	7			3	
	8*			4	
235	1		87	1	
	2			2	
	6			3	
	7			4	
237	1		88	1	
	2			2	
	3	T. I and T. II reversed		3*	
	4		89	1	
	5			2	
	6			3*	
	7*		90	1	
238	1		91	1	
	2	A. and T. I reversed	92	1	
	3		93	1	
239	3*		94	1	
240	1			2	
	2			3*	

But when you put in a sixth then of force must the fifth be left out, A caveat for
except at a cadence or close where a discord is taken thus:

the sixth.
How the
fifth and
sixth may be
both used
together.

which is the best manner of closing and the only way of taking the fifth
and sixth together.

PHI. I think I understand that, for proof whereof here be two other
parts to those which you have set down.

MA. Indeed you have taken great pains about them for in the second
and third notes you have taken two octaves betwixt the tenor and bass Faults
part, which fault is committed by leaving out the tenth in your second controlled in
note in the tenor, for the octave you had before betwixt the bass and this lesson.
treble; in your third note you have a flat cadence in your Countertenor [4]
which is a thing against nature for every cadence is sharp; but some may
reply that all these three following:

[1] Chromatic alteration within a phrase.
[2] M. divides this example into three bars of two S each, thus making the suspended D
in T. II fall on a weak beat.
[3] M.'s bar lines are placed a S to the right. [4] Tenor I.

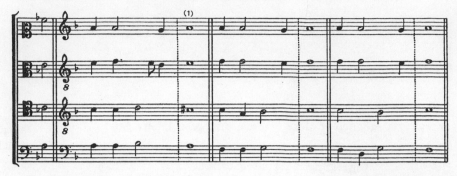

(the first whereof hath only one cadence in the treble, the second hath two cadences together, the one in the treble the other in the Counter; in the third the Mean, Counter, and tenor cadence all at once [2]) be flat cadences, which thing, though it might require long disputation for solution of many arguments which to divers purposes might be brought, yet will I leave to speak any more of it at this time but only that they be all three passing closes and not of the nature of yours, which is a kind of full or final close, although it be commonly used both in passing manner in divers places of your composition and finally at the close; [3] but if

[1] Cf. p. 223, footnote 2.

[2] This only makes sense if the tenor is a dotted minim C and crotchet B flat, making an unusual triple suspension.

[3] An analysis of these closes and those in three to six parts and in M.'s published work results in the following observations:

1. F and D are never keynotes when there is *no* B♮ either in the signature or 'accidentally' in the parts; C and A are never keynotes when there *is* a B♭ in the signature. (This applies to the Madrigal school in general.)

2. Passing closes, in modern terms, are of four kinds:
 (*a*) Dominant root (with a suspension) falling via a seventh in the bass to a tonic first inversion (p. 224, no. 4; p. 231, no. 4).
 (*b*) Interrupted cadence: dominant root (with a suspension) to submediant root or first inversion, *or* dominant first inversion (with a suspension) to submediant first inversion (p. 223, no. 5; p. 224, no. 9; p. 231, no. 6).
 (*c*) Imperfect cadence: subdominant minor first inversion (with a suspension) to dominant major root (p. 229, no. 8; p. 230, no. 6 (?); p. 244, no. 1); *or* tonic root to dominant root (no suspension in either) (p. 229, no. 9; p. 231, nos. 2 and 3; p. 236, nos. 1, 2, 5, and 6.
 (*d*) Leading note cadence: leading note first inversion (with a suspension) to tonic root (p. 224, nos. 1 and 3; p. 225, nos. 1, 2, and 5; p. 229, no. 7; p. 230, nos. 6(?) and 8; p. 231, no. 5; p. 235, no. 6; p. 238, no. 1; p. 244, nos. 2 and 3); *or* leading note root (with a suspension) to tonic root (p. 230, no. 11).

3. Final closes are of two kinds:
 (*a*) Perfect cadence: dominant root or first inversion (with a suspension) (p. 224).
 (*b*) Plagal cadence: subdominant root to tonic root, usually after a previous perfect cadence (p. 224, no. 4).

4. p. 229, no. 3 is a final close because there is no B♭ in the signature (hence D cannot be the keynote) and there is a suspension on the penultimate chord.
 p. 231, no. 4 is a final close because there is a B♭ in the signature and a suspension on the last chord which gives finality.

your bass ascend half a note thus: , any of the other parts making syncopation (which we abusively call a cadence) then of force must your syncopation be in that order as the first of the afore-showed examples is, the other two, not having that necessity, be not in such common use, though being aptly taken they might in some places be both used and allowed. But of this too much; therefore to return to the other faults of your lesson: in your fifth and sixth notes your bass and Counter make two octaves and the bass and tenor two fifths; likewise in the ninth note you have in your tenor part a sharp octave, which fault I gave you in your descant to be avoided; but if you had made the tenor part an octave to the treble it had been far better; last of all your eleventh and twelfth notes be two fifths in the tenor and bass.

POL. Brother, methinketh your setting is no better than my descanting.

PHI. It were well if it were so good for then could I in a moment make it better. But I pray you, master, show me how these faults may be avoided hereafter, for that I have observed your rule everywhere saving in the second and twelfth notes in the tenor part.

MA. In this example you may see all your oversights mended.

p. 233, nos. 3, 4, and 5 are final closes because E is the keynote, and as the chord of B major was not generally accepted a perfect cadence was impossible.

p. 238, no. 5 is a final close because D is the keynote; if G were the keynote there would be an E♮ in sopranos I and II.

Canzonets for Three Voices, No. 10: a final close, i.e. a plagal cadence preceded by a perfect cadence in D.

Canzonets for Three Voices, No. 11 (cf. No. 10).

Canzonets for Five and Six Voices, No. 17: An ambiguous cadence.

Canzonets for Five and Six Voices, No. 19: A final close, i.e. a plagal cadence preceded by a perfect cadence in G; C cannot be the keynote because of the B♭ signature.

Canzonets for Five and Six Voices, No. 21: A final close; a perfect cadence in E is impossible, but this chord is stressed by the final suspension. (The entries at the beginning also point to E as the keynote.)

Madrigals for Four Voices, No. 3 (cf. *Canzonets for Five and Six Voices*, No. 19).

Balletts for Five Voices, No. 6: This is clearly a leading-note cadence (cf. p. 244, nos. 2 and 3) and its use as a final close is quite exceptional.

[1] M.'s bar lines are placed a S to the right in this and the next five examples.

POL. But when your bass and treble do ascend in tenths, as in the fifth and sixth notes of this example, if you must not leave out the fifth and the octave I see no other but it will fall out to be two octaves betwixt the bass and Counter, and likewise two fifths betwixt the bass and tenor.

Solution with rules for true ascending or descending. MA. Then for avoiding of that fault take this for a general rule, that when the bass and treble ascend so in tenths then must the tenor be the octave to the treble in the second note, as for example:

But by the contrary, if the bass and treble descend in tenths then must the tenor be the octave to the treble in the first of them; example:

The middle parts may go one through another. PHI. These be necessary good rules and easy to be understood. But may you carry your tenor part higher than your Counter as you have done in your example of tenths ascending?

MA. You may.

PHI. But what needed it, seeing you might have caused the Counter sing those notes which the tenor did, and contrary the tenor those which the Counter did?

For what reason one part may sing that which the other may not. MA. No, for if I had placed the fourth note of the tenor in the Counter and the fourth note of the Counter in the tenor then had the third and fourth notes been two fifths betwixt the Counter and the

treble, and the fourth and fifth notes been two octaves between the tenor and treble.

PHI. You say true, and I was a fool who could not conceive the reason thereof before you told it me; but why did you not set the fourth note of the tenor in C sol fa ut, seeing it is a fifth and good in the ear?

MA. Because although it were sufferable it were not good to skip up to the fifth in that manner, but if it were taken descending then it were very good, thus:

Coming from the octave to the fifth, both parts ascending naught.

PHI. This example I like very well for these reasons, for, brother, if you mark the artifice of the composition you shall see that as the treble ascendeth five notes so the tenor descendeth five notes; likewise the binding of the third and fourth notes in the tenor, the bass ascending from a sixth to a fifth, causeth that sharp fifth show very well in the ear, and it must needs be better than if it had been taken ascending in the first way as I desired to have had it; last of all, the Counter in the last four notes doth answer the bass in imitation from the second to the fifth. But now I will try to make four parts all of mine own invention.

POL. Take heed of breaking Priscian's head, for if you do I assure you (if I perceive it) I will laugh as heartily at it as you did at my 'Sellenger's Round.'

PHI. I fear you not; but, master, how like you this?

MA. Well, for your first trial. But why did you not put the sixth, seventh, and eighth notes of the tenor eight notes higher and set them in the Counter part, seeing they would have gone nearer to the treble than that Counter which you have set down?

PHI. Because I should have gone out of the compass of my lines.

MA. I like you well for that reason; but if you had liked the other way so well you might have altered your clefs thus:

whereby you should both have had scope enough to bring up your parts and caused them come closer together, which would so much the more have graced your example, for the closer the parts go the better is the harmony and when they stand far asunder the harmony vanisheth, there- fore hereafter study so much as you can to make your parts go close together, for so shall you both show most art and make your compositions fittest for the singing of all companies.

The parts must be close so that no other may be put in betwixt them.

PHI. I will. But why do you smile?

MA. Let your brother Polymathes look to that.

POL. If you have perused his lesson sufficiently I pray you show it me.

MA. Here it is and look what you can spy in it.

PHI. I do not think there be a fault so sensible in it as that he may spy it.

POL. But either my sight is dazzled or then, brother, I have you by the back, and therefore I pray you be not offended if I serve you with the same measure you served me.

PHI. What is the matter?

POL. Do you see the fifth note of the tenor part?

PHI. I do.

POL. What chord is it to the bass?

PHI. An octave; but how then?

POL. *Ergo* I conclude that the next is an octave likewise with the

bass, both descending, and so that you have broken Priscian's head, wherefore I may, *lege talionis*, laugh at incongruity as well as you might at informality; but now I cry quittance with you.

PHI. Indeed I confess you have overtaken me. But master, do you find no other thing discommendable in my lesson?

MA. Yes, for you have in the closing gone out of your key, which is one of the grossest faults which may be committed.

PHI. What do you call going out of the key?

MA. The leaving of that key wherein you did begin and ending in another.

PHI. What fault is in that?

MA. A great fault, for every key hath a peculiar air proper unto itself, so that if you go into another than that wherein you begun you change the air of the song, which is as much as to wrest a thing out of his nature, making the ass leap upon his master and the spaniel bear the load. The perfect knowledge of these airs (which the antiquity termed 'Modi') was in such estimation amongst the learned as therein they placed the perfection of music, as you may perceive at large in the fourth book of Severinus Boethius his *Music*; and Glareanus hath written a learned book which he took in hand only for the explanation of those modes; and though the air of every key be different one from the other yet some love (by a wonder of nature) to be joined to others, so that if you begin your song in Gam ut you may conclude it either in C fa ut or D sol re and from thence come again to Gam ut; likewise if you begin your song in D sol re you may end in A re and come again to D sol re, etc.

Going out of the key a great fault.

PHI. Have you no general rule to be given for an instruction for keeping of the key?

MA. No, for it must proceed only of the judgment of the composer; yet the churchmen for keeping their keys have devised certain notes commonly called the Eight Tunes,[1] so that according to the tune which is to be observed at that time, if it begin in such a key it may end in such and such others, as you shall immediately know. And these be, although not the true substance, yet some shadow of the ancient 'modi' whereof Boethius and Glareanus have written so much.[2]

PHI. I pray you set down those eight tunes, for the ancient 'modi' I mean by the grace of God to study hereafter.

MA. Here they be in four parts, the tenor still keeping the plainsong.

[1] 'Tunes' is probably a corruption of 'Tones,' for Glareanus in the first book of his *Dodecachordon* says that the moderns persistently call the Modes 'Tones,' obliging him to do the same. He adds that Boethius states that the Modes were sometimes called 'Tropes' or 'Tones.'

[2] Cf. Annotations, p. 300 et seq.

THE THIRD PART

THE EIGHT TUNES [1]

The First Tune (3)

(2)

The Second Tune

The Third Tune

[1] A comparison between 'The Eight Tunes' and the Sarum Psalm Tones discloses the following:

First Tune. Termination: Fifth Psalm Tone.

Second Tune. Transposed up a fourth. Intonation: Gospel-canticle Tone. Inflexion and Mediant: Psalm Tone. Termination: First Psalm Tone.

Third Tune. Intonation: Insertion of a second G. Inflexion: None. Mediant: No penultimate B. Termination: Fifth Psalm Tone but a third higher.

Fourth Tune. Inflexion: None. Termination: Fourth Psalm Tone but G sharpened.

Fifth Tune. Termination: First Psalm Tone.

Sixth Tune. Inflexion: Insertion of an F.

Seventh Tune. Intonation, Inflexion, and Mediant: Introit Tone. Termination: First Psalm Tone.

Eighth Tune. Intonation, Inflexion, and Mediant: Psalm Tone minus the initial two notes (possibly an error). Termination: First Psalm Tone.

[2] M. has A.
[3] There are no bar lines in M.

The Fourth Tune

The Fifth Tune

The Sixth Tune

The Seventh Tune

PHI. I will insist no further to crave the use of them at this time, but because the day is far spent I will pray you to go forward with some other matter.

MA. Then leave counterpoint and make four parts of mingled notes.

PHI. I will.

POL. I think you will now beware of letting me take you tardy in false chords.

PHI. You shall not by my good will.

MA. Peruse your lesson after that you have made it and so you shall not so often commit such faults as proceed of oversight.

POL. That is true indeed.

PHI. I pray you, master, peruse this lesson for I find no sensible fault in it.

POL. I pray you show it me before you show it to our master that it may pass censures by degrees.

PHI. I will, so you will play the Aristarchus [1] cunningly.

POL. Yea, a Diogenes [2] if you will.

PHI. On that condition you shall have it.

MA. And what have you spied in it?

POL. As much as he did, which is just nothing.

MA. Then let me have it.

POL. Here it is and it may be that you may spy some informality in it, but I will answer for the true composition.

[1] A severe Greek critic. [2] A Cynic philosopher noted for his caustic sayings.

MA. This lesson is tolerable but yet there be some things in it which I very much dislike; and first, that skipping from the tenth to the octave in the last note of the first bar and first note of the second in the Counter and bass parts, not being enjoined thereunto by any necessity either of imitation or canon but in plain counterpoint where enough of other shift was to be had; I know you might defend yourself with the authorities of almost all the composers who at all times and almost in every song of their Madrigals and Canzonets have some such *quiditie*; [1] and though it cannot be disproved as false descant yet would not I use it, no more than many other things which are to be found in their works, as skipping from the sixth to the octave, from the sixth to the unison, from a tenth to an octave, ascending or descending, and infinite more faults which you shall find by excellent men committed, specially in taking of unisons which are seldom to be used but in passing wise, ascending or descending, or then for the first or latter part of a note and so away, not standing long upon it; whereas they, by the contrary, will skip up to it from a sixth, third, or fifth which (as I told you before) we call hitting an unison or other chord on the face; but they, before they will break the air of their wanton, amorous humour, will choose to run into any inconvenience in music whatsoever, and yet they have gotten the name of music masters through the world by their Madrigals and quick inventions; for you must understand that few of them compose Motets, whereas by the contrary they make infinite volumes of Madrigals, Canzonets, and other such aireable music, yea, though he were a priest he would rather choose to excel in that wanton and pleasing music than in that which properly belongeth to his profession, so much be they by nature inclined to love; and therein are they to be commended, for one musician amongst them will honour and reverence another whereas by the contrary we (if two of us be of one profession) will never cease to backbite one another so much as we can.

POL. You play upon the homonymy [3] of the word 'love,' for in that they be inclined to lust, therein I see no reason why they should be commended; but whereas one musician amongst them will reverence and love another, that is indeed praiseworthy; and whereas you justly complain of the hate and backbiting amongst the musicians of our country that I know to be most true, and specially in these young fellows who having no more skill than to sing a part of a song perfectly (and scarcely that) will take upon them to censure excellent men and to backbite them too; but I would not wish to live so long as to see a set of books of one of those young yonker's [4] compositions who are so ready to condemn others.

MA. I perceive you are a choleric; but let us return to your brother's lesson. Though imitation be an excellent thing yet would I wish no

Marginal notes: Skipping from the tenth to the octave, both parts ascending, [condemned].

Faults to be avoided in imitation. [2]

A note for taking of unison.

[1] 'Quiddity'—subtlety (Shakespeare). [2] i.e. 'Faults which must not be imitated.'
[3] Equivocalness. [4] Or 'younker'—a novice (Shakespeare).

man so to imitate as to take whatsoever his author saith, be it good or
bad, and as for these scapes, though in singing they be quickly over-
passed (as being committed in Madrigals, Canzonets, and such like light
music) and in small notes, yet they give occasion to the ignorant of
committing the same in longer notes, as in Motets, where the fault would
be more offensive and sooner spied; and even as one with a quick hand
playing upon an instrument, showing in voluntary the agility of his
fingers will, by the haste of his conveyance cloak many faults which, if
they were stood upon, would mightily offend the ear, so those musicians,
because the faults are quickly overpassed as being in short notes, think
them no faults; but yet we must learn to distinguish betwixt an
instrument playing division and a voice expressing a ditty.

And as for the going from the tenth to the octave in this place ascend-
ing, if the bass had descended to Gam ut where it ascended to G sol
re ut then had it been better; but those fiery spirits from whence you had
it would rather choose to make a whole new song than to correct one
which is already made, although never so little alteration would have
avoided that inconvenience, else would they not suffer so many fifths and
octaves to pass in their works; yea, Croce [1] himself hath let five fifths
together slip in one of his songs,* and in many of them you shall find two
(which with him is no fault as it should seem by his use of them),
although the east wind have not yet blown that custom on this side of
the Alps. But though Croce and divers others have made no scruple
of taking those fifths yet will we leave to imitate him in that, nor yet will
I take upon me to say so much as Zarlino doth (though I think as much)
who, in the 29th chapter of the third part of his *Institutions of Music*,[3]
discoursing of taking of those chords together, writeth thus: 'Et non si
dee haver riguardo ch'alcuni habbiano voluto fare il contrario, piu presto
per presuntione,[4] che per ragione alcuna, che loro habbiano havuto,
come vediamo nelle loro compositioni; conciosia che non si deve imitar
coloro, che fanno sfacciatamente contra i buoni costumi, & buoni
precetti d'un' arte & di una scienza, senza renderne ragione alcuna: ma
dobbiamo imitar quelli, che sono stati [5] osservatori dei [6] buoni precetti,
& accostarsi a loro & abbracciarli come buoni maestri: lasciando sempre
il tristo, & pigliando il buono: & questo dico perche si come il vedere
una pittura, che sia dipinta con varii colori, maggiormente diletta l'occhio,
di quello che non farebbe se fusse dipinta con un solo colore: cosi l'udito
maggiormente si diletta & piglia piacere delle consonanze & delle modu-

* The 17th
song of his
second book
of Madrigals
of 5 voices in
the 11th and
12th semi-
breves. See
also the 5th,
8th, 9th, and
15th of the
same set.[2]

[1] Giovanni Croce (*c.* 1567–1609). [2] Published 1592. [3] p. 217.
[4] Zarlino inserts '& propria autorita' ('and on their own authority').
[5] Zarlino inserts 'buoni.'
[6] Omitted in Zarlino. (There are various minor differences also between the two versions
which have not been indicated).

latione variate, poste dal diligentissimo compositore nelle sue composi-
tione, che delle semplici & non variate.' Which is in English: 'Nor
ought we to have any regard, though others have done the contrary
rather upon a presumption than any reason which they have had to do so,
as we may see in their compositions; although we ought not to imitate
them who do, without any shame, go against the good rules and precepts
of an art and a science without giving any reason for their doings, but
we ought to imitate those who have been observers of those precepts,
join us to them and embrace them as good masters, ever leaving the bad
and taking the good; and this I say because that even as a picture painted
with divers colours doth more delight the eye to behold it than if it were
done but with one colour alone, so the ear is more delighted and taketh
more pleasure of the consonants [1] by the diligent musician placed in his
compositions with variety than of the simple concords put together with-
out any variety at all.' This much Zarlino; yet do not I speak this nor
seek this opinion of his for derogation from Croce or any of those excellent
men, but wish as they take great pains to compose so they will not think
much to take a little to correct; and though some of them do boldly
take those fifths and octaves yet shall you hardly find either in Master
Alfonso (except in that place which I cited to you before), Orlando,
Striggio, Clemens non Papa,[2] or any before them, nor shall you readily
find in the works of any of those famous Englishmen who have been
nothing inferior in art to any of the aforenamed, as Fayrfax, Taverner,
Shepherd,[3] Mundy,[4] Whyte, Parsons,[5] Mr. Byrd, and divers others who
never thought it greater sacrilege to spurn against the image of a saint
than to take two perfect chords of one kind together; but if you chance
to find any such thing in their works you may be bold to impute it to
the oversight of the copiers, for, copies passing from hand to hand, a
small oversight committed by the first writer by the second will be made
worse, which will give occasion to the third to alter much, both in the
words and notes, according as shall seem best to his own judgement,
though (God knows) it will be far enough from the meaning of the
author; so that errors passing from hand to hand in written copies be
easily augmented, but for such of their works as be in print I dare be
bold to affirm that in them no such thing is to be found.[6]

PHI. You have given us a good caveat how to behave ourselves in
perusing the works of other men, and likewise you have given us a good
observation for coming into a unison, therefore now go forward with the
rest of the faults of my lesson.

[1] M. has omitted 'and modulations.' [2] Clemens non Papa (died c. 1557).
[3] John Shepherd (died c. 1563). [4] William Mundy (died c. 1591).
[5] Robert Parsons (died 1569/70).
[6] There are, however, several consecutive fifths and octaves in Byrd's published work!

MA. The second fault which I dislike in it is in the latter end of the fifth bar and beginning of the next where you stand in octaves, for the Counter is an octave to the bass and the tenor an octave to the treble, which fault is committed by leaving out the tenth; but if you had caused the Counter rise in thirds with the treble it had been good, thus:

The third fault of your lesson is in the last note of your seventh bar, coming from B fa b mi to F fa ut ascending in the tenor part, of which fault I told you enough in your descant; the like fault of informal skipping is in the same notes of the same bar in the Counter part; and lastly in the same Counter part you have left out the cadence at the close.

PHI. That informal fifth was committed because I would not come from the sixth to the fifth ascending between the tenor and the treble, but if I had considered where the note stood I would rather have come from the sixth to the fifth than have made it as it is.

MA. That is no excuse for you, for if your parts do not come to your liking but be forced to skip in that order you may alter the other parts (as being tied to nothing), for the altering of the leading part will much help the thing; so that sometime one part may lead and sometime another, according as the nature of the music or of the point is, for all points will not be brought in alike, yet always the music is so to be cast as the point be not offensive, being compelled to run into unisons, and therefore when the parts have scope enough the music goeth well, but when they be so scattered as though they lay aloof, fearing to come near one to another, then is not the harmony so good.

PHI. That is very true indeed; but is not the close of the Counter a cadence?

MA. No, for a cadence must always be bound or then odd, driving a small note through a greater, which the Latins and those who have of late days written the art of music call 'syncopation,' for all binding and hanging upon notes is called syncopation, as this and such like:

Examples of Syncopation.

[1] Vertical strokes show M.'s barring, in this and the next example.

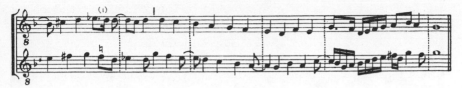

Here be also other examples of syncopation in three parts which, if you consider diligently, you shall find (beside the syncopation) a laudable and commendable manner of causing your parts drive odd, either ascend- ing or descending; and if you cause three parts ascend or descend driving you shall not possibly do it after any other manner than here is set down. It is true that you may do it in longer or shorter notes at your pleasure but that will alter nothing of the substance of the matter. Also these drivings you shall find in many songs of the most approved authors, yet shall you not see them otherwise chorded either in music for voices or instruments than here you may see.

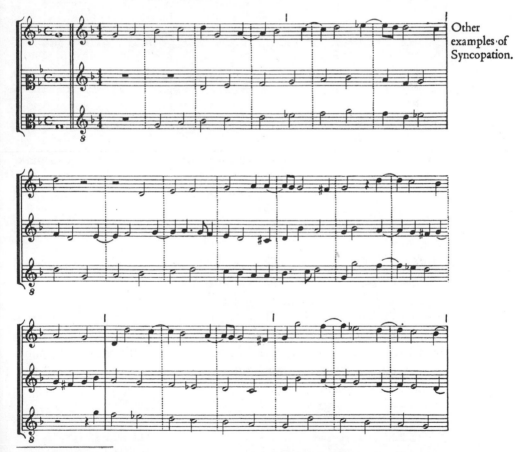

Other examples·of Syncopation.

[1] This type is set upside down in the original, becoming G instead of D. The bar contains an unusual melodic progression B♮, C♯, D, E♭ in the soprano (reversed 'chromatic clausula').

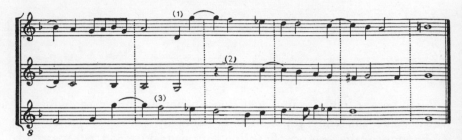

PHI. This I will both diligently mark and carefully keep. But now I pray you set down my lesson corrected after your manner, that I may the better remember the correction of the faults committed in it.

MA. Here it is according as you might have made it without those faults.

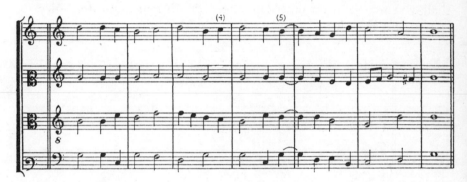

PHI. I will peruse this at leisure. But now brother, I pray you make a lesson as I have done and join practice with your speculation.

POL. I am contented so you will not laugh at my errors if you find any, but rather show me how they may be corrected.

PHI. I will if I can, but if I cannot here is one who shall supply that want.

POL. I pray you then be silent for I must have deliberation and quietness also, else shall I never do anything.

PHI. You shall rather think us stones than men.

POL. But master, before I begin, I remember a piece of composition of four parts of Master Taverner in one of his Kyries,[6] which Master Bold and all his companions did highly commend for exceeding good, and I would gladly have your opinion of it.

MA. Show it me.

POL. Here it is.

[1] Leap of an eleventh. [2] M gives 2 M.
[3] M. gives a black S in error.
[4] M. has not corrected the 'second fault' mentioned on p. 256.
[5] Tie omitted in M. [6] Not in the Tudor Church Music volumes.

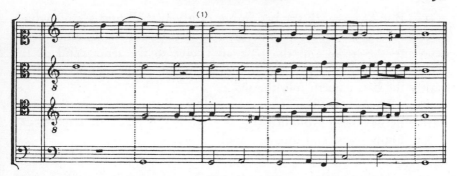

MA. Although Master Taverner did it I would not imitate it.

POL. For what reasons?

MA. First of all, the beginning is neither pleasing nor artificial because Faults in
this lesson. of that ninth taken for the last part of the first note and first of the next, which is a thing intolerable except there were a sixth to bear it out, for discords are not to be taken except they have imperfect chords to bear them out; likewise betwixt the treble and Counter parts another might easily be placed. All the rest of the music is harsh, and the close in the Counter part is both naught and stale, like unto a garment of a strange fashion which being new put on for a day or two will please because of the novelty, but being worn threadbare will grow in contempt; and so this point, when the lesson was made, being a new fashion was admitted for the rarity, although the descant was naught as being only devised to be foisted in at a close amongst many parts for lack of other shift; for though the song were of ten or more parts yet would that point serve for one, not troubling any of the rest, but nowadays it is grown in such common use as divers will make no scruple to use it in few parts whereas it might well enough be left out, though it be very usual with our organists.[2]

POL. That is very true, for if you will but once walk to Paul's Church you shall hear it three or four times at the least in one service if not in one verse.[3]

[1] M. only gives the alternate bar lines in this and the next two examples.

[2] It is surprising that M. should criticize this particular form of cadence so vigorously, as it is so characteristic of the English school, and in fact he uses it himself several times; the following example is more dissonant than most (No. 13, *Madrigals for Four Voices*). Cf. also p. 272, footnote 2.

[3] It seems clear from these remarks that M. was no longer organist at St. Paul's at the time of writing; in fact it seems probable that he had resigned from the post some time before on account of bad health.

K

MA. But if you mark the beginning of it you shall find a fault which even now I condemned in your brother's lesson, for the Counter is an octave to the treble and the bass an octave to the tenor, and as the Counter cometh in after the treble so in the same manner without variety the bass cometh into the tenor.

POL. These be sufficient reasons indeed; but how might the point have otherwise been brought in?

MA. Many ways, and thus for one:

The former lesson bettered.

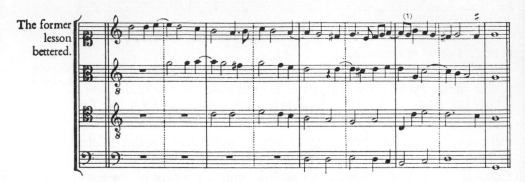

POL. I would I could set down such another.

PHI. Wishing will not avail but 'fabricando fabri fimus,'[2] therefore never leave practising, for that is, in my opinion, the readiest way to make such another.

POL. You say true and therefore I will try to bring the same point another way.

PHI. I see not what you can make worth the hearing upon that point having such two going before you.

MA. Be not by his words terrified but hold forward your determination, for by such like contentions you shall profit more than you look for.

POL. How like you this way?

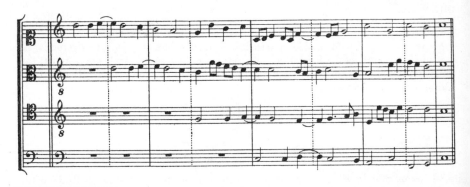

[1] Q resolution. [2] 'By working we become workmen.'

MA. Very ill.

POL. I pray you show me particularly every fault.

MA. First of all you begin upon a discord. Secondly the parts be Faults in
informal; and lastly the bass is brought in out of the key, which fault is this lesson.
committed because of not causing the bass answer to the Counter in the
octave, or at least to the tenor; but because the tenor is in the low key
it were too low to cause the bass answer it in the octave, and therefore
it had been better in this place to have brought in the bass in D sol re,
for by bringing it in C fa ut (the Counter being in D la sol re) you have
changed the air and made it quite informal, for you must cause your
imitation answer your leading part either in the fifth, in the fourth, or in
the octave, and so likewise every part to answer other. Although this
rule be not general yet is it the best manner of maintaining points, for
those ways of bringing in of imitations in the third, sixth, and every such
like chords, though they show great sight, yet are they unpleasant and
seldom used.

POL. So I perceive that if I had studied of purpose to make an evil
lesson I could not have made a worse than this, therefore once again I will
try if I can make one which may in some sort content you.

MA. Take heed that your last be not the worst.

POL. I would not have it so but 'tandem aliquando' how like you
this?

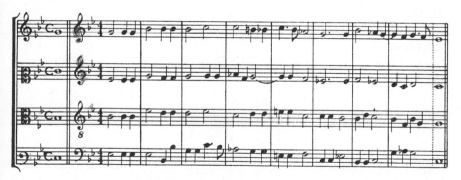

MA. The music is indeed true, but you have set it in such a key as no
man would have done, except it had been to have played it on the organs
with a choir of singing men, for indeed such shifts the organists are
many times compelled to make for ease of the singers. But some have
brought it from the organ and have gone about to bring it in common
use of singing, with bad success if they respect their credit; for take me
any of their songs so set down and you shall not find a musician (how
perfect soever he be) able to sol fa it right, because he shall either sing a
note in such a key as it is not naturally, as la in C sol fa ut, sol in B fa
b mi, and fa in A la mi re, or then he shall be compelled to sing one

note in two several keys in continual deduction, as fa in B fa b mi and
fa in A la mi re immediately one after another, which is against our very
first rule of the singing our six notes or tunings. And as for them who
have not practised that kind of songs, the very sight of those flat clefs
(which stand at the beginning of the stave or line like a pair of stairs,
with great offence to the eye but more to the amazing of the young singer)
make them misterm their notes and so go out of tune, whereas by the
contrary if your song were pricked in another key any young scholar
might easily and perfectly sing it; and what can they possibly do with
such a number of flat ♭♭ which I could not as well bring to pass by
pricking the song a note higher? [1]

Lastly, in the last notes of your third bar and first of the next, and
likewise in your last bar, you have committed a gross oversight of leaving
out the cadence, first in your alto and lastly in the tenor at the very
close; and as for those notes which you have put in the tenor part
instead of the cadence, though they be true unto the parts, yet would
your cadence in this place have been far better for that you cannot
formally close without a cadence in some one of the parts; as for the
other it is an old, stale fashion of closing, commonly used in the fifth
part to these four (as you shall know more at large when I shall show you
the practice of five parts), but if you would set down of purpose to study
for the finding out of a bad close you could not readily light upon a
worse than this.[2]

POL. Then I pray you correct those faults, retaining that which is
sufferable.

MA. Here is your own way altered in nothing but in the cadences
and key.

[1] Although, so far as I know, M. never used the two ♭ signature himself (except the last
example on p. 18) it was fairly common both in England and on the Continent. The
usual inserted accidentals ranged from B♭ to A♭ and F♯ to D♯, the last rarely (but see p. 95,
footnote 11), though D♭ and even A♯ can be found.

[2] M. does not comment on the minor third in the last chord.

But here you must note that, your song being governed with flats, it is as informal to touch a sharp octave in E la mi as in this key to touch it in F fa ut,[1] and in both places the sixth would have been much better, which would have been an octave to the treble; besides (which I had almost forgotten) when they make their songs with those flats, they not only pester the beginning of every stave with them but also, when a note cometh in any place where they should be used, they will set another flat before it, so that of necessity it must in one of the places be superfluous.[2] Likewise I have seen divers songs with those three flats at the beginning of every stave and, notwithstanding, not one note in some of the places where the flat is set from the beginning of the song to the end. But the strangers never pester their stave with those flats, but if the song be naturally flat they will set one ♭ at the beginning of the staves of every part, and if there happen any extraordinary flat or sharp they will set the sign before it which may serve for the note and no more; likewise if the song be sharp, if there happen any extraordinary flat or sharp they will signify it as before, the sign still serving but for that note before which it standeth and for no more.

POL. This I will remember. But once again I will see if I can with a lesson please you any better, and for that effect I pray you give me some point which I may maintain.

PHI.[3] I will show you that piece of favour if you will promise to requite me with the like favour.

POL. I promise you that you shall have the hardest in all my budget.

PHI. I will deal more gently with you, for here is one which in my opinion is familiar enough and easy to be maintained:[4]

POL. Doubt not but my descant will be as familiar and as easy to be amended; but I pray you keep silence for a little while else shall I never do any good.

PHI. I pray God it be good when it comes for you have already made it long enough.

POL. Because you say so I will proceed no further; and now let me hear your opinion of it, hereafter I will show it to our master.

[1] This is not a contradiction of what he has said on p. 175, for there the important word is 'naturally,' i.e. provided there is no E♭ in the key signature (as there is in the example on p. 261). In the above example the F♯ is also chromatic to the key signature and is therefore subject to the same stricture.

[2] M. himself is guilty of this, e.g. on p. 18 (cf. footnote 2).

[3] M. has 'Pol.' This is corrected in the Errata, but p. 155 is given instead of p. 157.

[4] The initial notes of 'Now Robin lend to me thy bow,' 'Non nobis, Domine,' and countless other sixteenth-century pieces.

PHI. I can perceive no gross faults in it except that the leading part goeth too far before any of the rest follow and that you have made the three first parts go too wide in distance.

POL. For the soon bringing in of the point I care not, but indeed I fear my master's reprehension for the compass, therefore I will presently be out of fear and show it him. I pray you, sir, show me the faults of this lesson.

Faults in
the lesson
precedent. MA. The first thing which I dislike in it is the wideness and distance of your parts one from another, for in your fourth bar it were an easy matter to put in two parts betwixt your treble and Mean, and likewise

[1] S in M.

two others betwixt your Mean and tenor; therefore in any case hereafter take heed of scattering your parts in that order for it maketh the music seem wild.

Secondly, in your fifth bar you go from the fifth to the octave in the treble and tenor parts, but if you had set that minim (which standeth in b *molle* [1]) in D sol re, causing it to come under the Counter part, it had been much better and more formal.[2]

Thirdly, in the seventh bar your Counter and tenor come into an unison whereas it is an easy matter to put in three several parts between your Counter and treble.

Fourthly, in the eighth bar your tenor and bass go into an unison without any necessity.

Fifthly, in the tenth bar all the rest of the parts pause while the tenor leadeth and beginneth the imitation which causeth the music to seem bare and lame; indeed if it had been at the beginning of the second part of a song or after a full close the fault had been more excusable, but as it is used in this place it disgraceth the music very much.

Sixthly, the last note of the fourteenth [3] bar and first of the next are two fifths in the bass and tenor parts.

Lastly, your close in the treble part is so stale that it is almost worm-eaten, and generally your treble part lieth so aloof from the rest as though it were afraid to come nigh them, which maketh all the music both informal and unpleasing, for the most artificial form of composing is to couch the parts close together so that nothing may be either added or taken away without great hindrance to the other parts.

POL. My brother blamed the beginning because the leading part went so far before the next, therefore I pray you let me hear your opinion of that matter.

MA. Indeed it is true that the nearer the following part be unto the leading the better the imitation is perceived and the more plainly discerned, and therefore did the musicians strive to bring in their points the soonest they could, but the continuation of that nearness caused them fall into such a common manner of composing that all their points were brought in after one sort, so that now there is almost no imitation to be found in any book which hath not been many times used by others, and therefore we must give the imitation some more scope to come in and by that means we shall show some variety which cannot the other way be shown.

[1] M. has 'square' in error.

[2] The progression of the fifth to the octave in contrary motion is not wrong in itself for M. does it himself (cf. example on p. 258, b. 3), but when the third of the chord is omitted it sounds bare.

[3] M. has 'fifteenth' in error.

POL. Now, sir, I pray you desire my brother Philomathes to maintain the same point that I may censure him with the same liberty wherewith he censured me, for he hath heard nothing of all which you have said of my lesson.

MA. I will. Philomathes, let me hear how you can handle this same point.

PHI. How hath my brother handled it?

MA. That shall be counsel[1] to you till we see yours.

PHI. Then shall you quickly see mine; I have rubbed it out at length though with much ado; here it is, show me the faults.

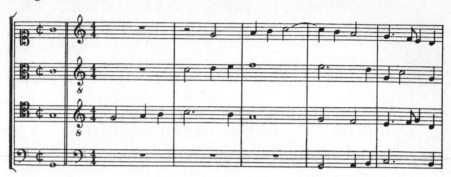

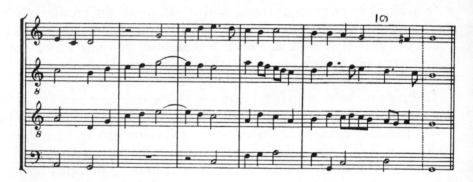

MA. We will first hear what your brother saith to it and then will I declare mine opinion.

PHI. If he be the examiner I am not afraid of condemnation.

POL. What, do you think I will spare you?

PHI. Not so, but I doubt of your sufficiency to spy and examine the faults, for they will be very gross if you find them.

POL. It may be that before I have done you will think them gross enough.

MA. Go then roundly to work and show us what you mislike in the lesson.

[1] 'A secret.' [2] Bar line in M.

POL. Then *imprimis*, I mislike the beginning upon an unison. Item, I mislike two discords (that is a second and a fourth) taken both together after the unison in the second bar betwixt the tenor and Counter. Item *tertio*, I condemn as naught the standing in the sixth a whole breve together in the third bar in the Counter and tenor parts, for though it be true and withal other shift enough to be had yet be those imperfect chords seldom used of the skilful except when some perfect [chord] cometh immediately after them, and therefore being taken but to sweeten the music, though they make great variety, they must not be holden out in length and stood upon so long as others but lightly touched and so away; besides, in many parts if the sixth be so stood upon it will be the harder to make good parts to them. Item *quarto*, I condemn the standing in the unison a whole semibreve in the last note of the seventh bar in the treble and Counter parts, where you must note that the fault is in the treble and not in the Counter. Lastly, I condemn two fifths in the penult and last notes of the tenth bar in the treble and tenor parts; likewise that close of the tenor is of the ancient block which is now grown out of fashion, because it is thought better and more commendable to come to a close deliberately with drawing and binding descant than so suddenly to close, except you had an 'Euouae' [1] or Amen to sing after it.

How say you, Master,[2] have I not said prettily well to my young master's lesson?

MA. Indeed you have spied well, but yet there be two things which have escaped your sight.

POL. It may be it passed my skill to perceive them, but I pray you which be those two?

MA. The taking of a cadence in the end of the fifth bar and beginning of the next, which might either have been below in the tenor or above in the treble, and is such a thing in all music as of all other things must not be left out, especially in closing, either passing in the midst of a song or ending, for though it were but in two parts yet would it grace the music, and the oftener it were used the better the song or lesson would be; much more in many parts, and in this place it had been far better to have left out any chords whatsoever than the cadence; and though you would keep all the four parts as they be yet if you sing it in G sol re ut, either in the treble or tenor it would make a true fifth part to them. The cadence likewise is left out where it might have been taken in the ninth bar and Counter part, which if it had been taken would have caused the tenor to come up nearer to the Counter and the Counter to the treble, and thereby so much the more have graced the music.

[1] M. has 'æuoue.' This is the shortened form of 'Seculorum Amen,' being the vowels from these two words.
[2] M. has 'M.'

*K

PHI. It grieves me that he should have found so many holes in my coat, but it may be that he hath been taken with some of those faults himself in his last lesson and so might the more easily find them in mine.

MA. You may peruse his lesson and see that.

POL. But sir, seeing both we have tried our skill upon one point I pray you take the same point and make something of it which we may imitate, for I am sure my brother will be as willing to see it as I.

PHI. And more willingly (if more may be), therefore let us entreat you to do it.

MA. Little entreaty will serve for such a matter and therefore here it is.

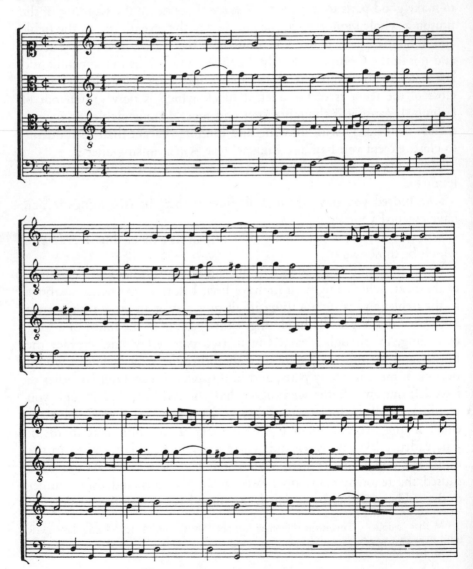

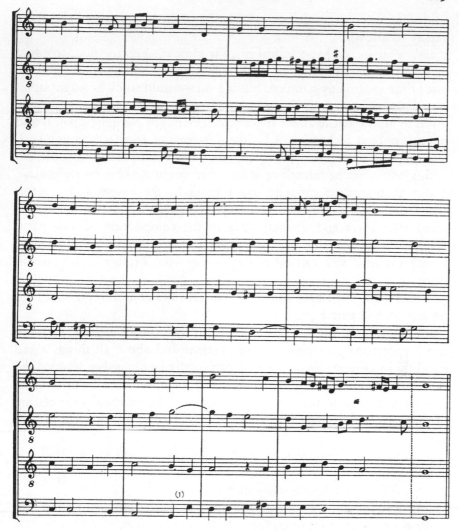

POL. In mine opinion he who can but rightly imitate this one lesson may be counted a good musician.

PHI. Why so?

POL. Because there be so many and divers ways of bringing in the imitation showed in it as would cause any of my humour be in love with it, for the point is brought in in the true air, the parts going so close and formally that nothing more artificial can be wished. Likewise mark in what manner any part beginneth and you shall see some other reply upon it in the same point, either in shorter or longer notes. Also in the twenty-second bar when the tenor expresseth the point the bass reverteth it; and, at a word, I can compare it to nothing but to a well garnished

¹ Leap of a major sixth.

garden of most sweet flowers which the more it is searched the more variety it yieldeth.

MA. You are too hyperbolical in your phrases, speaking not according to skill but affection; but in truth it is a most common point and no more than commonly handled, but if a man would study he might upon it find variety enough to fill up many sheets of paper, yea, though it were given to all the musicians of the world they might compose upon it and not one of their compositions be like unto that of another, and you shall find no point so well handled by any man, either composer or organist, but with study either he himself or some other might make it much better.

But of this matter enough; and I think by the lessons and precepts which you have already had you may well enough understand the most usual allowances and disallowances in the composition of four parts. It followeth now to show you the practice of five, therefore, Philomathes, let me see what you can do at five, seeing your brother hath gone on before you in four.

PHI. I will; but I pray you what general rules and observations are to be kept in five parts?

MA. I can give you no general rule but that you must have a care to cause your parts give place one to another, and above all things avoid standing in unisons, for seeing they can hardly be altogether avoided the more care is to be taken in the good use of them, which is best shown in passing notes and in the last part of a note. The other rules for casting of the parts and taking of allowances be the same which were in four parts.

PHI. Give me leave then to pause a little and I will try my skill.

MA. Pause much and you shall do better.

POL. What, will much study help?

MA. Too much study dulleth the understanding, but when I bid him pause much I will him to correct often before he leave.

POL. But when he hath once set down a thing right what need him to study any more at that time?

MA. When he hath once set down a point, though it be right, yet ought he not to rest there but should rather look more earnestly how he may bring it more artificially about.

POL. By that means he may scrape out that which is good and bring in that which will be worse.

MA. It may be that he will do so at the first but afterwards, when he hath discretion to discern the goodness of one point above another, he will take the best and leave the worst; and in that kind the Italians and other strangers are greatly to be commended who, taking any point in hand, will not stand long upon it but will take the best of it and so away to another, whereas by the contrary we are so tedious that of one point

we will make as much as may serve for a whole song, which, though it
show great art in variety, yet is it more than needeth, except one would
take upon them to make a whole Fancy of one point; and in that also
you shall find excellent Fantasies both of Master Alfonso, Horatio
Vecchi,[1] and others; but such they seldom compose except it either be
to show their variety at some odd time to see what may be done upon a
point without a ditty, or at the request of some friend to show the
diversity of sundry men's veins upon one subject.[2] And though the
lawyers say that it were better to suffer a hundred guilty persons escape
than to punish one guiltless, yet ought a musician rather blot out twenty
good points than to suffer one point pass in his compositions unartificially
brought in.

PHI. I have at length wrested out a way; I pray you, sir, peruse it
and correct the faults.

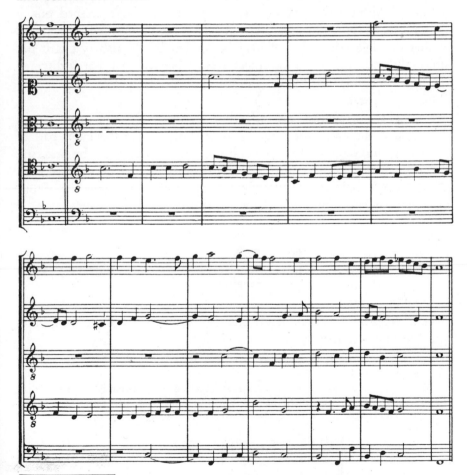

[1] Orazio Vecchi (1550-1605). Published works too numerous to list.
[2] See Duo No. IV, p. 93.

MA. You have wrested it out indeed; as for the faults they be not to be corrected.

PHI. What, is the lesson so excellent well contrived?

MA. No, but except you change it all you cannot correct the fault which like unto an hereditary leprosy in a man's body is incurable without the dissolution of the whole.

PHI. I pray you what is the fault?

MA. The compass; for as it standeth you shall hardly find five ordinary voices to sing it; and is it not a shame for you, being told of that fault so many times before to fall into it now again? For if you mark your fifth bar you may easily put three parts betwixt your Mean and tenor;[1] and in the eighth bar you may put likewise three parts between your treble and Mean—gross faults and only committed by negligence. Your last notes of the ninth bar and first of the next are two fifths in the treble and Mean parts, and your two last bars you have robbed out of the capcase of some old organist; but that close, though it fit the fingers as that the deformity whereof may be hidden by flourish, yet is it not sufferable in compositions for voices, seeing there be such harsh discords taken as are flat against the rules of music.

PHI. As how?

MA. Discord against discord, that is the treble and tenor are a discord and the bass and tenor likewise a discord in the latter part of the first semibreve of the last bar; and this fault is committed by breaking the notes in division; but that and many other such closings have been in too much estimation heretofore amongst the very chiefest of our musicians, whereof amongst many evil this is one of the worst.[2]

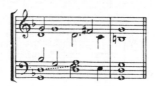

PHI. Wherein do ye condemn this close seeing it is both in long notes and likewise a cadence?

[1] Tenor II.

[2] M. gives separate parts. The simultaneous false relation was obviously much rarer than the successive, but M. must surely have known that Byrd used both forms, e.g. in this example from the 1588 set, 'Lullaby,' No. 32, p. 182 (cf. example on p. 54):

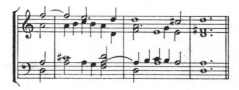

MA. No man can condemn it in the treble, Counter, or bass parts, but the tenor [1] is a blemish to the other, and such a blemish as if you will study of purpose to make a bad part to any others you could not possibly make a worse, therefore in any case abstain from it and such like.

PHI. Seeing the other parts be good, how might the tenor be altered and made better?

MA. Thus: . Now let your ear be judge in the singing and you yourself will not deny but that you find much better air and more fullness than was before. You may reply and say the other was fuller because it did more offend the ear, but by that reason you might likewise argue that a song full of false descant is fuller than that which is made of true chords; but (as I told you before) the best coming to a close is in binding wise in long drawing notes (as you see in the first of these examples following) and most chiefly when a point [2] which hath been in the same song handled is drawn out to make the close in binding wise; as imagine that this point hath in your song been main

tained, , you may draw it out to make the close, as you

see in the last of these examples:

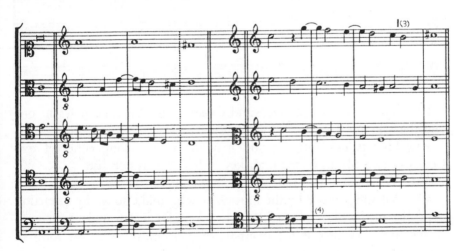

PHI. I pray you take the point [2] of my lesson and show me how it might have been followed better.

MA. Many ways, and thus for one:

[1] D F E D

[3] Bar line in M.

[2] M. has 'fugue.'

[4] M. gives D.

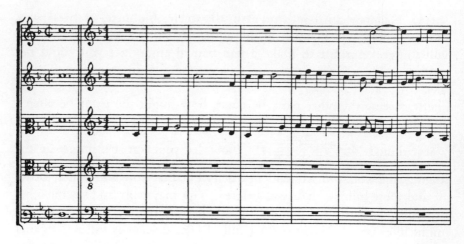

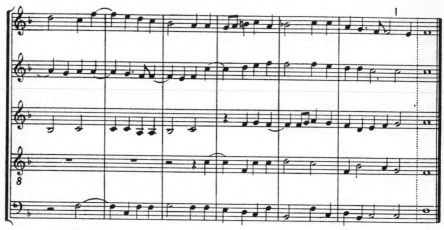

PHI. You have caused two sundry parts sing the same notes in one and the selfsame key.

MA. That is no fault, for you may make your song either of two trebles or two Means in the high key or low key as you list.

PHI. What do you mean by the 'high key'?

MA. All songs made by the musicians who make songs by discretion are either in the high key or in the low key, for if you make your song in the high key here is the compass of your music with the form of setting the clefs for every part.

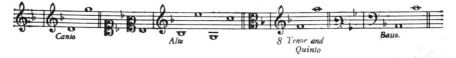

But if you would make your song of two trebles you may make the two highest parts both with one clef, in which case one of them is

called Quinto. If the song be not two trebles then is the Quinto always of the same pitch with the tenor. Your alto or Mean you may make high or low as you list, setting the clef on the lowest or second line.

If you make your song in the low key or for Means, then must you keep the compass and set your clefs as you see here:

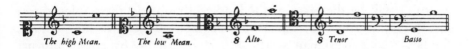

The high Mean. The low Mean. 8 Alto. 8 Tenor Basso

The musicians also used to make some compositions for men only to sing, in which case they never pass this compass:

8 Alto 8 Tenor primus 8 Tenor secundus Bassus

Now must you diligently mark that in which of all these compasses you make your music you must not suffer any part to go without the compass of his lines (except one note at the most, above or below) with-out it be upon an extremity for the ditty's sake or in notes taken for diapasons in the bass. It is true that the high and low keys come both to one pitch (or rather compass) but you must understand that those songs which are made for the high key be made for more life, the other in the low key with more gravity and staidness, so that if you sing them in contrary keys they will lose their grace and will be wrested, as it were, out of their nature; for take an instrument as a lute, orpharion, pandora, or such like being in the natural pitch, and set it a note or two lower, it will go much heavier and duller and far from that spirit which it had before; much more being four notes lower than the natural pitch. Like-wise take a voice (being never so good) and cause it sing above the natural reach, it will make an unpleasing and unsweet[1] noise, displeasing both the singer because of the straining and the hearer because of the wildness of the sound. Even so if songs of the high key be sung in the low pitch and they of the low key sung in the high pitch, though it will not be so offensive as the other, yet will it not breed so much contentment in the hearer as otherwise it would do.

Likewise in what key soever you compose let not your parts be so far asunder as that you may put in any other betwixt them (as you have done in your last lesson) but keep them close together; and if it happen that the point cause them go an octave one from the other (as in the

[1] M. has 'sweet.'

beginning of my example you may see) yet let them come close together again; and above all things keep the air of your key, be it in the first tune, second tune, or other,[1] except you be by the words forced to bear it, for the ditty (as you shall know hereafter) will compel the author many times to admit great absurdities in his music, altering both time, tune, colour,[2] air, and whatsoever else, which is commendable so he can cunningly come into his former air again.

PHI. I will by the grace of God diligently observe these rules, there/ fore I pray you give us some more examples which we may imitate, for how can a workman work who hath had no pattern to instruct him?

MA. If you would compose well the best patterns for that effect are the works of excellent men, wherein you may perceive how points are brought in, the best way of which is when either the song beginneth two several points in two several parts at once, or one point foreright and reverted. And though your foreright points[3] be very good yet are they such as any man of skill may in a manner at the first sight bring in, if he do but hear the leading part sung, but this way of two or three several points going together is the most artificial kind of composing which hitherto hath been invented either for Motets or Madrigals, specially when it is mingled with reverts, because so it maketh the music seem more strange; whereof let this be an example:

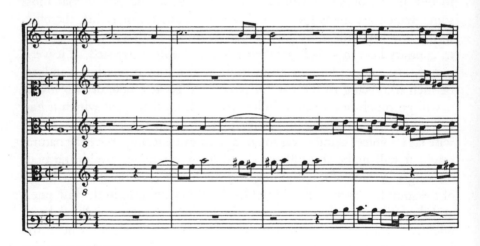

[1] By 'tune' M. does not mean here 'The Eight Tunes' in the tenor part given on pp. 250-2, but the 'keys' implied by these eight tunes.

[2] M. is probably referring here to the practice of some fifteenth/ and sixteenth/century composers, who in their attempts to illustrate the text as realistically as possible went so far as to use only black notes when, for instance, night or darkness were mentioned. (Cf. A. Einstein, *The Italian Madrigal*, vol. i, pp. 234-44.)

[3] M. has 'fugues.'

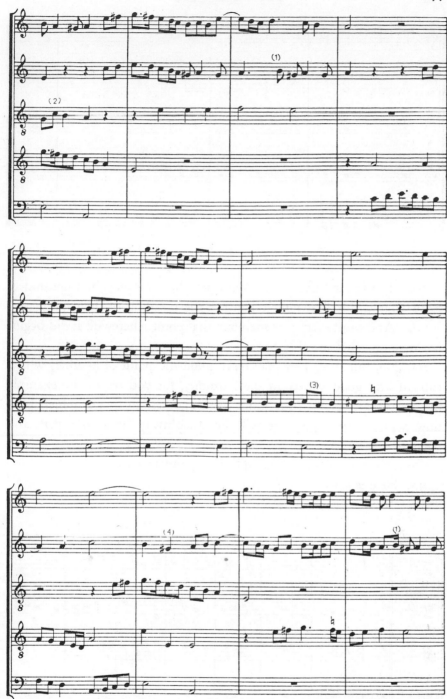

¹ *Échappée*. ² Weak C approached by a leap up and quitted by a step down.
³ Jumped passing note.
⁴ This is very similar to the passage in the Taverner 'Kyrie' which M. condemned on p. 259.

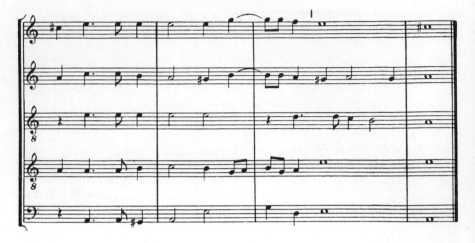

POL. In truth if I had not looked upon the example I had not under-
stood your words, but now I perceive the meaning of them.

PHI. And must every part maintain that point wherewith it did begin,
not touching that of other parts?

MA. No, but every part may reply upon the point of another, which
causeth very good variety in the harmony, for you see in the example
that every part catcheth the point from another, so that it which even
now was in the high part will be straightway in a low part, and
contrarily.

POL. Now show us an example of a point reverted.

MA. Here is one.

POL. Brother, here is a lesson worthy the noting, for every part goeth a contrary way, so that it may be called a revert reverted.

PHI. It is easy to be understood but I am afraid it will carry great difficulty in the practice.

POL. The more pains must be taken in learning of it. But the time passeth away, therefore I pray you, sir, give us another example of a foreright point without any reverting.

MA. Here is one, peruse it, for these maintaining of long points, either foreright or revert, are very good in Motets and all other kinds of grave music.

¹ Augmented triad.

PHI. Here be good instructions; but in the ninth bar there is a discord so taken and so mixed with flats and sharps as I have not seen any taken in the like order.

POL. You must not think but that our master hath some one secret in composition which is not common to every scholar, and though this seem absurd in our dull and weak judgement yet out of doubt our master hath not set it down to us without judgement.

PHI. Yet if it were lawful for me to declare mine opinion it is scant tolerable.

MA. It is not only tolerable but commendable, and so much the more commendable as it is far from the common and vulgar vein of closing; but if you come to peruse the works of excellent musicians you shall find many such bindings, the strangeness of the invention of which chiefly caused them to be had in estimation amongst the skilful.[4]

POL. You have hitherto given us all our examples in Motet's manner,

[1] An unusual resolution. [2] M. gives an undotted S. [3] An unusual form of Cambiata.

[4] The past tense 'caused' is worth noting, implying a more conservative attitude on M.'s part. This 'chromatic clausula,' nevertheless, is exceptional for it can only be found very occasionally in some late fifteenth-century French chansons, the Netherland School, e.g. Clemens non Papa, 'Vox in Rama':

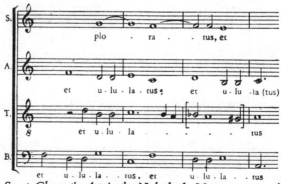

(cf. Lowinsky, *Secret Chromatic Art in the Netherlands Motet*, pp. 11–13), and also in a

therefore I pray you give us now some in form of a Madrigal, that we may perceive the nature of that music as well as that of the other.

MA. The time is almost spent, therefore that you may perceive the manner of composition in six parts and the nature of a Madrigal both at once here is an example of that kind of music in six parts:

few sixteenth-century Italian madrigals, e.g. 'Crudele acerba inexorabil morte' by de Rore (cf. A. Einstein, *The Italian Madrigal,* vol. iii, p. 114:

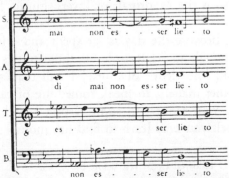

also p. 116, S. b. 1 and T. b. 8). M. uses it again in the motet 'O Amica mea. There are four examples in *Musica Transalpina* (1588) and four in the 1597 set.

¹ Original note values—*note nere.* ² M. has B.

(1)

so that if you mark this well you shall see that no point is long stayed upon, but once or twice driven through all the parts, and sometimes reverted, and so to the close, then taking another; and that kind of handling points is most esteemed in Madrigals, either of five or six parts, specially when two parts go one way and two another way, and most commonly in tenths or thirds, as you may see in my former example of five parts of maintaining two points or more at once.

Likewise the more variety of points be showed in one song the more is the Madrigal esteemed; and withal you must bring in fine bindings and strange closes according as the words of your ditty shall move you. Also in these compositions of six parts you must have an especial care of causing your parts give place one to another, which you cannot do without restings; nor can you (as you shall know more at large anon[2]) cause them rest till they have expressed that part of the dittying which they have begun, and this is the cause that the parts of a Madrigal, either of five or six parts, go sometimes full, sometimes very single, sometimes jumping together, and sometime quite contrary ways, like unto the passion which they express; for as you scholars say that love is full of hopes and fears so is the Madrigal, or lovers' music, full of diversity of passions and airs.

PHI. Now sir, because the day is far spent and I fear that you shall not have time enough to relate unto us those things which might be desired for the full knowledge of music, I will request you, before you proceed to any other matters, to speak something of canons.

MA. To satisfy your request in some respect I will show you a few, whereby of yourself you may learn to find out more. A canon then (as

[1] M. has S D followed by M rest before the C C.
[2] Cf. p. 291.

I told you before, scholar Philomathes) may be made in any distance comprehended within the reach of the voice, as the third, fifth, sixth, seventh, eighth, ninth, tenth, eleventh, twelfth, or other;[1] but for the composition of canons no general rule can be given as that which is performed by plain sight, wherefore I will refer it to your own study to find out such points as you shall think meetest to be followed and to frame and make them fit for your canon.

The authors use the canons in such diversity that it were folly to think to set down all the forms of them because they be infinite, and also daily more and more augmented by divers, but most commonly they set some dark words by them signifying obscurely how they are to be found out and sung, as by this of Josquin you may see:

CANON

In gradus undenos descendant multiplicantes,
Consimilique modo crescant antipodes uno.

For he, setting down a song of four parts having pricked all the other parts at length, setteth this for the bass; and by the word 'antipodes' you must understand 'per arsin & thesin,' though the word 'multipli‑cantes' be too obscure a direction to signify that every note must be four times the value of itself, as you may perceive by this:

And though this be no canon in that sense as we commonly take it, as not being more parts in one, yet be these words a canon; if you desire to see the rest of the parts at length you may find them in the third book of Glareanus his *Dodecachordon*.[2]

But to come to those canons which in one part have some others con‑cluded, here is one without any canon in words composed by an old author, Petrus Platensis,[3] wherein the beginning of every part is signified with a letter, S signifying the highest or *suprema vox*, C the Counter, T, Tenor, and B the Bass; but the end of every part he signified by the same letters enclosed in a semicircle,[4] thus:

[1] It is odd that the fourth is omitted, as M. gives a rule for composing one on pp.180 and 182.

[2] p. 389; Agnus Dei from the Mass 'Fortuna Desperata.'

[3] Pierre de la Rue (died 1518). This is also in *Dodecachordon*, p. 445. Kyrie from the Mass 'O Salutaris Hostia.'

[4] Glareanus gives the dot in ◡ (the inversion of our modern 'pause' sign), but M. omits it.

But lest this which I have spoken may seem obscure here is the resolution of the beginning of every part:

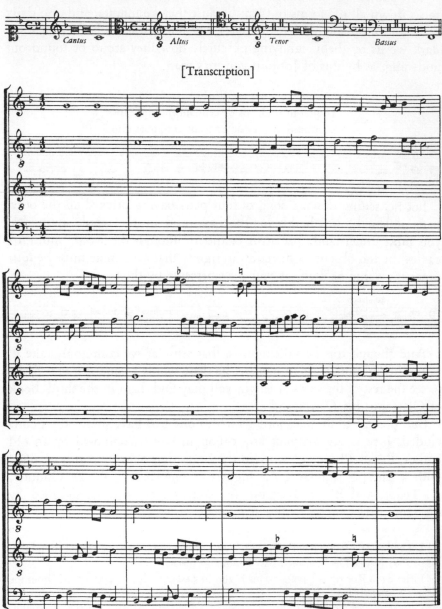

[Transcription]

Of this kind and such like you shall find many both of two, three, four, five, and six parts everywhere in the works of Josquin, Petrus Platensis, Brumel,[1] and (in our time) in the Introductions of Raselius[2] and Calvisius,[3] with their resolutions and rules how to make them, therefore I will cease to speak any more of them; but many other canons there be with enigmatical words set by them which not only strangers have used but also many Englishmen, and I myself (being, as your Maro[4] saith, 'audax iuventa') for exercise did make this cross without any clefs with these words set by it :

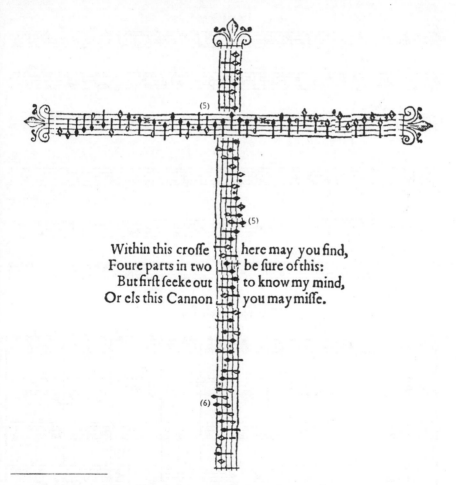

Within this croſſe here may you find,
Foure parts in two be ſure of this:
But firſt ſeeke out to know my mind,
Or els this Cannon you may miſſe.

[1] Antoine Brumel (late fifteenth century–early sixteenth century).

[2] Andreas Raselius (c. 1563–1602). *Hexachordum seu Quaestiones musicae practicae* . . . (1589). M. gives 'Baselius' here and 'Rasselius' in the list of authors at the end of the book.

[3] Sethus Calvisius (1556–1615). *Melopeiam* . . . (1592); *Compendium Musicae practicae* . . . (1594).

[4] Virgil. The quotation comes from *Georgics*, iv. 565, and means 'venturesome in my youth.'

[5] Second edition has ⌒.

[6] This note should be a dotted C, not a Q.

which is indeed so obscure that no man without the Resolution will find out how it may be sung; therefore you must note that the 'trans, versary' or arms of the cross contain a canon in the twelfth, above which singeth every note of the bass a dotted minim till you come to this sign ⌢ where it endeth.[1] The 'radius' or staff of the cross containeth likewise two parts in one in the twelfth under the treble, singing every note of it a semibreve till it come to this sign as before ⌢. Likewise you must note that all the parts begin together without any resting, as this Resolution you may see.

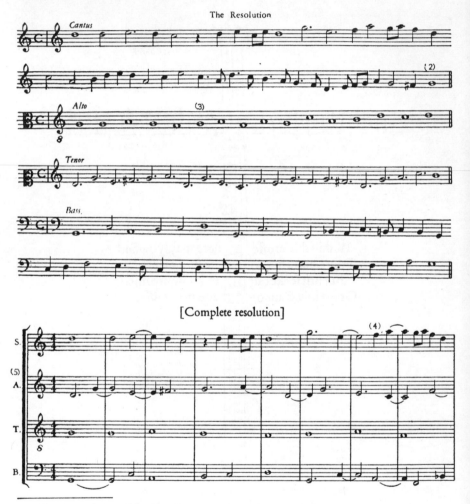

The Resolution

[Complete resolution]

[1] i.e. 'above which the tenor sings every note of the bass as a dotted minim until it comes to this sign. . . .' M. omits to state that the arm is upside down.

[2] This S is missing in 1597, but present in 1608.

[3] M. gives another F here in error in both editions.

[4] Accented dissonant C quitted by a leap.

[5] The alto and tenor parts have been exchanged for convenience.

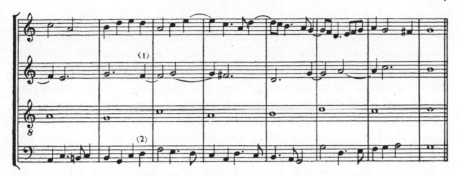

There be also some compositions which at the first sight seem very hard to be done, yet having the rules of composition of them delivered unto you they will seem very easy to be made; as to make two parts in one to be repeated as oft as you will, and at every repetition to fall a note, which though it seem strange yet it is performed by taking your final cadence one note lower than your first note was, making your first the close, as in this example by the director you may perceive.

Canon in epidiatessaron.

Resolution [4]

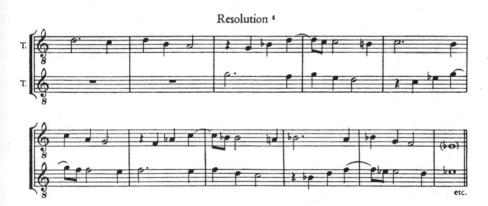

etc.

Likewise you may make eight parts in four (or fewer or more as you list) which may be sung backward and forward, that is one beginning at

[1] Exact inversion of a normal suspension.

[2] Consecutive fifths separated by an unusual passing note. These details have been mentioned in order to show the licence permitted in strict canon.

[3] Missing in 1597 but present in 1608.

[4] This could be called a 'Whole-tone Canon,' for (theoretically) after six repetitions the two parts will reach the point at which they began, but an octave lower; it shows the same kind of chromatic experimentation as Willaert's famous 'Quid non ebrietas?' which travels through the entire circle of fifths.

the beginning of every part and another at the ending and so sing it quite through; and the rules to make it be these: make how many parts you list, making two of a kind (as two trebles, two tenors, two Counters, and two basses) but this caveat you must have, that at the beginning of the song all the parts must begin together full, and that you must not set any dot in all the song, for though in singing the part forward it will go well yet when the other cometh backward it will make a disturbance in the music, because the singer will be in a doubt to which note the dot belongeth, for if he should hold it out with the note which it followeth it would make an odd number, or then he must hold it in that tune wherein the following note is, making it of that time as if it followed that note, which would be a great absurdity, to set a dot before the note of which it taketh the time. Having so made your song you must set one part at the end of the other of the same kind (as treble after treble, bass after bass, etc.) so that the end of the one be joined to the end of the other, so shall your music go right, forward and backward, as thus for example:

Canon eight parts in four; recte & retro.

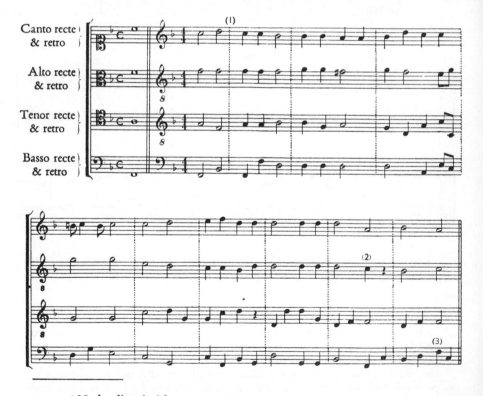

[1] No bar lines in M.

[2] M. gives *M* rest followed by *M C.*

[3] M. gives E.

Resolution[1]

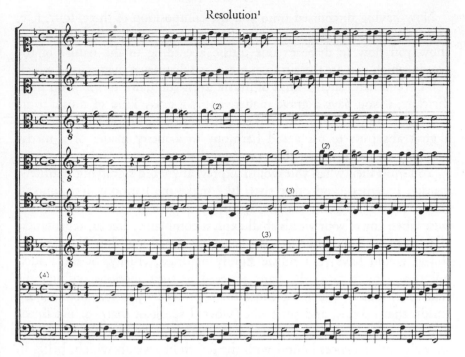

If you desire more examples of this kind you may find one of Master Byrd's, being the last song of those Latin Motets which under his and Master Tallis his name, were published.[5]

In this manner also be the Catches made, making how many parts you list and setting them all after one, thus:

Four parts in one in the unison.

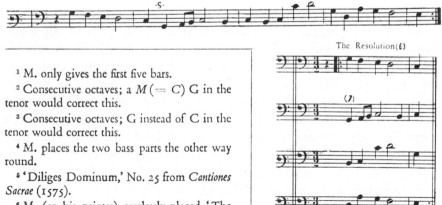

The Resolution(6)

[1] M. only gives the first five bars.

[2] Consecutive octaves; a M (= C) G in the tenor would correct this.

[3] Consecutive octaves; G instead of C in the tenor would correct this.

[4] M. places the two bass parts the other way round.

[5] 'Diliges Dominum,' No. 25 from *Cantiones Sacrae* (1575).

[6] M. (or his printer) carelessly placed 'The Resolution' over the other example, and even the resolution is wrongly written out, the four parts being in inverse order to that given here. M. does not give the bar lines or repeat marks in this example, but in the 'four parts in one' he gives the repeat marks at the end.

[7] Consecutive fifths.

Now having discoursed unto you the composition of three, four, five, and six parts with these few ways of canons and catches, it followeth to show you how to dispose your music according to the nature of the words which you are therein to express, as whatsoever matter it be which you have in hand such a kind of music must you frame to it.[1] You must therefore, if you have a grave matter, apply a grave kind of music to it; if a merry subject you must make your music also merry, for it will be a great absurdity to use a sad harmony to a merry matter or a merry harmony to a sad, lamentable, or tragical ditty.

You must then when you would express any word signifying hardness, cruelty, bitterness, and other such like make the harmony like unto it, that is somewhat harsh and hard, but yet so that it offend not. Like/ wise when any of your words shall express complaint, dolour, repentance, sighs, tears, and such like let your harmony be sad and doleful. So that if you would have your music signify hardness, cruelty, or other such affects you must cause the parts proceed in their motions without the half note, that is, you must cause them proceed by whole notes, sharp thirds, sharp sixths, and such like (when I speak of sharp or flat thirds and sixths you must understand that they ought to be so to the bass); you may also use cadences bound with the fourth or seventh which, being in long notes, will exasperate the harmony. But when you would express a lamentable passion then must you use motions proceeding by half notes, flat thirds, and flat sixths, which of their nature are sweet, specially being taken in the true tune and natural air with discretion and judgement.

But those chords so taken as I have said before are not the sole and only cause of expressing those passions, but also the motions which the parts make in singing do greatly help; which motions are either natural or accidental. The natural motions are those which are naturally made betwixt the keys without the mixture of any accidental sign or chord, be it either flat or sharp, and these motions be more masculine, causing in the song more virility than those accidental chords which are marked with these signs, ✗ ♭, which be indeed accidental and make the song, as it were, more effeminate and languishing than the other motions which make the song rude and sounding. So that those natural motions may serve to express those effects of cruelty, tyranny, bitterness, and such others, and those accidental motions may fitly express the passions of grief, weeping, sighs, sorrows, sobs, and such like.

Also if the subject be light you must cause your music go in motions which carry with them a celerity or quickness of time, as minims, crotchets, and quavers; if it be lamentable the notes must go in slow and heavy motions as semibreves, breves, and such like; and of all this you shall

[1] The following exposition is largely a précis from Zarlino's *Institutioni armoniche*, Ch. 32.

find examples everywhere in the works of the good musicians.

Moreover you must have a care that when your matter signifieth 'ascending,' 'high,' 'heaven,' and such like you make your music ascend; and by the contrary where your ditty speaketh of 'descending,' 'lowness,' 'depth,' 'hell,' and others such you must make your music descend; for as it will be thought a great absurdity to talk of heaven and point downwards to the earth, so will it be counted great incongruity if a musician upon the words 'he ascended into heaven' should cause his music descend, or by the contrary upon the descension should cause his music to ascend.

We must also have a care so to apply the notes to the words as in singing there be no barbarism committed; that is that we cause no syllable which is by nature short be expressed by many notes or one long note, nor no long syllables be expressed with a short note. But in this fault do the practitioners err more grossly than in any other, for you shall find few songs wherein the penult syllables of these words 'Dominus,' 'Angelus,' 'filius,' 'miraculum,' 'gloria,' and such like are not expressed with a long note, yea many times with a whole dozen of notes, and though one should speak of forty he should not say much amiss, which is a gross barbarism and yet might be easily amended.

We must also take heed of separating any part of a word from another by a rest, as some dunces have not slacked to do, yea one whose name is John Dunstable [1] (an ancient English author) hath not only divided the sentence but in the very middle of a word hath made two Long rests thus, in a song of four parts upon these words: 'Nesciens virgo mater virum.'[2]

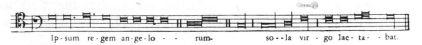

Ip - sum re - gem an - ge - lo - - rum. so - - la vir - go lae - ta - - bat.

For these be his own notes and words, which is one of the greatest absurdities which I have seen committed in the dittying of music. But to show you in a word the use of the rests in the ditty, you may set a crotchet or minim rest above a comma or colon, but a longer rest than that of a minim you may not make till the sentence be perfect, and then at a full point you may set what number of rests you will. Also when you would express sighs you may use the crotchet or minim rest at the most, but a longer than a minim rest you may not use because it will rather seem a breath taking than a sigh, an example whereof you may see in a very good song of Stefano Venturi to five voices upon this ditty 'Quell' aura che spirando a Laura mia?',[3] for, coming to the word

[1] M. gives Johannes Dunstaple (died 1453). Another pun!

[2] This motet is no longer extant.

[3] Stefano Venturi (Florence, late sixteenth century). *Madrigals a 5* (2 books, 1592, 1596); *Madrigals a 4* (1594). M. has 'Paura.'

L

'sospiri' (that is 'sighs') he giveth it such a natural grace by breaking a minim into a crotchet rest and a crotchet that the excellency of his judgement in expressing and gracing his ditty doth therein manifestly appear.[1]

Lastly you must not make a close (especially a full close) till the full sense of the words be perfect. So that keeping these rules you shall have a perfect agreement and, as it were, an harmonical consent betwixt the matter and the music, and likewise you shall be perfectly understood of the auditor what you sing, which is one of the highest degrees of praise which a musician in dittying can attain unto or wish for.

Many other petty observations there be which of force must be left out in this place and remitted to the discretion and good judgement of the skilful composer.

POL. Now sir, seeing you have so largely discoursed of framing a fit music to the nature of a ditty we must earnestly entreat you (if it be not a thing too troublesome) to discourse unto us at large all the kinds of music, with the observations which are to be kept in composing of every one of them.

MA. Although by that which I have already showed you you might with study collect the nature of all kinds of music, yet to ease you of that pain I will satisfy your request though not at full, yet with so many kinds as I can call to memory, for it will be a hard matter upon the sudden to remember them all.

And therefore (to go to the matter roundly and without circumstances) I say that all music for voices (for only of that kind have we Division hitherto spoken) is made either for a ditty or without a ditty. If it be of music. with a ditty it is either grave or light; the grave ditties they have still kept in one kind, so that whatsoever music be made upon it is comprehended under the name of a Motet.

A Motet. A Motet is properly a song made for the church, either upon some hymn or anthem or such like, and that name I take to have been given to that kind of music in opposition to the other which they call Canto Firmo and we do commonly call Plainsong; for as nothing is more opposite to standing and firmness than motion, so did they give the Motet that name of moving because it is in a manner quite contrary to the other, which after some sort and in respect of the other standeth still.[2] This kind of all others which are made on a ditty requireth most art and moveth and causeth most strange effects in the hearer, being aptly framed for the ditty and well expressed by the singer, for it will draw the auditor

[1] This was a standard device for setting the word *sospiri*, for Peacham (a pupil of Vecchi) in his *Compleat Gentleman* (1634) describes a similar instance in a madrigal by the latter ('S'io potessi raccor' i mei sospiri'), where 'the breaking of the word *sospiri* with crotchet and crotchet rest in sighs' gives the same effect as in the Venturi madrigal.

[2] This explanation is, of course, quite incorrect.

(and specially the skilful auditor) into a devout and reverent kind of consideration of Him for whose praise it was made. But I see not what passions or motions it can stir up being sung as most men do commonly sing it, that is leaving out the ditty and singing only the bare note, as it were a music made only for instruments, which will indeed show the nature of the music but never carry the spirit and, as it were, that lively soul which the ditty giveth.[1] But of this enough; and to return to the expressing of the ditty, the matter is now come to that state that though a song be never so well made and never so aptly applied to the words yet shall you hardly find singers to express it as it ought to be, for most of our churchmen, so they can cry louder in their choir than their fellows, care for no more, whereas by the contrary they ought to study how to vowel and sing clean, expressing their words with devotion and passion whereby to draw the hearer, as it were, in chains of gold by the ears to the consideration of holy things. But this for the most part you shall find amongst them, that let them continue never so long in the church, yea though it were twenty years, they will never study to sing better than they did the first day of their preferment to that place, so that it should seem that having obtained the living which they sought for they have little or no care at all, either of their own credit or well discharging of that duty whereby they have their maintenance. But to return to our Motets, if you compose in this kind you must cause your harmony to carry a majesty, taking discords and bindings so often as you can, but let it be in long notes, for the nature of it will not bear short notes and quick motions which denote a kind of wantonness.

This music (a lamentable case) being the chiefest both for art and utility is, notwithstanding, little esteemed and in small request with the greatest number of those who most highly seem to favour art, which is the cause that the composers of music, who otherwise would follow the depth of their skill in this kind, are compelled for lack of *Maecenates*[2] to put on another humour and follow that kind whereunto they have neither been brought up nor yet (except so much as they can learn by seeing other men's works in an unknown tongue) do perfectly understand the nature of it; such be the new-fangled opinions of our countrymen who will highly esteem whatsoever cometh from beyond the seas (and specially from Italy) be it never so simple, condemning that which is done at home though it be never so excellent.[3] Nor yet is that fault of esteeming so

[1] 'Pre-Reformation mass music had grown so elaborate that it sometimes omitted words altogether' (Walker, *History of Music in England*, 3rd ed., p. 50). The context, however, makes it appear that M. was condemning a contemporary custom; was this, perhaps, a means of retaining the Pre-Reformation music while complying with the Reformation decree that no Latin was to be sung in churches, or was it just laziness?

[2] Maecenas, the great Roman patron of literature.

[3] An attitude which unfortunately persisted for several centuries.

L*

highly the light music particular to us in England but general through
the world, which is the cause that the musicians in all countries (and
chiefly in Italy) have employed most of their studies in it, whereupon a
learned man of our time, writing upon Cicero his dream of Scipio,
saith that the musicians of this age, instead of drawing the minds of men
to the consideration of heaven and heavenly things, do by the contrary
set wide open the gates of hell, causing such as delight in the exercise of
their art tumble headlong into perdition.[1]

This much for Motets, under which I comprehend all grave and
sober music. The light music hath been of late more deeply dived into
so that there is no vanity which in it hath not been followed to the full;
but the best kind of it is termed Madrigal, a word for the etymology of
which I can give no reason; yet use showeth that it is a kind of music
made upon songs and sonnets such as Petrarch and many poets of our
time have excelled in. This kind of music were not so much disallow-
able if the poets who compose the ditties would abstain from some
obscenities which all honest ears abhor, and sometime from blasphemies
to such as this, 'ch'altro di te iddio non voglio,'[2] which no man (at
least who hath any hope of salvation) can sing without trembling. As
for the music it is, next unto the Motet, the most artificial and, to men
of understanding, most delightful. If therefore you will compose in
this kind you must possess yourself with an amorous humour (for in no
composition shall you prove admirable except you put on and possess
yourself wholly with that vein wherein you compose[3]), so that you must
in your music be wavering like the wind, sometime wanton, sometime
drooping, sometime grave and staid, otherwhile effeminate; you may
maintain points and revert them, use Triplas, and show the very utter-
most of your variety, and the more variety you show the better shall you
please. In this kind our age excelleth, so that if you would imitate any
I would appoint you these for guides: Alfonso Ferrabosco for deep skill,
Luca Marenzio for good air and fine invention, Horatio Vecchi, Stephano
Venturi, Ruggiero Giovanelli,[4] and John Croce, with divers others who
are very good but not so generally good as these.

Light music.

A Madrigal.

[1] Oddly enough, M. does not mention the Catholic mass or the Anglican service, although
under the term Motet he includes by implication the Anthem.

[2] 'I wish no other god but thee.'

[3] It is interesting to compare this with Byrd's well-known statement: 'There is a certain
hidden power, as I learnt by experience, in the thoughts underlying the words themselves,
so that as one meditates upon the sacred words and constantly and seriously considers them,
the right notes, in some inexplicable manner, suggest themselves quite spontaneously.'
(*Gradualia,* Book I (1605), Fellowes's translation.)

[4] Luca Marenzio (1553–99) published works too numerous to list; Ruggiero Giovanelli
(1560–1625). *Madrigals a 5* (2 books, 1586, 1593); *Madrigals a 4* (2 books, 1585, 1589); *Vil-
lanelle et Arie alla Napoletana a 3* (1588). Both these composers are represented in the collection
of Italian madrigals which M. published in 1598, the other composers being Ferrabosco,

The second degree of gravity in this light music is given to Canzonets, Canzonets.
that is little short songs (wherein little art can be showed, being made in
strains, the beginning of which is some point lightly touched and every
strain repeated except the middle) which is, in composition of the music,
a counterfeit of the Madrigal. Of the nature of these are the Neapolitans Neapolitans.
or 'Canzone a la Napolitana,' different from them in nothing saving
in name, so that whosoever knoweth the nature of the one must needs
know the other also; and if you think them worthy of your pains to
compose them you have a pattern of them in Luca Marenzio and John
Ferretti[1] who, as it should seem, hath employed most of all his study
that way.

The last degree of gravity (if they have any at all) is given to the Villanelle.
Villanelle or country songs, which are made only for the ditty's sake for,
so they be aptly set to express the nature of the ditty, the composer (though
he were never so excellent) will not stick to take many perfect chords of
one kind together,[2] for in this kind they think it no fault (as being a kind
of keeping decorum) to make a clownish music to a clownish matter,
and though many times the ditty be fine enough yet because it carrieth
that name Villanella they take those disallowances, as being good enough
for plough and cart.

There is also another kind more light than this which they term
Balletti or dances, and are songs which being sung to a ditty may like- Balletts.
wise be danced. These, and all other kinds of light music (saving the
Madrigal) are by a general name called 'airs.'

There be also another kind of Balletts commonly called 'Fa las.' The
first set of that kind which I have seen was made by Gastoldi;[3] if others
have laboured in the same field I know not, but a slight kind of music
it is and, as I take it, devised to be danced to voices.

The slightest kind of music (if they deserve the name of music) are the
.Vinate or drinking songs, for, as I said before, there is no kind of vanity Vinate.
whereunto they have not applied some music or other, as they have
framed this to be sung in their drinking; but that vice being so rare
among the Italians and Spaniards I rather think that music to have been
devised by or for the Germans (who in swarms do flock to the University
of Italy) rather than for the Italians themselves.

There is likewise a kind of songs (which I had almost forgotten) called

Ferretti, Vecchi, Phillips, Venturi, di Macque, Mosto, Belli, Orologio, and Sabino; all of
these are either mentioned in the text or in the list at the end of the book save the last four.
As can be seen, Peter Phillips was ranked as an Italian.
 [1] Giovanni Ferretti (c. 1540–c. 1610). Canzoni alla Napoletana a 6 (2 books, 1573, 1575);
Canzoni alla Napoletana a 5 (5 books, 1567, 1569, 1571, 1572 (?), 1585).
 [2] i.e. consecutive fifths and octaves.
 [3] Giovanni Giacomo Gastoldi (c. 1550–c. 1610). Balletti a 5 (1591); Balletti a 3 (1594).

Giustinianas. Giustinianas [1] and are all written in the Bergamasca language; a wanton
and rude kind of music it is, and like enough to carry the name of some
notable courtesan of the city of Bergamo, for no man will deny that
Justiniana is the name of a woman.

Pastourelles, There be also many other kinds of songs which the Italians make, as
Passamezzos, Pastourelles and Passamezzos with a ditty, and such like, which it would
with ditties. be both tedious and superfluous to dilate unto you in words, therefore
I will leave to speak any more of them and begin to declare unto you
those kinds which they make without ditties.

Fantasies. The most principal and chiefest kind of music which is made without
a ditty is the Fantasy, that is when a musician taketh a point at his
pleasure and wresteth and turneth it as he list, making either much or
little of it according as shall seem best in his own conceit. In this may
more art be shown than in any other music because the composer is tied
to nothing, but that he may add, diminish, and alter at his pleasure.
And this kind will bear any allowances whatsoever tolerable in other
music except changing the air and leaving the key, which in Fantasie
may never be suffered. Other things you may use at your pleasure, as
bindings with discords, quick motions, slow motions, Proportions,
and what you list. Likewise this kind of music is, with them who
practise instruments of parts, in greatest use, but for voices it is but
seldom used.

Pavans. The next in gravity and goodness unto this is called a Pavan, a kind
of staid music ordained for grave dancing and most commonly made of
three strains, whereof every strain is played or sung twice; a strain they
make to contain eight, twelve, or sixteen semibreves as they list, yet
fewer than eight I have not seen in any Pavan. In this you may not so
much insist in following the point as in a Fantasy, but it shall be enough
to touch it once and so away to some close. Also in this you must cast
your music by four, so that if you keep that rule it is no matter how many
fours you put in your strain for it will fall out well enough in the end,
the art of dancing being come to that perfection that every reasonable
dancer will make measure of no measure, so that it is no great matter of
what number [2] you make your strain.

Galliards. After every Pavan we usually set a Galliard (that is a kind of music
made out of the other), causing it go by a measure which the learned
call 'trochaicam rationem,' consisting of a long and short stroke succes-
sively, for as the foot *trochaeus* consisteth of one syllable of two times and
another of one time so is the first of these two strokes double to the latter,
the first being in time of a semibreve and the latter of a minim. This is

[1] Cf. A. Einstein's article in the *Journal of Renaissance and Baroque Music*, Vol. I, No. 1.
p. 19. M. spells it 'Justiniana.'
[2] i.e. number of groups of four.

a lighter and more stirring kind of dancing than the Pavan, consisting
of the same number of strains; and look how many fours of semibreves
you put in the strain of your Pavan so many times six minims must you
put in the strain of your Galliard.[1] The Italians make their Galliards
(which they term Saltarelli) plain, and frame ditties to them which in
their masquerades they sing and dance, and many times without any
instruments at all, but instead of instruments they have courtesans
disguised in men's apparel who sing and dance to their own songs.

The Alman is a more heavy dance than this (fitly representing the Almans.
nature of the people whose name it carrieth) so that no extraordinary
motions are used in dancing of it. It is made of strains, sometimes two,
sometimes three, and every strain is made by four;[2] but you must mark
that the four of the Pavan measure is in Dupla Proportion to the four
of the Alman measure, so that as the usual Pavan containeth in a strain
the time of sixteen semibreves, so the usual Alman containeth the time
of eight, and most commonly in short notes.

Like unto this is the French Branle (which they call 'Branle Simple') Branles.
which goeth somewhat rounder in time than this, otherwise the measure
is all one. The 'Branle de Poictou' or 'Branle Double' is more quick
in time (as being in a round Tripla) but the strain is longer, containing
most usually twelve whole strokes.

Like unto this (but more light) be the Voltes and Courantes which Voltes,
being both of a measure are, notwithstanding, danced after sundry Courantes.
fashions, the Volte rising and leaping, the Courante travising[3] and
running, in which measure also our Country Dance is made though it be Country
danced after another form than any of the former. All these be made in Dances.
strains, either two or three as shall seem best to the maker, but the Courante
hath twice so much in a strain as the English Country Dance.

There be also many other kinds of dances, as Hornpipes, Jigs, and
infinite more which I cannot nominate unto you, but knowing these the
rest cannot but be understood as being one with some of these which
I have already told you. And as there be divers kinds of music so will Divers men
some men's humours be more inclined to one kind than to another; as diversly
some will be good descanters and excel in descant and yet will be but affected to
bad composers, others will be good composers and but bad descanters of music.
extempore upon a plainsong; some will excel in composition of Motets
and being set or enjoined to make a Madrigal will be very far from the
nature of it; likewise some will be so possessed with the Madrigal humour
as no man may be compared with them in that kind and yet being

[1] This was by no means the usual construction in the late sixteenth century.

[2] i.e. groups of four S. By 'strain,' M. means different sections, regardless of whether
each section was repeated as a variation.

[3] O.E. for 'traversing.'

enjoined to compose a Motet or some sad and heavy music will be far from the excellency which they had in their own vein. Lastly some will be so excellent in points of voluntary upon an instrument as one would think it impossible for him not to be a good composer and yet being enjoined to make a song will do it so simply as one would think a scholar of one year's practice might easily compose a better. And I dare boldly affirm that look which is he who thinketh himself the best descanter of all his neighbours, enjoin him to make but a Scottish Jig, he will grossly err in the true nature and quality of it.

The con-
clusion of
the dialogue.
Thus have you briefly those precepts which I think necessary and sufficient for you whereby to understand the composition of three, four, five, or more parts, whereof I might have spoken much more; but to have done it without being tedious unto you, that is to me a great doubt, seeing there is no precept nor rule omitted which may be any way profitable unto you in the practice. Seeing therefore you lack nothing of perfect musicians but only use to make you prompt and quick in your com/positions, and that practice must only be done in time as well by your/selves as with me, and seeing night is already begun I think it best to return, you to your lodgings and I to my book.

POL. To/morrow we must be busied making provision for our journey to the University so that we cannot possibly see you again before our departure, therefore we must at this time both take our leave of you and entreat you that at every convenient occasion and your leisure you will let us hear from you.

MA. I hope before such time as you have sufficiently ruminated and digested those precepts which I have given you that you shall hear from me in a new kind of matter.[1]

PHI. I will not only look for that but also pray you that we may have some songs which may serve both to direct us in our compositions and, by singing them, recreate us after our more serious studies.

MA. As I never denied my scholars any reasonable request so will I satisfy this of yours, therefore take these scrolls, wherein there be some grave and some light, some of more parts and some of fewer, and according as you shall have occasion use them.

PHI. I thank you for them, and never did miserable usurer more carefully keep his coin (which is his only hope and felicity) than I shall these.

POL. If it were possible to do anything which might countervail that

[1] Was Morley planning a sequel to this book which, perhaps, his health prevented him from carrying out? Or does the 'new kind of matter' refer to his *Canzonets or Little Short Airs to Five and Six Voices* (1597); the selection of Italian madrigals (1598); *The First Book of Consort Lessons* (1599); *The First Book of Ayres* (1600); or *The Triumphs of Oriana* (1601)? The *Consort Lessons* are probably the most likely.

which you have done for us we would show you the like favour in doing as much for you, but since that is impossible we can no otherwise requite your courtesy than by thankful minds and dutiful reverence, which (as all scholars do owe unto their masters) you shall have of us in such ample manner as when we begin to be undutiful we wish that the world may know that we cease to be honest.

MA. Farewell, and the Lord of Lords direct you in all wisdom and learning, that when hereafter you shall be admitted to the handling of the weighty affairs of the commonwealth you may discreetly and worthily discharge the offices whereunto you shall be called.

POL. The same Lord preserve and direct you in all your actions and keep perfect your health which I fear is already declining.

ANNOTATIONS

UPON THE

THIRD PART

Page 249, line 30: 'the Eight Tunes.'

The tunes (which are also called *modi musici*) the practitioners do define to be 'a rule whereby the melody of every song is directed.' Now these tunes arise out of the tunes of the octave [1] according to the diversity of setting the fifth and fourth together, for the fourth may be set in the octave either above the fifth, which is the 'Harmonical division' or 'mediation' (as they term it) of the octave, or under the fifth, which is the 'Arithmetical mediation'; and seeing there be seven kinds of octaves it followeth that there be fourteen several tunes, every octave making two; but of these fourteen (saith Glareanus [2]) the musicians of our age acknowledge but eight though they use thirteen,[3] some of which are in more use and some less usual than others; and these eight which they acknowledge they neither distinguish truly nor set down perfectly but prescribe unto them certain rules which are neither general nor to the purpose, but such as they be the effect of them is this: some tunes (say they) are of the odd number, as the first, third, fifth, and seventh; others of the even number, as the second, fourth, sixth, and eighth; the odd they call 'Autentas,' the even 'Plagales.' To the Autentas they give more liberty of ascending than to the Plagales which have more liberty of descending than they, according to this verse: 'Vult descendere par, sed scandere vult modus impar.'[4]

[1] i.e. 'notes of the octave.'

[2] *Dodecachordon,* Book I, chap. 11.

[3] Cf. p. 304, footnote 2. The *Dodecachordon* was written to prove that there are twelve true Modes, not seven as Ptolemy maintained. The eight Modes generally acknowledged were the seven of Ptolemy, viz. Hypodorian, Hypophrygian, Hypolydian, Dorian, Phrygian, Lydian, and Mixolydian, plus the Hypomixolydian added by Hermannus Contractus in the eleventh century. The thirteen Modes are those of Aristoxenos, six of which Ptolemy later condemned.

[4] 'The even-numbered mode tends to descend, but the odd-numbered mode tends to ascend.'

Also for the better helping of the scholar's memory they have devised these verses following:

> Impare de numero tonus est autentas, in altum
> Cuius neuma salit, sede à propria diapason
> Pertingens, à qua descendere vix datur illi:
> Vult pare de numero tonus esse plagalis in ima
> Ab regione sua descendens ad diatessaron,
> Cui datur ad quintam, raróque, ascendere sextam.[1]

Now these tunes consisting of the kinds of diapason· or octaves it followeth to know which tunes each kind of diapason doth make; it is therefore to be understood that one octave having but one diapente or fifth, it followeth that one diapente must be common to two tunes, the lowest key of which diapente ought to be the final key of them both. It is also to be noted that every Autenta may go a whole octave above the final key and that the Plagale may go but a fifth above it but it may go a fourth under it, as in the verses now set down is manifest. So then the first tune is from D sol re to D la sol re, his fifth being from D sol re to A la mi re; the second tune is from A la mi re to A re, the fifth being the same which was before, the lowest key of which is common final to both. In like manner the third tune is from E la mi to E la mi, and the fourth from B fa b mi to ♮ mi, the diapente from E la mi to B fa b mi being common to both.

Now for the discerning of these tunes one from another they make three ways, the beginning, middle, and end; and for the beginning (say they) every song which about the beginning riseth a fifth above the final key is of an authentical tune, if it rise not unto the fifth it is a plagal; and for the middle, every song (say they) which in the middle hath an octave above the final key is of an authentical tune, if not it is a plagal; and as for the end they give this rule, that every song (which is not transposed) ending in G sol re ut with the sharp in b fa b mi is of the seventh or eighth tune, in F fa ut of the fifth or sixth tune, in E la mi of the third or fourth tune, in D sol re is of the first or second tune.

And thus much for the eight tunes as they be commonly taught. But Glareanus broke the ice for others to follow him into a further specula⸗ tion and perfect knowledge of these tunes or *modi,* and for the means to discern one from another of them he saith thus: the tunes or *modi musici* (which the Greek writers call ἁρμονίας, sometimes also νόμους καὶ τρόπους) are distinguished no otherwise than the kinds of the diapason or octave from which they arise are distinguished, and other kinds of octave are

[1] 'The odd⸗numbered mode is Authentic, which ranges upwards to the octave from its fundamental from which it rarely descends; the even⸗numbered mode is Plagal, which may descend to the fourth below the fundamental and ascend a fifth, and occasionally a sixth, above the fundamental.'

distinguished no otherwise than according to the place of the half notes or *semitonia* contained in them, as all the kinds of other consonants are distinguished; for in the diatessaron there be four sounds and three distances (that is two whole notes and one less half note), therefore there be three places where the half note may stand, for either it is in the middle place having a whole note under it and another above it, and so produceth the first kind of diatessaron as from A re to D sol re, or then it standeth in the lowest place having both the whole notes above it, producing the second kind of diatessaron as from ♮ mi to E la mi, or then is in the highest place having both the whole notes under it, in which case it produceth the third and last kind of diatessaron as from C fa ut to F fa ut; so that how many distances any consonant hath so many kinds of that consonant there must be, because the half note may stand in any of the places, and therefore diapente having five sounds and four distances (that is three whole notes and a half note) there must be four kinds of diapente, the first from D sol re to A la mi re, the second from E la mi to B fa b mi, the third from F fa ut to C sol fa ut, the fourth and last from G sol re ut to D la sol re. If you proceed to make any more the fifth will be the same with the first, having the half note in the second place from below. Now the diapason containing both the diapente and diatessaron as consisting of the conjunction of them together, it must follow that there be as many kinds of diapason as of both the other, which is seven. Therefore it is manifest that our practitioners have erred in making eight tunes, separating the nature of the eighth from that of the first, seeing they have both one kind of diapason, though divided after another manner in the last than in the first; but if they will separate the eighth from the first because in the eighth the fourth is lowest which in the first was highest then of force must they divide all the other sorts of diapason likewise after two manners, by which means there will arise fourteen kinds of forms, tunes, or *modi.*[1]

And to begin at the first kind of diapason (that is from A re to A la mi re), if you divide it arithmetically, that is if you set the fourth lowest and the fifth highest, then shall you have the compass of our second Mode[2] or tune, though it be the first with Boethius and those who wrote before him[3] and is called by them Hypodorius. Also if you divide the same kind of diapason harmonically, that is set the fifth lowest and the fourth highest, you shall have the compass of that tune which

[1] The first tune is in the Dorian Mode (D–A–D), the eighth is in the Hypomixolydian Mode (D–G–D); these are the only two tunes in the eight which have the same octave and looked at in this way are identical; but if it is argued that they are constructed differently then, as M. says, each of the other six octaves can equally be constructed differently.

[2] Cf. p. 301.

[3] 'Boethius and those who wrote before him' means Ptolemy and other writers who upheld Ptolemy's seven Modes (e.g. Bryennius and Porphyry).

the ancients had for their ninth and was called Aeolius, though the latter age would not acknowledge it for one of the number of theirs.[1] Thus you see that the first kind of diapason produceth two tunes according to two forms of mediation or division.

But if you divide the second kind of diapason arithmetically you shall have that tune which the latter age termed the fourth and in the old time was the second, called Hypophrygius. But if you divide the same harmonically, setting the fifth lowest, you shall have a tune or Mode which of the ancients was justly rejected, for if you join ♮ mi to F fa ut you shall not make a full fifth; also if you join F fa ut to B fa b mi you shall have a tritonus, which is more by a great half note than a fourth.[2] And because this division is false in the diatonical kind of music (in which you may not make a sharp in F fa ut) this tune, which was called Hyperaeolius,[3] arising of it was rejected.

If you divide the third kind of diapason from C fa ut to C sol fa ut arithmetically you shall have the compass and essential bounds of the sixth tune which the ancients named Hypolydius. If you divide it harmonically you shall have the ancient Ionicus or Iastius,[4] for both those names signify one thing.

If you divide the fourth kind of diapason from D to D arithmetically it will produce our eighth tune which is the ancient Hyperiastius or Hypomixolydius; if harmonically it is our first tune and the ancient Dorius, so famous and recommended in the writings of the philosophers.

If the fifth kind of diapason from E la mi to E la mi be divided arithmetically it maketh a tune which our age will acknowledge for none of theirs though it be our tenth indeed and the ancient Hypoaeolius; but if it be harmonically divided it maketh our third tune and the old Phrygius.

But if the sixth kind of the diapason be divided arithmetically it will produce a rejected Mode because from F fa ut to B fa b mi is a tritonus, which distance is not received in the diatonical kind; and as for the flat in B fa b mi it was not admitted in diatonical music no more than the sharp in F fa ut, which is a most certain argument that this music which we now use is not the true *diatonicum* nor any species of it. But again to our division of the octaves. If the sixth kind be divided harmonically it is our fifth tune and the ancient Lydius.

Lastly if you divide the seventh kind of diapason (which is from

[1] 'The ancients' means Aristoxenos and those who upheld his thirteen modes (e.g. Cassiodorus and Gaudentius); 'the latter age' or 'our age' means since the eleventh century when the eight Modes were established.

[2] Cf. p. 102.

[3] The later and more usual name is Locrian.

[4] Aristoxenos first used this term.

G to G) arithmetically it will make the ancient Hypoionicus or Hypoi-
astius (for both those are one); but if you divide it harmonically it will
make our seventh tune and the ancient Mixolydius.

Thus you see that every kind of diapason produceth two several tunes
or Modes except the second and sixth kinds [1] which make but one
apiece, so that now there must be twelve and not only eight.[2]

Now for the use of them (specially in tenors and plainsongs wherein
their nature is best perceived). It is to be understood that they be used
either simply by themselves or joined with others; and by themselves
sometimes they fill all their compass, sometimes they do not fill it, and
sometime they exceed it. And in the odd or authentical tunes the
church music doth often go a whole note under the final or lowest key,
and that most commonly in the first and seventh tunes; in the third it
cometh sometimes two whole notes under the final key, and in the fifth
but a half note. But by the contrary in plagal tunes they take a note
above the highest key of the fifth (which is the highest of the plagal) as
in the sixth and eighth; in the second and fourth they take but half a
note, though seldom in the second and more commonly in the fourth.
But if any song do exceed the compass of a tune then be there two tunes
joined together, which may be thus: the first and second, the third and
fourth, etc., an authentical still being joined with a plagal, but two
plagals or two authenticals joined together is a thing against nature.[3]

It is also to be understood that those examples which I have in my
book set down for the eight tunes be not the true and essential forms of
the eight tunes or usual Modes, but the forms of giving the tunes to their
psalms in the churches which the churchmen (falsely) believe to be the
modi or tunes, but if we consider them rightly they be all of some imperfect
Mode, none of them filling the true compass of any Mode.

And thus much for the twelve tunes, which if any man desire to know
more at large let him read the second and third books of Glareanus his
Dodecachordon, the fourth book of Zacconi his *Practice of Music,* and the
fourth part of Zarlino his *Harmonical Institutions,* where he may satisfy
his desire at full, for with the help of this which here is set down he
may understand easily all which is there handled, though some have
causeless complained of obscurity. Seeing therefore further discourse
will be superfluous I will here make an end.

[1] i.e. the octaves beginning on B and F respectively.

[2] The modes as enumerated above agree with the eight 'Gregorian' Modes, and though
M. mentions the thirteen 'ancient' Modes his nomenclature differs slightly from that of
Aristoxenos.

[3] Hawkins (p. 133) mentions a book entitled *Armonia Gregoriana* by one Gerolamo
Cantone and published in 1678 which approves of the practice of joining the Plagal and
Authentic forms of a Mode together, but which Hawkins calls 'a licence which seems
unwarranted by any precedent, at least in ancient practice,' yet M. regards it as customary.

PERORATIO

THUS hath thou (gentle reader) my book after that simple sort as I thought most convenient for the learner, in which, if they dislike the words (as bare of eloquence and lacking fine phrases to allure the mind of the reader), let them consider that 'ornari res ipsa negat, contenta doceri' that the matter itself denieth to be set out with flourish but is contented to be delivered after a plain and common manner, and that my intent in this book hath been to teach music not eloquence, also that the scholar will enter in the reading of it for the matter not for the words. Moreover there is no man of discretion but will think him foolish who, in the precepts of an art, will look for filed speech, rhetorical sentences, that being of all matters which a man can entreat of the most humble, and with most simplicity and sincerity to be handled; and to deck a lowly matter with lofty and swelling speech will be to put simplicity in plumes of feathers and a carter in cloth of gold.

But if any man of skill (for by such I love to be censured, condemning the injuries of the ignorant and making as little account of them as the moon doth of the barking of a dog) shall think me either defectious or faulty in the necessary precepts, let him boldly set down in print such things as I have either left out or falsely set down, which, if it be done without railing or biting words against me, I will not only take for no disgrace but by the contrary esteem of it as of a great good turn, as one as willing to learn that which I know not as to instruct others of that which I know; for I am not of their mind who envy the glory of other men, but by the contrary give them free course to run in the same field of praise which I have done, not scorning to be taught or make my profit of their works (so be it without their prejudice), thinking it praise enough for me that I have been the first who in our tongue have put the practice of music in this form, and that I may say with Horace 'Libera per vacuum posui vestigia princeps,'[1] that I have broken the ice for others. And if any man shall cavil at my using of the authorities of other men and think thereby to discredit the book, I am so far from thinking that any disparagement to me that I rather think it a greater credit, for if in Divinity, Law, and other sciences it be not only tolerable but commendable to cite the authorites of doctors for confirmation of their opinions, why should it not be likewise lawful for me to do that in

[1] 'I first trod on virgin soil' (*Epistles,* i. 19, 21).

305

mine art which they commonly use in theirs, and confirm my opinion by the authorities of those who have been no less famous in music than either Paulus,[1] Ulpianus,[2] Bartolus,[3] or Baldus[4] (who have made so many asses ride on foot clothes) have been in law?

As for the examples they be all mine own; but such of them as be in controverted matters, though I was counselled to take them of others, yet to avoid the wrangling of the envious I made them myself, confirmed by the authorities of the best authors extant.[5]

And whereas some may object that in the First Part there is nothing which hath not already been handled by some others, if they would indifferently judge they might answer themselves with this saying of the comical poet, 'nihil dictum, quod non dictum prius'; and in this matter, though I had made it but a bare translation yet could I not have been justly blamed seeing I have set down such matters as have been hitherto unknown to many who otherwise are reasonable good musicians; but such as know least will be readiest to condemn. And though the First Part of the book be of that nature that it could not have been set down but with that which others have done before yet shall you not find in any one book all those things which there be handled; but I have had such an especial care in collecting them that the most common things which everywhere are to be had be but slenderly touched. Other things which are as necessary and not so common are more largely handled, and all so plainly and after so familiar a sort delivered as none (how ignorant soever) can justly complain of obscurity.

But some have been so foolish as to say that I have employed much travail in vain in seeking out the depth of those Moods and other things which I have explained, and have not stuck to say that they be in no use and that I can write no more than they know already. Surely what they know already I know not, but if they account the Moods, Ligatures, Dots of Division and Alteration, Augmentation, Diminution, and Proportions things of no use they may as well account the whole art of music of no use, seeing that in the knowledge of them consisteth the whole or greatest part of the knowledge of pricksong. And although it be true that the Proportions have not such use in music in that form as they be now used but that the practice may be perfect without them, yet seeing they have been in common use with the musicians of former

[1] Julius Paulus. Third-century Roman lawyer; one of the greatest legal writers of ancient times.

[2] Domitius Ulpianus (c. 170–228). Roman jurist.

[3] A famous Italian jurist (1314–57).

[4] Petrus Baldus de Ubaldis (1327–1406). Pupil of Bartolus and equally as famous.

[5] This statement, of course, does not include those examples which M. has avowedly taken from other composers, e.g. Striggio and Renaldi in Part I, but it makes it all the more surprising that he does not mention Tigrini in the 'Closes' on pp. 229–40.

time it is necessary for us to know them if we mean to make any profit of their works.

But those men who think they know enough already when (God knoweth) they can scarce sing their part with the words, be like unto those who having once superficially read the *Tenors* of Littleton[1] or Justinian's *Institutes*[2] think that they have perfectly learned the whole law, and then being enjoined to discuss a case do at length perceive their own ignorance, and bear the shame of their falsely conceived opinions. But to such kind of men do I not write, for as a man having brought a horse to the water cannot compel him to drink except he list, so may I write a book to such a man but cannot compel him to read it; but this difference is betwixt the horse and the man, that the horse, though he drink not, will, notwithstanding, return quietly with his keeper to the stable and not kick at him for bringing him forth, our man, by the contrary, will not only not read that which might instruct him but also will backbite and malign him who hath for his and other men's benefit undertaken great labour and endured much pain, more than for any private gain or commodity in particular redounding to himself.

And though in the First Part I have boldly taken that which in particular I cannot challenge to be mine own, yet in the Second Part I have abstained from it as much as is possible, for except the chords of Descant and that common rule of prohibited consequence of perfect chords there is nothing in it which I have seen set down in writing by others.[3] And if in the Canons I shall seem to have too much affected brevity you must know that I have purposely left that part but slenderly handled, both because the scholar may by his own study become an accomplished musician having perfectly practised those few rules which be there set down, as also because I do shortly look for the publication in print of those never enough praised travails of Mr. Waterhouse, whose flowing and most sweet springs in that kind may be sufficient to quench the thirst of the most insatiate scholar whatsoever. But if mine opinion may be in any estimation with him I would counsel him that when he doth publish his labours he would set by every several way some words whereby the learner may perceive it to be a Canon, and how one of the parts is brought out of another (for many of them which I have seen be so intricate as, being pricked in several books, one shall hardly perceive it to be any Canon at all) so shall he by his labours both most benefit his country in showing the invention of such variety and reap most

[1] Sir Thomas Littleton (c. 1407–81). *Treatise on Tenures* (1481).
[2] Flavius Anicius Justinianus (483–565). His *Institutes* was intended as a students' manual.
[3] M. must surely have seen Zarlino's examples of Double Counterpoint (cf. pp. 188–199).

commendations to himself in that he hath been the first who hath invented it.[1]

And as for the last part of the book, there is nothing in it which is not mine own; and in that place I have used so great facility as none (how simple soever) but may at the first reading conceive the true meaning of the words; and this have I so much affected because that part will be both most usual and most profitable to the young practitioners who (for the most part) know no more learning than to write their own names.

Thus hast thou the whole form of my book, which if thou accept in that good meaning wherein it was written I have hit the mark which I shot at; if otherwise, accept my good will who would have done better if I could. But if thou think the whole art not worthy the pains of any good wit or learning, though I might answer as Alfonso, king of Aragon, did to one of his courtiers who, saying that the knowledge of sciences was not requisite in a nobleman, the king gave him only this answer, 'Questa 'a' voce d'un bue non d'un huomo,'[2] yet will I not take upon me to say so, but only for removing of that opinion, set down the authorities of some of the best learned of ancient time. And to begin with Plato he, in the seventh book of his *Commonwealth*, doth so admire music as that he called it δαιμόνιον πρᾶγμα—a heavenly thing, καὶ χρήσιμον πρὸς τὴν τῶν καλῶν τε καὶ ἀγαθῶν ζήτησιν—and profitable for the seeking out of that which is good and honest. Also in the first book of his *Laws* he saith that music cannot be entreated or taught without the knowledge of all other sciences, which if it be true how far hath the music of that time been different from ours, which by the negligence of the professors is almost fallen into the nature of a mechanical art rather than reckoned in amongst other sciences.

The next authority I may take from Aristophanes who, though he many times scoff at other sciences, yet termeth he music ἐγκυκλοπαιδεία —a perfect knowledge of all sciences and disciplines.

But the authorities of Aristoxenos,[3] Ptolemaeus, and Severinus Boethius who have painfully delivered the art to us may be sufficient to cause the best wits think it worthy their travail, specially of Boethius, who being by birth noble and most excellent well versed in Divinity, Philosophy, Law, Mathematics, Poetry, and matters of estate, did, notwithstanding, write more of music than of all the other mathematical sciences, so that it may be justly said that if it had not been for him the knowledge of

[1] These canons were not published, but there are two manuscript copies in the University Library, Cambridge, and the Bodleian Library, Oxford, respectively, both bequeathed by Waterhouse. The parts are not in score but the solutions are indicated by signs in the majority of cases.

[2] 'This remark befits an ox rather than a man.'

[3] Aristoxenos (born *c.* 354 B.C.).

music had not yet come into our western part of the world, the Greek tongue lying, as it were, dead under the barbarism of the Goths and Huns, and music buried in the bowels of the Greek works of Ptolemaeus and Aristoxenos, the one of which as yet hath never come to light but lies in written copies in some bibliothèques [1] of Italy, the other hath been set out in print but the copies are everywhere so scant and hard to come by that many doubt if he have been set out or no.

And these few authorities will serve to dissuade the discreet from the aforenamed opinion (because few discreet men will hold it); as for others many will be so self-willed in their opinions that though a man should bring all the arguments and authorities in the world against it yet should he not persuade them to leave it. But if any man shall think me prolix and tedious in this place I must for that point crave pardon and will here make an end, wishing unto all men that discretion as to measure so to other men as they would be measured themselves.

[1] M. has 'Bibliothekes.'

FINIS

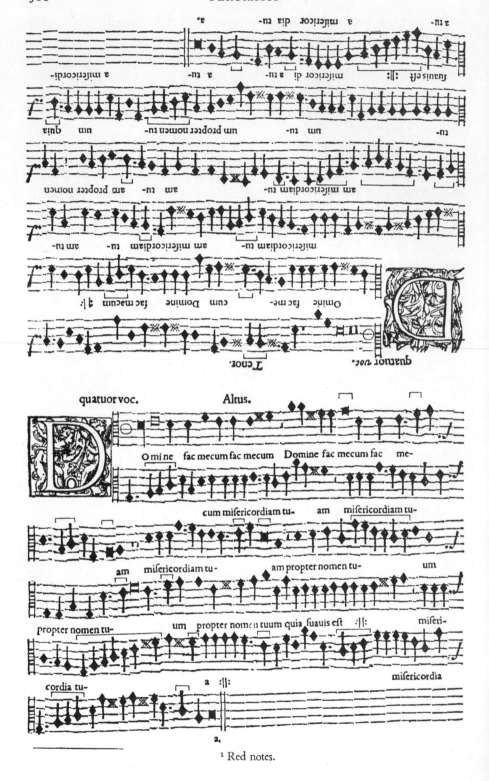

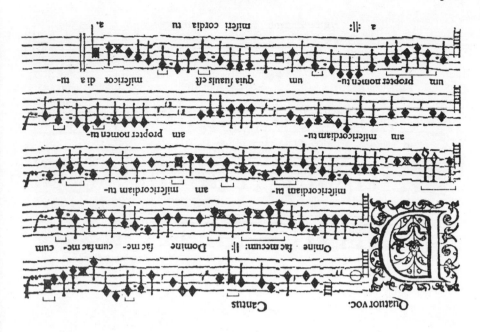

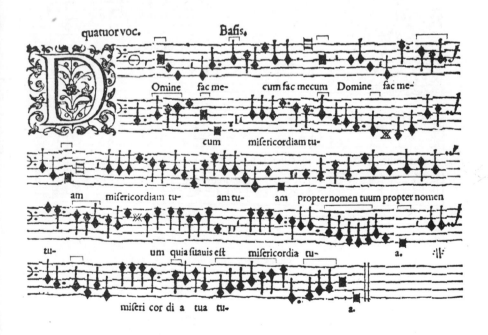

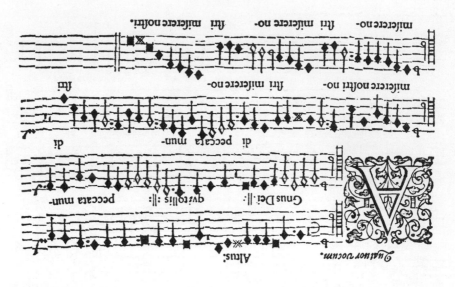

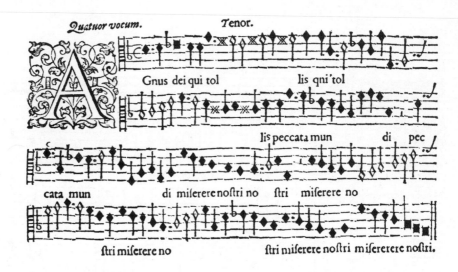

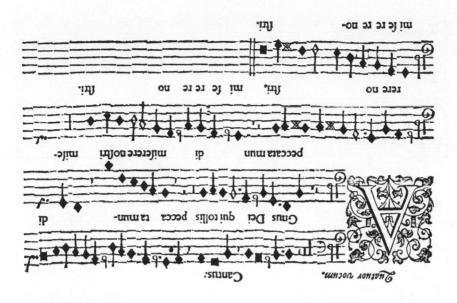

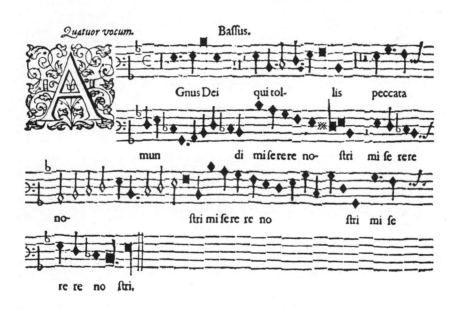

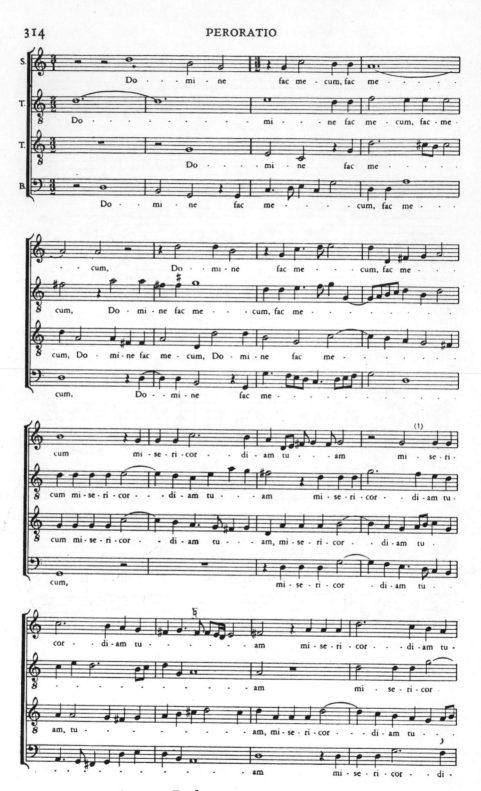

For footnotes, see page 316.

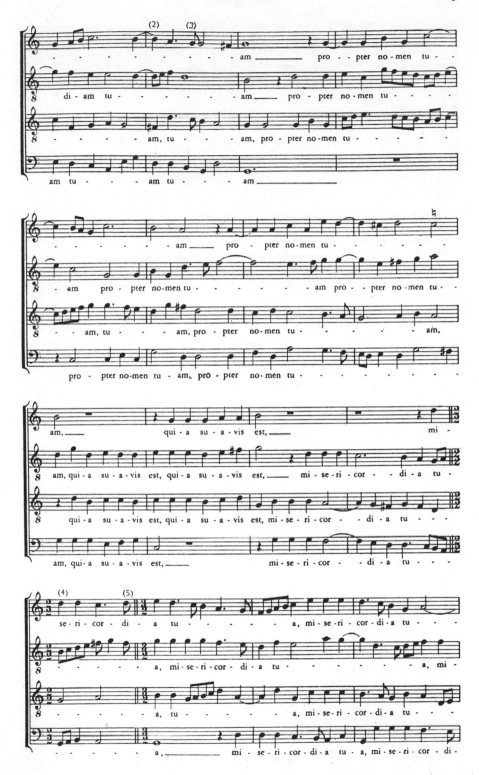

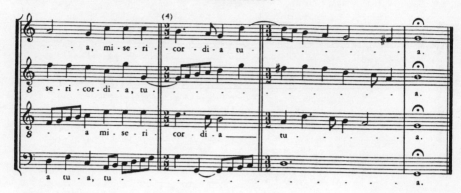

¹ C resolution on to discord caused by passing note.

² B minor chord.

³ Consecutive fifths.

⁴ In this example (and the succeeding one) M. is being deliberately archaic in his manner of notation, but here he has 'broken a rule' by disrupting the ♩♩♩|♩♩♩ implied by 'o'.

⁵ This form of 'consonant seventh' implies C harmony, hence this chord is a passing six-four.

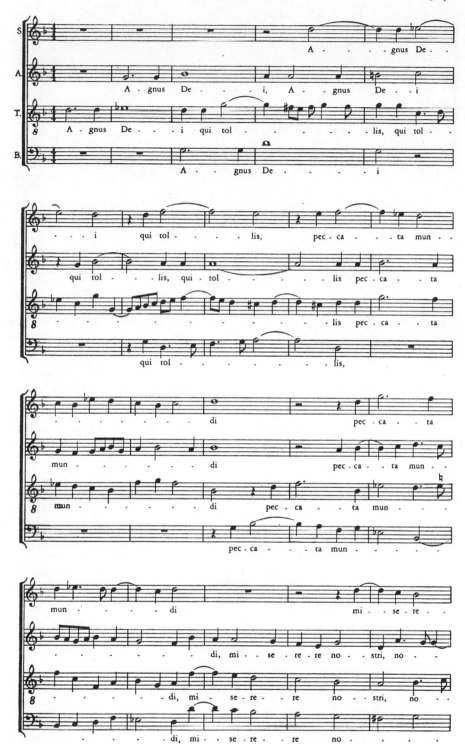

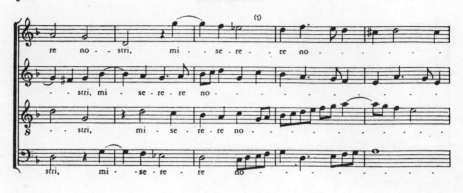

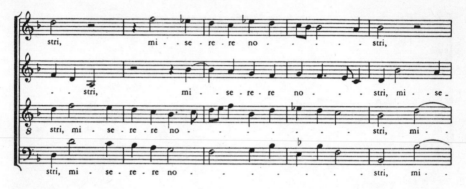

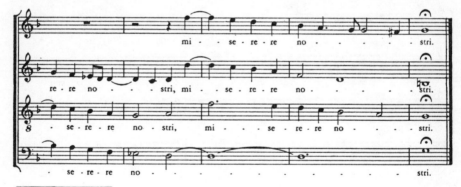

¹ Simultaneous false relation.

AUTHORS

WHOSE AUTHORITIES BE EITHER CITED OR USED IN THIS BOOK [1]

Such as have written of the Art of Music

LATE WRITERS

Jacobus Faber Stapulensis

Franchinus Gaufurius

John Spataro

Peter Aron

Author Quatuor Principal

Francho

Robertus de Haulo

Andreas Ornitoparcus

Incertus Impressus Basileae [?]

Ludovicus Zaccone

Josepho Zarlino

Henric. Loritus Glareanus

Lucas Lossius

Joannes Listenius

Joannes Thomas Freigius [(1543–83). Mentioned in the preface to the 1580 edition of Beurhusius's book.]

Fredericus Beurhusius

Sethus Calvisius

Andreas Rasselius

Nicolaus Faber [*Institutiones Musicae* (1553).]

Joannes Magirus [(*d.* 1531) *Artis musicae* . . . (1611); *Musicae rudimenta* . . . (1619) (first editions must have been earlier).]

Manfredus Barbarinus Coregiensis [Lupus Manfredus Barbarinus.]

[1] I have not added details to any name in this list that occurs either in a footnote in the text or in Grove's *Dictionary*. M.'s spelling is kept, the modern form of surname only being given when the original is misleading. [D.] means that one or more music examples are to be found in Glareanus's *Dodecachordon*. In the list of English composers 'M.' means 'Master of Arts' and 'D.' 'Doctor of Music.' At the end I have added those composers and theorists who occur in the text but not in M.'s list. It is perhaps rather strange that in such a formidable array of 'authorities' the following (amongst others) have been omitted: Victoria, A. Gabrieli, Arcadelt, Willaert, Vicentino, Salinas, Festa, Dufay, Binchois, Goudimel, Isaac, Obrecht.

Ancient Writers

Psellus [Michael. Eleventh century. *Michael Psellus de Arithmetica, Musica, Geometrica* . . . (1557) was probably the work Morley knew.]

Boethius

Ptolomaeus ⎫

Aristoxenus ⎬ Cited by Franchinus

Guido Aretinus ⎭

Practitioners, the most part of whose works we have diligently perused for finding the true use of the Moods.

Jusquin [de Pres. D.]

Jo. Okenheim [Ockeghem. D.]

Clement Janequin

Petrus Platensis [D.]

Nicolas Craen [*Fl.* early sixteenth century at Bois-le-duc. Unsuccessfully applied for the post of choirmaster at Bruges in 1504. D.]

Johannes Ghiselin [D.]

Antonius Brumel [D.]

Johannes Mouton [D.]

Adamus a Fulda [D.]

Lutavich Senfli [D.]

Johannes Richaforte [D.]

Fevin [D.]

Sixtus Dietrich [D.]

De Orto [D.]

Gerardus de Salice [Gerard Dussaulx or Du Saule. *Fl.* first half sixteenth century. D.]

Vaquieras [Vacqueras. D.]

Nicolas Payen [*c.* 1512–59.]

Passereau [Late fifteenth century to early sixteenth. A French priest who published four-part chansons.]

François Lagendre [Jean le Gendre. D.]

Andreas Sylvanus [de Silva? D.]

Antonius a Vinea [*b.* Utrecht, late fifteenth century. D.]

Gregorius Meyer [D.]

Thomas Tzamen [*b.* Aix-la-Chapelle, late fifteenth century. D.]

Jacques de Vert [Giaches de Wert.]

Jacques du Pont [*Fl.* 1535–50.]

Nicolas Gomberte

Clemens non Papa

Certon

Damianus a Goes [D.]

Adam Luyre [*b.* Aix-la-Chapelle, late fifteenth century. A pupil of Tzamen. D.]

Johannes Vannius [Wannenmacher. D.]

Hurteur [?]

Rinaldo del Mel
Alexander Utendal
Horatio Ingelini [Orazio Angelini. *Fl*. second half sixteenth century.]
Laelio Bertani [*Fl*. second half sixteenth century.]
Horatio Vecchi
Orlando de Lassus
Alfonso Ferrabosco
Cyprian de Rore
Alessandro Striggio
Philippo de Monte
Hieronimo Conversi
Jo. Battista Lucatello [Locatello.]
Jo. Pierluigi Palestina
Stephano Venturi
Joan. de Macque
Hippolito Baccuse
Paulo Quagliati
Luca Marenzo

Englishmen

M. Pashe [W. Pasche.]
Robert Jones [*c*. 1485–*c*. 1535. Welshman. Music in the first set of Peterhouse
 MSS.]
Jo. Dunstable
Leonel Power
Robert Orwel [*Fl*. mid fifteenth century.]
M. Wilkinson
Jo. Guinneth [*c*. 1498–*c*. 1563. Welshman. One four-part song in the fragment
 (1530) formerly known as Wynkyn de Worde's Song Book.]
Robert Davis [Davies. *Fl*. second half fifteenth century. Welshman.]
M. Risby [*Fl*. first half sixteenth century.]
D. Farfax
D. Kirby
Morgan Grig [Welshman.]
Tho. Ashwell
M. Sturton [William Stourton. Music in the Eton MS. and in Lambeth MS. 1.]
Jacket [Jacquet? Organist Magdalen College, *c*. 1530–50.]
Corbrand [Or Corbronde. Pieces in Pepysian Library.]
Testwood [A 'singing man' at St. George's Chapel, Windsor. Burnt for heresy
 in 1544.]
Ungle [?]
Beech [?]
Bramston
S. Jo. Mason
Ludford
Farding

Cornish [Cornyshe.]
Pyggot
Taverner
Redford
Hodges
Selby [Shelbye.]
Thorne
Oclande [Or Okeland. *Fl.* first half sixteenth century. Included in Day's Service
 Book of 1560. Member of the Chapel Royal.]
Averie [Averie Burton. *Fl.* mid sixteenth century. Member of the Chapel Royal.]
D. Tie
D. Cooper
D. Newton
M. Tallis
M. White
M. Persons [Parsons.]
M. Byrde

[The following occur in the text but not in Morley's list of Authors.]

[Anon.] *The Guide to the Pathway of Music*

Cochlaeus
Croce
Gastoldi
Giovanelli
Jacobus de Navernia
Jordanus
Mundy
Parsley
Preston
Renaldi
Shepherd
de Vitry
Waterhouse
[Lengenbrunner]
[Heyden]

INDEX

As the book contains no chapter synopses the more important references to subjects have been indicated by numerals in bold type. Numerals in italics refer to footnotes only.